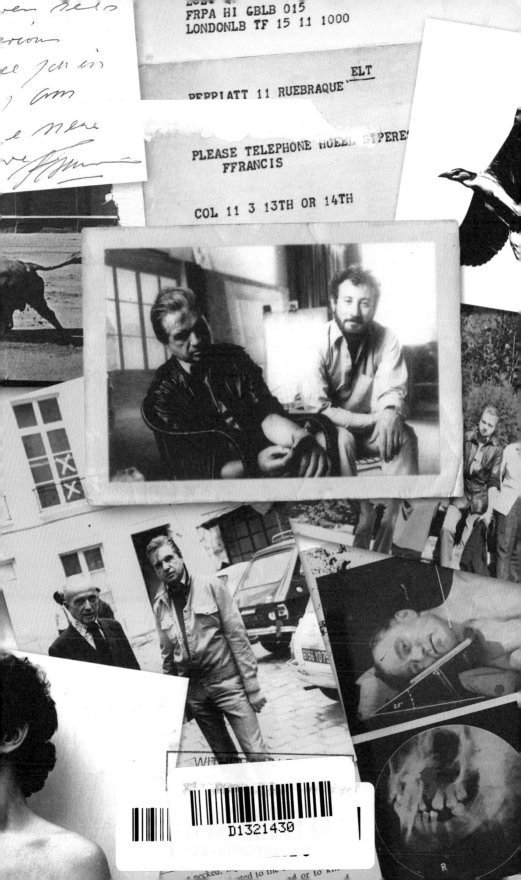

FRANCIS BACON IN YOUR BLOOD

Modern Art in Britain
The School of London
Francis Bacon: Anatomy of an Enigma
Alberto Giacometti in Postwar Paris
Francis Bacon: Le sacré et le profane
Francis Bacon in the 1950s
Francis Bacon: Studies for a Portrait
Caravaggio / Bacon
In Giacometti's Studio
Interviews with Artists (1966–2012)
Joan Miró: A Painter among Poets

FRANCIS BACON IN YOUR BLOOD

A Memoir

MICHAEL PEPPIATT

B L O O M S B U R Y C I R C U S
LONDON · OXFORD · NEW YORK · NEW DELHI · SYDNEY

Bloomsbury Circus
An imprint of Bloomsbury Publishing Plc

50 Bedford Square
London
WC1B 3DP
UK

1385 Broadway
New York
NY 10018
USA

www.bloomsbury.com

BLOOMSBURY and the Diana logo are trademarks of Bloomsbury Publishing Plc

First published in Great Britain 2015

British Library Cataloguing-in-Publication Data
A catalogue record for this book is available from the British Library.

ISBN: HB: 978-1-4088-5624-6
ePub: 978-1-4088-5623-9

2 4 6 8 10 9 7 5 3 1

Typeset by Newgen Knowledge Works (P) Ltd, Chennai, India
Printed and bound in Great Britain by CPI Group (UK) Ltd, Croydon CR0 4YY

MIX
Paper from
responsible sources
FSC® C020471

To find out more about our authors and books visit www.bloomsbury.com.
Here you will find extracts, author interviews, details of forthcoming
events and the option to sign up for our newsletters.

To Jill, Clio and Alex

Contents

Preface

'Mad, bad and dangerous to know' as he was, Francis Bacon became a father figure for me and the central influence on my life. I was twenty-one when I first met him in Soho in 1963, and Bacon was fifty-three, still youthful, energetic and keenly enjoying the attention that his first retrospective exhibition at the Tate had brought him. What began as a brief interview for a student magazine turned into a close friendship that lasted nearly thirty years.

I have already published a biography of Francis Bacon, bringing together all the available information about his life and setting it against the background of his achievement as one of the most inventive, influential and subversive artists of the twentieth century – and, arguably, of art history as a whole.

The book I have written here is a very different animal. Far from the objective account of a life, this is the subjective story of two lives, focusing on the complex, volatile relationship that bound Bacon and me together over those three decades. Drawn from diaries and records I kept at the time, it presents an intimate, revealing portrait of the artist as friend and mentor. Bacon comes across here in ways that no formal biography could convey: close up and unguarded, grand and petty, tender and treacherous by turn, and often quite unlike the legend that has grown up around him.

The story also recounts what it was like for me, an impressionable young man, to be drawn deeply into the orbit of an immensely vitalizing, manipulative genius. Fascinated by his magnetism and sheer devilry, I followed Bacon for years into a maze of louche bars and clubs night after night until dawn, discovering the worlds he moved in, recording what he said, who we fell in with and how he behaved. I was entranced by the freedom and gusto with which Bacon drove his life and his luck forward, recklessly. As we cut a swathe through Soho I came across all kinds of extraordinary people and strange places, eventually joining Bacon's inner circle and spending memorable evenings with George Dyer, Sonia Orwell, Lucian Freud, John Deakin and Michel Leiris.

Long after my original interview was published, I kept going back to Soho, where Bacon would always greet me with champagne and marvellous meals in the best restaurants in town. Desperate to find my own direction in life, I was drawn to Bacon not just because I had enormous fun going around with him but because he exuded such self-confidence and purpose. In my eyes, he was first and foremost an artist whose vision had been forged by extreme inner conflict. From Bacon I learnt that my own contradictions could only be resolved by letting myself drift as freely as possible. Drifting with Bacon, from the Ritz to the last seedy outpost of the night, grew more important to me than any career or university degree. I wanted to go further and know more, and as new horizons opened, so did the hidden temptations and pitfalls. But I had Bacon at my side. He always knew how to avert danger at the last possible instant. Perceptive and adroit, he also knew exactly how to respond to a confused young man and, as he put it, 'to pull him through his despair'.

From time to time, when he had finished a new picture he particularly liked, Bacon would invite me to come and look at it in his studio, where few people were ever admitted. I talked to him in depth about his paintings, and as he took me into his confidence about the sources, aims and techniques of his art, I began to write about his work. Soon I was as fixated by the

intense, twisted vision of Bacon's paintings as by the power of his iron-willed personality.

Having left Cambridge without finding a job I wanted in London, I set off for Paris in 1966 to work on a French magazine. Once there, I imagined my friendship with Bacon would fall away. But Paris, the city of Picasso and Giacometti, was the place where Bacon most craved recognition as an artist. My living there acted as a catalyst for him to cross the Channel more frequently, and in time he asked me to find him a studio where he could work whenever he wanted. Paris turned out to be the theatre of Bacon's greatest triumph and his worst disaster. Just as his Grand Palais exhibition opened to universal acclaim, Bacon's ill-starred lover and muse George Dyer committed suicide in their hotel room.

In the aftermath of that tragedy Bacon spent longer and longer periods in Paris, feeding his guilt and completing a series of profoundly moving paintings dedicated to the memory of his dead companion. During those two remaining decades of Bacon's life, our friendship deepened and I shared his innermost thoughts about life and death, love and art and, as he saw it, the ultimate futility of human existence. We embarked on endless conversations and epic drinking bouts, blurring night into day, day into night, that continued until shortly before Bacon's death.

Having lived to tell the tale, I recount it here as indiscreetly as Bacon once recommended I should, sketching in the parallel events of my own life as the story unfolds. In this respect, *Francis Bacon in Your Blood* can be seen as a double portrait, a diptych of the kind Bacon sometimes painted, showing two profiles, two personalities, two lives closely intertwined.

A feature article came out a while ago in the *Observer* in which the author, Peter Conrad, interviewed three men who had been close to Francis Bacon in their youth. He described each of them as having been 'burnt' for life by their contact with the painter.

The implication was that you did not survive the influence of a genius as dark and powerful as Bacon. The three men were the photographer Peter Beard, the artist Michael Clark, and myself.

Since reading the article I've thought on and off about that provocative view. Yes, of course, there are risks involved when, at the age of twenty-one, you get caught up in a whirl of drink, drugs and gambling, predatory homosexuals, seedy clubs and East End thugs. But, if you do survive, what a revealingly accelerated introduction to life it is – and what an unusual story it leaves you to tell.

And although to some extent Conrad was right, because the intensity that Bacon radiated did transform my life, I am convinced I should have been a much duller person if I had not passed through his fire. I think it was the making of me, and certainly proof of Nietzsche's dictum that what does not destroy us makes us stronger. So I have decided to tell that story in full, with its seamier sides set in the perspective of my own self-discovery, its harshness and despair leavened by profound admiration, gratitude and love.

It's a story I have been wanting to write for years, telling it as it really was, before the world I shared with Bacon vanishes and is retold by those who were never there.

Michael Peppiatt
Paris, May 2015

PART ONE

1963–1966

Absolute Beginner

It is June 1963. The streets of Soho have just been hosed down and look almost fresh in the midday sun. Inside the French House it is darker and danker, and the scrubbed floorboards give off a sour odour of detergent mixed with beer. A few scattered drinkers are at the bar, communing quietly with the glass before them or exchanging the odd word with the burly manager with a walrus moustache standing behind the beer pumps. They are all regulars and all much older than me. I feel out of place, out of my element and uncomfortably conspicuous, even though no one has bothered to so much as look my way.

Then the lunchtime crowd comes in, rapidly filling the room with loud banter and laughter. The warmer smell of wine and cigarettes takes over. A faint, brownish sunlight brightens the room for a moment, illuminating the clouds of smoke. Everyone is growing increasingly relaxed and jovial, talking across the bar in booming voices and laughing at their own and one another's jokes. It would be dead easy to talk to them, but I can't. I can't even pretend to be part of all this. I have been standing here since opening time, nursing a half-pint, ill at ease and nervous, rehearsing what I have to say. And if I don't manage to say it soon I will have failed and I'll have to go all the way back to college empty-handed. Somewhere among the drinkers in this growing fug I have to find a photographer

called John Deakin. I need to track him down and ask him for
a favour . . .

This was the first time I had been in the French House, which
took me a while to find that morning since, confusingly, it was
still known to most locals by its pre-war name, the York Minster.
Although I had turned twenty-one and knew London well
enough, I wasn't that familiar with Soho beyond its reputation as
a louche area where sex and exotic foreign food were on offer. As
a teenager I'd gone on a rite of passage to the 2i's café to listen to
skiffle groups, sipping frothy coffee out of transparent cups and
hanging around in the hope of spotting Tommy Steele. I went
back occasionally because the markets, clubs and prostitutes
made the area more alluring and colourful than most of drab,
post-war London.

 Both my parents were London-born but my father later
insisted we had to live 'right in' (he himself had been brought
up on Clarges Street, a stone's throw from Piccadilly) or 'right
out' of the capital. Since he did not have enough money to buy a
house in the centre of town, we moved 'right out' to a village in
Hertfordshire called Stocking Pelham, where I spent long, bored
holidays, frustratingly out of touch with the friends with whom
I boarded at Brentwood, the minor public school my father
had chosen to send me to. I travelled to London occasionally,
often on my way to France or Germany, to improve the two
languages I had specialized in at school. After changing from
Modern Languages to Moral Sciences very briefly after my first
year at Cambridge University, I settled on the History of Art,
although I was soon chafing at the assumption underlying the
whole syllabus that nothing of lasting quality or interest had
been achieved in art since Raphael, or at most Rubens – to both
of whom I developed a distinct allergy that lasted for years.
But this was the early sixties, and although we students had
been corralled into the Renaissance and told to consider it the
unsurpassable peak of human achievement we were aware that,

minor as it seemed beside the thriving music scene, a modern art world existed out there beyond the faculty walls. Progressively disenchanted with my professor, himself the world expert on Rubens, I was determined to get to know more about what was happening in contemporary art – 'living art', as I thought of it – driven more by an impulse to challenge entrenched attitudes, it has to be said, than to explore the new . . .

At the same time, having failed to get a short story published in the literary review *Granta* – where I so feared rejection that I sent my text in anonymously – I found some solace in another student magazine called *Cambridge Opinion*. What set this august-looking publication apart was that, although produced by undergraduates, it devoted each issue to a particular theme, usually of a scientific or political nature, and invited the acknowledged specialists in that field to contribute their expert views. This editorial method worked well enough for a number of years, but the magazine had recently fallen on hard times and run up debts with the printers, who decided they no longer wanted to be part of such a risky venture. With the confidence of youth and total inexperience, I persuaded the printers that only by continuing publication could they hope to recoup even part of the outstanding sum. Then, to bolster the impression that the magazine might become financially viable, I grandly recruited a staff of other students, appointing two of them to bring in whatever paid advertising they could find. As for the theme of my first issue, there had never been any doubt. *Cambridge Opinion* had barely touched on the arts in any shape or form, at least not in the handful of past issues that had come my way. This only convinced me further that I was on the right track, preferring to see my choice as a way of extending the magazine's scope rather than cocking a snook at the hidebound art history course I was about to quit. The revived magazine would of course focus on the then rarely discussed, indeed virtually unheard-of, theme of 'Modern Art in Britain'.

It was only once I had proudly announced my new role as editor to everyone I knew and basked for a moment in the

unspecified importance it appeared to confer that I realized
with a jolt I had no idea how or where to start on my first
issue. Although I had gone to the odd exhibition at the
Fitzwilliam Museum and had even seen the modest twentieth-
century collection at Jim Ede's 'open house' in Kettle's Yard,
my understanding of what constituted the 'Modern', whether
in Britain or anywhere else, stopped at a few billowing forms
with holes in them – the stuff of newspaper cartoons, which
usually mocked the foolish pretentiousness of it all. Brought
up in a house that had no pictures of interest on the wall, my
first-hand experience of contemporary image-making was
limited to the watercolours that my father produced during
holidays on the beach in Suffolk; although I would never have
admitted it later, as a small boy I was entranced by the ease with
which he would pencil in random V's to evoke gulls hovering
over a still aptly wet sea; and the more adventurous of these
seascapes were eventually framed and displayed at home, until
one day there must have been an abrupt change of mood since
they were taken down to a cupboard where my father kept
relics of other abandoned pursuits, including a forlorn bag
bristling with golf clubs.

Then David Blow, a friend at Trinity Hall who came from
a more sophisticated background than mine and had some
contacts in the London art world, suggested that if I wanted
my first issue to be taken seriously I had to include a painter
called Francis Bacon. Although the name for me evoked only an
Elizabethan philosopher whose essays I had never read, David
told me that this living Bacon had just had a successful, if highly
controversial, exhibition at the Tate. Since the war, David said,
the British art scene had grown accustomed to a mild-mannered
imagery that avoided disturbing the viewer at all costs; our
parents had after all been through enough nightmares. For
sure there had been occasional eruptions from the continent in
the form of painters like Picasso and Dalí, David went on, but
foreigners didn't in the end affect us so much. Bacon, on the

other hand, the scion of a long-established English family, was seen as having painted deliberately provocative and manifestly godless pictures. Nevertheless, a core of strong supporters in the more avant-garde circles thought of him as the most important living painter in the country. David easily convinced me that if I could get an interview with Bacon this whole new venture of mine would gain credibility. By meeting the well-known Soho photographer John Deakin, who had taken numerous photos of Bacon's models, David added, I might get just the introduction to Bacon that I needed. Deakin had also photographed David's own glamorous mother, so that already provided some kind of link. All I had to do was to get myself down to the French House in Soho and hang around . . .

A small man is sitting just behind me on a stool by the bar, talking in an exaggeratedly posh, camp voice and waving his cigarette holder about. He is oddly dressed, in stained sweater and ancient trousers, with his head nestling in the upturned collar of a grubby shearling jacket. I don't remember seeing him come in, but now he looks as if he has always been there, as if he were the pub's mascot, addressing his running commentary to the whole room rather than to anyone in particular. I recognize him right away, even though his face is much puffier and more lined than in the self-portrait photos I'd seen of him. I edge closer, draining my glass with what I hope is nonchalance, and blurt out my request for an introduction to Bacon.

'First of all, my dear,' the little man enunciates in pompously drawn-out tones, 'you should know that you have the privilege, the rare honour, to be addressing the celebrated photographer *and* artist John Deakin, also frequently known, sometimes with nostalgia, always with respect, as the "Mona Lisa of Paddington".' Here he rolls his big spaniel eyes up as if in prayer to the pub's mottled ceiling. 'Then, my dear, you should consider that the maestro you mention has of late become so *famous*', Deakin's voice rises here, nettlingly, emphasizing each syllable over the

din of lunchtime booze, 'that *she* no longer talks to the flot-sam and jet-sam, the Tom, Dick or Harry, the *je ne sais qui* and the *je ne sais quoi* of the hoi polloi. Now that *she* has had an exhibition at the Tate Gallery of London Town and become so *fa-mous*, so *fa-mous*, I fear *she* wouldn't even consider meeting a mere student like you!'

There is a commotion at the bar, and a man about four backs down turns round. He has a wide face with piercing pale eyes.

'Don't listen to that old fool,' he says. 'I simply adore students. Come and join us. Now what are you having to drink?'

After such a long tense wait I am a bit startled to have got what I wanted so soon. However young, inept and poorly dressed I feel, I am suddenly the centre of attention, transformed into a novelty, with bystanders moving in to greet me with genial interest. Francis Bacon has thrust a glass of white wine into my hand and is looking at me intently. 'Here's to everything you want,' he says to me, anointing our newly formed group with a radiant smile. 'I can't wish you more than that, can I?' 'To everything you want,' the others repeat in unison, as if we have engaged in a secret rite. The glasses go back, the toast is drunk, the glasses are refilled.

An hour later, with my idea of an interview already accepted as if it were a privilege for a famous artist to share his creative thoughts and process with a tiny student readership, Francis Bacon has swept me off, with Deakin and the others who are all apparently part of his inner circle, round the corner to lunch at Wheeler's. As soon as Bacon pushes the door back and leads in his band of now visibly merry men, heads turn and the temperature in the murky dining room shoots up. Waiters are all smiles and the manager hurries past the oyster bar to greet his famous guest and lead him to his favourite table by the restaurant's mullioned windows. More bottles appear, orders are taken, jovial remarks exchanged, then platters of oysters on ice and seaweed arrive in rapid succession as if time itself has accelerated. Buoyed by the

Chablis and flattered by the attentions of my host, who includes me in every turn of the conversation, I watch surreptitiously to see how the others negotiate their oysters and soon follow suit, too caught up in the cut and thrust of the talk to wonder whether I like either the briny taste or their slimy texture. Then various exotic-sounding soles are served, *sole meunière, sole bonne femme, sole Walewska,* and the conversation opens out.

'For some reason oysters are supposed to be terribly good for you,' Bacon is saying between gales of laughter. 'It sounds mad but my mother used to make a kind of mousse out of seaweed when we lived in Ireland. It was very delicious and apparently very nourishing. And I was in Nice the other day and they gave us these things, I've forgotten what they're called, *violets* I think, and they're like little leather pouches that are also full of iodine. You slit them open to eat them. A doctor down there told me they're terribly good for you because they filter out what's called all the impurities of the sea and they're given especially to anaemic children. Well . . .'

'Francis, you're the least anaemic child I've ever known,' says one of his guests, pushing his purplish face forward.

'Well, I'm afraid with all the drink the goodness is probably just washed through,' says Bacon with mock remorse.

'You might not believe it now,' Purple ventures, 'but I once knew someone who was so in love with me that he said he wanted to lick caviare off the back of my throat. I had a large pot of beluga . . .'

John Deakin, sitting demurely opposite him, rolls his eyes at me.

'I can't think who you expect to impress with that kind of rubbish,' Bacon ripostes, suddenly looking cross. 'The trouble with you, Denis, is that you're coarse. The very texture of your sensibility is coarse. And I'm afraid it's what shows in those ghastly little paintings you do.'

Denis seems to relish the rebuff, exult in it even. He is about to come back with a further witticism, but a pale, wiry man

called Lucian heads him off. Lucian's wearing a white shirt
with the sleeves rolled up tightly and the sort of thin, blue-and-
white-chequered trousers that chefs use in hot kitchens. 'Did
you know that for all their Dover soles and French recipes the
cooks here are actually Chinese to a man?' he says in a soft,
lisping voice that sounds oddly foreign. 'I met one of them
just outside the other day and asked him how he was. Mustn't
glumble, he said.'

'Well, he's right,' says Bacon, emptying his glass emphatically.
'There's no point. After all, life is all we've got, so we might as well
enjoy it as much as we can. Nietzsche said that since the whole
thing is such a charade we might as well be as brilliant as we can
be. Even if it is only being brilliant about nothing. Because we
come from nothing and go into nothing, and in between there's
only the brilliance of life, even if it means nothing. We don't
know much, but that at least I think we do know. Don't you
think, Michael?'

I nod vigorously, old head on young shoulders, anxious to look
as though I could be frequently brilliant about nothing. Just say
the word.

'I've been looking at Michael's ginger sideburns,' says Denis,
his purple cheeks gleaming with suppressed innuendo, 'and
thinking they must be the exact colour of his pubic hair.'

'Oh do shut up, Denis,' Bacon says irritably. 'The more she
drinks, the more rubbish she talks.' He takes a pink comb with
half its teeth missing out of his jacket and puts it in his ear like a
hearing aid. 'What's the silly old cunt saying now? What she say?
Same old rubbish? Well, there it is, we might as well be brilliant,
even though we have to put up with Denis's stupidity, because
there's simply nothing else to do, even to pass the time. After all,
life itself is nothing but a series of sensations. We just drift from
moment to moment. My whole life has been like that, you know,
drifting from bar to bar, person to person, instant to instant. And
I think particularly when you're very young and very shy, with
all that talent welling up inside you, it's what you have to do.

You have to drift until you find yourself. Simply drift and see . . . There you are. I expect I've been talking too much. Now let's have some more wine.'

'The thing about Nietzsche', Lucian says, softly enunciating each syllable with his faintly foreign accent, 'is that he is terribly, terribly clear about our human predicament. He says that marvellous thing about all history being placed in the balance again when a genius is born with, what is it, "a thousand secrets of the past crawling out – into his sun".'

'Well, of course that is a marvellous way of putting it,' says Bacon, opening his hands widely towards the whole table. 'But then I've always thought that Nietzsche said everything that your grandfather was to say, that all Freud is contained in Nietzsche, even though I admire Freud very much, but more as a writer than anything else. I think he was a marvellous writer, but Nietzsche was this kind of extraordinary precursor. Every now and then there's a writer or an artist who comes along and completely alters the course of things, breaks the accepted mould and reinvents the way thought and feeling are conveyed. Because you could also say that you get the whole of Cubism in Cézanne. That it was already there, like a distillation. And I know people say how marvellous Cubism was, but I see it almost as a kind of decoration on Cézanne.'

Bacon pauses, to see if there is any reaction among his guests. Then he goes on:

'When I was young Cézanne was the god, but I myself have always preferred Van Gogh. I think he was the more extraordinary artist and a more extraordinary man. You get everything in his letters, for instance. I reread them all the time. People make him out to be some sort of inspired fool, a naïf, but he was immensely intelligent and sophisticated, with ideas about everything you can think of, even about cancer and things like that.'

There's a moment's silence as we all take a slow, reflective pull at our wine, evaluating and absorbing this compact statement. Halfway along the table there's a powerfully built man in a

formal suit and tightly knotted tie who's said nothing but who's been drinking steadily right through the meal. A large plate of pale smoked salmon with two wedges of lemon lies untouched in front of him. He looks like a retired wrestler or a nightclub bouncer. Alongside the white wine, he's been ordering gin and tonics regularly, but otherwise he seems elsewhere, closing his eyes from time to time and just feeling for his glass. Even with his eyes shut, he exudes a kind of threat, and I sense he is someone to be wary of. But I am too excited by the wine and the exalted talk – Nietzsche, futility, Cézanne, drifting – to take much notice. It's all much more than I could ever have expected. The interview seems already in the bag because Bacon clearly likes to talk and all I have to do is to make a mental note of what he's saying and get it down on paper once I'm back in Cambridge. It couldn't be easier, it seems, especially since Bacon often repeats the same phrase or comes back to something he's already said and expands on it. It's as simple as getting the gist of a lecture but without the complicated dates and developments, and much more exciting. Much more about life and about the way things are. Bacon also actually seems interested in what you have to say and responds to it, even defers to you, saying things like 'I'm sure you know much more about this than I do', unlike all those dons who simply talk at you and expect you to note it down. More vital to be here at the centre of things, in the middle of Soho, drinking and talking freely with someone creating images now, than sitting in a lecture room looking at slides of things done centuries ago in churches in Bruges or Perugia or wherever. Much more fun: life on another plane, speeded up, more glamorous.

'Now why don't we have just a little port with the Stilton,' Bacon suggests, and at exactly the same moment the bouncer's head crashes forward on to the table.

'He's passed out!' Denis cries out exultantly. 'I thought he might. Our friend here has clearly been on one mighty bender for days and days.'

Once again, Deakin rolls his eyes, as if all the niceties of behaviour to which he is accustomed have been flung to the wind, and gazes over at me meaningfully.

Scenting trouble, two couples finishing their lunch behind us move discreetly to another table. Still smiling, the manager comes bustling over, visibly unfazed by such a minor fracas.

'Had the one too many, has he, Francis?' he asks.

'I'm afraid he has,' Bacon replies, with his hands outstretched. 'I am most terribly sorry. I had simply no idea he was in what's called such an advanced state.'

'Don't you worry, we'll soon have him right,' says the manager, and with Lucian's help he props the bouncer back in his chair and delicately peels off the fragments of smoked salmon sticking to his face. The bouncer's eyes open unseeingly for a moment then close again as he slumps to one side.

'I don't really know who he is,' says Bacon. 'He just always seems to be there whenever I go into the French so I thought I'd better ask him to join us. I'm not even sure what his name is. There it is,' he continues, with an apologetic chuckle towards me, 'I suppose that's the kind of thing that happens when you lead the sort of gilded gutter life that I do, constantly surrounded by nothing but drunks, layabouts and crooks.'

'I'm afraid it is,' Deakin intones solemnly. 'I think it's what's called "the company she keeps".'

Everyone laughs, the port is poured, the conversation gets under way again, but more slurringly now. Bacon begins to repeat some of the same phrases, with growing emphasis, as if someone were contradicting him. 'The whole thing is so ridiculous.' But his guests seem to take no notice as they finish their cheese and savour the dark wine. 'We might as well be absolutely brilliant.' Even Denis nods dutifully in approval at what he clearly accepts as self-evident truths. 'Bar to bar, person to person.' Drunk as I've become, I want to make sure I don't outstay my welcome, even though no one else makes a move and it looks as if the talk might go on through the rest of the afternoon and into the night.

'Moment to moment.' I get a rush of panic, not least because my glass has been filled once more to the brim and it occurs to me that, having got here and been so warmly embraced as the newcomer, the latest addition to the group, I may never get out again but be held there in ever-decreasing circles of words for ever. It feels as if all sense of time has been siphoned out of the air and replaced by repetition. 'Drift and see.' The room, even the ring of faces round the table, is closing in. 'Drift and see . . .' I'm desperate to leave, even a bit panicky, and decide I'll say I absolutely have to be back in Cambridge this evening. I'll thank my host very sincerely and ask him whether we might meet again to take the interview forward, but before I can struggle to my feet I realize Francis has turned towards me saying, 'Dan Farson has opened this pub on the Isle of Dogs and he's got a party on there tonight so I thought we might have a little more of this port, it's really rather good, then get a taxi down to the East End. I don't know whether you're at all free this evening but there is something extraordinary about the people Dan manages to lure to his place, a kind of mixture of what they call villains and film stars. I took Bill Burroughs down there the other evening and I think he did actually find the whole thing quite curious. So if you've got nothing better to do why don't you come along, you might just find it amusing.'

I'd been eyeing the door as the only way out of this weird sensation of time circling and decreasing. But the very name of Bill Burroughs stops me in my tracks since at Easter I managed to smuggle Olympia Press's banned edition of *The Naked Lunch* in its murky green covers back from Paris and, quite apart from the jolt its experimental techniques deliver, the very fact I have it prominently displayed in my college room gives me undeniable status as someone in the vanguard, abreast of the radically and dangerously new. The idea of meeting Burroughs – and even being able to think of him as 'Bill' rather than 'William' – is astonishing, barely more probable and certainly more exciting than the suggestion that I might rub shoulders with Botticelli, or

even Michelangelo, whose *terribilità* makes him the Renaissance
figure I'm most drawn to. But Bill Burroughs, as I suddenly feel
empowered to think of him, has completely altered the way we
think and write at this our very own point in time, just as Bacon
is transforming the effects and future of painting and, even more
importantly I'm beginning to sense, the way one feels about life
itself. The 5.45pm back to Cambridge slips soundlessly away
and I vaguely entertain the possibility of the milk train that I've
heard leaves King's Cross towards dawn, since the last late train
will no doubt be long gone by the time we get down to the Isle
of Dogs, which sounds more like a moated penitentiary than a
pub, have a few drinks and manage to get back into town.

I've never had this much to drink and so I'm pleased to see as
we get up after punishing another bottle of port that I'm walking
more or less normally, at least as far as I can make out, as well
as feeling more confident and relaxed again. But John Deakin is
insisting we go down to some wine cellar he knows and as Lucian
slips off with barely a word I wish I could follow him, particularly
since the sun's still shining, it's such a beautiful late afternoon you
could be reading under a tree in the park, and when we get down
to John's *cave* it's pitch black, apart from the candles guttering
away on upturned barrels, and a sharp vinegary smell pervades
the place. That doesn't stop John from ordering what he calls
his favourite Côtes du Rhône or Francis from paying for it, with
John acquiescing without a word since Francis says, 'Look, I've
got all this money on me, what's the point of having money if
you can't buy things with it.' But when the wine comes Francis
pronounces it 'filthy' and pours his glass on to the ground and
we all follow suit, and he orders a fancy-sounding vintage which
I can see in the flickering candlelight from a list chalked up on the
wall costs several times as much, and which Francis, whose mood
seems to have swung, deems possibly corked and barely better.
His breathing has become slightly wheezy and laboured.

'I might live in squalor,' Francis confides in an undertone, 'but
I don't see why I have to drink filth. After all, even if what are

called one's friends have no taste,' and here he shoots a venomous glance at John, who flinches perceptibly, 'I myself always want the best of everything, for myself and for my friends. I want the best food and wine I can get as well as the most excitement and the most interesting people around. The thing is I have known a few extraordinary people in my life,' he continues, waving a meaty hand towards the ceiling which seems to exclude present company, 'people with real natural wit and who were tougher and more intelligent than me. And of course when you've known one or two people like that, most of the others just come across as weak and dreary, poor things,' he emphasizes, looking pointedly at John and Denis, but not I'm relieved to find at me, whose eye he catches now.

'The thing is, Michael,' Francis says, 'I have known just a few people like that, who thickened the texture of life and took you out of the banality of existence just for a moment, as I believe Velázquez must have done for Philip IV, brightened his existence by his wit and his talent just for a moment. But there it is, life is nothing but a finite series of moments, so the more intense they are the better. Perhaps that's why I don't sleep very much any more even though I have got all these pills to relax me. I can't see the point of relaxing or going to sleep. I could never relax on a beach, the way people do, and just doze. After all, I've got such a big sleep coming up, it's coming closer and closer, always closer and closer,' he adds with a laugh, 'that there's no point in sleeping, *c'est pas la peine*. There it is. I decided early on that I wanted an extraordinary life, to go everywhere and meet everybody, even if I had to use everybody I met to get there. Life's like that. We all live off one another. You only have to look at the chop on your plate to see that. I expect that sounds pompous, it probably is pompous. But there it is. I've always bought my way through life,' Francis concludes, more exuberantly now, and pulling a ball of banknotes from his pocket he drops the price of another expensive bottle as a tip on to the wine barrel in front of us, 'but then what else is money for?'

We get to our feet again, and I see John, as imperturbable now as before, eye the large tip greedily as we clump up the steps into the evening, dark into dark, and settle ourselves in a taxi crossing first the heart of the city then some of the grimmest areas of London I have ever seen, with deserted dark streets, low black bridges and the occasional half-reclaimed bombsite on either side, followed by a long trip through a virtual vacuum eerily lit by towering overhead sodium lamps. Francis has insisted I sit in comfort in the back with John Deakin and Denis Wirth-Miller while he has the jump-seat opposite; he clings to the strap overhead with both hands as if his life depends on it. Francis seems to seek out situations where he is worsted or punished. He didn't have to pay for John's bad wine or to leave such a huge tip for the little service it took to plonk two dubious bottles and some glasses down. It's like a sort of masochistic generosity, but I notice that it stops when he expresses opinions about other people which are harsh and apparently definitive. I'm glad to be on the right side of him and wonder if it will last once he gets to know me better and sees through me, as I'm sure he will, with those eyes that seem to pierce and take everything apart even when he's being friendly. I'm cheered, though, to have passed the test this far. We all sit in silence in the jolting, creaking cab for a while; even Denis has stopped talking, numbed by the accumulation of wine which hangs over us like a pall. Drink is our element now, I think confusedly, we have to live by its rules. I lapse into sleep for what I think is a couple of minutes and only wake up as the cab comes to a halt in front of a large, brightly lit building with 'THE WATERMANS ARMS' announced in gold letters on a red ground running right around its top floor.

Inside is the biggest party I've ever seen. There's music and some couples dancing, but most people are just standing round with glasses in their hands talking and laughing. I see some attractive girls but they're all older than me and a bit intimidating in the eye-catching short skirts they're wearing. I'm also struck by how smooth many of the men look in their velvet jackets and

bright ruffled shirts. Nobody seems to mind my dull polo-neck
sweater and I'm soon finding my feet (forget those old, cracked
shoes) and feeling proud to be at the centre of a new world as
Francis's new protégé with lots of fashionable chat and the feel of
easy money flowing through the cavernous room. I vow to buy
myself a shocking-pink shirt, which I've never seen anywhere
in Cambridge, and I fall into conversation with someone in
advertising, florid and middle-aged but still boyish-looking, who
seems to be very interested in art and my opinions about this and
that until he gets a funny look in his eyes and I feel he might be
interested in me for the wrong reasons, clearly a lot of it going
on here, and I move on, from group to group, exulting in my
ease and not even minding being extravagantly propositioned,
this one is suggesting I go on to another party, perfectly alright,
people he knows, all I have to do is to stand naked and take the
whip, a guinea a lash, just have to stand there, nothing to it, won't
hurt because they'll probably want the plastic mac bit anyway,
you know, breaks the blows but everything shows and flows, and
he won't take no it's not something I've ever done for an answer,
pursuing me round – fish to water, specially with the mac bit,
marvellously handy for some extra cash – until I get back into
the orbit of my protector, who's talking to a very manly-looking
man with blond hair and bright-blue eyes. 'Ah Michael,' Francis
says, 'I want you to meet our host Dan Farson, who's been telling
me about some of the people who are in tonight. There are plenty
of East End villains, of course, Dan has a soft spot for them,
don't you, Dan, but more interestingly that man over there', I
follow his eyes to where an elegant-looking middle-aged chap in
a blazer and dark glasses is chatting to a couple of girls with pale
powdered faces and impressive beehives, 'is Stephen Ward, you
know, who's at the centre of all this ridiculous scandal. Now that
Profumo has gone I can't think he's got anywhere to hide. But
to look at him just chatting those girls up you wouldn't think he
had a care in the world. It's very interesting to watch people who
are what's called in extreme situations.'

Having given me an inquisitive once-over, Dan says, 'What I really want to know is where's Philby?' He moves on to greet some newly arrived guests and, chuckling, Francis says in a low voice, 'You could say that Dan himself is in a kind of extreme situation the whole time. The last time I was here this East End tough told me he'd gone back to Dan's place for a drink and Dan said to him, "Excuse me, I just have to go upstairs to change," and the next thing he knew, he says, "there's this manly man coming down the stairs in a fur coat with women's undies on like some great big fucking lady!" There it is, you never know about other people's sexuality, or their sexual fantasies, which are really interesting – often the most interesting things about them if you ever get them to tell you what they are. Dan is very strange in that way, because he really doesn't look what's called queer at all but he's queer through and through. You never know with people. They say Hemingway was probably queer, but that he didn't realize it or didn't want to accept it. It doesn't really matter what he was. What difference does it make? But what I did hate about him was the way he wanted to *appear* so masculine. It's the same with Norman Mailer. I've always thought that the way Mailer wears hair on his chest is just like a woman wearing pearls. I mean why is he so keen to convince everyone he's so masculine? Why, I wonder, does he feel he has to go to those lengths? After all, there's very little difference between the sexes if you really think about it. There it is. People try to emphasize the differences, I don't know why. Now I myself have always known I'm queer. There was never any question about it, right from the beginning I used to trail after my father's grooms. I was also attracted to my father, even though we never got on, but that's another story. Of course most people don't know what they are. They're just waiting for something to happen to them . . .'

Francis's face goes in and out of focus. As I start to sway, all the drink of the day seems to freeze in my body. Everything freezes, the talking mouths, the heavily made-up pale faces, the bottle on the way to the glass, all is in stasis. Panic rises up in

me again and I know this time I must leave. Guinea-a-lash is looking at me fixedly, meaningfully, from the bar. Francis seems to be talking still, but the words flatten back against his face, distorting it. Everything static and distorted. Must get out now. Butt in and blurt out thanks, how wonderful it's been but have to get back now and perhaps get together again to take interview further.

'We can take it further whenever you like, Michael,' says Bacon, suddenly focused and sober and completely present. 'After all, what is more fascinating than what's called talking about oneself? It's a long story, and of course it all depends how you tell it. I should think one could go on talking for ever – at least until the other person couldn't bear it any longer and simply did you in! Call me any time you like, Knightsbridge 2925, the earlier in the morning the better.'

I stumble out into the night and eventually find my way from the Isle of Dogs to the more familiar solitude of King's Cross Station, relieved to be alone with my thoughts but also with Francis's telephone number etched into my mind, and exhilarated by all the new possibilities opened up by one chance meeting . . .

2

Under the Spell

After that first memorable encounter with Bacon, I had at least the wit to get hold of the catalogue to his retrospective, which had taken place exactly a year before at the Tate, primarily because I needed a more developed notion of what his work was like before interviewing him about it. Leafing through that historic little document without any preconception of what I was going to see, I was taken aback and deeply disturbed by the brutal ugliness of the imagery. Although the reproductions were small, the shock waves coming off them were palpable, and I was almost relieved not to have had to confront them head on during their relatively brief showing. They reminded me of a sort of horror show, exposed to the public for a moment, then hurried like a collection of freaks out of view. Where paintings like that ended up I had no idea, because the thought of having to live with them was unbearable – a deliberate, constant reminder of things better left unseen and unsaid.

There was nothing in my admittedly limited visual vocabulary to begin to compare these pictures to – none of the simpering Madonnas with heavenward gazes that I was familiar with, certainly, nor any crucifixions or martyrdoms that I could bring to mind, even in the work of the quirkier artists of the quattro- or cinquecento. Compared to Bacon's onslaught, all the Christs on the Cross and arrow-studded St Sebastians I'd seen conveyed

a degree of serenity, since their suffering was contained within a vast redemptive scheme. Bacon's writhing figures, on the other hand, clearly had no future and no exit; their suffering took place in anonymous rooms that were vacuums unto themselves, signifying nothing and leading nowhere. Even from the reproductions, one could see how the paint itself revealed pain, as if the skin of the swirling red, green and black oils had been pulled back, the grain cut open, to show the confusion beneath.

Part of my shock on encountering these brightly blurred images, even in reproduction, was that they seemed so alien to the exuberant bonhomie, the Bacchic joie de vivre, that characterized Bacon when I met him. For sure, his utterances – 'We come from nowhere and we go nowhere' – were bleak enough, but they were delivered like a toast, with a glass aloft and a gleaming smile. How could these two extremes be reconciled, the generous well-wisher who offered you everything you wanted and the scourge who stripped life of all meaning and faith? And how did he laugh and drink and enjoy good company while staring into the abyss?

I was shocked and nauseated by what came over as the systematically wilful distortion of every form – figures corkscrewed, sofas buckled, perspectives skewed; the only straight lines were those that immured these mutant elements in their airless space. I found the screaming popes particularly intimidating, as if I had been made brutally aware of a shameful truth kept hidden for centuries. Was the Pope himself, the head of the Catholic church and spiritual leader of millions, just another victim of bestial emotion and despair? Behind the pomp and dogma of religion, did he dissolve like Bacon's naked lovers into spasms of lust and rage?

Seeing so much flesh racked by anxiety and guilt also recalled and strangely validated an intimate, barely avowed anguish in myself, something I tried to keep at bay and not think about. Here, in Bacon's mise-en-scène, it was translated to a grander, more dramatic plane, framed in gold and exhibited with defiant

panache at one of the country's foremost museums. If I thought
I had been held back by having my art studies cut off at the
Renaissance, the imagery now before me so outstripped my
understanding that instead of constraint I felt in complete free
fall.

For all my initial reluctance and alarm, deep down I
nevertheless had an instinctive inkling of what Francis Bacon's
twisted world was about. I was particularly struck, not only by
the brutally pagan, blood-red Crucifixion triptych Bacon had
completed especially for the show, but by the way beast changed
into man and man into beast, as if the two were in a constant,
unpredictable flux. This was something that I had been aware of,
in myself and others, in my family and in the youths all thrown
together at boarding school. Looking at the Tate catalogue more
carefully, trying to take in one alarming image after another, my
fascination with Francis accelerated. He seemed to have created
a vision in paint that took the pictorial grandeur of the past – the
one I had been studying – and reinterpreted it, or rather twisted
it, so as to absorb and convey our own specific, post-war anxiety.
Once I'd overcome my initial revulsion, which I gradually
realized consisted more of shock than disgust, I was aware of
a spontaneous kinship with what, a little research revealed, had
been dismissed as 'gratuitous horror' in many critical reviews.
At the same time, underneath the nascent sympathy I felt, there
ran a powerful dark foreboding, a sense of having got involved
in something that went altogether beyond my control.

Entranced by the prospect of more wine and talk and flattery, new
restaurants and increasingly bizarre little clubs, I was soon going
to Soho regularly, almost as though these trips had become part
of my syllabus, a new course in general awareness, a broadening
out where, as well as being out on the town and having fun, I
could test the merits of Borges or existentialism or Antonioni or
Ray Charles – or any of my other enthusiasms of the moment –
against my new circle of friends' more mature judgements and

experienced tastes. The world was more alive and up to date here, and everything in the news, like the thunderbolt of Kennedy's assassination, more immediate and meaningful.

Dimly, intuitively, I sensed the importance of my discovery of these unknown shores, and the threat of the quicksands that lurked beneath them, ready to suck the unsuspecting in; the lost souls of Soho that I saw, passed out in the sawdust on the pub floor or jabbering to themselves in the afternoon drinking clubs, were a constant reminder. But being Francis's protégé seemed to me to confer a certain inviolability, even though other people around him came to grief. I quickly grew adept at parrying unwelcome attention in the late-night bars and, like a girl who knows her way around, at brushing off the hand that strayed above the knee.

Francis constantly smoothed my path through this uncertain, treacherous, looking-glass world. He also knew instinctively how to put me at my ease, readily deferring to my halting views about this and that, fussing in restaurants to make sure I was given the best of everything and making me feel very sophisticated by appearing to share his innermost thoughts with me. At every meeting I became more deeply flattered and more involved. How could I not? Among his many talents, Francis was an arch seducer, as lavish with his praise as with his wounding criticism, knowing unerringly in both cases where to aim. One evening, on the crest of several bottles of champagne, my open-handed host turned to me under the bar's dimmed lights and said, 'Listen, Michael. You've got looks, you've got charm and you've got intelligence. Your life's only just beginning, you've got everything before you. You can go anywhere and have anyone you want.' Now that really did hit the spot for an obscure young man filled with self-doubt and painfully adrift in the universe . . .

———

For days I've been mooching around Cambridge with Francis's telephone number – KNI 2925 – carefully inscribed in my

diary (although I know it now by heart), trying to screw up the courage to give him yet another call. I am very conscious that while I am regularly at a loose end, dodging lectures and not really knowing what to do with myself, he is almost certainly in the studio, squaring up to a new blank canvas or battling some terrifying new image into existence. It's obvious even to me that my trips to London have become a kind of necessity, giving my whole existence a point that it otherwise wouldn't have, but I am also aware that Francis has more pressing things to do than take students endlessly out on the town. Sometimes I think of myself wryly as a footnote in art history: the young man who prevented Bacon from painting more masterpieces: a sort of perpetual 'person from Porlock'. Eventually I do go into a phone box, on impulse, and once more nothing could have seemed simpler or more obvious. It's as if Francis has been almost waiting to hear from me, and this time we've decided to meet in the studio so that I can get some order into the interview we are meant to be doing – which tends to start off well then get lost as drinks go into dinner and dinner into a round of the bars. So far I've just managed to get some scraps of conversation together – short, individual statements that don't really link up or create a coherent whole, even if I resort to putting lots of suspension points between them. On the other hand Bacon does tend to talk like that, in one-sentence definitions and clearly rehearsed phrases that sound like maxims (he's a great admirer of La Rochefoucauld). He's always repeating things, trying to make them more vivid and concise – 'I like phrases that cut me,' he says at one point – and I want to catch as much of the tone of his talk as possible, which is not easy and doesn't sound the same or have the same impact once it's been lifted out of the drink-drenched moment of its delivery.

Before calling, I'd thought Francis would suggest we meet in a pub like the French or somewhere where there were other people around, as we have before. I certainly didn't expect to be going to his studio in Reece Mews, which I imagine as a very

private, even secret place, like an alchemist's or sorcerer's cell. This intimidates me even more, so I carefully memorize a map of the area before setting off as if I might have to negotiate a complex labyrinth, but it turns out it's only a short walk from the South Kensington tube and quite easy to find. You go up the Old Brompton Road, then right into a cobblestone mews, where the houses basically consist of big garages with living quarters perched on top. One of my Cambridge friends whose mother is an actress tells me that Lionel Bart – his musicals are always in the news – lives in one of them too. I suspect every house here belongs to someone famous and that I'll recognize anyone who happens to walk past. At number 7 the battered old grey-blue door has been left open and the moment I go in Francis is standing at the top of a very steep flight of stairs, his arms opened out in welcome. It's like going up a ship's ladder, with a thick, greasy rope screwed to the wall to help you pull yourself up. As I get to the top I have a quick look into the studio itself because the paint-splattered door on the right hand of the landing is ajar. There's a great big strew of photos and magazines and cloths and paintbrushes and pots right across the floor, with huge multi-coloured explosions of paint on the walls. There's something frightening, even sinister, about it, but it also feels liberating, as if someone has managed to let loose all the chaos inside himself and live surrounded by it – recognizing it for what it is and channelling it into a specific purpose. I'm amazed and intrigued, as I sense my own confusion welling up in me and seeking a way out. It's a very tantalizing sight, a glimpse of a kind of mad, secret, visual treasure chamber.

But instead of going in, which I was hoping we would, we go to the little kitchen area, which has photos of recent paintings pinned up over the sink, and oddly the gas on the cooking range is on, perhaps to get the heating up, I've done that myself in various digs, though Bacon is wearing a thick, sky-blue cashmere sweater and a black leather blouson so he could hardly be cold, and then we go into the living room – an anonymous rectangular

space where there's a deal table cluttered with books and letters, a dark-green velvet sofa, a big-bellied commode and at the far end a bed. The exotic-looking bedspread is about the only splash of colour in this very ordinary space with its rough grey floorboards made even greyer by the dull, wettish afternoon light filtering through the small windows. Francis turns on the lights – a couple of bright naked bulbs hanging from the ceiling – but the room looks quite as austere. He seems intent on talking to me about painting, especially about his own way of what he calls 'trapping the image at its most living point'. Perhaps he's been thinking about our interview, though I'd be surprised if he's gone to any trouble and I'm beginning to think I've got enough for what the magazine needs. Yet he talks quickly and deliberately, as if he had prepared things he wanted to say. I put aside notebook and pencil because I want to engage more fully in the conversation and just hope, since he often repeats and emphasizes things, I'll be able to recall and note down exactly what he says later.

'The thing is, Michael,' Francis remarks diffidently, 'one can't really talk about painting, only around it. After all if you could explain it why would you bother to do it?' He's brought us both a very strong cup of tea and we sit perched at either end of the soft, squidgy green sofa. 'Those things are very strange. I've no idea how you could present them in a factual way in your interview and yet make them a little bit interesting. That's what I feel so often in painting. I mean I know exactly what I want to do, but I can't find the *way* in which this thing can be made. I want a deeply ordered image, you see, but I want it to come about by chance. You always hope that the paint will do more for you, but mostly it's like painting a wall when the very first brushstroke you do gives a sudden shock of reality that is cancelled out as you paint the whole surface.

'What one wants in art nowadays is a shorthand where the sensation comes across right away. You have to give things right away, otherwise people can't be bothered. All you can ever do, obviously, is to work as close to your instinct as possible. What

I always hope for – this sounds terribly pretentious, perhaps one always sounds pretentious when one's talking about oneself – is this one absolutely perfect image which will cancel all the others out. Make this thing like an idol which would blink out all kinds of other beautiful images. When I'm away from the studio, abroad for instance, I keep thinking how I might do this thing. I was walking round those formal gardens at Versailles not very long ago and all these images kept simply dropping in to my mind, just like that, one after another, like slides. Well, it's marvellous when that happens, of course, and I couldn't wait to get back to London and work.

'What one longs to do above all, I think, is to reinvent appearance, make it stranger, and more exciting. That's what's so extraordinary about Velázquez: he reinvented the very outline of appearance. You only have to look at the way things are in his paintings. He managed to come back to appearance by way of something that lay quite outside the kind of illustration that was expected of him at the time. But it's a hair's-breadth thing, particularly nowadays. If you go too far, you just fall into abstraction.

'You would love somehow to make this marvellous, poignant image and at the same time elevate it on to a kind of stage. So that without using any kind of narrative, you managed to fill it with all sorts of implications. I myself am always looking as I go to and fro every morning in my cage here for ways in which I might make sensation come across with as much immediacy as possible. But this is only something you can do for yourself. I can only paint for myself, to excite myself, you see, and I'm always surprised when other people are interested in it. All painting, well all art, is about sensation. Or at least it should be. After all, life itself is about sensation.'

Francis produces this last phrase like a rabbit out of a hat which makes me laugh, which in turn seems to please him. He goes padding off in his silent desert boots and comes back with a frosted bottle of Krug and two glasses.

'Now where shall we have dinner?' he asks, as if that is a far more important issue than talking about art and life. He seems almost embarrassed to have talked at length, as if he had been boring me.

'Everything you've just said would be really good for my interview,' I suggest enthusiastically. 'As long as I can remember it by the time I get back to Cambridge. I'm not sure people have ever thought about art, or even about life, like that up there. It just seems to make so much more sense.'

'Well, it might be just your charm saying that, because one never really manages to say things directly enough,' Francis says, fingering the thin watch on his wrist with unexpectedly long, thick white fingers. The fingers of a butcher, I find myself thinking. Or even a murderer. 'Now listen,' he goes on, 'the restaurants round here are all rather dreary – there's something called the Ordinary and I tried it the other day and I have to say it was *very* ordinary. There's the Hungry Horse of course but the people who run it now have started drowning everything in these terrible sauces, so shall we find a taxi and see if we can get a table at Sheekey's? They at least can give you a piece of plain grilled fish. I think I've told you about this new friend I have called George, and he happens to terribly like eating there. Would that be a bore for you? I've also invited Sonia Orwell, who I think you might quite like.'

We make our way gingerly down the ship's ladder and out into the early London evening. It must have rained while we were talking because the cobblestones outside the mews glisten under the street lamps and there is an odd metallic tang to the air. We clamber into a cab which heads nimbly off towards the West End. Francis has gone silent, holding on to the handle above his seat with both meaty hands, apparently lost in thought. I've just noticed how smartly dressed he is, in a grey flannel suit with a blue button-down shirt and a black knitted tie, although the desert boots he's got on make the whole thing look less formal. I'm wearing the best I can muster: a grey polo-neck, a sports

jacket I've recently dyed dark blue, charcoal trousers and my
rather cracked, Italian winkle-pickers. I watch Francis's profile
against the evening light: not exactly handsome, but strong, well
carved, like the figurehead on a ship's prow or a gargoyle sticking
out against the elements.

Francis keeps checking his watch, a clearly expensive wafer-
thin model on a gold strap, but we arrive early at the restaurant.
He is known here and warmly welcomed like a regular, which
perhaps he is since he clearly dines as well as lunches out every
day. At all events he seems to be treated as a regular wherever we
go, I think with admiration and an odd sense of pride. A table
is no trouble, of course, and another bottle of Krug arrives in a
silver ice bucket. I sense that Francis has not said as much as he
would have liked to in our earlier talk, so I try my luck, asking
him if he could tell me more. After all, I've got a key article for
my magazine riding on this.

'Well, I suppose I could what's called tell all, if anyone could
be bothered to listen. Whoever tires of talking about themselves?
Although when you hear others droning on you think how
dreary you must sound yourself. Anyone's life sounds dreary, I
suppose, unless it's presented in a certain way. That's the thing.
At times I do feel there are a great many things I'd like to talk
about. Growing up in Ireland. And about Berlin, which was
very, very curious at the time I happened to be there. Or about
why I think painting is in the situation it is in now. Those kinds
of things.

'But then, at other times, I wish I'd never let anything about
myself out. When I feel that, I only wish that when I die, just
before, I'll be able to see everything to do with me simply blow
up. Just like that. Blow up so there'd be nothing left.'

'Could one say that your painting is in some way
autobiographical?' I venture, rather primly.

'Autobiographical? Well yes, inevitably, it's about my life, at
some level. It's filled with my thoughts about things. And yet
when I'm in the middle of it, I forget about everything, about

myself and about friends and things that have happened. That might sound as if I'm talking about inspiration, but it's not that. I mean, most of the time I simply don't know what I'm doing. I just get the bits of paint down and hope they suggest a way I can make something that looks as if it's come directly off the nervous system. And if it comes at all, it usually comes very quickly and by a kind of accident. I might be working and thinking "Oh my God, this is awful" and put the brush right through the image I've been trying to make and, every now and then, just by chance, with the fluidity of oil paint, that gesture will suggest the image I've been looking for all along.

'But there's no complete explanation as to how these images come up. Otherwise I suppose one wouldn't bother to try and do them. In my case, I spend a great deal of time looking at things that have no direct relevance to what I want to do or anything and then one of them might crop up, just like that. I think one makes this kind of huge well inside oneself and images keep rising out of it the whole time. But you can't analyse how, because it's not really conscious. That's why I say, half the time I don't know what my painting's about. I was doing a picture once and looking at a photograph of birds diving into the sea, and for some reason this curious double image came up. I couldn't really tell you what it is, I mean I think of it as two people moving and it reminds me of certain Greek things too. But I couldn't explain it.

'D'you know I think one thing about artists – there are very few real artists, of course – is that they remain much more constant to their childhood sensations. Other people often change completely, but artists tend to stay much the way they've always been. In my case, I've always been obsessed by images. Well, all sorts of things. When I was very young, for instance, I had this obsession with filters, I don't know why, industrial filters and things. And I couldn't stop looking at them. I've never found out why, it was really rather mad. Though I suppose if you really think about it the body itself is a kind of filter, filtering everything through the whole time.

'Of course I never expected to make a living by painting images, they were simply something that haunted me and that I knew I wanted to do. In that sense, I've been very fortunate. It probably won't last, the way everything's going. My things probably won't sell any more. But then if I'm absolutely poor tomorrow, what difference will it make? If I have nothing, well, there it is, I have nothing. It won't change my life. I'll go back to being a manservant – because I was someone's manservant once when I was very young. That's another story, though – a very funny story, as it happens. But I should still go on painting. I should like to go on just as long as I can move my arm. Because there's so much I still want to do. Sometimes I get all these ideas for new things, and I think if only I could get them all down in a single image: like slapping a sole on the wall, I'd like to slap this thing down, with all the facts and intuitions in it, and it would be there, with all its bones and things – complete and absolutely perfect.

'I never stop thinking about images, you know, I can't just sit around and relax. The other night I had this dream, usually I don't remember them, I was going down a street and my shadow was going along the wall with me and I reached out and tore the shadow off and immediately I thought, ah this might help me with my painting. Of course I probably won't be able to do anything at all with it – oh good I can see George and Sonia coming in. You've been drinking nothing, Michael, have a little more champagne.'

I look round and see a buxom blonde lady sailing across the room with a pale, athletic-looking younger man in her wake. She's wearing a cream-coloured shirt buttoned up to the neck and a pleated, grey skirt. Francis makes the introductions, then busies himself filling their glasses from the bottle beside the table and orders some important-sounding Bordeaux as well.

'Almost impossible to find a taxi in this ghastly drizzle,' Sonia says breathlessly. She takes a lipstick and compact out of her large handbag and quickly refreshes her crimson lips. 'We thought we were never going to get here, didn't we, George?'

'Yeh, wasn't 'alf difficult,' George agrees shyly, half swallowing his words. He seems to have a speech impediment or even a cleft palate, which makes his thick Cockney accent even more impenetrable. 'It was orful. Fing is, we nearly didn't get 'ere.' Sonia has been seated opposite Francis and next to me. I don't think she's even taken in my existence yet, although I'm certainly aware of hers, not only as the wife of the man who wrote *Down and Out in Paris and London* but as having worked with Cyril Connolly, whom I revere both as an essayist and as the editor of *Horizon*. I feel overawed to be sitting next to someone who has been at the absolute centre of contemporary literature for so long.

George, meanwhile, has placed his cigarettes and a chunky silver lighter neatly in front of him, like weapons. He's chain-smoking in a controlled, studious fashion. I take out a cigarette to keep him company, and he immediately clicks his Ronson lighter into action beneath my nose. I notice the deep little pleat of concentration between George's eyebrows and the tightly knotted dark-blue tie he's wearing with a white shirt and dark-blue suit. If I hadn't heard a bit about him already, I would have thought George was a successful East End entrepreneur in his early thirties. As it is, from the banter in the Soho bars, I've made out that he's actually an unsuccessful thief and burglar of that age. There's a story going about that Francis actually caught him breaking in to Reece Mews from the skylight above the studio. But Francis says that's nonsense and they just met in the French pub. 'I was having a drink with John Deakin and all those others,' he's told me, 'and George was standing on the other side of the bar. And he came over and said, "You all seem to be having a good time. Can I buy you all a drink?" So he just joined us, and there it was.'

'Now, I just had a call from Michel Leiris as I was coming out,' Sonia is saying rapidly, 'and he and Zette are coming over from Paris next week so I thought I'd do a dinner on the Tuesday, if you and George are free, and possibly ask Lucian and David

Sylvester or has David written something recently about Lucian that Lucian doesn't like and they're not actually talking?'

'I think they're still talking – or you could invite Michael?' Francis suggests. 'I believe his French is very good.'

'*Alors on va voir ça tout de suite,*' Sonia says, rounding on me suspiciously. '*Qu'est-ce que vous pensez pouvoir dire en français, mon pauvre jeune homme?*'

'*Plus ou moins ce que je veux, selon les circonstances,*' I answer blushing but promptly. Speaking French is perhaps the one area I can have some confidence in.

'Well, I suppose you can come if you think you'll fit in,' says Sonia, clearly reluctantly, 'but I should warn you you'll be out of your depth intellectually, and probably socially. Michel Leiris is reckoned after all to be the greatest French writer alive, and he's just finished the latest volume of *La Règle du jeu* which as I hope you know has become a fundamental text. Everyone in Paris is raving about it. We'll also have the new French cultural attaché who's the author of *Marx est mort*, which I have to say is *tout ce qu'il y a de plus controversé en ce moment*, and André Masson's son, Diego, the conductor. I won't say *le tout-Paris des arts et des lettres* will be there but not so very damned far off. Then we'll probably have the publisher Nikos Stangos who's delightful and a very talented American writer called David Plante. Do you think you can hold your own in a soirée like that?'

'Yeah,' says George with a derisive snort. 'You reckon you can 'old your own with all of 'em?' He's perked up and is following the scene with obvious amusement.

'Well, I'll try,' I say lamely, feeling exposed and regretting the anonymity my role as interviewer has so far conferred on me.

'I don't think you need worry, Sonia,' Francis says. 'I've noticed Michael's at ease in any company. He might seem shy to you, but he understands everything. After all, we're all shy when we're young, what with all that talent welling up inside us, even though with time we realize there's simply no point in being shy. *C'est pas la peine*, as your friends in Paris would say. So why

don't we have just a leet-el more of this Château La Lagune,
then go on to Muriel's for some champagne?'

We tumble in and out of a taxi up a dank stairway and into a
low-lit, green room heavy with cigarette smoke and seething
with people where someone is playing an invisible piano and
crooning, 'And that's why darling it's incredible – that someone
who's unforgettable', and there's a severe-looking woman dressed
in black with her shiny black hair pulled into a tight bun who
looks like a retired ballerina sitting straight-backed on a stool by
the bar who turns and says: 'There you are, my daughter, no not
you, you cunt, I'm talking to Francis.'

With the three of us in tow, Francis kisses her and orders
champagne all round. As the corks pop and everyone's glass is
filled to the brim, he raises his own, with the golden liquid slopping
over his wrist, and like a challenge calls out: 'Champagne for my
real friends, real pain for my sham friends,' and amid the laughter,
some frank, some furtive, he knocks the drink back and orders
more and introduces me to the severe lady who turns out to be
Muriel. She seems kindly disposed towards me as another round
of champagne breaks like a wave over the room and says that as
'daughter' has said such nice things about me she'll make me a
member of the Colony Room and Ian behind the bar will give me
the card I need. As I down my champagne with the best of them
I notice her whisk the bubbles out of her own glass with a little
silver cocktail stick and I'm taken aback when she says politely,
'That's my clitoris, dear, always keep it moving's my motto, I've
never liked the bubbles, just the effect.' The piano starts up again
and it's 'Non, je ne regrette rien', and I notice Sonia, red-faced
and almost tearful, joining in while George stands to one side
silently keeping himself to himself with cigarette and glass, now
one going up to his mouth, now the other. Muriel controls the
unruly swell around her by regularly issuing orders to punters
who seem to be called alternatively 'Sod', 'Granny' or 'Lottie' –
'Come on, Lottie,' she says, 'open up your bead bag and pay for

last night's round' – or sending other customers packing with one of her choice farewells: 'Back to your filthy urinal, Granny, back to your cottaging, and don't show that cock-sucking face of yours here again or I'll give you a fourpenny one,' while pausing elegantly, with perfect erect composure, to receive a compliment from a more favoured member kissing her hand whom I dimly recognize from photos in the papers as someone famous. And Francis, who told me he first came here with the queer Oxford aesthete Brian Howard twenty years ago, is again at my side making sure my glass is full but, unaccountably, we're now somewhere smaller and underground where there's a jukebox playing Johnnie Ray's 'Just Walking in the Rain' and a couple of large amiable men with big red forearms are dealing out drinks from behind the bar and talking to each other in snatches of Polari. 'There's a palone putting on her slap in the carsey,' says one, with an exaggerated moue. I start getting interested, always up for a new lingo, but minutes later, I don't know why, we're outside again, just Francis, George and me now, and we go up more stairs and across landings with Francis saying, 'I just know it's here somewhere, you can always get a drink before dawn, for some reason I think it's called the Pink Elephant,' and then oddly we are back in Muriel's, which Francis says is a place to go to lose your inhibitions, except there are not many people now, not many inhibitions either, and we are all standing around the bar and there's banter between Muriel and Francis. 'That's all the facts when you come down to it,' Francis is saying. 'When did you last have all the fucks, de-ah?' Muriel is saying. But everything's slowed up, slowed down, and we have been here for ever, haven't moved for as far back as I can remember from these same four walls with the same music in this same unchanging world, and I don't remember anything more until I wake up and hear George asking Francis plaintively in his blocked nasal tones, 'What d'you 'ave to givim ten pahn for? All 'e ad to do was open the fuckin' door,' and Francis saying, 'Try to get some sleep, George, we've got to leave early in the morning you know,' and everything's still

turning in the dark and I work out I'm on the green velvet sofa and the dark goes round and round and George starts talking again in fits and starts nasal-thick as he sleeps. I want to throw up but I know I can't, I mustn't be sick, and I drift back into sleep for a few moments before Francis, all dressed and fresh and rosy, is handing me a cup of steaming tea and saying he and George, who's standing behind looking like a successful boxer in neatly pressed singlet and trousers with red braces hanging down by his sides, are going over to Paris via Newhaven and Dieppe, then taking a *wagon-lit* in the night train down to the Côte d'Azur which sounds so glamorous and shimmeringly alluring, and never more so than when we're standing outside in the damp grey morning on the cobblestone court, with George lighting his first cigarette of the day.

I bid them goodbye, transformed like Cinderella back into student boy, the threadbare scholar in his grey polo-neck sweater, ill at ease, with all the time in the world to drift and be unhappy and have no destination in sight beyond the provincial cloisters where his friends won't believe all he's done and seen even if, he reasons confusedly as the train rumbles up towards Cambridge, he could be bothered to let them in on this his big new secret.

3

Bacon's Boswell

I always come back to Cambridge in a strange state. I'm really pleased to be going around with Bacon like this and talking to him, often alone and late into the night. I really like going to all these restaurants, bars and clubs I never knew about and couldn't in any case afford, meeting all kinds of people I'd never come across as a student going between college and lecture room. I love the delicious, expensive food and all the fine wine too, even if it sometimes takes me a day or two to come round from the hangovers. There's no doubt it's already brought a whole new dimension to my life, changing the way I see myself and my future.

And that in itself is part of the problem. Since I'd spent two years after school studying languages, first in Göttingen, then in Perugia, I already felt older and more experienced than my contemporaries when I first came up, and now that I'm going regularly to London and starting to be part of another, more sophisticated world, the disaffection has grown apace. It reminds me of when I was 'held down' for a year at school because I was the youngest in my class and had started momentarily falling behind; so that afterwards everyone who had been a year beneath me became, to my lasting shame, my contemporaries. Something similar has occurred now that I'm at university, although I do have a small circle of close friends I'm really fond of. I've noticed, however, that whenever

I mention my Soho exploits to them, it soon sounds suspiciously like bragging, and I'm particularly irritated that no one has remarked on the dark-blue, fly-fronted John Michael shirt that Francis bought me on Old Compton Street – I've been looking and I haven't noticed anyone else with one in Cambridge, where tweed jackets and pipes still dominate as if Carnaby Street fashion and the King's Road simply don't exist. Regardless, I wear my new shirt as frequently and defiantly as I can.

So I've come to accept that I'm now leading a kind of double life: gowned student by day, huddled with other youths round gas fires in damp cloistered quads, endlessly soul-searching and trading shallow banter as we wonder who we are and what we might become; Bacon's chosen companion by night, invested with special powers, riding a crest of champagne as all doors from the Ritz to the last seedy outpost at dawn open before me. I get used to the duality, but it does nothing to bind me more closely to my undergraduate status. And regular contact with artists like Frank Auerbach, Kitaj and David Hockney – the new Sunday colour magazines have just photographed him like a film star, in a gold lamé jacket – has only served to convince me further that it's time to leave Renaissance art behind and look for something new. As my final subject of study, I choose what I have always loved most and might have read from the beginning: English Literature. But before I can even begin to cram into one year what would normally take three, I am still struggling to complete my issue on 'Modern Art in Britain', which has taken me off any kind of even desultory study for the past few months.

To be fair, I've been incredibly lucky with the contents so far. Hockney, Kitaj, Paolozzi and others have all written texts specially for the issue, and I've done an exchange of letters with Auerbach. I've also bagged some big essays from critics as important as Lawrence Alloway, Norbert Lynton and Jasia Reichardt. I'd hoped to include David Sylvester, who first asked me to come down to London to talk about the possibility, then explained to me, walking me up and down the station platform

when I arrived, that he could not write, like the others, without proper compensation. We are a student magazine and there was never any question of paying anybody; the return fare for this fruitless visit has already taken a good few bob out of my meagre budget; I just hope we get enough in from the advertisements to go some way towards settling the printer's bill. My Bacon interview has been pieced together from scraps of conversation. I've tried to touch on various aspects of his beliefs – or lack of beliefs – about life and art. It's a bit disjointed, and still with a lot of suspension points between unrelated phrases; but it's the best I've been able to do so far, and I have to say his conversation is a bit like that – like a series of brief definitions, things like 'art is a shorthand of sensation' or 'we only give life meaning by our drives', which often have more impact after a couple of bottles of Chablis than they do in cold sober print.

The only artist I haven't been able to pin down is Lucian Freud. He's often there at the lunches and dinners, but not so much once we start on the round of bars and clubs because he doesn't want to drink. Actually, he doesn't eat much either, just nibbles things from his plate and puts them back, half chewed, if he doesn't like them. We've been talking about his doing a kind of 'statement' about art for some time, but it never materializes. He doesn't want an interview and I can't do more than politely remind him. It would be important to have him in the issue, though, if only because of all the artists I've met over recent months he is certainly the one closest to Bacon. They have an odd relationship. When I've been with them both, they never mention painting, only people they both know. Lucian makes a point of relaying the latest gossip about their mutual friends, and Francis clearly relishes this, interjecting comments they both seem to agree on, like 'I've always known he was a rat. He'd rat on you just like that if he thought he could get something out of it' or 'I hear that now John Russell has left Vera, that stammer of his has got so much better.'

Lucian also clowns around, specially for Francis. One of his favourite turns is to pick up the restaurant bill when it comes,

give it a cursory look and then pretend to faint, falling sideways on the banquette like Charlie Chaplin, while Francis chuckles and writes out a cheque. Sometimes he comes with a waif-like girlfriend in a faded frock, but mostly he comes alone. He is quite funny in an ironic way, with his lightly inflected patter doing quick pirouettes around the people he describes, but I think he is in awe of Francis, or even in love with him. But then I suppose most of us are, whether it's Lucian or George or me, Sonia Orwell or models like Henrietta Moraes, or Miss Beston, who looks after everything to do with Francis at the Marlborough gallery, from his exhibitions (where she always gives the glass on his pictures a last go-over with a shammy leather she keeps in her handbag) to his laundry bills or medical prescriptions. He is the point, whether we know it or not, around which we all turn. Because of this, I mention to Francis that the issue is pretty much complete except for Lucian's long-awaited statement, and the next thing I know I get a message from Lucian – the first ever – suggesting we meet.

I've never been alone with Lucian. I've never felt particularly at ease with him. He has none of Bacon's warmth and geniality; on the contrary, although he is clearly an unusual and rather exotic person, he seems to me coldly self-centred and calculating. So I'm not particularly looking forward to this encounter near Paddington Station, but when I find Delamere Terrace and see Freud waiting by a large stylish car I have no time to think because as soon as I get in, the Bentley takes off with a squeal and we hurtle through a few streets, squeal round corners, bounce up on to pavements and ricochet off the wrong way into one-way streets at a speed I've never travelled through any city before. I'm terrified at first, thinking we're going to smash into other cars or a wall, but it soon becomes clear this is what 'driving' means to Lucian, full pelt, hell for leather, as if this is a getaway he'll only get one crack at, and that he's very skilled at it, so the fear subsides a bit and I begin to enjoy the sense of complete anarchy and the breaking of every rule they teach you when you

first take to the road. This breathtaking journey turns London into the most compact of cities and within minutes we come to a squealing halt outside a grand townhouse in an elegant crescent in Knightsbridge.

Lucian produces a key from his jacket, and for the first time I notice he's wearing a well-cut double-breasted grey suit but with no shirt or apparently anything else beneath. Without explanation, though I suppose he must know the grandee who lives here, Lucian opens the front door and ushers me up the stately staircase, past sitting rooms filled with impressive paintings, some Old Masters in carved frames but mainly modern, to a sparsely furnished, low-ceilinged room at the top. There are only two chairs, prepared as if for an interview. The late-autumn light is fading, but Lucian begins a soft, lisping monologue that has vaguely threatening undertones, as if he might at any moment say 'We have ways of making you talk,' but of course he says nothing of the kind but rambles on about the 'situation' we or painters or somebody is in now and there's little we can do about it but attempt to return to a certain truth that only stumbling on through the dark can tell, and truth to tell it has become dark now in the room and I can't note down anything of what Lucian's saying and he's got up and he's moving through the darkness talking, it's unnerving, he's become just a disembodied voice, distant, and I'm trying to make out the soft lisping sounds, it all sounds rather abstract and about 'the way things are', then suddenly he comes closer, standing right by me, and I'm wondering what might happen next, until all the lights suddenly go on in a blaze like the end of a film and I'm invited to take the stairs down and leave and make whatever I can of these utterances with their quotes from Nietzsche and turn them into something that will pass muster in my magazine, as I find myself back on the street, breathing in the night air, blinking in the lamplight, relieved and suddenly free again.

———

Knowing I'd be in London I'd called Francis and we've arranged to meet for dinner. There's already something comforting about the whole ritual of a night out as we sit in the snug bar at Wheeler's and as usual I am starving and make my way through several bowls of peanuts with the first few glasses of wine and Francis chats to the barman who tells us about his girlfriend getting her 'knickers in a twist', a silly phrase which somehow helps soothe the unrequited sexual pangs that torment me day and night and keep the great enigma of love at bay. Perhaps Francis has sensed this. He seems to accept the fact that I only like women, even if I find the company of homosexual men in many ways more interesting, and frequently more flattering, and if he has made a pass at me it must have been so subtle that I haven't noticed it. So I was intrigued the other day when I went to see him that he suggested I meet one of his models, Henrietta Moraes, whom I've heard is very 'free'. And he took one of the copies of *Paris Match* he had lying around and over a double page of photographs of war atrocities in Vietnam he wrote me a sort of letter of introduction to her, but while I was waiting for what I thought might be the right moment to make contact with her, John Deakin showed me a sheaf of photographs he had taken of Henrietta naked on the bed, originally commissioned by Francis so that he could do portraits of her. Several of them focused on Henrietta with her legs splayed, and they were so graphic, not to say hirsute, that whatever lust impelled me quailed; so my need for female company continues to be spotlit and exacerbated, much as in Cambridge, by being in entirely male company virtually all the time.

Francis is in good form, he says the work is going well 'even if you never really know about those things', and he is very affable with everyone, leaving the barman a noticeably large tip, and I wonder whether that isn't in itself a form of seduction, certainly all the staff seem more interested in serving us than anybody else in the crowded restaurant and every time a new bottle of wine is brought he has a note at the ready to crush

into the waiter's hand. Of course, he did say at one point, 'I've bought my way through life,' and I wondered what he meant, but perhaps this is it. What is also very attractive is the feel of boundless energy coming off him, radiating through his gestures and the relentless way he keeps returning to a subject until he feels it can't be analysed and defined further, even if he's only had a couple of hours' sleep and has been doing the bars all afternoon. That must be the reason that even when he's saying ultimately very negative things like 'We go from nothing to nothing' or 'Life's a complete charade' they sound almost positive and cheerful, or at least liberating, as if he's proposing a toast. We're well into the ritual now, oysters, sole and Stilton dispatched, and pleasantly drunk, and if it were anyone else they might be saying it's been a long day I think I might get an early night, but Francis is saying: 'I don't know if you're at all free after dinner but I have to go to Muriel's because one of those ridiculous Sunday papers wants to do an article and Snowdon's going to do the photographs.'

So of course I'm free, nobody is freer than me as more doors open and another strange evening beckons. 'I'm greedy for life,' Francis has said to me at one point, 'I'm greedy for food and drink, for friends, for things happening,' and I relate immediately to that. I'm greedy for experience, I realize, following him up the evil-smelling little staircase to the Colony and into an atmosphere which is quite different from anything that, as a proud, new, card-carrying member, I've known before. It's quite crowded, with a mixture of regulars and their guests, and the word is clearly out that Lord Snowdon is coming, but although the members are flattered they've decided with instinctive club spirit they won't show it. 'Christ almighty,' a character behind me is saying, with a great show of being put upon, 'can't we fucking come in here for a quiet drink without having some little pansy photographing us?' 'Well,' says his friend, more philosophically, 'you can't get away from the press these days, my old mate, can you?' Muriel is clearly unimpressed. 'We've never had royalty in

before,' she says, 'but I hear she's a nice little lady so we'll make her welcome. Well come isn't in it is it, dear,' she continues in a lofty patter. 'I expect she's had more cocks than you've had hot dinners,' she remarks to the amorphous group of drinking heads around her, 'so back to your filthy urinals now darlings before your very presence before the highest in the land brings my lovely little club into disrepute.'

Francis has been assiduously doing the rounds, tipping one bottle of champagne after another into everyone's glass, as if to excuse himself in advance for all the attention that he is about to receive. 'Why he wants to photograph my old pudding face', he says, slopping more wine into the out-held glasses, 'I can't imagine. Never mind. Let's simply amuse ourselves while we can. Cheers. Cheerio. Here's to you.' And he weaves his way round, half swaggering, half staggering, until the mood of the room changes imperceptibly, alerting all Colony members that Snowdon has been sighted at the entrance. And so he comes among us, slight and smiling in a safari jacket, his camera at the ready as if he is about to snap wildlife in the veld, and after declining a glass from Francis he also begins to weave round the room. There are the two of them now, eager hunter Tony, lithe and intent, and willing prey Francis, his wide head thrown back in laughter, as if in a life filled with charades this is the silliest role he's ever had to play. But he's playing it so well, our Francis, the big beast in the jungle, hidden in the club's recesses then breaking cover in a clearing between two stands of solid boozers, and with the champagne working its beneficent magic the members decide as a man to take the lovely little lord to their bosom and begin to act up for the camera, a couple of them putting their arms round Francis for a group photo, Muriel's Boys November 1963, their mottled, wattled faces split into grins full of native wit. And a cheer goes up from the bar as more toasts are made and a man with a huge scar down his cheek begins to intone in a fine tenor voice 'Oh wouldn't it be loverly', and other voices take up the chorus while Snowdon, sensing a

coup, closes in clicking, Soho at song, and Francis makes up to
the camera like a star, mumbling to me as he passes, 'I can't think
what he's going to do with all those ghastly photos,' and from
having felt generally put upon the Colony might have outdone
itself in bohemian bonhomie had one very large regular known
as Tiny not been rocking to and fro on his stool at the bar and
suddenly catapulted himself back into the throng, scattering
drinkers and breaking glass and landing out cold on the floor
behind, unrecorded but unquestionably the scoop of the day,
bringing the party to an abrupt end – to be later enshrined in
Colony myth and fondly recalled by Muriel in later years as
'that fucking orgy in space, dear'.

One of the things I'm coming to appreciate more and more
about going around with Bacon is that we talk so freely, even
if the conversation tends to be mostly about him, his life and
painting – which is of course why I originally sought him out.
But he talks quite as willingly about the latest news or politics
or medical research; at one point, apparently, he read every issue
of the *Lancet* he could lay his hands on. It didn't occur to me,
though, that he took a deep interest in literature until he started
passing on to me this or that odd book he had lying around in
the studio. Of course, it's true, and I picked up on that right
away, that he has all kinds of writers and literary people among
his friends or at least within his orbit, and not just art critics like
David Sylvester, John Russell and Lawrence Gowing. Stephen
Spender he sees quite a lot of (and I've met him with Francis, and
to my embarrassment, and even more I imagine to his, I keep
confusing his poetry with Auden's, which I know much better;
Auden, I soon found out, is someone Francis can't stand because
of what he calls his 'Christian hypocrisy'). Cyril Connolly he
met through Sonia, as well as the much loved Peter Watson,
now dead, who put up the money for the review *Horizon*. Then
he knows Burroughs, of course, and 'Cal' Lowell, who he says
sometimes thinks he's Hitler or Napoleon. And a lot of writers

send him their books – I've noticed Elizabeth Smart, Paddy Leigh Fermor and Caroline Blackwood, and from Paris Michel Leiris, Georges Limbour, Gaëtan Picon and Jacques Dupin – and I get a glimpse of the latest ones whenever we go into the living room because they're scattered all over the big table by the window.

Out of the blue Francis has just handed me Djuna Barnes's *Nightwood*, saying 'You might try this book, which I suppose you could say is about despair. Djuna Barnes must have been a very remarkable woman, living that lesbian life of American women in Paris in the 1920s. She's very old now. Someone told me nobody's been able to talk to her for years because she lives in this flat in New York behind a great wall of gin bottles.' I've been finding it difficult to get into but since Francis has recommended the book I've persevered and now I'm fascinated by its rich perversity and realize it's quite different from anything I've ever read. His tastes in literature are as definitive, not to say peremptory, as they are in art. Just as he goes in one bound from the Egyptians to Michelangelo, so there seems to be nothing in his literary pantheon between Greek tragedy and Shakespeare. He's told me that some plays or poems have influenced him even more than painting by the power of their imagery. 'Even in poetry I've always been obsessed by images,' he said to me the other afternoon in the studio, as we were trying once again to conclude our interview. 'When I was very young I found this marvellous translation of Aeschylus. It was really more of a free rendering I expect than a translation. But it had these images in it I thought so beautiful they've been with me ever since. There was something so extraordinarily vivid about them. "The reek of human blood smiles out at me" was one. Then there was this other one I can't quite remember about Clytemnestra sitting over her sorrow like a hen. They are superbly visual. I feel myself very close to the world of Greek tragedy . . . often, in my painting, I have this sensation of following a long call from antiquity.'

After Shakespeare little seems to have found Francis's favour, in English literature at least (Racine and Saint-Simon are two of

the French writers he admires most), until the twentieth century. 'English literature in my lifetime has been made by Irishmen and Americans. Of course the Irish have always had this marvellous way with words. They talk marvellously, talking is really a way of life with them. They seem to exist to talk. I can't read novels. I find them so boring. I really prefer either documentary things or great art, great poetry. I don't think there's anything between the two nowadays. I love poetry that's a kind of shorthand about life. When you have everything there, in a most marvellous brief form. And I've always particularly loved Yeats, who I think becomes more and more remarkable as he gets older. I think Yeats is probably a greater poet than Eliot but in the end I prefer that whole atmosphere of Eliot. Even if he did go religious later on, I love the feeling you get in *The Waste Land*.'

Just as he enjoys comparing Yeats and Eliot, Francis loves to discuss the respective merits of Proust and Joyce, both of whom he admires deeply, even though he sometimes misquotes them. The other day I came out with a definition I was quite pleased with about Proust's having lived so he could write and having written so he could die, and that immediately set Francis off:

'Yes, that's true. In a way Proust's was the last saintly life, wasn't it? I've always thought of him as a great artist who left this profound record of his time – I think it's the last great tragedy that's been written, I think it's a very tragic book, in the grand sense. I keep rereading the *Temps retrouvé*, it might be the morbid side of my nature, but there's something so extraordinary about the way all these characters he's made change. When Charlus falls on the cobblestones, he's really reduced to nothing – after being so pompous and so on, he becomes completely pathetic, fallen there. And of course it goes on for pages. In the end all the people turn out to be kinds of cyphers out of which the whole book has been made.'

'But Francis, you always say, like Ezra Pound, that you have to make it new,' I venture. 'So wouldn't you think of Joyce, who after all, completely reinvented technique – like Picasso, with all

these great stylistic fireworks – as the more important writer, the one who changed the course of literature?'

'Well yes, Joyce is marvellous,' Francis concedes, as I thought he would. 'It's remarkable the way you get the whole feeling of Dublin in *Ulysses*. It really is like that, you know. And the way he just invented one technique after another. It's an extraordinary thing to have done. But I myself feel he went too far in that last book of his. He made it quite abstract, I think, and that of course is bound to be less interesting. Because abstraction can never convey fact in a precise way. It can't be made to convey anything precisely. In that sense, I prefer Proust. I know it's ridiculous to compare them, but for some reason people do. With Proust, you get this profound change *within* tradition. That's what I love, and of course the fact that it is the last great document – a deeply edited document, it's true – about social behaviour. You just get everything in it, it's a complete record. I'm not sure that kind of thing is at all possible any more. People have tried it of course, but I don't think it's worked. I imagine things have become terribly difficult since Proust and Joyce, just as they've become so difficult in painting. I don't know. But I do think there's less and less nowadays between the documentary and *great* art, the art that returns you more vividly to life.

'In painting, well, in all art I imagine, one always hopes to recreate experience in a way that makes it come back on to the nervous system with greater intensity. Makes it more specific and more direct. What one wants is that thing Valéry meant when he talked about giving the sensation without the boredom of its conveyance. Ah, but whether one can actually ever get that is another story.'

On other evenings we get caught up again in a round of bars like mice on a treadmill without stopping until exhaustion sets in and we part, grey with fatigue and barely able to stand, at dawn. I follow him now unquestioningly through secret Soho, from forgotten afternoon drinking dens to specialist clubs run by ageing

lesbians, retired policemen or ex-prostitutes in marquise wigs. The Iron Lung gives way to the Music Box and the Maisonette. In one of them, presided over by a voluminous *patronne* with a black velvet beauty spot, they are playing Chubby Checker on the jukebox and to my delight, having delivered himself of a long, drunken diatribe against the futility of life, Francis is invited to dance by the bouncer figure who passed out at Wheeler's and, without hesitation, he breaks into a supple, dainty twist that would not look out of place on a professional dance floor. In another crowded bar, while the evening is still young, a girl comes over to Francis and drops some little triangular capsules into his hand and he knocks them back without even looking at them. She puts some into my hand, too, with a knowing look, and I hesitate before discreetly dropping them on to the floor. I think of a story Francis has told me about how he rented a room in Chelsea when he was very young and found a large pill stuck in the floorboards and just swallowed it, and afterwards he needed to go to hospital to get it pumped out of him. ('Why did you do it?' I asked him. 'I don't know,' he said, a bit irritatedly. 'Just for something to do, I suppose.') So I'm relieved I'm not taking this risk, even though they're probably purple hearts or bennies or some other upper, because I think, with all the new people, places, drink and talk, I've got about as many kicks going as I can handle. Francis says you always have to go too far to get anywhere at all, in art or in life. I guess he's right, he's certainly shown it in his own art and life, and it certainly sounds more exciting than the kind of middle-class values and behaviour that I've been brought up with and, beyond a certain general rebelliousness, have never deeply questioned. I've had vaguely existentialist attitudes, gone to the cafés in Paris and worn the clothes, but I've never gone off the deep end and radically contested things. Nevertheless it's quite clear I'm drawn like a moth to the flame to this flouting of convention, this going off the rails and doing things people say you shouldn't. You have to drift to find yourself, Francis said, and this is what I feel I'm doing even though at times I know I'm out of my depth, with

no safety cord beyond an alcoholic, sadomasochistic homosexual who likes me, and I'm terrified . . .

At the time, I didn't question the reasons why I was drawn so strongly to this man and his world, apart from an anxiety that the attraction belied a homosexuality so deep and so repressed in me that it might at any instant erupt, fully fledged, in camp gear and shrieking. Nor did I know then that Bacon was attracted above all to young heterosexual men whom he thought were just waiting to be 'turned', and that his attraction to me stemmed in part from the fact that I was so straight it didn't even occur to me there could be any ambiguity about our friendship. I see now that since an *amitié amoureuse* requires no consummation it tends to last longer than a sexual one, though at several points in our long relationship this would also be put to the test. Otherwise the fact that I was regularly lured back to Bacon's world – from a needy student existence, in which one was forever hoping to become someone, to a life of being fêted with champagne merely for being who one already was – needed little explanation.

Although I could not have formulated it clearly at the time, the lure did in fact go much deeper than that. I had found not only a more exciting mode of life but an older man whom I admired increasingly for his freedom, vitality and artistic brilliance. What I needed, way beyond the flattery and luxury that I lapped up as a threadbare student, was a father figure. And in Francis I had found him.

My parents, Edward and Elsa, were neither monstrous nor wantonly cruel. But in their increasingly loveless marriage a bitterness and despair had set in that corroded everything within their sphere. This mismatch, held together by middle-class convention and always on the point of unravelling, brought out the worst in each of them: in my mother a frivolous, snobbish superficiality, in my father a brooding egotism. I was nevertheless close to my overbearing father as a boy (apart from a painful spell with foster parents while my father was hospitalized). But

at the onset of adolescence my whole outlook changed: the docile child was replaced – as radically as my lank hair which suddenly bunched into curls – by an insolent, opinionated teenager whose main aim in existence was to oppose and wear down his father's entrenched tyranny. Even though I was packed off to boarding school shortly thereafter, the war between us endured. I challenged his authority at every turn, mimicking him to my mother and sister and eventually – when he no longer dared hit me – to his face.

But however hard I struggled to subvert him, my father always held the upper hand. Not only was he my father, but along with all his other sins he had inherited the family illness which he would, he promised, bequeath in turn to me. His father had suffered from 'melancholia' (which led, it was rumoured in the family, to his suicide); my father himself had manic depression – the same illness under another name. This insidious condition, with its aura of secrecy and shame, had been treated disastrously after the war with electroshock, which in desperation my father had undergone; and after bouts in clinics had yielded no improvement, the illness was supposed to be kept at bay – the violent mood swings held in chemical equilibrium – by the mauve, purple and sky-blue pills that he kept in clusters on his bedside table. Nevertheless our household knew only two totally distinct seasons: the brief, hectic, super-exuberant summer phase, then the never-ending depressive one, each of them so extreme that my mother, sister and I all wordlessly yearned for the change, only to regret it as soon as it got under way.

The sense of oppression this illness instilled in the family came from never knowing what to expect, coupled with constantly fearing the worst. After months of my zombie-like father being barely able to make it through the day, let alone drag himself into the pharmaceutical company he ran – while keeping the whole family's plans and hopes on hold – there would be a burst of activity in which suddenly nothing was impossible and no bounds known. Workmen would turn up to add extensions

to house and garden, expensive holidays were booked, cars purchased, outlandish bills (intercepted by my mother) arrived from louche-sounding nightclubs, the drinks cabinet was filled to bursting and as regularly depleted.

Similarly, where my father had been so withdrawn that it was impossible to get an answer from him, he now became so voluble no one else could get a word in. He shouted in restaurants, made scenes in shops and drove his latest car with aggressive speed and copious hooting; if no one laughed at his jokes, he would repeat them loudly until their wit was acknowledged. Money that had been hoarded morphed into overdrafts and any hint of caution was contemptuously brushed aside. As we cowered in fear and embarrassment, my father came into his own with a vengeance, making up for lost time – just before sinking once again into his long, sad, silent winter. And all this, he promised looking into my eyes, would be mine. I was his son, and he had seen the signs.

So when I came across an older man in whom bleak despair and spectacular exuberance warred but were miraculously held in check, not by pills but through an iron will and startling inventiveness, I was entranced. It did not matter how warped or distorted the means if it helped me live with the family curse. My father had not known how to survive; he became the victim of his illness, and that gave me an example not to follow but to avoid. Apart from opening all kinds of tantalizing vistas on to the future, meeting Francis ignited a deep, secret hope . . .

'It is terribly marvellous for you to be going around with him, seeing and hearing simply everything,' John Deakin is saying in his richly enunciated, plummy tones. I've scraped together a little spare cash and, as a belated thank-you for his clever way of introducing me to Francis, I've taken him for lunch at a Soho trattoria where he says the *tonno vitellato* is divine.

'I hope you're getting it all down, my dear. One day it will be of such value,' he remarks, nursing a glass of house red. 'It's incredible, but you've become a sort of Boswell to Francis. It's

simply marvellous. He talks to you about everything. Even I
didn't foresee that. Don't screw it all up now, kiddo. Remember.
Get it down.'

Eyes go up in a down-drawn face.

We talk about the people I've met with Francis and the places
we've been to. John chuckles occasionally at my description of
things getting out of hand, like the session with Snowdon, and
fills the conversation in with reminiscences of his own.

'When I first came to London before the war I used to go
to a queer club where there was music and we all danced,' he
says. 'Then one evening it was raided by the police, I think they
were having one of their crackdowns on what they called so
appetizingly the "filthspots" of London, and about twenty of us
were carted off to the station for the night. Then in the morning
we had to appear before the magistrate. And at one point the
magistrate said to me, "Mr Deakin, did you not find it odd to
be in a club where men were dancing with men." And I didn't
really know what to say, as he stared at me with that perfectly
frightful wig on. So I simply replied: "I've only just arrived from
Liverpool, m'Lud. How could I possibly be expected to know
how people in London behave?" In the end we all got off. But
those sorts of thing used to happen quite often . . . Good thing
they never came to the attention of my wife.'

'Your what, John?'

'You might well take on that look of aghast surprise, my dear.
Who could say you haven't every reason? But I am a married
man.'

John enjoys my astonishment for a moment, then goes on
mellifluously, 'Yes, married, my dear. A long story – I wouldn't
dream of boring you with it.'

Fill his glass and wait until he feels he's built up the right
suspense. There. Oh go on. Tell us.

'Well, if you really want to know, it all began in Rome, where
I happened to be shortly after the war. Things were not, I might
say, going altogether swimmingly. Of course I was attempting, as

always, to eke out a meagre living, to scratch a subsistence, with photography. Then I had to go and pick up some dreadful tough, and of course find myself the very next day, at dawn, lying in the gutter with nothing, ab-so-lute-ly nothing. All my money gone, need I say, but what was far far worse, the very tools of my trade. Not a sign of my beloved camera. Nor, of course, of that gruesome lout I'd had the misfortune to fall in with.

'Well, as luck would have it, that same day, while I was at my wits' end wondering what to do, a man I knew from Milan made me what you might call a proposition. Of course at that time, there were all kinds of women, uprooted by the war, who would do anything, and I mean just anything, to get British nationality. It turned out that this man was in Rome looking for a British subject who would be willing to marry an Eastern European lady temporarily living in Milan. He asked me if I were free. Mmm. Of course, I had precious little choice in the whole affair. Stranded as I was, with neither money nor the wherewithal of my profession. That ruffian, I might add, had stripped the very coat off my back.

'In essence, what the lady proposed was the return fare, in first class of course, marriage and a cash payment. Who was I to decline so timely an offer? I thanked my lucky stars and got straight on the train to Milan.

'The whole thing might have been acutely embarrassing, but it was arranged with such discretion that it turned out to be really rather enjoyable. The lady in question was absolutely charming. We met in that very good hotel in Milan and took tea together. Very civilized. When we'd finished tea and decided on the exact, mmm, details, we went for the civil ceremony. I need perhaps not add, my dear, that we dispensed with union at the altar.

'My wife was quite marvellous throughout. We shook hands afterwards, like dear friends, and I got back on the train for Rome, clutching the money. The moment I got off at Termini, I went to my special little shop and bought the most marvellous new camera. But instead of going straight back to my miserable hotel

room, I had to go like a fool to one of those unspeakable bars
where I'd sworn I'd never set foot again. Of course I got quite
hopelessly drunk. Exactly what happened, my dear, like many
other events in my life, remains a matter of pure conjecture. The
outcome, however, was quite clear. I was left virtually for dead
in some stinking gutter, with everything gone – both money and
camera having disappeared into thin air.

'It's what you might call a recurring pattern, one in two, at a
highly conservative estimate, being a thug, my dear. Still,' John
concludes, his eyes rising in liquid appeal to the strange forces of
love, 'I suppose one should be merely thankful one doesn't get
beaten and robbed every single time.'

———

If I ever need concrete proof that I now belong to Soho as much
as to Cambridge I only have to look at my new Colony Room
membership card. No one in Muriel's club has ever asked me
to produce it since I always get a welcome from the barman
or from Muriel herself when I go in. So I've taken to leaving
it prominently on my desk in the rooms in college I've been
sharing this year with Magnus Linklater, rather like a spy
flaunting his double identity. I've started telling Magnus bits
about Francis and various incidents in Soho, like the one the
other day when a literary critic called John Davenport, who's
as wide as he's tall, picked me up under one arm and carried
me along the pavement all the way to Muriel's bar, which I
think would have been impressive even if I hadn't been heavy
enough at school to have proved useful in a rugby scrum. I think
I sometimes detect a passing glint of disbelief in Magnus's eyes
as I relate these exploits, although he's too wary or polite to say
anything. This look needles me a bit when I'm in full flow but I
realize that I would probably do the same if I were regaled with
such tall talk without ever being invited to join in and see for
myself. So on my next foray into deepest, darkest Soho I turn
up with a slightly sceptical Magnus who nevertheless warms

to Francis and quite sees the point of the extravagant lunch he offers us at La Terrazza, where we are fussed over by Mario, one of the flamboyant Italian owners. Francis tells me he has to pick up some cash at his gallery afterwards and suggests we meet at Muriel's, so I lead Magnus proudly up the malodorous staircase as if I were taking him to an enchanted realm and am sufficiently buoyed up on lunchtime wine not to flinch when Muriel, sitting erect and regal on her barside stool, says, 'Does your mother know you're out, dear?', then with a condescending look at Magnus, 'And who have we brought with us, dear, your blowjob?' But luckily Ian, in a flowered shirt and dark glasses that do nothing to disguise his strawberry nose, stops giggling to open a bottle of champagne and pushes two foaming glasses towards us, which we grasp as symbols of having made it past Muriel's Cerberus-like presence and into the murky green depths of her club in mid-afternoon.

There are only about a dozen other drinkers propping up the bar or seated in the gloom. I notice Frank Norman, with the big white scar running down one side of his face, whose 'Fings Ain't Wot They Used T'Be' has become such a success. Then purple-faced Denis Wirth-Miller, looking more pleased with himself than ever, comes over to greet us exuberantly. Behind him, at the far end of the bar, looms the heavy-set frame of David Sylvester, deep in conversation with a slight girl who gazes raptly at him as if expecting a revelation. I become vaguely conscious of a certain unease in the room as I nod toward Sylvester, who looks through me and continues to talk urgently to the girl. Denis meanwhile has been prancing from one side of the room past the silent piano to the bar and back. He's wearing a light linen suit and his head is thrown back in exultation, as if he were savouring some private triumph.

'Do stop pooving around, Denis,' Muriel shoots from the bar. 'If you can't keep still, why don't you open your bead bag and buy all my lovely members some more champagne?'

'I think it should be champagne, champagne all round,' Denis rejoins, waggling his exultant head from side to side. 'Now that I've exposed the fat critic for what he is, a fake and a smarmer who's made it up the ladder by clinging to Francis's coat tails.'

Sylvester is breathing heavily and beads of sweat have begun to snake down his face and disappear into his beard.

'You little worm,' he says, his bulky chest heaving. 'If I have never included you in a review, it's because you're a nothing. You can't call what you do "painting". It's a travesty of painting, even if Francis once allowed you to paint some grass in for him.'

'And such beautiful grass it was,' says Denis, moving towards him. 'I expect it's what you liked best about the picture because Francis says you have no eye for painting at all. He says you only see things when they're pointed out to you. Those I'm afraid are simply all the facts.'

'When did you last have all the fucks, dear?' says Muriel, sensing trouble. 'I think it's time you both piped down and stayed with the fucks.'

But Sylvester is clearly not about to restrain himself.

'You pathetic little pansy,' he bellows, throwing the contents of his glass in Denis's face. 'How dare you try to come between Francis and me?'

'Can't face the truth, critic, can we? Dish out the criticism but can't take it!' says Denis, his face gleaming as much from the aptness of his remarks as from the thrown wine.

But before he can continue the performance, Sylvester roars like a wounded man and with his pendulous belly swaying lunges out to punch Denis full in the face. Denis staggers back and collapses on the floor, face up, with blood streaming from his nose. As Sylvester retires heaving with emotion to his corner by the bar, Magnus and I approach tentatively, with not much in mind, trying desperately to remember whether you are meant to move the wounded or not. Meanwhile, Denis seems to be continuing his anti-Sylvester campaign from the floor, his mouth bubbling with blood but forming perfectly modulated fragments

of conversation to which 'You've always punched beneath your weight, you ghastly tub of lard' returns like a refrain. Gingerly we prop him up, then help him to his feet, standing on either side of him and holding his elbows. Then we realize that behind the blood coursing over his lips and chin Denis is actually grinning, as ghastly a sight as it is incomprehensible. He actually seems to be enjoying the situation, and he totters over to the bar crying out: 'Champagne! Champagne for everyone!'

At which Muriel, who has been watching the scene from her stool in unconcealed alarm, turns to the barman quick as a whip and says: 'Come on, dear, open the champagne before our bleedin' heroine changes her mind.'

'First blood, now wine,' Ian pipes up. 'Like a li-bation.'

'More like a bleedin' li-ability, dear. Now open the bottle and take the money.'

Champagne served, Denis begins a tour of triumph, oblivious to Sylvester, still pouring out his grievances to anyone in earshot, as if he had been awarded a distinction – wounded in a fight for truth. No one begrudges him this self-conferred honour, especially as, in a rare departure from Colony Room convention, Ian has darted out from behind the bar to ensure the wine keeps flowing. Also very visibly flowing is the blood from Denis's nose which has swelled to twice its size and taken on an even darker purplish hue than the rest of his face. None of this appears to concern its owner, however, who is weaving from group to group to receive his due and would no doubt have continued until evening had the club door not opened to reveal Dickie, his companion in what was well known as the longest queer marriage in the land, who strode over and took the situation in at a glance, saying 'Your poor old conk will never be the same, cunty,' enjoining Magnus and me to help manoeuvre Denis down the stairs into a cab to Hyde Park Corner and thence to the tender care of emergency at St George's Hospital.

Mischief in Morocco

'We go from nothing to nothing.' I'm staggering around my room with its leaded windows overlooking Avery Court. 'And in the interval between we can try and give our lives a meaning through our drives.' Here I cannon into a wall and a roar of laughter goes up, but I recover just in time to steady myself against the table. 'There it is. Life is all we have and since the whole thing is meaningless, we might as well be as brilliant as we can, as Nietzsche says. Brilliant even if it is being brilliant about nothing. I myself', I continue, spreading my arms wide to take in all present company, 'am probably the most artificial person you've ever met. I've worked on myself a great deal. There it is,' I conclude, pretending to put on lipstick and mincing over towards the gas fire. 'Those are just the facts. There's nothing you can do about those things. I've always known I was totally homosexual.'

This last bit is greeted with wild hoots from the group of friends, back from lectures and supervisions with their gowns dumped on the floor, who are sitting round the gas fire toasting crumpets on long forks. I'm now called on to do my Bacon imitation regularly by the group of us in college who go around together. This afternoon, in the fading light, there's Magnus Linklater, Peter Webb, Max Wilkinson and Martin Kingsbury. We all moved into digs together last year and now we're back

in Trinity Hall, living in rooms dotted all round its medieval network of courts and lawns and libraries, constantly dropping in on each other for tea or a glass of sticky sherry. 'Come on, do the Bacon,' they say, and I'm quite pleased to oblige, since I'm always ready to fool around and I'll do almost anything to get a laugh, but also because it's a way of keeping in touch with them about the way my life is changing without giving too many details about what is going on there in deepest, darkest Soho.

I try not to do it too often, partly because I'm enough of a ham to want to keep my little act in demand but also because I feel I've been stupidly sacrilegious every time I finish and lap up the merriment it provokes, a bit as if I were doing a parody of the Last Supper or the Stations of the Cross. Paradoxical as it might certainly be, Bacon has become a kind of religion for me, or certainly a form of belief.

At boarding school, not long after I'd been through a belated confirmation, I became transfixed by the notion of infinity in time and space, but above all in space, which seemed marginally less abstract and easier to picture, an endless void that stretched over you like a night sky when you were trying to sleep but couldn't because of the panic that thinking about nothingness, lit by a few cold stars, induced. Almost without realizing it, all dogma and any specifically Christian belief slipped at that moment from my consciousness as merely man-made and not cosmic – never to reappear. A year or so on, I recovered from the disturbing sensation of being a mere particle falling through infinity, and the more reassuring parameters of the here and now returned, thanks mainly to a sudden avid interest in sex and girls.

The experience nevertheless left a significant question mark lurking behind until Bacon's incessant tirades against the futility of life, the nothingness of existence, drew it back to the fore. Part of my chronic confusion stemmed I thought from the lack of any firm belief, and even though I was both repelled and unconvinced by the bleak finality of Bacon's views, I was

impressed by the vehemence with which he appeared to adhere
to them, as if believing in nothing had in itself become a faith
so strongly anchored in him that he felt bound to proclaim it
wherever he went and make whatever converts he could. In his
eyes it was bad enough, as I had witnessed several times, to prefer
a Beaujolais to a Bordeaux, or Rubens to Rembrandt, but when
he discovered some unfortunate with a hope of salvation and an
afterlife he could not contain his scorn and anger and berated
the believer as savagely as he could. If he had seen the light of
nothingness, why should others stumble on in their benighted
darkness? It was as if he had a sacred duty to open their eyes to
the stark limits of the brief futility that made up their existence
as it did his.

I got a glimpse of just how closely Bacon kept to his faith,
terrifying and comfortless as it was, when I was last with him in
London on a bender that took us through to dawn. We'd had an
excellent dinner with abundant champagne and red wine, but I
noticed that George was particularly withdrawn and that Francis
didn't make any fuss of him. In a good mood, he'd usually call
him 'Sir George', but there was none of that, and in the taxi
from the studio to the Etoile on Charlotte Street he'd suddenly
snapped at George, studiously smoking as ever: 'Keep that filthy
cigarette of yours to yourself.' We'd gone to a few clubs after
that, and as I hadn't drunk much over the past week or so, I
was pleased to be surrounded by so much excess. Then I noticed
Francis's mood darkening, almost from one glass to the next,
and by the time we'd reached the end of the night in some dark
basement club whose name I never even glimpsed he seemed
barely conscious, not wanting to stay but unable to leave, and
since the champagne was not to his liking we switched to whisky,
and Francis was swaying in his seat, rimmed by a strange blue
light, with his eyes closed, his face closed to anything outside
the darkness in his mind, repeating like a chant, a mantra, over
and over again, 'There's nothing, see. Nothing. *Nada*. Just *nada,
nada*,' until George and I got him up the steps and into a cab

back to Reece Mews. But in that darkness I could see how he clung, as tightly as he clung to the black leather coat in his lap, to the core belief of his religion. And I wondered whether he had chosen it not only for the freedom it conferred but also because, in its unconditional harshness, it was the one that gave him the least hope and the greatest pain.

If I can be persuaded to 'do the Bacon' a bit more freely at the moment it's because, after a couple of years sunk in existential gloom and doubt, I can make out at least the semblance of light at the end of the tunnel. *Cambridge Opinion* has just come out. It's taken an age to get all the texts and photographs together and see the whole thing through the press, but I'm over the moon now it's actually there, and I keep turning over the pages as though it's not yet quite real and might disappear if I stop looking at it. Both Kitaj and Hockney came up trumps, providing very articulate commentary on their own work, with Kitaj producing a painting specially for the cover. There's a lively exchange of letters between Auerbach and me, an interview with Anthony Caro by Lawrence Alloway and a rather wild text called the 'History of Nothing' by Paolozzi. We've also got Freud's terse declaration (I had to call him repeatedly in London, then at some glamorous-sounding castle in Scotland, to get his final agreement to it just as we were going to print) and a distillation of my various conversations with Bacon opposite a striking portrait of him by John Deakin (whom I've thanked in the issue, but I expect I'll have to buy him a few drinks at the French or the Coach and Horses as compensation). Then there are all the critical essays to counterbalance the various artists' statements. Even the advertising, which my colleagues have rustled up from all over the place – including a whole back page from *Paris Match* – looks good.

If this weren't enough to make me feel I'm riding high, I get a flattering review of the 'Modern Art in Britain' issue from John Russell in the *Sunday Times*. It had never occurred to me

that our little magazine would reach Fleet Street, let alone get a notice by a well-known art critic in a leading newspaper. Perhaps good things, like bad ones, come in threes, because shortly after that comes an invitation from Nigel Gosling, the art critic on the *Observer*, to drop in to see him next time I'm in London. I'm down there within the week, slightly suspicious he might just be angling for an introduction to one of the artists I've met, but he's very affable and takes me to a packed pub near by. He clearly relishes a liquid lunch, and when he asks me whether I would like to choose a few of the most interesting shows on in London each week and write short reviews on them – a 'gallery roundup', he calls it – I wonder whether he hasn't had a gin too many. I try to look as if I'm weighing pros and contras up for a few seconds, then jump at the offer. Even though I'm not sure I want a career in arts journalism (wasn't my ideal supposed to be writing 'for myself', whatever that was, in some exotic location overlooking the sea?), I could hardly turn down such an alluring prospect before Finals are even on the horizon; after all, this could lead, my new journalist and drinking friend says, to a permanent position on the *Observer*. I'm also mindful that coming to London every week to snoop round the galleries means I will see more of Bacon and the people in his orbit as we all continue to revolve on his unique whirligig of posh restaurants, louche bars and kinky clubs.

'Do be an angel and open that whole case of wine,' Sonia is saying to me. 'I so hate it when there's a good conversation going and I'm endlessly having to jump up and fiddle around with a corkscrew. By the way, do you know how to change a light bulb? Do you really? Oh, that's absolutely marvellous. All the men I know are totally impractical. They may be wonderful looking or absolutely brilliant but none of them can change a bloody light bulb. Can you imagine asking Francis or Michel Leiris to change a light bulb? Thank goodness you're here. Even if you've achieved nothing in life so far and can hardly be expected to

make any worthwhile contribution to what people will be saying this evening, you can at least change a light bulb. Why would you want to write when there are so many people who have already written such important and wonderful things? You'd be of much greater use to mankind if you became a plumber or an electrician. Oh, the light that needs changing is over there, by the dining table.'

This is the second time I've been to Sonia's house on Gloucester Road. Rather pointedly, she had not invited me earlier to the soirée I knew she was organizing for Michel Leiris but to a small dinner party where, as she put it, 'there would be no really important people'. But the Leirises are back in London and they are coming this evening as well as Francis and Lucian and David Sylvester. I am already feeling a bit overawed, I realize as I make myself useful, and it's not much help when Sonia keeps reminding me what a privilege it is for me to be there. I suspect Francis must have said he wanted me to meet to Leiris, because Sonia, who has already introduced me loudly as 'an obscure young man' to her lesser friends, clearly doesn't think I'm going to be much good at the elevated intellectual talk she expects around her dinner table. All the same I'm pleased she's asked me early to give a hand because she's one of the few women to appear regularly on Francis's nightly round and although I'm amused and flattered to be part of it I sometimes find the homosexual atmosphere suffocating and I crave female company.

I've found out quite a bit about Sonia from Francis, who often talks about her when she's not there. He seems to be drawn to her mainly by her unhappiness. 'She's always been unhappy,' he says. 'I don't really know why. Cyril Connolly once said to me, "The very idea of Sonia being happy is obscene." She had two disastrous marriages. She married Orwell on his death bed when he had only weeks to live, and then she married Michael Pitt-Rivers, who had been charged with buggery during that whole Montagu affair. Sonia knew he was queer of course but decided she could change him or some nonsense, and of course that didn't

work. She was very beautiful and a lot of men have been in love with her. She had an affair with the philosopher Merleau-Ponty in Paris that lasted for a while, basically because he treated her just as a sort of English blonde. There've been all kinds of other people, but it's never really worked. Most of her real friends are women, and I've often wondered whether she wasn't *au fond* lesbian. She's always wanted to be with artists and writers, you know she worked with Connolly on *Horizon*, and I think she wanted to write herself but it's never worked either and so I suppose that's also been a frustration. But she has found a kind of role by giving all these dinner parties where she brings English and French people together. That's the rather marvellous, generous side to her. She's created a kind of salon where people can meet and talk, and that is of course a very rare thing nowadays and a very valuable one.'

There's plenty of talk this evening. Sonia has been drinking all through the evening, and even when she was making her *boeuf bourguignon* she was pouring one glass into the stew and another for herself regularly, so now she's a bit red-faced and bleary-eyed and argumentative. She keeps repeating things like '*Mais c'est fondamental!*' or '*Il n'a rien compris*' or '*C'est un faux problème*' very emphatically, although it's less and less clear what she's referring to. Leiris is very courteous to her and that seems to calm her down a bit. Lucian is polite, too, but he looks abstracted and a little bored and he has already announced that he has to leave straight after dinner. Sylvester I find rather ponderous, but he's made some good remarks, first about *Macbeth*, which is one of Francis's favourite plays, then about the rue des Saints-Pères which is apparently where Francis stays when he goes to Paris. 'I often wonder', he booms, as Sonia ladles another helping of the *boeuf* on to his plate, 'why there isn't a rue des Impairs!' I wish I'd been able to say that, but I reason it would sound more odd than witty coming from a student. I also wonder whether Sylvester hadn't prepared the remark or heard it elsewhere, and I focus more on following the conversation rather than trying to join

in, even though I mentally prepare what I hope are a few fluent phrases in French. Whenever I do say something, however brief, Sonia rounds on me with a '*Soyez pas idiot!*', so I decide simply to keep mum. I'm fascinated by Leiris's face, which is inhabited by numerous tics, but I'm also fascinated by how formal he is, tightly buttoned up in his suit and speaking in long sentences full of subordinate clauses and a regular use of the present and even the past subjunctive. Somehow I had imagined a kind of Left Bank intellectual in black clothes and possibly even dark glasses, involved to the hilt in the latest intellectual movements and snortingly dismissive of anybody who wasn't, rather than this elaborately mannered, deferential older man dressed more like a Swiss banker than a bohemian.

The real point of the evening, I'm beginning to realize, is for Leiris and Bacon to get to know one another better, and most of the conversation, which I'd thought would be so full of complex, subtle twists and turns I would barely be able to follow, is an exchange of what to any outsider would sound like outrageous compliments. '*Votre dernier livre est tellement merveilleux,*' Bacon has told him several times, opening up his arms to demonstrate how wide the book's appeal was, and Leiris, his face agitated by depth of feeling, has concluded his appreciation of Bacon's paintings with a perfectly honed '*Elles sont d'une puissance non seulement magistrale mais totalement réaliste,*' which makes Francis glisten with pride. He knows that Leiris has been closely involved with Picasso and Giacometti, and that praise from Leiris to some extent elevates him to their company. Sensing that the dinner has been a success, Sonia has fallen into a melancholy silence, her drinking and smoking still defiantly confirming her presence even though her essential role has now been played. Sylvester meanwhile, who has known both Bacon and Leiris for many years, has been following the mounting crescendo of compliments and fanning the flames of flattery, his corpulent frame heaving with the enthusiasm of an artistic matchmaker and the witness of a unique moment in

cultural history as writer and painter see eye to eye on everything from realism to Surrealism (except for one brief moment when they touch on Beckett, whom Bacon dismisses, saying, 'I loathe all those ghastly dustbins on stage,' and Leiris defends mildly, saying, 'There's enormous charm in the work').

I stay behind to help Sonia clear up the mountain of plates, glasses and bottles, and while moving dutifully between table and sink I make a drunken, desperate and wholly inappropriate lunge at my hostess which I expect to be appropriately brushed aside. But, to my surprise, it is reciprocated, without a moment's hesitation, as though it's accepted that that's what men do at this time of night, and all thought of clearing the dishes is suddenly, miraculously, suspended. I am further taken aback, however, when Sonia breaks out of my clumsy fumbling to say, 'Everybody's doing it like this in Paris,' and proceeds with grim efficiency to move on to something I've heard of but more as a kind of dirty joke and certainly never done. I try to adapt to this turn of events with enthusiasm as well as a dash of what I hope comes across as Gallic nonchalance, but we both become aware of an urgent pacing up and down just outside the kitchen, and Sonia breaks off to say, 'I told Cyril to go to bed,' before we resume, and Cyril, about whom I have heard enough to identify instantly as the great man of letters and Sonia's former boss at *Horizon*, continues to pad more and more noisily in the corridor outside. Standing with my back to the kitchen door, I feel increasingly detached, imagining myself no longer as a footloose student but as an aspirant against all odds firmly sandwiched now between two great names in literature, Orwell and Connolly, and thus elevated, almost like Francis so recently risen between Picasso and Giacometti, to undreamt-of realms of achievement but in my case with no justification, particularly as the farcical side of the situation begins to overwhelm all else, undoing alas what was so well begun, and crestfallen but oddly relieved I realize that to all my other failures in Sonia's eyes both intellectual and social I now have to add failure at this. Meanwhile, I repeat to myself,

hastily dressing in case an irate man of letters bursts in, although we bit off more than we could chew we might get another crack at the whip, however mixed my metaphors are and however real my shame, although even now I'm rearranging the whole thing as a story in my head, as Sonia says despondently, gazing at the unwashed dishes and apparently unaware I am still there: 'To think that Cyril's still after me, after all these years.'

Finals are over and Cambridge is fading, even though the summer light on the ancient courts is so mellow, the celebrations last through the night and the morning's promise arrives undimmed. We are torn between nostalgia at leaving such a gilded haven and the world beckoning beyond, but all of us in our tightly knit little group realize that we are leaving for good.

Real life, whatever that is, won't start quite yet, however. For some months we have been planning to make a major trip together, driving the length of France and down to Barcelona, then the length of Spain to Algeciras, where we will board the ferry to Tangier. Our choice of destination hasn't been picked out of a hat. From my tales of Soho and its master magician (the 'magician of the night', as I often think of him), Bacon is now part of our group myth, and some time ago I reported back that he would be in Tangier, where I know he's been going for years. So that's where we're headed, since it seems as good a reason as any, though we are also going to make the most of the journey taking us there.

France is pleasant and mild but unremarkable, a series of long roads bordered by plane trees, picnics in fields and efficiently run camping sites. Then Barcelona hits us between the eyes. There had been the odd, mainly chaste encounter on the way down, but what we hadn't expected, once some ancient male instinct had guided us to the red-light district on the lower Ramblas, is the profusion of brightly dressed, amiably chatty whores. Far from the threatening, sleazy atmosphere of the doorway

trade in Soho, the women here seem light-hearted and friendly, as ready to share a drink, a dance and a chat as to proceed to more earnest business between bidet and bed in a dark cubicle. We are entranced, as if we had stumbled on a local fiesta where the girls, while clearly not just out of the convent, nevertheless have a certain natural poise and charm. We are also daunted by the very availability of so much sex, since our experience hasn't gone much beyond unfulfilled gropings with girls of our own background or the very occasional and usually depressing paid transaction. Here we seem to be in an entirely new realm where what is usually furtive and shameful resembles a celebration, with drinks and laughter. We practise our fledgling Spanish and in the badinage that ensues pick up a few memorable phrases, notably one girl's clear demarcation of services rendered – '¡Fuckee fuckee sí, suckee suckee no!' – that thenceforth becomes a war-cry regularly roared out of the windows of our trusty red Mini as we speed southwards to Grenada and get the first real impact of Arab culture. When we come to Seville, we make a beeline like pilgrims to a shrine for Bacon's favourite hotel there, the Alfonso XIII (or 'Alfontho Trethe', as he calls it, just as in perfectly camp Castilian he calls his favourite painter 'Belathqueth'), before beating a hasty retreat to an inexpensive hostel. Both the cities and the landscapes of Andalusia enchant us and we no longer see ourselves as tourists but as intrepid explorers as we continue barrelling across the sierra in search of the gateway to Africa.

From the moment we get off the ferry in Tangier, things speed up even more. A couple of friendly bystanders in striped djellabahs who speak French and are about our age show us the way to the medina and actually take us to a run-down little hotel where they seem to know the owner. The rooms are on the basic, not to say grotty, side but the price seems reasonable enough so we unpack and wash and the two boys are still hanging around when we come down. They call us all 'Ali Baba', and me in particular 'Ali Baba in glasses', which is quite funny, and they say we should visit the kasbah right away, and it's true it looks

totally exotic when we get there with great pyramids of olives and spices in sacks and dates on the branch. We get a fantastic flatbread sandwich on the way to the carpet shop which the boys say their uncle runs and it turns out he's sitting on top of this amazing pile of carpets which reaches almost to the ceiling and he's very friendly and says we were predestined to come to his shop even before we set off from Cambridge. It's really mysterious how he could have worked this out, it's not exactly as if we're wearing college scarves and he and the boys have only had a couple of quick, guttural exchanges in Arabic. Before we can ponder this much more they all very generously offer us some kief to smoke. That has been something we wanted to do anyhow but as we puff away, trying to look as if we did it all the time, it doesn't seem to have much effect beyond making us feel pleasantly sleepy and amused. After a while, though, I feel I could lie right down on one of those carpets and doze off and the others feel just the same and in the end, giggling a bit among ourselves, we agree to buy one of the cheaper carpets just so the boys can take us back to the hotel which we've lost track of completely but hope to get to soon before we totally conk out.

When I wake up the next morning I feel dazed and discontent and I become even more irritable when I find the garish, synthetic-looking rug we bought glaring up at me from the floor as well as some kief or hashish or whatever it is neatly tied up in plastic bags at the foot of the bed that I can't even remember buying. A good chunk of our budget for the stay in Tangier has been blown on these stupid purchases for which we didn't even haggle over like the idiots we are, probably could have got them down by half, so we realize we're going to have to pull in our belts, which is unfortunate since the drug seems to have made us ravenous. As we pick our way through the maze of streets and the crowds of veiled women shopping in the souk, I am convinced a couple have winked at me, brown eyes flashing in a yashmak, but put it down to the lingering effects of the weed. We are hoping to find a good, cheap couscous with mint tea but the skewers of lamb are

covered in flies so we settle for another tuna and olive flatbread and wolf it down while gazing at crudely painted earthenware dishes and piles of Moroccan slippers. At least we'll get one good meal this evening, we tell each other, since I've called Francis at his hotel and he's told us to meet him at a posh-sounding French restaurant in the *ville nouvelle*.

Hunger makes sure we arrive at the restaurant promptly and as we troop in to the air-conditioned dining room I realize how rough we've been living between tent, hostel and street food. We look rough, too, in our crumpled shirts and baggy trousers, particularly as the head waiter in immaculate black takes us past waiters in immaculate white tunics with gold buttons to the table where Francis is already sitting. We're also still a little woozy from the weed. I'm always glad to see Francis, but this time he appears like a saviour, lifting us out of scruffy travel and on to an altogether more sophisticated plane. I make the introductions, wondering uncomfortably whether Francis will sound at all like my impersonations of him to my friends, before I note that their attention is completely fixed on the menus they have been given and the expensive, French culinary treats in store. Francis encourages everybody to order lavishly, fills our glasses and also fills in a bit of background.

'Tangier is a rather curious place,' he says. 'It's a bit like Muriel's club, Michael, on a large scale. People come here to lose their inhibitions, above all queers from England and America. I'm not sure it will last but it has been a very tolerant place. All the Beats, Ginsberg and the others, were here, as you know, and they made a great thing of going native and living rough, drinking wine out of old tin cans and so on, but of course they always had a return ticket to America in the back pocket of their jeans. So I don't think they were taking too many risks. I used to come here a lot to see a friend of mine, who's unfortunately dead now. But that's another story. I used to see Ginsberg a bit, and Paul and Janie Bowles and Bill Burroughs and people like that. Ginsberg actually asked me to do a picture of him and his

lover having sex on their bed, and he gave me all these photos. So I said, well this could be a bit awkward if you want me to paint you as you're doing it, Allen. How long can you hold it for? Anyway, the lover wasn't very interesting, I'm afraid, but there was something about this striped mattress and the way it spilled over the metal spindles that was so poignant and despairing that I've kept the photos of the bed and used them ever since.'

After our blowout we go on to the Tangier, or *tangerois* as we are already calling it since it sounds more hip than 'Tangerine', night life. Francis says there's a bar called the Oasis which we might like but it's full of middle-aged homos, all very affable, and we learn that our Cambridge tutor is a regular visitor which amuses us, and we talk to someone our age from London called Mikey Portman who's sure Bill Burroughs will be in, but I feel I've already been waiting too long for Bill Burroughs and what would be much nicer is a cuddly girl to talk to. And Francis seems aware that this is what we're keener on and takes us to a great bar with lots of smooth-looking people of both sexes and we are well oiled enough now not to mind if we look a bit rough, on the contrary we're just following on the great Beat tradition that's made this place what it is, and we're chatting up the ladies like there's no tomorrow and of course Pete has got the prettiest one, a willowy blonde very audibly from the East End, and I notice Francis looking a little concerned and he comes over and takes me aside and whispers: 'Tell your friend Pete that the Billy Hill mob is in town and he's making a play for Billy's girlfriend and that could get him into real harm.' And I try to relay the message to Pete, who's remained more strung out on the dope than any of us, and he repeats amusedly to the girl, 'I hear the Billy Hill mob's in town,' and before you know it she's disappeared and Pete's blinking into space and wondering what to do with himself.

I feel I've done enough chaperoning for one evening and go back to Francis's table and share the champagne he's ordered. Although he's tanned and his hair has been bleached by the sun

and he's looking good in his blue gingham shirt and jeans, he
seems withdrawn and sad. He's been out to Cape Malabata,
he says, where a great friend of his is buried. He pauses for a
moment, then launches abruptly into a monologue.

'I don't know whether I ever told you about Peter Lacy?'

'You've mentioned him, yes. He had a tremendous effect on
you, didn't he?'

'Listen, in one way I've had a rotten life because I've always
lost the people I've been deeply attached to. That side of things
has always been impossible, for me at least . . . I don't know why.
I met Peter completely by chance one evening at Muriel's bar. I'd
known lots of people before but, even though I was over forty
and everything, I'd never really fallen in love. Well, what Peter
himself liked was young boys. He was actually younger than
me, but for some time he didn't seem to realize it. It was one of
those very odd things, an anomaly, and he went with me. It was
the most total disaster right from the start. Being in love in that
extreme way – being utterly obsessed by someone as I was – it's
like having a dreadful disease. I wouldn't wish it on my worst
enemy. And we had these four years of continuous horror, with
nothing but violent rows.

'Peter was marvellous looking, you know. He had this physique,
it was so extraordinary. Even his calves were beautiful. And he
could be the most marvellous company. He was a kind of playboy,
I suppose. He used to play the piano and sing, and he had that real
kind of natural wit, he used to come out with one amusing remark
after another – just like that – unlike those people who spend their
lives planning what they're going to say from morning to night.
But it never worked. You see, he said to me once, "You've ruined
my life by making me think about myself." There you are. Of
course, he was also the most terrible kind of drunk.

'He'd always had plenty of money when he was young, and in
that way, since he'd never had to do anything, I think he felt the
futility of life more clearly. The war was really ideal for a person
like him, he fitted into that kind of tension. He was a fighter

pilot, then when the war ended he worked as a test pilot for a bit. All those things help shatter your nerves, obviously. I must say most of the time he was extremely neurotic, hysterical even.

'He said to me once, "Why bother to paint?" Of course, he hated my painting and was always trying to destroy it. I know everyone hates it now but he hated it from the start. "You could leave your painting and come and live with me," he said to me once. And I said, "What does living with you mean?"

'And he said, "Well you could live in a corner of my cottage on straw. You could sleep and shit there." He wanted me to live chained to the wall. Well, as it happened, I did terribly want to go on painting. It would never have worked in any case. He was a complete sadomasochist, and kinky in all sorts of ways.'

Asking Francis questions has become almost automatic, even when they're indiscreet.

'What sorts of ways?'

'Well, one of the things he liked, these things can be embarrassing to say, but he liked to have someone bugger me and then bugger me himself while what's called the spunk was still there. He also liked having other people watching and that sort of thing. He was very extreme, he had a collection of rhino whips and he went right to the end of everything he did . . .

'There were comic sides to it as well. We went away together on a boat once and I'd brought all these suits and things for the trip. And as soon as the boat left we had a row and Peter pushed the lot out of the porthole. I had absolutely nothing left, I just had to try and buy some shorts on board.

'The whole trip was comic in a way. Looking back on it at least. Peter used to behave in such an extreme fashion. He was dead drunk the whole time and he used to go around with a very menacing look. People came up to me and said, "Who is that awful man you're with?", and of course I had to say, "Well, I don't really know." And all the stewards were queer, they always are on those boats, and that made the whole situation even more curious. But Peter was completely impossible. We tried to live

together for a while, in a place out in the Thames Valley where there's just one luxury pub after another. It didn't last, naturally. In the end, he left me. He fell for some boy and went to live in Tangier. When I knew him, he was really tough, tougher than me. But after he left and went to live in North Africa he lost that kind of toughness. I think it had something to do with the Arab men.

'Of course, by that time, he was drinking three bottles of whisky a day, which nobody can take. This boy had left him and so on. In the end, I think his pancreas simply exploded. Anyway, he no longer wanted to see me. Of course. And well . . . I was very upset because I had been deeply fond of him. Outside of certain artists, I think he was the most remarkable man I've ever known. But he just left me and said he never wanted to see me again. He called one day, before going off to Tangier, and said, "From now on, consider me as dead."

'And then, much later, for some reason he sent me this telegram asking me to go out and stay with him in Tangier. It was all over between us, but like a fool I went. It turned into a real disaster. Peter wasn't there when I arrived. Of course. But there was this Arab boy, well it sounds mad, but he was sitting up in a fig tree in the courtyard and he asked me whether he could pick the figs. I said yes certainly he could. And in the end he climbed through the window and, well, he was terribly good-looking. Anyway, Peter came back just then, I'm afraid, and found us both in bed and he got so absolutely mad, he went round and broke everything in the place. He became so impossible. Even though there was nothing between us any more. He broke everything. In the end, I had to go out and try and spend the night on the beach. I can see now that he was absolutely neurotic, even mad at times. He really killed himself with drink. He set out to do it, like a suicide.

'And then the day that exhibition of mine opened at the Tate a couple of years ago, along with the other telegrams I got this one saying he had just died.'

5

Conversations at Night

No sooner do I get back to London than I find I'm obsessed, not by the mysterious alleyways of Tangier or Andalusia's Arab palaces, but by memories of the bright girls in the bars of Barcelona. The easy naturalness with which they ply their trade is unlike anything I've known and I can't get it out of my mind. It's not the actual commerce that draws me, since the idea of love for sale would put me off in all but the most desperate situations; I'm also vain enough to think that I don't need to pay for it, despite regular indications in my life that demand in this department is always going to be greater than supply. The lasting allure of Barcelona for me lies in the extraordinary freedom it seemed to convey, like an explosion of the senses, with sex, food and wine all on offer after a day spent swimming and taking in the sun on the beach. Then the laughing girls in their tight skirts slit up the sides and stiletto heels tottering from dance floor to bar and to bed in a kind of continuous homage to pleasure. They called me '*el inglés*' and '*el rubio*', which have an agreeably mythical ring, and one of them, on the mere basis of a gin-tonic and a quick trot on the dance floor, introduced me to all the other revellers as '*mi hombre*', which would have rung alarming marriage bells in English but sounded heroic in Spanish. It's as though there's a big party going on, with all the excitement you can handle, and you only have to go back

there to join in. Thinking over our trip as I try to get to sleep at night, it's not the admirable balance of France nor the exotic foreignness of Morocco that attracts me. It's the romance of Spain, where love and death seem so closely intertwined.

Now that we're back in London, we've all stuck together, my old friends from Cambridge and me, and we've decided to rent a basement flat on Tregunter Road in Chelsea. It's been let to us by a mannish woman who lives with her mother in the big house above and who calls all of us 'guffins', which we take to be her own, fairly affectionate way of saying we are nincompoops. We move in and create the same comfortable, careless chaos we lived in at University, which comes back to haunt us when Pete leaves a pot of honey spilling slowly but surely over all our treasured 78 records. He and Magnus already have jobs whereas I seem impervious to the odd offer that comes along and reluctant to get myself started on the first rung of whatever ladder I'm meant to be climbing. I go on doing my exhibition reviews but my heart is no longer in it, and any notion of securing a more permanent position as junior art critic on the *Observer* falls conveniently away. I scribble down disjointed thoughts, maxims, scraps of poetry and exhortations to myself to get up earlier, be more disciplined, write something worthwhile, and I fail on all counts. Deep down there's only one thing that I really long for, and that is to return to Spain for a whole year.

Once I knew what I wanted, I felt I knew who I was, and from late mornings spent at the launderette or wandering among the graves in Brompton Cemetery, I am fully focused on finding a job, not in the Smoke but in the land where the cicada sings, although pinning something down in Barcelona is proving tricky. There is however an Oxford Institute of English in Gijón, right the other side of Spain on the Asturian coast, that has shown interest in my willingness to teach, and since I'm pretty sure I can use it as a stepping stone to Barcelona I snap the offer up. Things begin badly enough on the first evening I arrive. I come down for the evening meal at the cheap local *pensión* and polish off the

whole litre of strong 'black' wine that's been left provocatively on the table, and when the grinning waiter asks me if I want another I order one more, as if I've got something to prove, then spend the rest of the night in a sleepless stupor. The man running the Institute is a former British navy officer who's joined some mysterious religious order but who's kind and tolerant. His best friend in Gijón runs a maritime insurance agency who impresses me because he was tortured by the Japanese in the war and had all his fingernails pulled out one by one. While teaching I acquire a girlfriend, clearly intent on marriage, with whom I go for stately walks, accompanied by her aunt, through the quiet little town to the port. I've found a room with an elderly couple who make wicker baskets for a living and every evening before dinner we raise a toast 'To Churchill', but my Spanish is still too feeble to take the conversation much further. I miss my friends and I miss the evenings out on the town with Bacon, with whom I feel a tenuous link because my mother is sending me a weekly allowance just as his mother did when he was in Berlin and Paris (that was in the 1920s, and I somehow feel his allowance must have stretched further than mine appears to be doing). I'm plotting my next move and when the man from the shipping insurance says he can get me a paid berth as third mate on a coal steamer going all the way round the coast to Ceuta and then up to Barcelona I jump at it.

Edging round the whole Spanish coast on this slow old bulker takes a couple of weeks, which I while away by reading an English dictionary, the only book on board, from cover to cover and comparing my much admired Zippo lighter with those of the other crew members when we gather for lunch at 10am and dinner at 5pm, both meals usually centring round salt cod and a dessert made of Carnation milk, followed by unlimited contraband cigarettes and Torres brandy. When we drop anchor in Barcelona harbour, I and my luggage are rowed ashore by a sturdy cabin boy, who insists on carrying my bags until we arrive at the foot of the Ramblas. I stand there alone for

a while, savouring the moment, too excited to regret that I am
not wearing a white linen suit with a Panama, and convinced in
my bones that a major page in my life is just about to turn.

Day after day crisscrossing the *barrio gótico* until I know it by
heart and gazing at the street girls and the bar girls until I've had
my fill has left me no further forward in my grand plan to make
Barcelona the new hub of my life. The narrow medieval streets
with their palaces and churches are all powerfully evocative, and
while the girls plying their trade there seem considerably less
attractive than those I remember, I enjoy the sense of licence
they give to daily life. I've rented a small hotel room by the week
and identified the best cheap restaurants around the huge food
market. The area is full of elderly beggars with terrible loss of
limb and other injuries caused during the Civil War. There's a café
I pass every day that's full of people gesticulating wildly, which I
avoid because I imagine the noise inside must be overwhelming.
Then I go in one afternoon out of curiosity and am astonished
to find it's completely silent because the city's deaf-mutes all
congregate here to communicate in sign language.

 Since I have no paid work to do, however, I soon find I can
barely make ends meet. I also feel I'm not going anywhere or
meeting anybody. I occasionally get into conversation with
tourists, but I avoid it because I am determined to transcend my
current status as *el inglés* and merge with the city as seamlessly
as possible. Meanwhile I am finding my exalted solitude
increasingly oppressive and decide to play the one potential
trump card I hold. Before I left England, the mother of a friend
told me that a young Spanish poet had boarded with them while
he was studying at Oxford some ten years earlier and that they
had stayed in touch ever since. She had written to him to say I'd
be arriving at some point in Barcelona and to me she had given
an imposingly enigmatic address where I could contact him:
Sr Don Jaime Gil de Biedma, c/o Compañia General de Tabacos
de Filipinas, Las Ramblas 109, Barcelona. Having agonized for

hours over whether to address him as Dear Señor Don Gil de Biedma or Dear Señor Gil de Biedma, I opt for Dear Don Jaime, which seems both grander and more intimate, despite a slightly worrying Mafia overtone, and I take my letter round directly to this august personage, leaving it with the receptionist in the foyer of his office building where the air conditioning feels icy cold after the afternoon heat lying heavily on the Ramblas outside.

'Don Jaime' is back in touch the next day, suggesting lunch over the weekend. As soon as we meet, I can see there is nothing sinister or particularly grand about him. He is on the small side, compact and powerfully built, with well-defined, sensual features. What surprises me is just how fluent his English is and how well he knows modern English poetry, particularly Auden and Eliot, whose *Use of Poetry and the Use of Criticism* he has translated into Spanish. We go on talking, drinking and smoking until early evening, and I'm entranced, tucking away certain phrases of his that strike me as particularly witty. When he tells me that he first thought he wanted to be a poet then realized that deep down he wanted to be a poem, I know I want to go on seeing him. Later, since Jaime's invited me to go with him to have drinks with his friends at a bar called El Cristal uptown, I tag along and in one evening I meet most of the people who are going to transform my stay in Spain: the publisher Carlos Barral, the novelist Juan Marsé and the Catalan poet Gabriel Ferrater. By the time I weave my way back through the dark streets, where people are calling out '*¡Sereno!*' for the night watchman to come and open their front doors, I have the promise through my new friends of finding a bigger, better room to live in and a paid job as reader of English, French and German novels for Seix Barral, Carlos's publishing house.

I see Jaime at least a couple of times a week from then on, usually for dinner and a trawl round the Barcelona bars. We talk about all kinds of books and he gives me a copy of Borges's *Ficciones* which, quite apart from amazing me by their brilliance, are written in such limpid prose that my Spanish takes a noticeable

leap forward. Juan Marsé is often with us. He looks pugnacious and I notice the girls in the bars treat him with respect. I read Juan's *Últimas tardes con Teresa*, which takes me further into the grittiness of Barcelona life. On one occasion in the spring, with Jaime's friend Luis Marquesán, we all drive out of Barcelona for a feast in the Catalan countryside where there's a prize for the person who can eat the most *calçots* or spring onions, grilled alongside lamb cutlets over a wood fire and served with a fiery sauce. On the way there Jaime gets agitated in the car that Juan is driving, and when Juan asks him if he is *nervioso*, he replies with impressive aplomb: '*¡No, estoy nerviosa!*' This makes me laugh because it sounds so much like the queer banter I remember from Soho. I find Gabriel Ferrater very amusing, too, because he is always ready, not unlike Bacon, to push an argument or a situation to the limits. Although pale and cadaverous, he is a great trencherman, and he invites me with his American girlfriend to lunch out in Barceloneta. The lunch turns into a gargantuan feast whose highpoint is seafood paella served in a vast flat frying pan. As we finish the meal late in the afternoon, Gabriel asks me whether I have enjoyed it, and when I enthusiastically confirm I have, he summons the restaurant owner and orders the same extravagant menu for the three of us all over again.

I tell Jaime about Bacon, whose painting he knows and admires but whose studio, of which he has seen some photos, he says is too messy for him to imagine they could ever see eye to eye. I suppose there is some parallel between my friendships with Francis and with Jaime. Both are brilliant men, creative and excessive, effortlessly dominating the people around them by their drive and their wit. They are also, of course, both homosexual, and I am not unaware that if I gravitate so unerringly towards this kind of company it must say something about me. I brood over this for some time, and one night when we've done all the bars and Jaime has picked up some drifting boy and the three of us go back to his apartment and I sit with my gin, a drink I've taken up because Jaime likes it and has even referred to it in one

of his poems addressing some pickup like the one who's with us now and whose eyes he describes as *'color de mala ginebra'* (the colour of bad gin), and I'm sipping this oily, melancholic alcohol and rocking slowly to and fro and the boy says to me, 'Do you like boys or girls?' and I shrug and say, 'Let's see,' and he leans over me and starts kissing me, and there's something like a grain of sand on his lips which in any case I find disgusting and I slip out of the embrace, out of the rocking chair and the apartment, and when I get back to my room I spend half the remaining night washing my mouth out obsessively with soap and water.

I'm now part of a group that's older, more sophisticated and demonstrably more gifted than I am, and I prize my membership hugely. One of our regular excursions at weekends is to Sitges, a picturesque little seaside town south of Barcelona that became fashionable in the late nineteenth century. Each time we go Jaime agonizes over whether he is going to be able to squeeze once more into the white trousers he likes to wear on these trips. Going round the bars in the evening I fall in with another English boy about my age who introduces me to his German girlfriend, Margaret, an older woman I find attractive. I start visiting Sitges regularly by train. Margaret has a small house not far from the beach where she lives with her mother and her two young children. We begin an affair. I move into her house where I enjoy telling her children stories and going on long walks over the cliffs above the sea with Brass, their German shepherd dog. I continue to go into Barcelona, where I take book reports in to Seix Barral and give English lessons. Otherwise my life is like an extended holiday. I write occasional poems and stories, swim a great deal and drink heavily. If ordered in sufficiently large quantities, wine, gin and brandy can be bought at wholesale prices. I also host large, inexpensive dinner parties that usually consist of artichokes and grilled sardines, which a friendly fish seller in the market guts and scales for me. Jaime, Luis and other friends come to visit regularly. Jaime comes alone on one occasion when he is depressed. After we've done the bars we

go down to the beach where he undresses and throws himself naked into the shallow, phosphorescent waves, crying 'I want to die!' several times, although the water barely covers his ghostly white bottom. A hippy couple who spend their nights on the beach follow me round for several days convinced that I'm Michael Caine going incognito. Otherwise Margaret and I see a mixture of other expatriates, mainly bar owners, property agents and assorted drifters as well as a huge, flaxen-haired American wrestler called Chuck, also known as '*El Vikingo de Oro*' ('The Golden Viking'), who takes on all-comers in a converted cinema in Sitges after putting away several roast chickens for lunch. Everyone is endlessly available, night and day. It's an idyllic existence in many ways but I can't see it leading anywhere. Lazy and wayward as I know I am, I'm plagued by a sense of futility. Everything I write seems so minor, so fragmentary. What is the point, I wonder, of writing for 'myself' when even myself is not interested? I begin to panic at the idea of spending a whole winter here drinking in the increasingly empty bars, watching the sky and water turn grey and complaining about the natives with the other expats. I correspond regularly with an old Cambridge friend called Adrian Dicks, now a journalist, who has written to say he'll be passing through Grenoble if I want a lift back to London. I look at the map and see Grenoble can't be too difficult to get to. Driving slowly up the backbone of France would give me time to distil what Spain has meant to me and what might still be to come. On impulse I destroy the desultory texts and notebooks I have been dragging around with me from room to room. I also prepare my farewells. Whatever life-transforming experience I'd hoped for in Spain hasn't happened, and now I am going back, empty-handed, with only lost illusions to show.

———

The basement flat in Tregunter Road is darker and damper than I remember it but otherwise unchanged, and I'm relieved to have a place still to lay my head, once the clutter that has built up

over the past year on my bed has been cleared away. The golden autumn days I had grown used to in Spain have been replaced by cold grey ones. People are already wearing overcoats, and nobody is lingering on café terraces or contemplating a swim in the Mediterranean as they hurry about their business. I'm pleased to be back, thankful to be back, but I feel I've been left behind. Both Magnus and Peter have jobs which they go out to early in the morning, while I sleep in and then moon disconsolately around the flat, half waiting for them to get back to hear how their day has gone. I meanwhile feel I have gone nowhere, particularly now that my tan has faded and my finances have reached an all-time low. I bestir myself to make a few phone calls in the hope of reviving past love affairs and am rewarded by the occasional nostalgic cuddle in front of the blue and yellow flames of the flat's ancient gas fire. I've been meaning to call Francis, too, but I'm embarrassed by having been out of touch for so long. When I do eventually call, it's as if I'd never been away. 'It's marvellous to hear you,' he says. 'And such a good idea you called now because Michel and Zette are over here and I terribly want him to see a picture I've just finished. And it would be marvellous if you felt like seeing it too. I don't really know if it works, of course, but I am quite excited about it because it's one of those things that just came about, I don't know how, and I'm not even sure what it's about, I'd been trying to do this image and didn't know how to do it and suddenly the paint suggested something quite different. Anyway, we'll be having dinner here afterwards because it'll be much easier. And Zette and Sonia are coming too, of course. I know they'd love to see you, if by any chance you were free.'

When I get to the studio, it really is like old times. Francis is standing at the top of the steep stairs, his arms held out in welcome. I pull myself up on the same old greasy rope, give a sideways glance into the studio as I get to the landing and promptly accept a frothing glass of Krug when we go into the living room. Leiris and Zette have both come down with a *grippe*,

Francis explains, and Sonia has gone to their hotel to make sure
they're comfortable and have everything they need. He tells me
this in an apologetic tone, as if seeing them had been the main
reason for my coming round in the first place. I'm actually quite
glad to be alone with Francis, since I haven't seen him for so
long, though I imagine he's disappointed that he won't be able
to show Leiris the new painting. I also suspect he won't take
me into the studio, which I've only seen when the door is ajar,
because as a rule he never lets anybody in there.

'I hope Michel feels better tomorrow,' Francis goes on, topping
up my glass. 'They can be very debilitating, those flus. And of
course he's not a young man any more. I did want him to see this
picture because I think he may decide to write something. But
I'd also love to know what you think of it, Michael.'

Without more ado, Francis crosses the sitting room with
his lithe, springy step and opens the battered, paint-splattered
door wide on to the studio and with a dramatic gesture pulls a
sheet off a large painting on an easel in the middle of the chaotic
room. I've been wanting to get into the studio ever since I got
a glimpse of the interior the first time I was here, and now I
simply don't know where to look first – at the threatening
image looming over me or at the incredible mess under foot,
washing from side to side right across the room, out of which
the picture seems to have grown like some huge evil flower.
Francis is staring fixedly at it, rubbing his thumbnail across
his lower lip.

'When I stopped working on it the other day,' he says, 'I really
did think it looked like George. But when I see it now I'm not
so sure.'

'Oh you can certainly see George,' I hasten to say, peering into
the pulped mass of pigment atop the figure's contorted body.
And it's true, within the confusion of pink, white and green
brushstrokes, there's the exact jut of George's nose and the
clear line of where his severely brushed-back hair meets his
closely barbered face. It's George badly beaten up, twisted and

scalloped, but recognizably still just about George. I wonder what goes on between them, since Francis has already hinted that he was a willing victim of Peter Lacy's sadism, to the point where he had been so badly thrashed by Peter he was left to wander round Tangier until the police picked him up and took him to the station, thinking he was the victim of a severe random assault. But why did Francis then smash and pummel the figures he painted until they teetered on the edge of extinction? Was it a kind of re-enactment of what he went through? Or the search for some irreducible visual identity, only arrived at through physical brutality? I knew it was the kind of question he avoided, but by now I'd had enough champagne to feel emboldened.

'Is there a particular reason why you twist and deform the people you paint?' I venture light-headedly.

'I'm only trying to deform into truth,' Francis says. 'After all, photography has done so much, so how are you to make a portrait nowadays unless you can bring what's called the facts of someone's appearance more directly and more violently back on to the nervous system? You have to deform appearance into image. There it is. If I didn't have to live, I wouldn't let any of this out.'

There's an irritation in his voice, and I know better not to push the question any further. You have to be very careful with Francis. His charm and generosity seem boundless, but every now and then you touch on something that's better left alone unless you want to get the very rough side of his tongue.

Having absorbed the new portrait, I gaze quickly round the whole studio. I've never seen a place like it, even though I went to quite a few artists' studios while I was doing the *Cambridge Opinion* issue. There is a chaos here which is so extreme it's hilarious, a monstrous joke, a mess beyond mess, taken further than anyone could imagine. Yet it's not a mess, it's an extraordinary, visually riveting creation. Anywhere you look you could scoop up an armful of fascinating images, photos of wild animals, boxers, Nazi leaders, crowds in flight, George in

profile, Lucian sitting on a bed, Henrietta naked and abandoned, old passports, paint-stiffened cashmere sweaters, brushes, paint cans, reproductions of Goya and Velázquez, Grünewald and Degas, Van Gogh and Michelangelo. You could scuffle to and fro throwing up new images, other strata, all the time because this carpet of heads and limbs and bodies, some killed, some with terrible wounds, is at least ankle deep. And I guess that's exactly what Francis does as he walks up to his painting and back as he works, constantly kicking up new combinations, new visual suggestions, 'triggers of ideas', as he calls them. It's like looking into some fascinating encyclopaedia of images, or into the head of someone who has spent a lifetime tracking down the most exciting visual phenomena that can be found. Just as you think you've memorised a list of contents, then come the photos of mediums at a séance, Rodin sculptures, a couple of champagne cartons, bits of a striped dressing gown, some letters and texts and books, copies of *Paris Match*, used tubes of paint – and paint itself, everywhere, covering all the crushed and scuffed items on the floor in a multi-coloured net, paint rising up the walls in trial marks, paint the real hero of the room over which it has established its dominion.

'Well, there it is,' Francis says, glancing at my astonished face. 'I live in this kind of squalor. But it's useful. This is my compost. It's the compost out of which my paintings come. Fifty years from now, people will see how simple the distortions I make really are. Simple and natural. You see, I've worked on myself a great deal. I've deliberately simplified myself, if you like, so that now you might say I'm what Gertrude Stein called "simply complicated". In the end, all those things come through in the paintings.

'Anyway, Michael,' he concludes, as if something more important has just occurred to him. 'You must be absolutely ravenous. If it's not too much of a bore, we could simply have dinner here. I've made something very ordinary. Just a roast chicken with bread sauce, which I know Michel and Zette like.

Apparently bread sauce is the one thing you can't find in Paris. A collector sent me a case of Bordeaux the other day. I think it's probably rather good, it's a 1961, but I'm such a fool about wine I can never remember if that's a very good year or one of those they tell you to avoid. I'd be curious to know what you think of it.'

While Francis busies himself in the tiny kitchen, I sit at the table, which has been cleared and considerably smartened up with gleaming cutlery and napkins, and reacquaint myself with his living room. The dark-green sofa I slept on and the inlaid commode are still there, along with the photos of Peter Lacy in the alcove, although they have now been joined by a photograph of an immaculately suited, anxious-looking George. The Moroccan bedcover and the naked overhead bulbs haven't changed either, but I realize with a start that the big wall mirror where Francis always checks his hair before going out now has an enormous starry smash in it. If you look into it and move from side to side your face becomes progressively fragmented before it falls into a black hole at the centre of the smash. It's not unlike what happens to a head in one of Francis's small triptychs, though he can hardly have done it deliberately himself. I know that things are occasionally very tense between Francis and George and wonder whether this didn't happen during one of their fights.

'A friend of mine threw a heavy glass ashtray at my head,' Francis is saying enigmatically. He's come back into the room with a huge, half-carved chicken. 'I managed to duck and it smashed into the mirror. I rather like the effect, there's something very poignant about it, like a memory trace, so I think I'll keep it that way.'

'I think the new picture is terrifically powerful,' I say as I help myself to the delicious bread sauce and attack my plate. 'I'm sure Michel will be impressed when he sees it.'

'Well, of course, one never knows about those things,' Francis says. 'But I'm particularly pleased that you like it, Michael ... So what will you do now that you're back in London?'

'I'm not sure. I suppose I'll keep trying to write, even though I find it very difficult, not only writing in itself but finding a subject that seems worth writing about.'

'I think those things are very difficult. It's just the same in painting. So much has already been done and then photography has cancelled out so many other possibilities. When I started painting I needed extreme subject matter. And then I found my subjects through my life and through the friends I came to have. I mean one's work is really a kind of diary or an autobiography.'

Francis reaches down into the wooden case beside the table and takes out a third bottle of the sumptuous wine we have been drinking. He seems to be in a communicative mood, and I'm pleased to be back in the undemanding role of interviewer. In a sense, I realize, interviewing him has become quite central to my life, and even though we've been out of touch for a while our conversations have continued to circle round my mind, to the extent that I can recall many of them verbatim. It's a quest I want to continue, it's become personally important to me, almost as if by finding out more about Francis's life and his painting I will have a better chance of finding myself and what I want to do with my life.

'So your paintings are really full of things about yourself?'

'About myself, my thoughts and feelings and what are called the *moeurs* of my times. But then I think I go deeper than my times. That may be a profoundly vain thing to say, but I often feel in my work that I'm close to the ancient world. I think you can convey all sorts of things about yourself, or about anything really, in painting. I think it's more difficult in words, even though one never tires of talking about oneself, *n'est-ce pas?* It's like confession. Or psychoanalysis. But of course it can be embarrassing. Or at least it's embarrassing if it's presented in certain ways. I wouldn't mind, and I do think the only way of telling one's life is to tell all of it – or everything you can remember. But there are still one or two people alive who would think it terribly cheap if I did. It probably is very cheap, but there you are.'

'Do you remember things from way back, from your childhood?'

'Some things, though of course one forgets a great deal. I remember being very excited when a cavalry detachment did some practice charges up and down the driveway to the house where we lived in Ireland. I had an older brother then who had this cycling cape I admired very much, and he let me wear it and I went marching up and down the avenue of trees outside, up and down, feeling very important. We used to hide behind those trees with other children we knew because we thought this bigger boy called Reggie we'd met at children's parties was coming after us. So we just hid there. Reggie never came, naturally, and in a way we knew perfectly well he wouldn't, but for some ridiculous reason we used to love hiding there and pretending he might find us. Of course, he was older and far too important to be interested in us.'

'I think you told me you never got on with your parents. What were they like, Francis?'

'I certainly never got on with my father, although he was a good-looking man and when I was growing up I was attracted to him. He wasn't interested in me because I was asthmatic – I was what's called the "weakling of the family". Anyway, he'd married my mother because she had a bit of money and set himself up to train horses in Ireland because it was cheaper to do it there than England. Things were easier with my mother, but she was much more interested in her own pleasures than in her children. The person I was most close to in the family was her mother, my grandmother, who was rather extraordinary. She married five times and was terribly free in her way of life. I mean when you think of what Ireland was like then! And with this way of hers she did fascinate a great many men. She just loved having lots and lots of people around her, and she used to give these marvellous parties. They sometimes seemed terribly lavish. The Aga Khan came once, and of course that did strike local people as something rather exotic.

'She and I used to tell each other everything. I suppose I was a kind of confidant for her – I used to take her to hunt balls and all those ridiculous things when I was sixteen. Of course I hadn't the faintest notion what to do with myself when we got there. Just stood around and looked silly I expect. Because I was really gauche, and of course having been brought up in Ireland I knew nothing about anything. But she was a remarkable woman, with this most marvellous ease and vitality. My own mother was less remarkable, but she had that same kind of easiness with people. And she adored entertaining too – though while my father was there she didn't get much chance. What was rather extraordinary about her was that way she managed to start a really new life after he died. I used to visit her after she moved to South Africa, and we got on much better then.'

'But your relationship never got better with your father?'

'It certainly didn't. The thing is, Michael, from as far back as I can remember, I used to trail about after the grooms he had working for him on this horse-breeding farm. I just liked being near them. In that sense, I suppose, I'm what you might call completely homosexual. I don't think there was actually any question of choice. It was there, right from the start. So when I was an adolescent I started dressing up in my mother's clothes and her underwear and that kind of thing. And my father caught me at it. Of course he was absolutely disgusted to see a son of his going to the bad and so he decided to send me to this very manly friend of his, you see, to straighten me out. But I'm afraid it didn't change anything, because a bit later we were in bed together. There it is. He was terribly odd, in his way, this man. A brute. Really tough – you know what I mean? Of course he used to fuck absolutely anything. The curious thing is I really don't think he cared one way or the other who he went with.

'He was going on a trip to Berlin and for some reason he decided to take me with him. At that time, in, well it would have been in 1927 I think, Berlin was absolutely extraordinary. It was

so somehow open. I don't know how to put it, but you had this feeling that you could get anything you wanted. Anything. Having never been outside Ireland before, you can imagine how exciting that was for me. I felt all of a sudden well now I can just drift and follow my instincts. Just drift and see. I always remember they had these streets of clubs, where people used to stand outside them and sort of mime the perversions going on indoors. After Ireland, I must say, the whole thing was absolutely fascinating! We stayed in this hotel, the, it's ridiculous I can never remember the names of things nowadays, well it was the Adlon that's it. I don't suppose it's there any more, or at least not in that way, because it had a kind of luxury that could hardly exist anywhere today. I mean I remember, it sounds so absurd now, but stretching my hand through the hangings of this four-poster bed and pulling the breakfast trolley, it was an extraordinary thing with a silver swan's neck at each corner, well just grasping one of these swan's necks and drawing the whole silver thing to the bed. And of course everything came in silver dishes with the toast wrapped in linen and that kind of thing. And all the time you knew that just outside this hotel there was the most appalling poverty all around.'

'And then you managed to go to Paris?'

'Yes, I did. After a while my father's friend went off and simply left me, so I hung on for a bit in Berlin and then, since I'd managed to keep a bit of money, I decided I'd go to Paris. I remember being so ridiculously gauche and shy in Paris I didn't dare talk to people or even to go into a shop and ask for something. Of course looking the way I do, with everything gone wrong, didn't help. But there it was. I stayed in that little hotel in the rue Delambre in Montparnasse. Of course it's been done up now and become rather smart. But it wasn't a bit like that then. I didn't keep myself to myself all that long – thank Gawd! Berlin had at least shown me how to follow out my instincts, and after a bit I started going round with this male prostitute. Well, round the bars, behind the Lido, and places like the Sélect,

which was the homosexual café at that time. And for a while I drifted round with him, living that kind of life.

'My mother used to send me an allowance of three pounds a week. That sounds ridiculous now, but in those days it did help a little. But most of the time I went about with people I picked up. By the time I got back to London, I still had no idea what I really wanted to do. I'd started to think about painting, and of course I'd been to see the Picasso show in Paris, but that was about all. So I just went on drifting. Well, in that same kind of way basically. I started putting advertisements in the personal columns of *The Times*, offering myself as a companion. The curious thing is that the replies simply poured in.

'I had my old nanny staying with me at that time. She came and lived with me almost everywhere I went, from place to place, for over ten years. She understood everything. She'd come from Cornwall, and I was far closer to her than to my family. Anyway, when the replies came in, we used to go through them together, and she used to pick out what she thought were the interesting ones. I have to say she was always right.

'I went back to Paris shortly afterwards, with a dreadful old thing who took this very expensive flat on the Avenue Pierre, what's it called, Pierre-Ier-de-Serbie, yes. Well of course, I didn't stay with *him* for very long. There you are. I used everybody I could. I was quite impossible then. I mean, with my sort of looks, everything gone wrong, and with that awful gaucheness from having been brought up in Ireland, things did seem terribly difficult. I've worked on myself a great deal since. Tried what's called to present myself as well as possible. I always remember this very interesting man in Paris, saying to me the important thing is how you present yourself. Of course I didn't know what he was talking about then, but now I do think it's very true. The French are terribly conscious of that presentation – of making the best of themselves. There was a woman I met once in Paris who looked much younger than she was. And I said to her, how do you manage to look so young? And she said, "*Ecoutez, Francis.*

Je me fais jeune. Voilà tout.'" She was quite right. You have to remake yourself. I've tried in different ways to remake myself over the years. Of course it hasn't really worked. But there it is. Nothing has ever really worked for me.'

I sense Francis's mood has changed. His face has hardened and his mouth is set in a bitter pout. I hadn't seen the change coming, although I know it can happen between one glass and the next, and we have worked our way through five or six bottles of the Bordeaux. He sits there, eyes downcast, as if turned to stone. To break the silence I suggest, without much conviction, that we go on to Soho for a last drink, and I am relieved when he tells me he wants to stay put and get up early to 'try to paint'. When he says nothing has worked for him, it's almost certainly the relationship with Peter Lacy he has in mind. He feels responsible for his death, however indirectly, and needs to scourge himself, to alleviate the sense of guilt, I suppose, or is it to intensify it? The paintings brim with violence and suffering. Do they feed off this guilt, and does Francis nurture it because he knows the deeper the guilt the more potent the images will be? What the fuck, I know I'm drunk too and that I should leave before Francis begins a monologue of ever terser, more acid phrases. 'In some ways I've had the most ghastly life.' 'There it is – there's nothing you can do about those things.' 'Everyone I've ever been really fond of has always been a drunk or a suicide.' I gather up fragments of our earlier talk in my mind like a spy memorizing secrets, then take my leave of Francis, picking my way gingerly down the steep stairs. Nightclouds scud overhead as I walk back through the dark empty streets to the basement on Tregunter.

On other nights we might have moved from pub to bar, restaurant to club, up and down stairs, crossing landings, knocking on doors. All London would have opened up, from luxury hotel to the latest trattoria or the last shack dispensing scalding tea and doorstop sandwiches to cab drivers at dawn. With Francis

life only takes place inside. We are condemned to a succession
of rooms, the outside being no more than the interval between
them. All human drama and interchange is concentrated here,
in interiors closely sealed off, as in his paintings, with figures
flailing. As we go around talking and drinking too much,
we become the figures he has created, contorted, distorted,
struggling to breathe in these airless interiors under the accrued
weight of the drink and the words. We go everywhere with the
magician of the night, from the cosy Maisonette to the uptight
Rockingham, the Ritz to the seedy Coronation Club, the
elusive Pink Elephant to the harsh, threatening but ultimately
welcoming Iron Lung. When we are in one club, we discuss
another, plotting our course through Soho's tightknit grid.
'There used to be something marvellous about the Gargoyle,'
Francis says, as we settle into a sofa at the Paint Box under
the *patronne*'s benevolent gaze. 'But I'm afraid it's become a
bit dreary these days. It has this extraordinary staircase with
thousands of mirrors broken into the walls designed by Matisse,
and when people came down it they looked like birds of paradise.
And everyone went there. Even Sartre used to go there when he
was in London. What? Well, he was very sympathetic, and he
told me to look him up when I was in Paris but for some reason
I never did. Anyway, the Gargoyle was a place where people
could let their hair down, and it was famous for its rows. It
was a club made for rows, and some of the members would
come back every evening to continue their own row or to listen
to someone else's. Of course the rows were usually to do with
unhappy love affairs, and what is more fascinating for onlookers
than what's called other people's unhappy love affairs?'

Since I have no particular hour to get up and no job to go out
to, I am happy to stay the course for as long as it takes. Sometimes
around midnight we have a second dinner, which always pleases
me, as a kind of rest between the harder drinking bouts in the
clubs. I'm always impressed by the fact that, whenever I leave
him, Francis will be up in a couple of hours and into the studio,

limbering up to project another big fearful image on to the canvas, or at least padding through the rags and photos on the floor, as I groan fitfully from under the covers, hoping against hope that my day won't be devoted to nursing a hangover.

Now that I'm used again to the rigours of the English weather, however, my life has become really quite acceptable. When not on the razzle with Francis, I concentrate on my love life which, in the wake of the Orwellian *mésaventure*, has grown agreeably varied and complex. As my flatmates sit in their offices, taking orders and tending to subaltern duties, I sit by the gas fire like some big fat sexual spider awaiting my latest victim and listening to a scratched version of 'Michelle ma belle' endlessly on the turntable. In between assignations I read widely and write fitfully, agonizing over the futility of my present lifestyle but not sufficiently to make any decisive move to change it. My mother continues to send me money, and I have even found a few honourable ways of supplementing this meagre income. I read books and translate some of them, as in Barcelona, for a variety of publishers such as John Calder and the strange, charming Tambimuttu (whom Francis can't stand – whenever he comes round and knocks on Francis's door, Francis puts his head out of the window and shouts down: 'I'm not here'). Tambi has got me translating Henri Michaux, whom I find exciting to read but near impossible to render adequately in English. But the challenge gives my days another focus, and in any case it seems unlikely, with Tambi being so disorganized and on the verge of bankruptcy, that these translations will ever actually be published.

Since I came back from Spain, I've had little contact with my parents but my father has found out that I've been getting regular handouts from my mother and, since he is in manic phase, he has decreed (my mother tells me over the phone) that if I am incapable of finding a job he will be taking up the cudgels on my behalf. 'It is high time', he has apparently been repeating over his pink gin, 'that Michael stood on his own two feet.' I'm

not too worried because I reckon that as the summer fades so will his monstrous manic energy and I will be forgotten once he subsides into melancholy. Meanwhile he has had his secretary scanning the classified ads on the front page of *The Times* every morning for any job that might sound suitable, and I'm a bit put out when she comes up with a 'Paris magazine seeks junior editor', because I can hardly say a job like that wasn't right up my alley even though I have no intention of leaving London, above all since I've just met a girl who's part oriental (an 'octoroon', she calls herself) and could not imagine life without her.

Mercifully there's little chance of my getting the job because when I call the number on the ad I am told the editor will be interviewing over sixty candidates while he is in London. Instead of the sallow, superior Frenchman I vaguely expected when I turn up for the interview there's a red-faced, blue-eyed Englishman called Garith Windsor who looks more like a camp naval officer or bluff character actor than an editor. He annoys me right away by asking a few trick questions, but since I've decided to be sufficiently aloof to make sure I don't make it through to any short list, I give a few brief condescending answers clearly demonstrating that I'm not taken in and feel the whole thing rather beneath me. This makes him laugh, and I find myself playing up to this unexpected turn of events, thinking he doesn't seem a bad sort and what a bore it must be to have to sit there for hours appraising a load of recent graduates. So we sit and chat for a while about Paris, which I haven't visited since spending a Christmas vacation there, holed up in a cheap Left Bank hotel picnicking off roast chestnuts bought from vendors in the street and reading modern French poetry whose very impenetrability impressed me as a mark of its intellectual rigour and depth. I tell Windsor how little I care for the French even though I'm quite addicted to their culture.

I think no more about the meeting over the next few days and resume my routine of recovering sufficiently from binges with Francis to further my afternoon amours by the gas fire's flames

in the blissfully empty basement. Then I get a rude awakening in the form of an official offer, first by telephone from Paris, then by telegram, to take up the post of assistant editor at *Réalités* as soon as I can get myself to Paris. I am dumbfounded at first, then intensely annoyed with myself for having been too clever in the interview. I can only think that I stood out as the one interviewee to be offhand and unenthusiastic about working in Paris, and this in turn must have invested some illusory qualities in me that Windsor did not detect in the other more eager to dead-keen applicants. I can't think how else I could have got the job, but now I feel trapped. I can't lie to my parents and I know that my mother's allowance will be cut off if I don't take the offer up. At heart I also know that, seductive as my daily round seems, I am not getting anywhere and that perhaps, after all, another stint abroad might be just the catalyst my lacklustre career requires.

I think I have persuaded my new love to come with me although she will have to give up her steady secretarial job and I've no idea where we'll live or what she'll do. I sweep all her objections before me since I'm convinced we'll find a way if we set our minds to it, but as the date approaches she seems increasingly evasive about giving in her notice. Meanwhile, I am letting all my friends know I'm about to leave, once again, and so soon it seems to me after getting back from Spain. Francis invites me to a last dinner before I leave, and when I go round to the studio to pick him up he opens a special vintage bottle of champagne to wish me luck.

'Now who do you know in Paris?' he asks me suavely as we sit there clinking glasses.

'Well, no one, not a soul,' I say, suddenly alarmed at the prospect.

'Did you ever meet Giacometti?' he asks.

'Never,' I say. I know vaguely he's talking about a famous sculptor who lives in a dusty cave in Montparnasse, but he might as well be asking me if I know Michelangelo or Rodin.

'Well, there is something terribly sympathetic about him,' Francis says. 'He took a great shine to George when he was over here for his Tate show. He said, "When I'm in London I feel homosexual," and he suggested George go over to Paris and he'd teach him French and perhaps get him a job in a picture-framing shop he knows. That would at least give George something to do. I think you'd like him so why don't you look him up when you get over there?'

'But Francis,' I say. 'I can't just go round and knock on his door and disturb him without any warning.'

'Of course you can't,' says Francis rather formally. 'I'll give you a letter of introduction and you can take it with you.'

He rummages round the books and papers on the table and comes up with a copy of *Paris Match* from which he rips a double page of war photos at the centre and with a thick green felt-tip writes: '*Mon cher Alberto je voudrais vous présenter un grand ami Michael Peppiatt qui arrive maintenant à Paris j'espère que vous allez bien Alberto. Francis.*'

We finish our celebratory bottle and move on to a special feast of caviare, baby lobster and grouse at Claridge's. It's clear I'm going out on a high, although my spirits are already dipping as I wake up the next morning with an aching head and pack my scuffed little suitcase with the one suit I possess, a charcoal grey that has seen better days. My old friends Magnus and Peter are there to give me a stirring farewell as I board the boat-train at Victoria. Then the backs of houses and the allotment gardens beside the track start to flit by, taking me closer and closer to a new fate, whatever that turns out to be.

PART TWO

1966–1976

6

Exile and Revolution

'One of us has to go,' I whisper to myself as I lie staring at the pock-marked floral wallpaper surrounding the bed. But however spot on Oscar Wilde's witticism seems in the circumstances, it does nothing to cheer me up. The sheets I have been sleeping in turn out to be a yellowish nylon that crackles irritatingly as I shift around looking for a more comfortable position. Next door, through the thin partition, I can hear another bed creak regularly and attempt to block out what it signifies. My narrow room, with its cracked washbasin and rickety little table scarred by cigarette burns, must have harboured a hundred commercial travellers down on their luck, I imagine, and for a moment I try to transform the dingy space into a haven for fragile hopes and dreams. But it's not working. There's also an indistinct, sweetish smell I can't identify. I wonder when the sheets were changed last. This at least gets me out of bed, which I should be doing anyway. I can hear the traffic getting louder in the street, or boulevard or whatever, outside, and I certainly don't want to be late in getting to the office on my first day. I clamber into my charcoal suit and study my hopeful face in the mirror as I knot my tie and comb my hair, dampening it down to try to make it look less wild. I put a notebook and pencil in my inside pocket, thinking that's what all up-and-coming journalists should have, and march purposefully over to the door. Then I

realize what the smell is. It's not so much the accrued odour of
other bodies as the smell of hopelessness.

It's not far to the *Réalités* offices on rue Saint-Georges. I
already paced it out last night since I had nothing better to do.
If I was keen to leave my squalid room then, I am keener still
now, so since I have a good half-hour in hand I make a beeline
for the café round the corner, stand at the zinc and order *un
express*, lighting a Gitane to complete the picture of the young
traveller effortlessly at home in foreign parts. But of course
I'm not in the least at home. First of all I want to get out of
that hotel for ever. Somehow I'd got it into my head that I was
going to be given special treatment, since the magazine seemed
so keen to get me, and be put up in comfort, if not in style.
That's why I travelled first class on the boat-train coming over,
not just because I was curious to see what first class was like
but to show that I was equally aware of my worth. Now I'm
beginning to wonder whether I'll ever get the fare reimbursed.
Perhaps I've spent too much time in grand hotels with Francis to
take kindly to seedy establishments, though even in Barcelona,
when every peseta counted, I always managed to find a *pensión*
with a smidgeon of continental charm. Nor, come to think of
it, do I care much for this café, with its neon lights blinking in
the grey morning, or the surly *patron* behind the bar whose
grubby nylon shirt reminds me of the bed sheets I've just left
behind.

Nothing gets better when I go through *Réalités*'s gloomy portal
and ask at the makeshift reception desk for the *Edition anglaise*.

'*Ah les Anglais*,' says the receptionist without enthusiasm. 'Go
down the stairs and keep going as far as you can go.'

The stairway smells more and more strongly of stale
cooking as I go down into the basement, and from the long
trestle tables and piled-up chairs I guess that this must be
the canteen for all the staff working on the various editorial
offices that take up the rest of the building. Neon strips are
flickering here too on the low ceiling, lighting up the metallic

serving counters that run down one wall. So far, so grotty, I say to myself airily, to keep my spirits up. At the end I spot another door, and as I get closer I can see a brass plaque with '*Rédaction anglaise*' engraved on it. I straighten my tie, pass a hand over my still-damp hair and knock discreetly but firmly on the door. Nothing happens. No welcoming secretary or curious colleague jumps to. I knock again, a little louder, then try the door to see if it's open.

The space inside is not unlike the canteen but smaller and slightly less smelly, with a half a dozen desks dominated by typewriters and a strew of books and papers. More surprisingly there seems to be a page-by-page dummy run of a whole new issue laid out on the floor. I tiptoe around it, taking in everything from a cover article on Courrèges's plastic-and-metal dresses to an essay on miniature portraits attributed to Jean Clouet and a recipe for sorrel omelette by the Duchesse de la Roche-Guyon. There is also a reportage on the sumptuous interiors of a château in the Loire valley where the scintillating chandeliers, gilt mirrors and furniture inlaid with brass and tortoiseshell contrast strongly with the drab desks and torn railway posters of famous French landscapes pinned to the office walls.

After half an hour I am getting sufficiently restless to think of writing a note to say I'll be back later, and I'm even reviewing what chances there are for a speedy return to Tregunter Road when the door is flung open by Garith, the red-faced man who interviewed me, and a slimmer, younger chap who glances over at me amiably.

'So sorry there was no one here to greet you,' the younger man says, shaking my hand. 'My name is David Warrilow.'

'Setting an example to the others already?' Garith exclaims, clapping me on the shoulder. 'That's the spirit. Show 'em up for the Beaujolais-swilling louts they are, too hung over to get themselves in on time. You really must crack the whip more often, David. Only the officers are pulling their weight in this bloody outfit.'

With that Garith disappears through another door I hadn't noticed into his own small office. He reopens the door a moment later.

'Just remind them when they do turn up that this isn't some charity for down-and-out drunks and other riff-raff,' he shouts, even redder in the face. The door slams to, only to reopen once more. 'After all this is meant to be a goddamn magazine, and if you can't control the troops, David, your position is at risk. Don't you bloody forget that, old boy,' Garith goes on, warming to his theme. 'Your job depends on it,' he concludes with a cackle before kicking his door to.

One by one the other members of the team troop in and slide behind their desks. There is some banter about who went where the previous evening, then we are all given various French texts to translate, then translations to edit and various photos to write snappy captions for. I focus on the work to blot out any other thoughts. It's not difficult, and I quickly get the hang of it. After a couple of hours' concentration, with all typewriters going, the room begins to resemble a hive of editorial activity. Then a siren goes off, somewhere outside, like an air-raid warning, but it's actually signalling midday. At the same moment Garith's door flies open.

'I suppose, to greet the new recruit,' he says, jamming a trilby on his head, 'I'll have to take the whole bloody lot of you out to lunch. But remember,' he warns, wagging a finger, 'no more than a litre of wine per head, and I want everybody back here at fourteen hundred. And that's an order.'

As we file out, there's speculation as to which local restaurant we'll be taken to. I wouldn't know the difference between Chez Renée and Le Bistrot du Coin, so I just nod thoughtfully. I'm beginning to wonder what sort of person Garith will be like to work for as we re-emerge at street level and think the best plan might be to get an idea about him from David Warrilow, who seems to act as a kind of buffer between Garith and the rest of the staff.

'Don't worry about Garith,' David says kindly, apparently guessing what's on my mind. 'He's not your everyday magazine editor, but you'll be fine. He just takes a little getting used to.'

Things have looked up a bit. When I explained to David Warrilow how I hated the hotel, he invited me to stay with him in his rather grand apartment on the Boulevard du Montparnasse until I found a place of my own. In the evenings we've been going round the big cafés. David seems to know, or at least to recognize, all sorts of people. He introduced me to the sculptor Zadkine, who's always at the Rotonde, and then at the Sélect we spotted Aragon and Ionesco. I was particularly pleased one Saturday afternoon, when I pushed up as far as the Closerie des Lilas, to see Samuel Beckett, who was clearly keen not to be spotted and kept holding his head in his hand, but you couldn't miss that face, which is just like the photos except milder and more approachable. I longed to tell him how much I admired his work but every phrase I came up with sounded impossibly banal and before I could find some halfway adequate remark a passing American tourist with a rucksack spotted him too and hailed him loudly, saying 'Are you Samuel Beckett?', then went over without the least embarrassment to talk to him.

I'm experiencing something of the same shyness about Giacometti. From the day I arrived in Paris I've been carrying Francis's introduction to him on the *Paris Match* pages around with me like a talisman, and I've been to Alésia to identify the studio building where Giacometti lives and works. You couldn't miss that either. It's set back from the street and looks semi-derelict, with a rusty corrugated tin roof and a big dirty window. It's easy to know it's his studio because 'Giacometti' has been painted in little white letters on the glass pane of the door. I'd love to meet him, too, but the idea of just turning up and knocking on his door seems a terrific cheek. I can just imagine how welcome it would be, as he's wrestling with a new sculpture, to have some unknown young foreigner, another person from

Porlock, on his doorstep. I went back there the other day and once again I couldn't bring myself to knock, so I just walked round and round the area, clutching the letter, trying to screw up the courage and feeling more and more useless. To make the idea of actually visiting Giacometti even more tantalizing, I've found some extraordinary photos of what the studio looks like inside – an amazing grey cave filled with either towering or tiny skeletal figures amid a chaos that reminds me of Francis's, except that this one is as colourless as dust. Perhaps I can find another way of introducing myself, in a café or at a gallery opening. Otherwise the place will remain a mystery to me, as so much else in this cold, forbidding city.

It's an odd feeling to be living in a place where you know next to no one. I've been to Paris before, of course, on schoolboy exchanges, then again, not that long ago, with Magnus, when we stayed for about a week in a small Left Bank hotel that seemed a favourite with American writers who discussed how their books were progressing with each other on the landing before they returned to solitary rooms and staccato bursts on their typewriters. We read Lautréamont in a paperback edition, where each page had to be cut to reveal its secrets, without fathoming why the Surrealists had become so entranced by him, drank litre bottles of cheap red wine and ate egg and chips with lots of baguette in student restaurants so packed that the windows got completely steamed up. But those were cosy short visits, holidays, not the unfolding of day after day stretching out towards an unknown horizon.

David has been incredibly kind and let me have the run of his spacious apartment in Montparnasse. I know I must find something of my own and not outstay my welcome, but he's very easy and hospitable, and it makes a huge difference to have someone to go around with. He's also very elegant. The other evening we were looking around for somewhere to have dinner near the Halles and I saw a restaurant that looked like the perfect, authentic Paris bistro. I noticed David looking

a little less convinced but we went in and were given a table and I suddenly realized it was a great deal more chic than I'd bargained for, a fact that was driven home when we took on board that the stylish lady dining on the banquette next to me was Marlene Dietrich ('*C'est bien Mademoiselle Dietrich?*' David murmured discreetly to the head waiter, who nodded with equal discretion). When we were given the menus, I was appalled by the prices and suggested we admit our mistake and leave, but David insisted we go ahead. As the meal progressed, it became quite clear that Miss Dietrich had been drinking. A glance between David and me had us shamelessly eavesdropping on what she was saying to the patient French couple sitting opposite her. I imagined it would be some fabulous anecdote involving stars of the same unbelievable calibre but all we heard, time and again like a mantra, was 'My husband never let me eat hot dogs.'

Part of David's decision to stay in the restaurant might have been that his real interest lies not in running a magazine but in acting, so he would have found the surprise presence of Marlene Dietrich particularly alluring. He began in some fairly conventional plays as a student in Reading, but now he is interested in tackling more experimental roles, whether in English or in French, of which he has an enviable, almost bilingual command. Since I was marginally involved in theatre at Cambridge, this forms an added link between us.

David is well established in Paris now and, when we are not simply relaxing with a beer at the Rotonde, listening for the nth time to 'Satisfaction' barking out its sexy plaint from the jukebox, he includes me in areas of what seems to me to be his very sophisticated social life. One evening he suggests I come with him to a dinner with a group of French actors he knows. I tag along, without thinking much about it, and find myself at the far end of a long table at another, rather superior restaurant on the rue des Ecoles called Balzar. The other guests all know each other and appear, perhaps predictably, self-assured to the point

of ennui. I greet my dining companions to left and right as I sit down but no one returns the compliment. Conversations engage up and down and across the table. David is far away at the top and flashes me the occasional smile. There seems little point in asking anyone around me any questions because they all seem beyond such basic social interplay. I focus on my bitter herring which is followed by a tough entrecôte. Any moment now, I feel sure, someone will sense I'm a bit out of my element and draw me into the general conversation. I look round expectantly, hopefully, but encounter a wall of indifference.

The meal continues, my frustration turns into panic. If no one so much as recognizes my presence, I do not exist. If I do not exist, I think, making my way through a *baba au rhum* with silent fury, then I die. The timidity that seemed justifiable before Beckett and Giacometti now seems intolerable, a burning insult that I should sit among people who will not even deign to recognize my existence. If no one will draw me out, I shall present, even exhibit, myself, even though no doubt I am the youngest person present and the least worthy of notice. If you do not talk, I tell myself, in the heaving emotions that the end of the meal breeds in me, you will cease to exist, in the very land of existentialism: speak or forever hold. For the past hour I have been working on a complex phrase, involving a significant past subjunctive, that describes my almost having met Beckett, whose work has featured prominently in the cross-table talk. I refine it endlessly, adding and taking away, until the bones stand out, pure and faultless, and in a momentary silence round the table I blurt it out loudly. The complex, bolted phrase hangs awkwardly in the air. Everyone turns to look at me for an instant, without surprise or interest, then the conversation resumes unchanged.

It's mid-morning and there's a haze hanging over the office where everybody's head is bent over their pale-green typewriters. I think of it as the hangover haze. Both David and I were out too late and drank too much, and Garith has just come storming in,

a trilby perched on the back of his head, exclaiming he had 'one hell of a bloody head' and slammed his door. He'll be out again soon asking if anyone has some Alka-Seltzers. Only the men seem to be in this condition. Both of our women editors are calm and collected. Denise, our languorously sexy secretary, is more likely to have had a good night out, but she shows no sign of strain as she fields the morning's phone calls. I almost never get a call at the office and I'm surprised when I see her waggling the receiver at me and saying, 'It's for you, sweetie-pie.'

'Is that you, Michael?' a voice on the other end asks. Suddenly an entire other world comes flooding back.

'Yes, absolutely, Francis,' I say. 'How lovely to hear from you.'

'Well, it's marvellous to hear you. Now, I'm coming over to Paris on the night ferry and wondered whether you might be free to have dinner with Michel and Zette Leiris tomorrow evening. I've managed to get a table at the Grand Véfour which, if you don't know it, can be rather good.'

'Yes, of course, Francis. I'd love to. Perfect. Yes, I know. It's just off the Palais-Royal gardens. Lovely. See you there at eight.'

I replace the receiver, sit back in my chair and savour this new perspective. I'd more or less assumed that I would hear from Francis only if I told him I was back in London, even though I'm aware how much he enjoys coming to Paris and thinks of it as the absolute centre of the art world, the place where Picasso and Giacometti, the only two living artists he admires, have made their reputations. But I know he also has a circle of important literary friends over here, and I'm not only pleased but overawed to have been included in this dinner, not least because the restaurant is so grand I only know it from pressing my nose against its windows to look at its decorated ceiling, then gasp at the prices listed on the flowery menu posted in its own little gilt box outside. It will certainly be a change from the office-canteen lunch and the Vietnamese noodle-soup dinner that provide my

usual daily fare. One thing I'll be able to relay to Francis is that *Connaissance des Arts*, our sister magazine, has just chosen him as one of the top ten living artists worldwide. I know Paris is the place he'd most like to succeed in, because he thinks the French are more demanding and discerning than any other nation when it comes to art. And he's clearly keen to see more of Leiris, who has not only got a huge reputation as a writer but has been close to and written about so many important artists, from Picasso and Giacometti to Masson and Miró. I suppose he wants me there because I'm pretty much bilingual now and I can help out at certain moments in the conversation, since Michel can read English but doesn't speak it fluently.

It's strange that Francis has picked me out. Obviously he likes the idea that I admire him and that I'm a good listener, and probably he's still intrigued by the possibility that there might be something between us one day, since he's convinced all men are really homosexual, as he often says, and it's only that some of them don't realize it. I find nothing even latently queer in myself, having been most attentive to a couple of former girlfriends from London who've visited me here and currently having my eye on a French girl who works in the *Réalités* layout department. But I do find it odd that I gravitate so often towards homosexuals. Perhaps it's because they're more flattering or have more time for me, or simply because they're more interesting. They combine male and female characteristics differently, and sometimes that seems to create a more complete person. Francis, for instance, can be as tough as old boots one moment, perhaps from the generations of soldiers in his blood, then as coquettish as any courtesan the next. And it's often very difficult to tell who's queer and who's not. It's slowly dawned on me that David is that way inclined, too, so to avoid any ambiguity I have accelerated my search for somewhere to live and I've found a little bed-sit in Alésia a stone's throw from Giacometti's studio. Someone at *Connaissance des Arts* told me the other day that Giacometti actually died a few weeks ago in Switzerland, so even if I had

knocked on his door he wouldn't have been there to answer. I still walk past the studio, thinking what a lost opportunity that turned out to be, since I might have met somebody Francis says was really exceptional rather than spending all my spare time with other English-speaking journalists. I'll ask Leiris tomorrow what the studio was like inside, because I know he used to visit Giacometti regularly. Anyway, my day has brightened, my hangover almost lifted. That's good enough for now.

Just then, Garith's door bursts open, and he stands there, with his hat still on, looking as if he's about to play the lead role in a Victorian melodrama.

'Anyone got a fizzy pill for a poor old josser whose head's about to explode?' he shouts.

All the pillars and the ceiling above them are filled with flowers and fruit and garlanded, allegorical figures of women, with lots of soft light and gilded mirrors and red plush seats. I feel intimidated from the moment I walk into the Grand Véfour and have my shabby raincoat whipped away from me by a severe-looking lady dressed in black. On the far side of the room I can see Francis and George sitting together and the gauntlet of eyes I imagine I have to run through as I cross the gilded space becomes easier to deal with as I keep Francis's welcoming smile directly in my sights. I take a mental snapshot of them as a talisman against what I know will be the colder, less privileged days to come. Francis is rosy and exuberant, as if everything is going his way, George looks tense and pale, with a deep furrow between his eyebrows. They are both immaculately dressed. George looks gangsterish in a very formal, dark-grey suit, a white shirt and a tightly knotted, burgundy-coloured tie. Francis looks a bit more casual. He's got a silver-grey herringbone suit on and a blue Oxford shirt with a tab collar and the loosely tied, black, silk-knit tie he always has. It's almost a kind of uniform. I've seen him wear it, with minor variations, for a couple of years now, as if at one point he'd decided once and for all how to dress

for formal occasions. Otherwise it tends to be cashmere polo-
necks, supple leather jackets, very tight, freshly pressed grey
trousers and desert boots. He said to me once that he wanted to
'look ordinary, but better than ordinary'. I should like that, too,
because I worry that my old, creased charcoal-grey number
isn't up to the occasion, is in fact worse than ordinary, so I slip
quickly into my seat, knowing that after a few glasses I will
cease to care so much.

'You're looking terribly well, Michael,' Francis says. 'Paris
must suit you.'

'Yeh,' George joins in. Although withdrawn and dragging on
his cigarette as if he were on life support, he seems quite at ease
in the restaurant's opulence and faintly amused to be the focus of
so much attention from the waiters hovering around our table. 'I
fink you must be 'avin' a good time 'ere.'

'Well, it's not an easy place to make your way,' I say ruefully.
'Especially when you don't know anyone. And the French, at
least the Parisians, don't give you the time of day if you can't
express yourself absolutely perfectly.'

'I've always liked that about the French,' says Francis. 'They're
much clearer about things than the English. I think they expect
quality in everything, and they're very aware of exactly how
they look and how they present themselves.'

Oddly, this remark reminds me that my father has much the
same admiration as Francis for all things French. I wonder if
it's because they were both brought up with the Edwardian
assumption that our Gallic cousins were more naturally
sophisticated than us and less inhibited about enjoying the
pleasures of life – notably food, wine and sex. For Francis, of
course, Paris remains the absolute centre of the art world, and
much of his respect for the way they do things stems from this.
I'm very impressed by Paris and the Parisians too, and by the way
that certain thoughts and attitudes sound so much more brilliant
when they are expressed in French. The French people I've come
across seem to think so as well, and I often feel they're talking

down to me, relishing the fact that I'm not as at ease in their quicksilver language as they are.

'Though I do remember when I first came here,' Francis continues, as if he'd read my mind, 'they made me feel so shy that I couldn't go into a shop to ask for anything. Especially with being so gauche and everything from being brought up in Ireland. But I've got over that now, and I've worked a great deal on myself, because I thought there's really no point in being both old *and* shy. Even though I'm still nervous, the whole time, and particularly when I come into these very grand French establishments. I think they're there to make you feel nervous.'

I now feel much more comfortable and gratefully accept a *coupe de champagne* from the grave wine waiter who has materialized at my side with a carafe. When he has served us he leaves the clear glass decanter bubbling up in the middle of the table.

'There's something marvellous about seeing champagne like that, just spending itself,' Francis says. 'But I've always thought you spoke marvellous French, Michael. To me you've always seemed to speak what's called more languages than exist.'

'Well, that's very nice of you to say so, Francis,' I counter, at ease in an old game of mutual flattery. 'But the French seem to me to be waiting for you to commit some small grammatical error, some *faux pas*, as they say. Then they pounce on it as though they've exposed you. That doesn't actually put you at your ease.'

'No, I do see that,' Francis says. 'Now, while we're waiting for Michel and Zette, let's see what we might like to eat. I myself am absolutely ravenous, although most of the time what I'd really like to eat is a lightly boiled egg with bread and butter. That would be a real luxury. I remember once going up in the lift at the Ritz with that very rich man called Gulbenkian and he was holding a brown paper bag and it burst and all these peas in the pod and new potatoes that he must have bought in the Berwick Street market fell out all over the floor. And I think he had been hoping just to cook something very simple

for himself over a stove in his room or his suite or whatever. And of course to eat very simple food like that is a kind of a luxury for a rich man.

'Anyway let's have a look at the menu. I think they have this roast lobster with fennel. I don't know whether you'd like to start with that, Michael? George wants something very simple. I'm not saying that because George is very rich. He may well be, of course. You never know about people and I've never been what's called so rude as to ask. But he's not been feeling very well, have you, George? Now what do you think you'd like, Sir George? I'm sure they do a very good roast chicken here.'

'N'ile 'ave that,' George says decisively as he lights another cigarette and twiddles his empty champagne glass round.

'Well, it would be marvellous to have something really good and simple, just there in the middle of your plate with nothing else. I must say, I love the way they'll give you just a grilled steak or piece of fish by itself in France, with the vegetables and things on a separate plate. Ah, look,' Francis announces suddenly, glancing in the mirror opposite, 'here's Michel and Zette.'

George and I turn round to see a frail, elderly couple making their way over, preceded by a statuesque maître d'hôtel. Francis has got to his feet, so we do too.

'Ah Francees,' Michel says, and they have a brief hug. Francis kisses Zette on the cheek.

'You're both looking terribly well,' Francis says, ushering them into their seats on the plush banquette. 'It's probably because Paris is so much more exhilarating than London, where everybody keeps going on strike and the pound seems to have turned to confetti it's gone down so much.'

'You always look well, Francees,' says Michel. 'You have the English complexion.'

'Well, look at Michael,' Francis says. 'He's got a kind of porcelain complexion. But then when you're young, you're not conscious of those kinds of things. That's the way life is. You're

not aware of your advantages until you've lost them. That colour looks terribly good on you, Zette. What d'you call it?'

'We call it *cassis*, Francees,' says Zette, pleased to be drawn in to the conversation. Slight but sitting bolt upright, she is wearing a dark-red silk dress with pearls, and with her perfectly groomed white hair she looks the picture of wealthy respectability. Barely bigger than Zette, Michel also looks very Establishment in a dark suit, but you can see he has been following the latest trends because the collar of his shirt is longer and his tie wider than those of the other clients in the restaurant. I think Francis told me that he always went to Savile Row to have his suits made. To me it seems extraordinary that a former Surrealist, who apparently nearly got lynched once for shouting 'A bas la France' during a demonstration, would cross the Channel in search of clothes. There are things I clearly don't understand, and I put them to one side to ponder on later because Michel is talking to me in his elaborately courteous way.

'We much regretted not being able to come to Francees's dinner in London,' he says, with all his facial features twitching as if they had a life of their own. 'I was particularly looking forward to it. I have heard so much about *le fameux bread sauce de Francees.*'

'Well, it was a delicious thing, Michel,' I say, well groomed in this kind of amiable repartee. 'We were just sorry you and Zette weren't well enough. But I think they will be serving us equally delicious food this evening.'

Several black-coated figures have gathered round our table like crows to take our orders. George snorts derisively several times while they note everything down with elaborate attention. It's been a moment since his glass has been refilled. Francis laughs at the whole performance, amused by George's reaction but also attentive to the Leirises's sense of decorum.

'Thank you so much for sending me your most recent book, Michel,' Francis says ceremoniously. 'I read it right away and thought it was simply marvellous.'

'I'm delighted you liked it, Francis,' says Michel. 'I only hope I can write something that does not totally misrepresent you in the catalogue that Galerie Maeght will publish for your exhibition there.'

'Well, it's an honour for me,' says Francis, 'that the greatest living French writer has accepted to do something about my work. I really can't thank you enough, Michel.'

The exchange of elaborate compliments reminds me of the last time I saw them both at Sonia's dinner in London.

'I have been thinking a great deal about realism and reality,' Michel says, wrinkling his forehead. A large, knotted vein throbs on his temple, and his face twitches constantly as he talks. But when he laughs all signs of anxiety disappear and he looks quite different. 'They turn out to be very complex notions, and I must admit that I have not been able to define them at all satisfactorily. I try to pin them down but they constantly wriggle out of reach.'

'They are complex,' Francis says, 'and of course it's almost impossible to define them. I think everyone has their own idea of reality. We think of it as something objective, but in the end it's perhaps the most subjective thing that exists. For me, realism is a question of capturing life as it is and returning it more violently, more intensely, on to the nervous system. People say I'm an Expressionist, but I think of myself as a realist. After all, I have nothing to express. I'm not trying to say anything in particular in my work. I'm simply attempting to convey my sensations about existence at the deepest level I can. After all, people live behind screens, they live screened off from reality, and perhaps, every now and then, my paintings record life and the way things are when some of those screens have been cleared away. That's probably why so many people find my work horrific.'

'I should like to do something similar in my writing,' says Michel. 'And I constantly wonder how I can put myself most at risk while writing. But in the end the only real risks are physical, when you put your life at risk.'

'I completely agree with you, Michel,' Francis says. 'People go on and on about moral risk, which I don't believe in. The real risks we take are physical. Now, I wonder whether we might have a little of that Château Latour they've decanted. I believe it's meant to be a good year, but I'm such a fool with those things. I remember the years clearly, but then of course I can't remember which were very good and which were very bad.'

George has been growing increasingly restive. I can hear his foot tapping next to mine under the table, and he is chain-smoking. Now that his champagne glass is empty and he's scooped the port out of his melon, leaving it otherwise untouched, he seems to have found nothing else to do but smoke. So far he has been following the conversation with a look of polite blankness, but now he's begun scowling at the haughty demeanour of the wine waiter who has begun his round, dispensing a minute quantity of the decanted Bordeaux into Zette's and then Michel's glass. As the sommelier comes closer, bearing the wine like a chalice before him, George gives a loudly dismissive snort and wrests the decanter from the alarmed waiter, filling his glass and mine, then leaning over to fill the others' to the brim.

As George pours the last drops into Francis's glass, the wine waiter recoils in horror, saying: 'But, Monsieur, those are the dregs.'

'But I love the dregs,' says Francis, beaming up at him. 'The *dregs* are what I prefer.'

Everyone at the table starts laughing. Even George is smiling. Another bottle of the same has been ordered. The conversation quickens. The gilt-framed mirrors glow with reflected light. Life has suddenly become more amusing.

'Where the bloody hell is Michael?' Garith comes out of his office shouting.

'He's at home doing background research for the interview he'll be doing in Rome with Balthus,' David replies.

'Doing research on his own bloody navel, I should think,' Garith roars. 'Just because he's got some poofter painter in town he goes flapping around getting bloody plastered with, he thinks he doesn't have to turn up at the office. I'm trying to run an international magazine here, David, not some bloody whorehouse for pisspots and nancy boys.'

He slams his door shut, only to open it a moment later.

'I'm trying to run a tight ship here, not some playground for pansies,' Garith shouts in an aggrieved voice. 'And all I get is subterfuge and evasiveness. Subterfuge and evasiveness,' he repeats, clearly relishing the portentous sound of the words.

'If you think an article as central to the February issue as a rare interview with the reclusive maestro of the Villa Medici is not worth a morning's research,' David replies icily, 'then I suggest you give up any pretensions about making the magazine more than a pale, awkward English-language version of French *Réalités* and fire the lot of us.'

It is first-class David. Even Garith realizes that. He goes back into his office, then reappears immediately afterwards. He has his hat still on but his jacket off and his braces flapping around his thighs.

'Got such a head this morning myself,' he concedes. 'Wouldn't have one of your fizzy pills, would you, old boy?'

David has just given me this latest update over the phone. It's true I was out on a massive bender with Francis last night that went from drinks at the Hôtel des Saints-Pères, where he's staying, to champagne and oysters at the Dôme, then later pigs' trotters and Burgundy in the fin-de-siècle splendour of Bofinger (I'm beginning to sound like one of the 'Around Paris' pieces I write for *Réalités*) and on through several bars round the Bastille. Francis constantly amazes me by the ease with which he seems to walk through walls into completely different spaces and situations. At one point in the early hours it looked as if everything had closed and then he lurched round a corner off the rue de la Roquette and there was a dingy Arab café with

its lights still on. I didn't like the look of it, or of the tough-looking men listening to a guttural, broken song coming from a transistor radio.

'Well, this is my life,' Francis said, as we drank cognac from a sticky bottle hidden at the back of the counter. 'From bar to bar, person to person.'

'Are you sure you want to stay, Francis?' I asked timidly. One of the men had started swaying his hips to the music and was grinning over at us. His front teeth were silver-coloured and caught the dim overhead light.

'I do want to stay,' Francis said very clearly. 'After all, I might just meet someone I could talk to,' he added archly, smiling back at the grim-faced men.

I wasn't so drunk that I didn't realize it was time for me to bow out. We seemed to have come a long way from the first glittering glasses of champagne to these dregs of the night. But then, I thought as I began walking back to my bed-sit and stopped on the Pont des Arts to watch dawn creep up over the Seine, that's exactly what Francis wanted: the dregs.

I've had enough of the dregs to last me for a while, which was why I called David to say I'd be working on my Balthus piece at home today. It's very nice to have an ally like him in the office. If I feel so exhausted and bilious this morning, I just wonder how Francis can be facing up to another day. Did he go on drinking that very iffy brandy? Worse still, did he get beaten up and robbed? I've noticed once or twice he's had difficulty walking or turning his head. I asked him once if he'd twisted something and he told me he'd slipped on the bathroom floor, but so tersely that I decided not to ask again. What could he see in those brutal-looking men? I thought back to the distorted, cream-and-pink bodies thrashing together in his pictures and felt sicker still. Each to his own, I say out aloud to my anonymous little room, and I go back to studying Balthus's gracefully suggestive adolescent girls.

'Would Francis have got any sleep at all?' I wonder, a few long silent seconds later. It's a very big moment for him. He's

got his opening tonight. If it had been me, I'd have probably been tucked up before midnight. He'll be dealing with the first press interviews right now, then he'll have to go to lunch with the gallery people and perhaps some collectors, then there'll be more interviews right the way through until the *vernissage* starts. If he's lucky, there'll be time for a hot bath and a change into a freshly pressed suit. That'll be the only luxury before more hard living through one more night. How does he do it? He's more than thirty years older than me, and I'm not exactly a slouch when it comes to burning the candle at both ends. But I'm tired and liverish even before I've begun. The idea of more drink and rich food, to say nothing of the strain of finding the right thing to say to an endless variety of people, makes me dizzy with fatigue just thinking about it.

But there's no point in going around with Francis if you can't stay the pace. However much you've drunk with him the night before, there's never any question of drinking more sensibly the day after. It's almost like a discipline, or a duty, with him. Where other people feel they should cut back and give their liver a rest, Francis seems to think that the only solution is continued, relentless excess. Back in London once, when I'd turned up green to the gills from the previous evening for a lunch with him at Claridge's, I left my glass of wine deliberately untouched, until Francis noticed it and topped it up twice until it started overflowing. I knew he was watching me now like a hawk, but I stuck to my resolution to drink only water, even if the wine he had ordered was a particularly fine, expensive Pauillac to go with our rack of lamb. After a moment, Francis summoned the wine waiter and said, 'My friend doesn't like this wine. Could you bring the list so that we can see if we can possibly find something he prefers.' And of course that was the end of it. I simply gave in and drank the newly chosen, priceless vintage and then whatever else was on offer until the hair of the dog really did work, at least until the next morning after.

Francis appears to have some magic knack for dealing with alcohol, almost as if his compact frame contained a spare pipe he could open at will to drain off the gallons of drink that have piled up in his system. I've left him sometimes in mid-afternoon barely able to stand, only to find him the same evening in a collector's apartment looking pink and fresh, complimenting the lady of the house on her exquisite taste (although on one occasion he was furious to find artificial flowers in an expensively decorated Parisian salon, and he hissed quietly to me, 'Why can't she have *real* flowers? The whole point of flowers is that they *die*').

So I'm not too surprised to find Francis alert and bright-eyed this evening, oozing energy and suavity in equal measure as he works his way round the throng at the Galerie Maeght. He knows he can ask a great deal of himself, and perhaps it's his gambler's instinct that makes him booze all night and consort with Algerian toughs just before a key event in his career. I know how much he's pinned on this, working flat out not only to get the right body of work together, but to secure the right space – he foresaw how Maeght's double-cube room would show off his pictures in a grand yet approachable, intimate way. He's also pulled off the coup of having a major French literary figure – Michel – present his work in the catalogue; and it's not by chance, moreover, that his show has been timed to coincide with the big Picasso retrospective at the Grand Palais. And now, having just been roughed up and God knows what else in an alleyway behind the Bastille, he's being all things to all men, and women as well: I've noticed a couple of elegant Parisiennes first recoil in alarm from the paintings and then melt with pleasure as they are presented to the affable *artiste*. I've gone over to greet Sonia, who's come to Paris especially for the opening, but she's deep in conversation with a diminutive lady with large glasses and only pauses to look at me meaningfully and say 'As I expect you know, this is Marguerite Duras,' a name that's vaguely familiar to me as someone who writes abstruse, 'new wave' novels.

I also say hallo to Jacques Dupin, a poet whose work, although also abstruse, I admire for the sheer evocative power of its language. He looks after all the major artists at Galerie Maeght and he was very close to Giacometti. Last time I had dinner with him and Francis, he told us he was trying to start up a magazine with some other poets called *L'Ephémère*, and they were going to devote the whole of their first issue to Giacometti. I thought that was a fantastic idea, although if it comes out it will probably be so hermetically written in that particular French way that I won't have much idea what's going on. I haven't got much idea what's going on this evening, either, except that there's a lot of expensively dressed, perfumed people chatting to each other and barely taking in the hotly coloured atrocities bottled up under glass in the gilt frames running round the room. There's no one else I really know, apart from one of Francis's irritating hangers-on, who invariably asks me, whenever I bump into him going round the galleries, how 'our' friend is doing, without even bothering to ask how I am.

Francis, on the other hand, seems to know everyone. He's talking to a couple of French art critics now with disarming phrases I've heard before, such as 'I really don't know myself where these images come from, they just sort of coalesce on the canvas,' and 'Painting has had so many possibilities cancelled out for itself by photography that it's more and more a question of trying to deepen the game through instinct and chance.'

I wonder what the critics scribbling down these gnomic statements will make of them when they're sitting over their typewriters trying to hammer out a review of the exhibition. They won't have much to go on because Michel's preface, which they're bound to take as gospel and quote widely, is pretty gnomic too. So they're going to have to deal with the paintings head on, and they'll find that a real problem because outside the earlier, overt references to Picasso (whose vast retrospective they will also be reviewing at far greater length) there are next to no references for them to follow up on. A hint

of Surrealism in the nightmarishly suffocating pictorial space, perhaps, a touch of Abstract Expressionism in the horizontal bands of background colour, but not much else. The *angoisse* of contemporary man, that should do for a paragraph or two, and perhaps a few words about distortion of form and chromatic clash. But basically Francis is simply not known here. He's not that fantastically well known back home, at least compared to someone like Picasso, but there have been regular gallery shows and a full-scale retrospective. In Paris, he had just one small gallery show about ten years ago and the odd inclusion in group exhibitions. So the critics are going to be up against it, I think, and just then, as Francis goes into a huddle with the sleek, extravagantly coiffed Monsieur Maeght, I spot George, buttonholed by one of the critics and looking desperate. I catch his eye and go over.

'You are the subject of so many of these paintings,' the critic is saying in English.

'Yeh. Spose I am,' says George, guardedly. ''Oo wants to know?'

'And how do you react to this attack, this visceral attack on your person and personality?' the critic asks.

'I dunno,' says George, his eyes narrowing with suspicion. 'I wouldn't know, would I?'

The critic presses a button on his bulky tape recorder, which clearly alarms George.

'So how can you psychologically withstand such an assault?' the critic asks. 'It menaces your very existence, isn't it?'

George blinks, then squares his shoulders, as if preparing for a fight.

'Why don't you fuckin' ask 'im?' he says eventually, jerking his thumb over towards Bacon. 'Ask 'im. 'E fuckin' did 'em, din't 'e?'

'I'm sure Monsieur Bacon can explain the paintings more satisfactorily than his friend Monsieur Dyer,' I intercede formally.

The critic retires and merges back into the circle round Bacon, whom Maeght is introducing to someone with an authoritarian mien and even more tics than Michel who I think must be André Malraux.

'I fink they're fuckin' 'orrible,' George says, snorting with what sounds like pride. 'Reely fuckin' orful. An 'e's getting all that money for 'em.'

We turn round to look at a recent portrait of George sitting on a stool. His features have been whipped into a multi-coloured mush.

''E finks I look like this,' George says, shaking his neatly barbered head at the folly of the world. 'An' he does loads and loads ov 'em an' 'en he goes and sells 'em for thasans and thasans of pahns.'

This point amuses him deeply.

'An 'ese,' he says to me quietly, confidentially, gesturing at the people standing round, ''ese cunts go and pay fuckin' thasans of pahns for 'em.'

––––––––

I'm beginning to feel more at home in Paris as I get used to the office routine and pick up all sorts of little tricks that make life here easier. I've learnt, for instance, to insist on being in the right because admitting that you're in the wrong, which often wins you points in England, just confirms that you're dim and worthless in France. When I told my landlord apologetically that I'd knocked over the bedside light and broken it, he made me pay for a new one, even though the old one was held together with electrical tape. The next time round, having slipped in the treacherous tub and yanked the shower head out of its lead, I complained fiercely to the landlord about how run down the whole tiny, stinky bathroom was and he eventually stumped up for a partial refurb. I count this as a minor triumph in coming to terms with my new life, but in turn everything here has started to change incredibly fast because revolution is in the air and it's affecting everybody,

breaking down barriers and transforming old, ingrained attitudes. People are excited and bursting with opinions which they share confidentially with complete strangers. Paris and the whole buttoned-up Parisian demeanour is undergoing an extraordinary metamorphosis, virtually hour by hour.

Even my concierge has started talking to me, something no one could ever have predicted. Until now, I've had to hang around every morning in the hope she would come to her door to give me whatever post has arrived. Now she beats me to it, opening the door with my letters stuffed into the pockets of the old flannel dressing gown she always wears, but she won't hand them over until we've discussed the latest turn of events which she follows obsessively on her radio.

'They've occupied the Sorbonne!' she tells me, waving an enticing bundle of envelopes in my face. 'I'm on the side of the students. France has to change. The police are disgusting.'

I'd watched a big demonstration turn nasty in the Latin Quarter a few days before. To begin with it seemed like a bit of student fun that had grown spontaneously out of all proportion, then begun to take itself seriously. Perhaps it's because it's in Paris, there's something that struck me as very romantic about the revolutionary look. You can wear a silk scarf or a bandana round your neck and use it elegantly to cover your nose and mouth when the tear gas starts exploding. And it did, the bombs landed all over the Boulevard Saint-Michel, and when the police charged, for a moment I thought they can't do anything to me I'm English, then I realized they were hitting everyone indiscriminately, delicate girls as well as boys, and when the crowd ran I ran with them.

Once I got home, I tried to put the whole thing out of my mind. I've never been involved in an uprising and realize I don't really know what it's about, for all the slogans and pamphlets and the graffiti plastered over every available wall. I've never considered myself particularly oppressed politically, but others apparently do, passionately, and I feel ashamed at having stayed

in my ivory tower rather than becoming more 'engaged'. Again I try hard to forget the whole thing; it's nothing to do with me, I am a foreigner, and these are internal problems. But I still feel the tear gas in my lungs and the excitement of chanting slogans and linking arms with comrades, some of them unbelievably appealing in tight, military-style shirts, others with their hair drawn back in a fetching ponytail.

So I'm involved now, just like my new friend in her dingy *loge*, and now that I'm speaking to her I speak to all kinds of people I've never given the time of day to. From the mournful newspaper vendor and the condescending cheese merchant down to the beggar on the pavement just outside, everyone has an opinion about the 'events' that they want to share. There's a pork butcher called Noblet just by the Alésia Métro station that has a pink neon sign of a pig winking day and night above its shopfront where I'm usually in and out in five minutes but have to queue now because the question is no longer which pâté to buy but a lengthy, generalized discussion about the latest demonstrations, the brutal repression and the likely outcome. Even the sullen, subterranean creature who punches your ticket every morning as you descend into the Métro's stale air has revealed himself as a human being of strong political persuasions.

French though she is, my new girlfriend keeps away from the demos and, when she's not working on the layout of a new issue of *Réalités*, she stays at home with her Siamese cat doing her own drawings. But I've become swept up in the whole movement. Nobody talks about anything else, and since strikes have virtually paralysed the whole country, everybody is more or less obliged to take a position. If I were asked why I joined in on the occupation of the Odéon, I'd be hard put to say it was out of solidarity with the workers at Renault. I'm there simply because that's where everything is happening, and I'm amazed, once we're all crammed together into Jean-Louis Barrault's theatre, at the eloquence of the speeches, some of them given impromptu by students who must be a couple of years younger

than me. A few of them are ironic or even funny. One red-haired hothead in a torn windcheater has been berating us for the last twenty minutes for not being in the Renault factory, standing squarely shoulder to shoulder with our worker comrades, rather than sitting smugly in a bourgeois theatre, and as we begin to feel collectively guilty, another voice pipes up saying: 'The question is not why we are not at the Renault factory, comrade, but why you are not.' For a blessed moment, laughter dissolves political intensity.

If I didn't have much idea why we occupied the Odéon, I'm very clear about the reasons we have stormed the Hôtel de Massa, which is France's most important literary society and whose corrupt, conventional values about fifty of us, all members of the newly formed Union des Ecrivains, are about to denounce and overthrow. We were prepared to fight to gain entry to the building, which sits in its own little park behind Montparnasse, but it turned out to be unguarded and empty. Such unopposed occupation feels a bit of an anticlimax, but it's a perfect late-spring evening and some Union members have brought guitars and someone else has gone out to buy wine, and soon a few couples start dancing on the lawn outside. I'm sitting next to a founder member of the Union who impresses me immediately because she sees Beckett regularly and has had two books published by Gallimard. Everything seems to be going fine, like some marvellous unexpected party, until she asks me why I joined the Union. I'm about to come out with the usual slogans but caught in her steady, sympathetic gaze I can't dissemble and I tell her that since I wanted to write it seemed better to join than not to join, even though I didn't think anything we did or said or wrote would change things much for the workers at Renault. I more or less expected her to drop me there and then but instead she leant over and kissed me.

I go to every Union meeting now. Most of them take place clandestinely. We meet by prearrangement in another member's

often unexpectedly comfortable apartment or in one of the 'safe' cafés we know outside the Latin Quarter. We never refer to each other by name, which is easy enough since everyone is known as *camarade*. Unlike the haranguing that went on at the Odéon, our discussions are kept to an urgent whisper, with a comrade posted at the window to alert us to any sign of potential police intervention. We have all developed a habit of looking over our shoulder at odd moments during the day and we take strict precautions when we come to meetings to arrive singly and ensure we have not been followed. This has the unfortunate result of heightening my sense of insecurity, which has always been a problem and is now becoming all but uncontrollable since at the same time I have fallen desperately in love with my new writer friend, Danielle, and my movements have become doubly clandestine and furtive as I try to camouflage my visits to her in her room high up over the city in Belleville from my unsuspecting girlfriend at *Réalités*.

Our Union discussions cover such a vast terrain, from certain members' Maoist tendencies to sweeping social reforms or improving writers' relationships with their worker comrades, that we have been separated into various *cellules* as a way of focusing on more specific issues. I am one of half a dozen members entrusted with denouncing by every available means the country's corrupt, bourgeois system of literary prizes, which will be awarded when we reconvene after the summer holidays. This is an odd coincidence because the literary editor at *The Times* for whom I've started writing bits and pieces from Paris has asked me to do an article about the forthcoming Prix Goncourt. I tell the comrades this and before I know what's happened a detailed plan has evolved whereby, as the *Times*'s Paris correspondent, I turn up at the awards ceremony with the other comrades from our cell disguised as my film crew. Then, as the Prix Goncourt is awarded, and all the other, real TV cameras are filming, the comrades will slap the new recipient and as many jury members as possible round the face and announce that the whole

French literary establishment is putrescent with complacency, convention and corruption; one comrade is particularly pleased with the alliteration this achieves. Meanwhile, as the moment draws closer, I grow jittery to the point of illness about how the whole thing will end. Over the summer, as the May uprising has been brutally quelled, foreigners suspected of any political activity in France have been given twenty-four hours to leave what is patriotically termed the 'national soil' for good. So that would put paid to the life I've been trying by hook or by crook to create here. I'm also worried about the basic legality of the situation. I could probably be charged with something like entering on false pretences with intent to defame this, that and the other, and be handed a prison sentence. I can't get any advice because we've all been sworn to secrecy, but the fact that I'm so vague about the implications makes me all the sicker with anxiety.

When the day comes everything goes eerily to plan. We are welcomed at the Drouant restaurant where the ceremony takes place although with our long hair and beards and scruffy clothes we actually look more like revolutionaries from Central Casting than journalists and cameramen. We don't in fact even have a proper film camera since the offer to lend us one fell through at the last moment, and a couple of comrades have brought their Kodaks and Focasports, probably with snapshots of the recent summer holidays still on them. Nobody appears to find this incongruous, and once we're past security, the comrades fan out to take up various strategic points round the restaurant's main, heavily ornate space. French national television is here in force and several professionals are hurrying to and fro getting the right lighting in place for the announcement. I am fighting a panicked impulse to rush out of the room and never be seen again, but I can't because I have given my word I would help the cause and the comrades. This seems totally daft given that my whole career is at stake, and I don't even know whether this

action directe, as one comrade has termed it, has a chance in hell of changing anything for the better. The cameras begin to whirr, the lights are dimmed, and I notice the comrades have gone into a huddle in the gloom. One of them then comes over and whispers in my ear, 'The comrades have decided this is not the moment for direct action.' The relief I feel is limitless, only to be replaced by a fury so intense that it is all I can do not to slap him and all the other comrades hard and publicly round the face.

I go to one more cell meeting. There is no explanation or apology for the failure to act. I am not asked for my reactions so I sit there and listen sulkily to the new directive that has been passed along to our cell. There is a government plan, it appears, to tear down the old Halles, the food markets once known as the 'belly of Paris', and replace them with a faceless complex of modern shops. The *action directe* comrade grows eloquent as he describes the loss of these soaring glass and iron 'cathedrals' that have become such a focal point of the city. I love the area, not least because I often end up there with Francis as one of our last ports of call during a night out, and I'm appalled by the idea that the whole area might be razed.

'So how do we prevent them from tearing down the Halles?' I ask.

'That's simple,' says *action directe*. 'We wait, and then the moment the bulldozing begins we dynamite the Sainte-Chapelle.'

I look at him in disbelief. From his manic smile, there is no doubt that he sincerely believes in what he has just said.

I leave the meeting abruptly, resolved to shun political action, direct or indirect, from this point on.

7

'Poor George'

The silver lights of Paris have disappeared and we fly through a dark-blue void above the Channel before the gold lights of London come slowly into view. I haven't been on many flights, and this is the first time I've taken the plane rather than the boat-train to London. The city stretches beneath us like a vast black map crisscrossed with bright tracer lines. I can make out the Thames snaking between the glowing sodium lamps and then the shapes of landmark buildings. As we come in to land, the rooftops and streets glisten with wet and I can almost smell the misty, metallic odour of the rain.

I am pleased to be strung between two cities. I am at home in both now but I don't belong to either. That is the advantage of places over the women in one's life: you can go from one to the other and enjoy each without guilt. Of course I came unstuck in my two-timing with Danielle, as I always knew I would. After weeks of fear, lies and secretive meetings, I was going out for the evening with one when I came face to face on a Métro platform with the other. I broke out into a panic sweat as if I had been caught with a dead body and a bleeding dagger in my hand. Why did I allow myself to drift into all this, I've wondered ever since the initial thrill, when I knew I could no more handle it than I could being a double agent, constantly pretending and covering my tracks, constantly fearing exposure? There was no

pleasure lying in *hôtels de passe* rented by the hour, making anguished love to one while worrying about the other. And cheating on both eventually came down to cheating on myself, since I could no longer be sure who I really was as I shuffled between my dual roles. So when I broke with one, at dusk on a bridge over the Seine, I had to break with the other. There was a logic to this that could not be denied. From having had too much to handle I woke up one morning alone in my own room with nothing at all.

The logic continued implacably. Breaking bonds is contagious. Having left my loves, I left my job. *Réalités* had sent me across Europe to write more or less what I pleased and allowed me to work as it suited me, drunk or sober, at home or in the office. Now, for no apparent professional reason, I also turned this down for the more demanding and totally unreliable métier of writing freelance for whoever would hire me. This doesn't seem to have begun too badly, I'm glad to say, creating the one bright spot on an otherwise gloomy landscape as I try to adapt to celibacy. *Art International*, an impressively serious, well-produced art magazine published in Switzerland, has been in contact with me because Miss Beston, who looks after Francis at Marlborough Fine Art, has suggested I write an essay about the new paintings Francis will be showing soon in their New York gallery. I am delighted by the idea. It's the sort of thing that would never have come my way if I'd stayed at *Réalités* where art was regarded as part of lifestyle and Francis's work would have seemed too tough and provocative to sit comfortably between the châteaux of the Loire and 'profiles' of up-and-coming actors or designers. It will give me the chance to write some real art criticism and to get more to grips intellectually and imaginatively with Francis's paintings, some of which must have already been included in the Maeght show I saw. I'll also be able to draw on the conversations I've had with Francis about his work over the past few years. At all events this is why, I repeat to myself triumphantly as the plane drops

bumpily down, I am on a BEA flight to Gatwick paid for by a Swiss magazine.

I feel considerably less triumphant when I push open the door to the Marlborough gallery on Bond Street. The atmosphere is very hushed, the lights are dimmed and the carpeting soft and deep. The main exhibition room is lined with nineteenth-century French painting in ornately carved frames which gives it the air of a private museum. There are no other visitors, only an aloof-looking secretary typing at her desk. I've been here a couple of times before with Francis, when the atmosphere was noticeably more welcoming. I pad silently round and notice there are some German Expressionist paintings mixed in with the Corots, Signacs and Monets. I also notice that my wet shoes have left clear damp imprints on the deep pile behind me. The secretary appears to have seen this, too.

'Can I help you?' she asks, putting on a pair of spectacles to examine me more closely.

With my old, wet raincoat in one hand and a notebook in the other, I clearly do not look like a potential client.

'Miss Beston said I'd be able to look at the new Francis Bacon paintings,' I say.

'Ah yes,' she concedes. 'We've been expecting you. Now, if you'd like to follow me.'

We go through a back door and down more carpeted steps into a harshly lit basement floor where several large canvases have been propped against the walls. A stool has been placed opposite them.

'Both Miss Beston and Mr Reichardt are out at the moment, but they asked Terry and his helper to put these pictures out for you to see,' the secretary explains. 'Let me know once you've had enough time to look at them and I'll ask Terry to bring the other works that are going to New York from the storeroom.'

I've seen quite a lot of Bacons reproduced in catalogues and had the chance quite recently to study a whole roomful of them at

Galerie Maeght. But being left alone in a silent space underground completely surrounded by them is another experience altogether. The bright lights play on the glazed gold frames so that at first you have no idea what's going on. Then twisted bodies rise to the surface of the glass like corpses in water, disfigured, discoloured, and stay there. Once you have seen them, there is no getting away, no exit. Each of the figures is held at some extremity – of pain, of guilt, of fear, of lust, or of all combined, it's never clear. There are screams issuing from wide-open mouths, but they are muffled, even soundless, because there is no space for screams to be heard and the bodies are pushed up, almost flattened, against the glass, and left there to gasp. There is no air for fear to scream or lust to pant, like a new degree of torment invented by a subtle medieval divine. Contours deliquesce, limbs buckle, and the head is reduced to a mere stump of misery. Trying to counter the great waves of threat I feel breaking over me I get up from my stool and go up to look at them close to, following the great swirls of pigment as if they might lead me to the source of so much pain. But the infinitely pliant, grainy paint only reveals further sadomasochistic refinement and humiliation. No facial feature has resisted the onslaught. Eyes are put out and noses splayed as a matter of course. Whole faces are flayed to a pulp around chattering teeth, while black and green spots bloom on the pink skin like a terminal disease.

I settle back on my stool and try to make some notes while I have the pictures in front of me, but I feel too overwhelmed to get much beyond inanities like 'v. violent clashes of colour' or 'skilful, wilful distortion'. If I'd seen Francis's painting up close like this before I met him, I probably would never have pursued him for an interview. How could I have imagined him as anything other than a kind of depraved monster, dedicated solely to the pain and horror of life, a kind of Dr Caligari of art? When I did meet him, I did of course become gradually aware that beneath the debonair charm, the elegance and the seductive generosity there was a deeper, darker streak that surfaced from

time to time, like a cobra about to strike, in a poisonously wounding remark ('She's got legs like bolsters and she's rotten to the core') or an excessively disparaging comment, often about other painters ('Jackson Pollock? Oh are you talking about the old lace-maker?'). There are lightning flashes of cruelty, and I have sometimes wondered whether George doesn't pay very dearly for his new, luxury, drink-sodden existence up west.

Most of the time, though, Francis is the perfect boulevardier, making his way through life with apparently not a care in the world beyond whether to order champagne or vodka with the caviare. The savagery of the painting, the attack on mankind, was confined to the studio. Once he'd washed and got into fresh clothes, he turned the key on all the nightmares and sauntered forth. More than the portrait of Dorian Gray, it was Jekyll and Hyde. The morning session, begun perhaps not long after returning from a night in the bars, cleansed Mr Hyde. He could work out all his murderous voluptuousness on the canvas and, thus purged, the urbane Dr Jekyll could straighten his tie in the mirror and walk out to an establishment in Soho to imbibe his first glass of champagne at midday and then carouse and entertain his friends until dawn.

Since none of the rivers of paint appears to lead back to any identifiable source, where did the fury originate? What could have happened to this suave adventurer, habitué of the Ritz and Crockford's Casino, as well as Muriel's and several of Soho's lowest dives, that he found himself marked out to express the horror and outrage of a whole generation? Francis may well have had a childhood inkling of the First World War and been aware of the Irish troubles from the vantage of his father's stud farm on the Curragh, but how many thousands at that time had not lived far closer to terror and death? Was the suffering that obsessed him sparked off by the images of the death camps that started to circulate just as he first began painting with a vengeance? Francis himself had said not, but then with dandyish disdain he had always refused to say where his imagery came from. The

brutality and horror just 'happened', pictures came about by the 'chance marks' the brush made as it moved oil paint across the canvas, and there was no explanation to anything since there was nothing to explain beyond the odd reference to Shakespeare or the *Oresteia*, Muybridge or Michelangelo, which seemed to be relevant but in the end merely diverted attention from the central enigma as to why Francis Bacon's paintings spoke only of pain and destruction.

'Are you ready for some more, sir?'

Two grinning assistants take the pictures away and replace them with a new batch.

The range and inventiveness in tearing and flaying human shapes is overwhelming. Heads and bodies tumble out in ever-greater extremity, ever-greater virtuosity, on to the picture plane. All the forms in this high-wire act are taken to the brink of abstraction. But they don't topple over, they're brought to the edge and held in check, a hair's breadth from dissolving into formless, painterly chaos. And this seems to me the key, though I could hardly ever explain it in a magazine review: the balance is maintained by the vitality that courses beneath. Under this raging destruction the blood runs so ruddily, as if in defiance, and thick white flares of sperm lace the mutilated body parts together. Are these things essentially about sex? I suddenly wonder. No one as far as I know has ever suggested this before. Far from an anguished record of our brutal times, from death camp to nuclear bomb, are the flailings and gougings, the twisted limbs and half-obliterated heads a kind of paean to the further reaches of sadomasochistic coupling? Is this an extended love song?

As this unthinkable thought occurs to me, there is a sudden subtle change in the room. An exotically beautiful woman has been led into the basement by the secretary. She takes off her dark glasses and looks round, filling the damp air with a haunting perfume. She's so familiar I feel I know her well, and then I realize it's Sophia Loren, and it's her films and photographs I know so well. Behind her, the thickset older man I take to be her husband

is peering into the paintings. I know they are connoisseurs of Bacon and have been buying his work since it was shown in the late 1950s in several galleries in Italy. I look back at the pictures I have spent the last hour with alone and imagine them in an ochre-coloured Roman palazzo or a white villa on the Amalfi coast, luxury objects with their human turmoil encased in gilt frames hanging among other masterpieces in elegant rooms filled with beautiful, bronzed people admiring them.

'Only three more to go now, sir,' says one of the assistants kindly. But I can't look at any more. My train of thought is completely broken by the idea that these dramatic statements about the human condition are also collectibles, destined for rich people's walls. May 1968 affected me more than I'd thought, I reflect wryly, and in any case it's naive of me to think that these paintings belong only in museums. They are made to be sold, and I'd better get used to it. I'm keen now to go and glad when the secretary tells me that Miss Beston has asked to see me. I follow her back up the carpeted stairs and through a warren of corridors.

Miss Beston looks up from her desk as I'm ushered in. Although diminutive and comfortably plump, she is a forbidding person, somehow reminding me of the stern matron we had at school. I take heart, however, when I notice that she is so tiny that her legs don't touch the floor. I have another advantage: since I've always met her with Francis, I call her Valerie, as he does ('Valerie at the gallery', as he refers to her when he's in a genial mood). There is an air of secrecy around her, and it's said that she did hush-hush work at Bletchley during the war. Perhaps because of that, her speech is clipped and her manner quite formal. I've heard that someone who was working closely with her on a Bacon exhibition suggested that he might call her 'Valerie', only to receive the sharp reminder from her: 'I think you'll find most people call me Miss Beston.'

'So what did you think of the new paintings, Michael?' she asks without wasting time on small talk.

I'm a bit at a loss to sum up the welter of reactions I've had in a single phrase.

'Well, they're, er, impressive,' I mumble.

'They certainly are,' says Miss Beston. 'He's caught George to an absolute T.'

'That's true,' I reflect. 'But he's got a bit beaten up in the process.'

It's immediately apparent that flippancy is not welcome.

'To an absolute T,' Miss Beston repeats with finality. 'And I love that marvellous bluey-green he's used on the latest one. It's such a beautiful colour.'

She might as well be talking about a Renoir, I think. How can she not be aware of the carnage going on – the blood spattered everywhere, to say nothing of the spunk. There can be no point asking her what she thinks the paintings are about. She would just go along with Francis's story, with a lovely bluey-green or two thrown in.

I gaze round Miss Beston's cubby-hole of a room. There are several large photographs of Francis pinned to the wall behind her. Then to one side some shelves with large leather-bound volumes with dates stamped in gold on their spine.

'Are those reviews about Francis?' I ask.

'We keep a complete archive of everything that's been written about Francis and all the press cuttings where he's mentioned,' she says, as if slightly resenting my curiosity.

This is a shrine to Francis, I realize. The sacred fire is tended here, and in however unlikely a guise Miss Beston serves as his vestal virgin. She is in love with him, as George is, as Muriel is, as Lucian is and as – however grotesque the notion – David Sylvester is. And perhaps, no less grotesquely, as I am.

So here's the weird thing. We are all Francis's vestal virgins tending to the sacred flame, yet none of us appears to know what is really going on. Lucian claims that Francis is 'the wildest and the wisest man' he has ever known. That's a good start, but it doesn't exactly explain anything. In fact, we all repeat the formulae of the

maestro as if we belonged to some superior claque. What is really going on, I long to ask Miss Beston, what does it all mean, but I think she is still committed to her Bletchley codes and will not be giving any secrets out, although I am struck by a throwaway remark of hers as we chat. 'I can't think of a worse fate', she suddenly suggests, apropos of nothing, 'than being loved by Francis.' For a moment the phrase lies, tantalizingly unexplained, in the air between us. Then Bletchley comes back, and Francis is officially limited to capturing George and beautiful bluey-greens.

'I will send you all the ektachromes you need to choose for your article,' Miss B. says, winding up our rendezvous. 'I know Francis is very pleased you will be writing about the new pictures. We all look forward to seeing the piece when it comes out.'

The Tregunter Road days are over. No guffins lurk in the basement any longer ready to welcome me back and offer me my old bedroom. My friends have moved on, Magnus to the *Evening Standard* to write for the 'Londoner's Diary', Peter to work with a fashion photographer, travelling the world to photograph ravishing, topless models on pristine beaches. *Art International* has provided my airfare but no living expenses, so a hotel is out of the question. In any case, staying in a hotel in my own town would be a kind of admission that I have no friends. Luckily one of my closest old contemporaries from Cambridge, David Blow, is back from what sounds like an exotic posting at the British Institute of Persian Studies in Tehran and he has taken a handsome flat in a substantial redbrick building in Knightsbridge. I think the style is called Pont Street Dutch and it's a definite step up from Fulham, because I am staying in the room at the front, overlooking the gardens, which is the size of a ballroom and has a very comfortable sofa. David says I can sleep there and stay as long as I want, so I've already placed my few belongings neatly round the sofa, demarcating my terrain. One incongruous item is a large, shiny brown handbag that Mary McCarthy, the American writer who is now living in Paris with her latest husband, a diplomat

called Mr West, has commandeered me to take to Sonia Orwell. I haven't been given the details, but the bag looks too used to be a gift, so I suppose Sonia must have left it behind, perhaps after too many drinks at the Wests' apartment, which is grand enough to feel like an official residence, on the rue de Rennes. I feel like some tiny envoy shuttling between two powerful female states, and I know there is some friction between them. After just an hour with the hard-eyed American writer, however, I have little doubt that she would always worst Sonia, who is vulnerable beneath all her bluster and probably acutely conscious that Mary has a literary reputation and she has not. I've called Sonia to let her know I've got the bag and she's asked me to bring it round this evening before I go on to meet Francis at the Connaught.

One of several nice things about being back in London is that I will be plucked out of obscurity and relative penury for a few days. I never starve in Paris but I have to eat cheaply and limit meals out to student standbys and basic Vietnamese. Making a living out of writing freelance for art magazines will never put much butter on the spinach, as the French say, particularly when the pounds I earn drop vis-à-vis the franc, but it doesn't much worry me because I have the luxury of being my own master. I often feel a bit threadbare, though, and I have to admit to an occasional twinge of envy when I see young men my age, whether here or in Paris, stepping out in smart suits or leather jackets. I suppose if I did have a lot of clothes I'd now be dithering as to what to wear to go to a grand hotel, and I grant myself that advantage as I get back into the old grey roll-neck and dark-blue jacket, once I have emptied it of used Métro tickets, a crumpled Gitanes packet, some scruffy notes wedged beneath a biro top and a few 20 centimes coins.

Sonia's house on the Gloucester Road looks much more homely than I remember it, as I stand, handbag embarrassingly in one hand and umbrella in the other, looking up at the cracks running down the shabby façade. I'm also a bit taken aback when Sonia opens the door in an old pink housecoat with her hair all over the place and a confused expression.

'Oh it's you,' she says. 'I thought you were coming tomorrow. Anyway, now you're here, you'd better come in.'

I hand over the bag and follow her into the kitchen, which looks as if she's given a dinner party the previous evening and hasn't managed to clear the dishes away.

'It's such a mess in here,' she says in an aggressive voice. 'But then my life's such a mess anyhow. I've fucked up my life, you know. Just fucked it up. We'd better have a drink.'

There are several bottles of Côtes du Rhône open. Sonia takes one, fills a large glass for me and tops up her own.

'Do you want me to give you a hand clearing up?' I venture, hoping this won't remind her of our previous dalliance over the dishes. This is hardly turning out to be the smooth, sophisticated soirée I'd imagined.

'No, just leave it. It'll get done, everything gets done in the end,' Sonia says, emptying her glass emphatically. 'That's part of the trouble. Anyway, what brings you to London?'

'I've been asked to write an essay on Francis's new paintings,' I announce, pleased to have such an impeccable reason for once for being anywhere.

'Who's it for?' Sonia demands.

'*Art International.*'

'Never heard of them,' Sonia says, shaking her head dismissively. 'So what are you going to say that all the others haven't already said? I suppose you know', she adds sharply, 'that Michel Leiris is writing a real essay about Francis.'

'I'm not sure yet,' I say. 'I expect I'll find something. After all the paintings are very powerful and I have talked to Francis a great deal, as you know, and I've been noting everything down.'

'We were talking about you just the other day,' Sonia says, using both hands to fill our glasses carefully. 'Francis said he was looking forward to seeing you. And then he said he had no idea who your grandfather was.'

'What an odd thing for Francis to say,' I remark with a laugh.

'Yes, it is an odd thing for Francis to say,' Sonia concedes, softening a little. She runs one hand through her hair and suddenly stares hard, as if trying to remember something, into the middle distance.

We have one more drink, but when I leave, it's as if I hadn't even been there.

I'm still early when I get to the Connaught. I imagined myself drifting inconspicuously into the bar but the concierge insists I put on a tie from the box he keeps specially, and now, even though I chose the most sober one, I feel I stick out a mile with it tied conspicuously round my polo-neck. The bar has a club-like feel with dark panelling and leather armchairs but you're left in no doubt that it's a club for the wealthy and powerful. There are a few other people having drinks and talking confidentially as I slip behind a table for two and tell the waiter I won't order until my friend arrives. There's some polite laughter just behind my back, which makes me feel increasingly uneasy.

Then I hear someone say:

'Well, what about a Mantegna? Surely you'd like a Mantegna?'

'I might hesitate over a Masaccio but I could hardly say no to a Mantegna, could I?' a slightly accented, richly indulgent voice replies.

'Well, we must find you something you'd really like, mustn't we?' says the first voice. 'After all, that's our job. That's what we do.'

I half turn my head and see a group of middle-aged men in dark suits smiling knowingly at each other.

Then I notice Francis making his way through the tables. He looks pink and genial, and I sense he may have spent the afternoon buying everyone champagne at Muriel's. He gives a brief smile to the group behind, then sits down opposite me.

'Have I kept you waiting, Michael?' he asks, looking pointedly at the thin gold watch on his wrist. Somebody when I was still

living in London told me that Francis flaunted his expensive-looking watches as a come-on when he was cruising in search of rough trade.

'No, I was early, Francis,' I say. 'I've just come from seeing Sonia.'

'Ah, how was she?' he asks. 'She does get terribly depressed, but then I don't think she's what's called ever been really happy in her whole life. As you know, Cyril Connolly once said to me, "The very idea of Sonia being happy is obscene." Well, I don't know about that but the thing is that she's always wanted to write but she's never been able to make anything of it. So when *Horizon* closed down she helped launch a magazine called *Art and Literature*, and of course that didn't last. Those things never do. She's also tried doing translations and I think that has worked a bit for her, but she still thinks she should have achieved more. I don't really see why when she's been able to create a kind of salon in her house where all kinds of writers and painters and so on can meet. I think that in itself is an achievement.'

The group behind us gets up to leave, still laughing cordially among themselves.

'Who are they?' I ask Francis quietly.

'I don't really know,' says Francis, 'but I think one of them is that art collector they call Heini Thyssen.'

'One of the others was suggesting he buy a picture by Mantegna,' I say, pleased to be passing on a piece of choice gossip.

'I'm sure he was,' Francis says. 'They'd be only too happy to sell him whatever they could and make a huge profit on it. The others must have been picture dealers, gathering round him like vultures. All dealers are crooks, as I'm sure you know. Somebody said to me the other day about some dealer, he can't be a crook he's an Hon. And I said, I'm afraid the Hons are quite as bad, in fact the Hons are usually the worst of the whole bunch. I know my gallery is only there to try to make money out of me. They do fuck all otherwise. But at the same time I do think that Frank

Lloyd has a really good eye. He can actually see painting, which most people can't. I mean I suppose David Sylvester can, but only once you've told him what to look for and then of course he stares at it for hours. Frank Lloyd has it naturally, although he's not really interested in it. He's only interested in making money, of course, which he's brilliant at. So in the end I prefer to have a successful crook selling my pictures than an unsuccessful one. Though whether my things will go on selling at all is another question. I've been very lucky to make a living out of something that obsesses me. Of course most people simply loathe the work. But that's another story. Ah, I think they're asking us to go in.'

'I've managed to get you your usual table, Mr Bacon,' the maître d'hôtel says discreetly.

'That's absolutely marvellous, Antonio,' Francis says, pushing a banknote into his hand. 'I can't thank you enough.'

We are escorted to the table, have the chairs pulled back for us and the napkins delicately unfurled over our laps.

'I must say I really love these luxury hotels,' says Francis, beaming broadly round the dining room. 'At least every now and then it is terribly nice to have everything laid on for you. I think if you lived in luxury every day the boredom would be ghastly. What I like is the distance between luxury and poverty, it's much more interesting to drift between the two in the kind of gilded squalor I live in. Now what do you think you'd like, Michael?'

I've been staring more at the prices than at what's actually on the menu. I know Francis too well not to know that he will always encourage his guests to eat the most expensive dishes, just as he never hesitates to order exorbitantly priced wines. I remember a dinner in Paris to which Francis had invited some very rich Greek collectors: when he asked for a particularly prized vintage he thought they might like they protested that it was too expensive; but Francis didn't flinch, and I saw how impressed they were, perhaps particularly because, although they were much wealthier than him, he was ready to throw his

money around recklessly. Even so, I plump for the *suprême de volaille* which seems to be about the least outrageously expensive dish, although even then I can see the meal will cost more than I can earn in a week.

'Why don't you try the lobster, Michael?' says Francis slightly sharply. 'They get them sent straight up from Cornwall. Then you could have the roast beef from the trolley, which is particularly good. There's no point coming to these palaces if you don't have what you really want. How have things been in Paris?'

'Not bad. The freelance writing is coming together, little by little,' I say.

'Well, it must be marvellous to write like that. I mean, you can do it anywhere, you don't have to have a studio or anything to work in. But I'm sure it's difficult to make a living like that, and I was just thinking before I left the studio that you might well need some money, so I brought some with me.'

'That's terribly kind of you, Francis,' I say, blushing. 'But you've already been more than generous towards me, and I'm managing to get by quite reasonably.'

'The thing is', says Francis, chuckling, 'that I did have an extraordinary run of luck at roulette the other evening, so I've got masses of the stuff on me.'

'I'm very grateful, Francis,' I say, feeling increasingly clumsy and ill at ease at the way the conversation has turned, unexpectedly focusing on me. 'Really, I don't need money at the moment.'

'Well, I have to say I've always needed money,' Francis goes on, unperturbed, 'and I've always taken it whenever I've needed it, by any means I could. I can't say I was at all honest when I was young, I used to rent rooms and leave without paying and that kind of thing. What's called morality has grown on me with age, and it would be a sort of stupid luxury for me to steal now, but I did steal on occasion. There was this Greek who picked me up once in Dover Street and we went up to his place and afterwards when he was in the bathroom I started going through his pockets and he must have been watching me in the mirror

because he came out and said, "What are you doing, Francis?" and I said, "Well, you can see what I'm doing," and he said, "You don't have to do that. You only have to ask." And he took me down to his bank and drew out £100, which was a lot of money in those days, and gave it to me. I must say it was a marvellous way to behave, and I've never forgotten it.'

The lobster has come and gone. After much consultation the wine waiter has filled our glasses with a magnificent Château Latour. I feel its subtle fire slip into my blood and burn away any lingering shyness. All evening I've been wanting to ask Francis about his new paintings, not just for my essay but out of a real need to know for myself. There is something about having seen the paintings in the gallery that's not unlike having witnessed a bad accident or a crime. I feel personally involved. I was hoping he'd bring the paintings up himself since he knows I'm writing about them and this is why I'm here. But it seems to be the last thing on his mind as he scans the wine list to see what we should have opened in advance of the cheese that will provide an even more exquisite experience.

'I thought the new paintings were incredibly powerful,' I say at what I hope is a suitable lull in the conversation.

'Ah, I'm particularly pleased *you* like them,' he replies smoothly, as if my reactions were the decisive factor. 'There are one or two I quite like too, but I never really know with my own things.'

'I was wondering what one could really say they were about,' I mumble over my rare roast beef. 'It occurred to me that on one level at least they were essentially about love or, um, sex.'

Francis pauses, his glass midway to his mouth. He looks almost startled. I can't see whether he thinks I'm merely stating the bleeding obvious or whether I've trivialized a far more metaphysical intent.

'Well, I don't actually think they're about anything,' he says slowly, almost as if he were giving evidence. 'I'm just trying to make my thoughts and sensations about life come back at me

with greater intensity. The paintings are about my life, and of course sex is part of that. I suppose I would like to make images that bring you closer to what being human is actually like. But you know painting's become so impossible now. One can just try and make things a bit more precise. What else is there to do with life but try and make oneself a bit more clear? Of course, after all these years, I don't know whether it's ever worked. Now and then I still get this marvellous feeling that I will be able to make it work for a moment. Perhaps I never shall. But I always hope for this great wave of instinct with which I might really be able to change and renew everything.'

I realize he's deftly sidestepped my question, but if I challenge him I know it will simply irritate him and he'll stop opening up.

'There's no saying whether I've been able to change anything at all, obviously,' Francis continues. 'Only time can tell about that sort of thing. But I've always been fascinated with the idea of making images. With the idea of finding something which will make my own visual experience come back to me more violently. You see, for me painting has always been a way in which I've tried to excite myself. Make my own sensations return with more poignancy. But with all the mechanical forms of recording, you see, it has become a much more close and difficult thing. Ah but it's also made it much more interesting, because if the image is going to be any good nowadays it has to go much deeper than simply recording appearance. Somehow you have to try to get the paint down in such a curious way that it comes back on to the nervous system more exactly and more profoundly. If this image is going to be worth making at all, you see, it has to unlock sensation at a deeper level, it has to go in at an instinctive level. Otherwise, a photograph can do the whole thing much better.'

'My impression is that you're working way outside photography while actually absorbing a lot of its techniques,' I say, 'a bit the way photography did when it first appeared and had to appropriate so much from painting.'

'Well, I hadn't thought about that, Michael, but it's probably true,' Francis says. After his initial surprise, he's clearly enjoying the chance to talk more openly about his work. 'At the same time, there is this very mysterious thing about the actual texture of paint. For some reason, we don't know why, it comes across on to the nervous system in a more immediate, more abrupt way than, well, the surface of a photo for instance. What's so strange, too, is that the medium of oil paint is so fluid that you can try to manipulate the chance marks it makes into suggesting how you might be able to develop the image in a way that lies outside illustration. Illustrational form tells you immediately what the form is about, whereas non-illustrational form works first on your sensibility, then gradually leaks back into fact. So that if you're very lucky, if this sort of accidental thing works for you, you see for a moment how you might be able to bring off this image outside illustration which makes it both a recording of appearance and something that unlocks sensation about life more deeply.

'Of course what one would really love in a portrait is a kind of Sahara of the appearance. To make it so like the thing you're trying to record, yet seem at the same time to have the distances of the Sahara. As you know, I myself terribly want to avoid telling a story. I only want the sensation – that thing Valéry said, the sensation without the boredom of its conveyance. What I long to do is to undercut all the anecdotes and story-telling yet make an image filled with implications. Make it more specific, yes, but at the same time more general. A kind of concentration that makes it more general. I've always believed that great art comes out of reinventing and concentrating what's called fact, what we know of our existence – a reconcentration that tears away the veils that fact, or truth if you like, acquires over time . . .

'What would be marvellous, in the end, would be to have something like the whole sea at the end of a kind of box you could look into. Just like that. So small and yet to have the whole

sea in it. I expect that sounds ridiculous, Michael. It probably is ridiculous. But then life itself is so ridiculous one might as well try to be as brilliant and ridiculous as one can. Now, why don't we go to Muriel's and have just a leet-el bit more to drink.'

We do, copiously, and when I get back to Knightsbridge I tiptoe into David's flat like a caricature drunk with my shoes in my hand. I try to settle down on the unfamiliar couch, but snatches of what Francis kept saying go round my head so obsessively – 'great wave of instinct', 'more violently on to the nervous system', 'brilliant and ridiculous' – that I think I'll be up all night and feel even more exhausted tomorrow. Then gradually the wine begins to burn down. I lie there watching the yellowish-orange light from the lamps outside make a gash on the ceiling over my head. So this is London, I remember saying to myself shortly before I fell asleep. This is London, and I travel from one illusion to another.

I'm going to have one last dinner with Francis before flying back to Paris. We're meeting at Sheekey's because that's where George likes to go. It's still early evening and I'm going to try to catch John Deakin at one of his haunts in Soho. I know I'm in something of a minority but I'm quite fond of John, perhaps because I like anyone who makes me laugh and also because I'm grateful to him for having introduced me to Francis so adroitly. If John isn't in the Caves de France, he'll probably be in the Coach and Horses or the French House. I haven't been to the French in ages so I go in and find John exactly as when I first met him, hunched in his sheepskin coat on a stool by the bar, cigarette and glass in hand like a saint with his symbols. I shake hands with Gaston behind the bar, like one Frenchman greeting another, and order two large white.

John is full of news and gossip but lets drop right away that he is now, at last, making sculpture.

'What kind of sculpture?' I ask. I'm genuinely surprised because I thought photography was his whole life.

'My dear, I see that only hard facts will satisfy your ardent mind,' John says, drawing out each syllable. 'If you must know, I'm engaged on a cycle of figurines.'

'Well, that's interesting,' I say, a bit too hesitantly. 'What are they of?'

'If you really must know,' says John, rolling his eyes to convey the suffering of the eternally misunderstood creator, 'they consist of a suite of small sculptures of Apollo. Fashioned in terracotta. *Et voilà!* But of course as with all great art they nearly, literally, killed me.'

'You're kidding, John?'

'I sure am not kidding, kiddo,' John says, his voice rising indignantly. 'In order to bring the figurines forth, first of all I completely stopped drinking.'

He pauses to let the enormity of the notion sink in.

'Then one morning, it was such a fine morning and the work had been going so well, I thought surely one tiny glass of white wine could do no harm. So I went to that loathsome house on the corner and ordered just one small glass. And the great clodhopper behind the bar – I still don't know whether it was because he simply didn't understand what white wine was, or because he thought it funny – served me a glass of Parazone.

'Yes, my dear, Parazone, I know, it simply staggers belief. It's like Jeyes Fluid. You can imagine. They shoot it down lavatories and things. And it's mighty strong, I can tell you. To make things worse, I happened to knock the filthy stuff back in one go. And then of course I just did not know what had hit me. I went out like a light, straight off my stool on to the floor. And the very next thing I knew, I was lying in bed in hospital.

'The doctor, who was quite delightful, told me that had my stomach not been so thoroughly lined with alcohol I might well have died,' John concludes, his voice dropping to a scandalized whisper. 'Suspended between life and death, my dear, and all because that

knucklehead could not, or would not, tell the difference between white wine and lavatory abrasive.'

By the time I get to Sheekey's, Francis and George are already sitting at their table. I sense Francis's irritation as I sit down because I'm a bit late. He himself is punctual to the minute, unless, very rarely, he's so drunk he's completely forgotten where he's meant to be. It's strange to feel so many contrary extremes in one person: genial and easy-going but also harsh and strict; generous with his time, help and money and mean in his opinions about people; sympathetic, even tender, and cruel. He can also show extraordinary, down-to-earth common sense one moment, then rely on chance or 'instinct' the next.

I tell them about John and although they already know the story this makes them laugh for a moment. But there's a tension between them. Francis is curt and testy, while George is looking particularly pale and withdrawn.

'The thing is,' Francis says, 'poor George hasn't been feeling at all well, have you, George?'

'No I 'aven't,' George nods, with an affirmative snort.

'He's been on the drink for so long he can't actually eat.'

'Can't keep anyfink dahn.'

'So I thought we'd come here because they do a kind of eel broth that sort of just slips down.'

Francis confers for a moment with the waiters. Then a chef appears and they all stand round nodding.

George continues to gaze down at the table, pulling hard on his cigarette, his brows knitted in concentration, as if he were trying to work out an insoluble problem.

'I'm going to have to leave you with George,' Francis suddenly says to me. 'I hope you don't mind. There's somebody I have to see about something, and unfortunately they are not free at any other time. Just order anything you want.'

I'm surprised, not only because Francis usually seems to have all the time in the world, and also because, however open-handed he is in introducing his friends to each other, he doesn't like the idea of their getting together when he isn't present. I wonder if Francis's in some kind of trouble. A gambling debt to settle, perhaps, or some trouble with the gangsters he knows from Tangier. He's mentioned the Kray twins several times. They're like celebrities now, always in the news, even though it's tacitly accepted that they torture and kill people.

The eel broth arrives. Chef and waiters group round our table. A motherly figure, perhaps the owner, joins us. A bowl of slippery-looking green is slid under George's nose. George stubs out his cigarette, mindful that he is at the centre of attention. He dips his spoon into the broth and hesitates, raises it to his mouth and hesitates, then manfully swallows it down. A small ripple of applause rewards him. A second, then a third, spoonful follows. George looks up. A faint colour has crept into his cheeks. I think it might be embarrassment. Once the staff have gone back about their business, I try to change the subject.

'I wonder why Francis had to leave,' I say.

'Oh, 'e's alwus upter sumfink,' says George, enigmatically. ''E's alwus seein' people.'

'Well,' I say, 'it's very nice to see you again, George.'

'Yeah,' says George. He seems to have perked up considerably. 'Fing is, I terribly like seein' you. 'Ere, do you want an 'ave a drink in a really special club? I mean it's full of really orful people, real villains. But I spose', he adds, with a cunning look, 'you college boys git all fright about going to them sort of places.'

'I'm not fright, I mean frightened,' I say airily. 'If you say it's special.'

'Lot of me old friends go there,' George says. 'Wenneycan.'

'What d'you mean, when they can?'

'When they're ahter prison.'

We clamber into a taxi and I soon lose any sense of where we're headed. I'm dulled by too much drink over too many days,

although my appetite is unimpaired. I wonder how Francis does it, so much booze and so many rich restaurant meals, day in, day out. I may have dozed off in the taxi, because the next thing I know is that George is presenting his member's card to a large commissionaire in a gold-braided black uniform.

''Ere,' he says, ''e's gotta ava tie.'

'You gotta ava tie,' George repeats rather reproachfully.

The commissionaire wraps a gaudy Hawaii-style number round my polo-neck.

'Our quaint old English customs,' I quip.

We move into a dimly lit space with candles winking at various spots round the room.

A girl in a Bunny-like outfit takes us to our table.

'We'll 'ave gins and tonics,' George says grandly.

He looks round the dark space.

'They're all 'ere and an' all tonight,' he announces.

The girl brings the drinks.

'Same again,' says George.

The drinks slowly pile up on the table, some drunk, others still fizzing softly away.

A cabaret begins.

'Them's reely orful,' says George admiringly, nodding in a vague direction across the room to a party that's just arrived. 'Them's slit froats.'

I peer across the room to a group of men in very white shirts and very dark suits.

'Them's the Twins,' George says with quiet pride.

I take this information in and tell myself I should be concerned. I have heard what the Krays do and never imagined I would be in the same room with them. At the same time, the drink has dulled any real sense of panic.

A new girl has come on. She is pretty and does a dance routine where she keeps changing dresses before going over to an imaginary window, which she rubs vigorously with her hand to look for someone outside.

'That's my girl,' George says, following my gaze. 'That's my girl. Just in case you fink there's sumfink funny goin' on wiv Francis and me. Ain't nuffink funny.' He gives an assertive snort and stubs out his cigarette in the overflowing ashtray.

'I never thought there was anything funny,' I assure him. 'Perfectly alright.'

The table has filled up with glasses. I'm conscious that some outrage might erupt from a neighbouring table. A throat cut or a head blasted away with a shotgun. I know I need to leave but I can't, a bit like a recurrent nightmare I have where I get stuck in cement-like mud. But here it isn't the mud clinging to my boots, it's George.

'You wanna come back with me?' George asks out of the blue.

'Don't be ridiculous, George,' I say stoutly. 'You know there isn't anything funny.'

The Bunny lookalike offers to clear the table, but George sends her away. We fumble among the empty glasses to find one that is full.

'I'm on this big job tomorrow,' George announces suddenly. 'Knocking off a load of TVs. But of course you college boys don't 'ave the balls for that kine of fing.'

I'm drunk and I'm exhausted. I know that. I also know that we shouldn't be having this conversation. But I'm susceptible to people telling me I don't have the balls for things.

'Oh I've got the balls, George,' I drawl, taking a long pull at a glass that turns out to be empty. 'Don't you worry about that.'

'Alright then. You're on,' says George. His manner has become almost businesslike. 'We do the job together. Fifty–fifty on the TV sets. I'll meet you tomorrow morning at twelve noon, punctual mind, outside the Dominion on the Tottenham Court Road.'

'OK,' I say decisively. 'See you there. Now I'm going to going, I mean I'm going to go.'

'Yeah,' says George, with a snort. 'If yer can.'

I get unsteadily to my feet and weave through the tables. Will one of the Krays trip me up or shoot me in the head? I wonder vaguely, pulling my jacket collar up protectively.

In the gloom I brush against a muscular shoulder, apologize profusely and am acknowledged by a grunt. The lights in the foyer blaze at the other end, beckoning me on.

Only another few steps, dodging this table and that, and I emerge into the brightness of freedom.

Loftily I bid the commissionaire goodnight.

'Wait a minute,' he says, and a big red hand goes for my throat. This is it, I realize in panic, I should be carrying a knife.

''Ere,' he says, ripping off the tie. 'Them's my ties.'

'His ties, his silly bloody old ties,' I say to myself as I stumble out into the welcome dark of the street. 'His silly bloody old ties.'

Next morning I wake up feeling distinctly hung over and queasy. David has gone off to do some research or other on Persian history at the exotic-sounding School of Oriental and African Studies where he can use the library, so I'm free to douse myself with strong coffee and work out a plan. I've said I'll meet George to do a job, so I'll meet George. That much is clear, and pretty bloody stupid. I haven't got myself into a fix like this since my short-lived revolutionary activities. From Mao to the Krays in three easy steps, I think to myself bitterly, you must need your bloody head examined. I get myself together with all the enthusiasm of a man mounting the scaffold, then make sure I arrive at Tottenham Court Road tube in good time. There are several other people waiting outside the Dominion, whom I scrutinize carefully. Are some of them here to do a job with us? There are four American tourists whom I discount immediately. The others are a mix of timid provincials, I think, and blasé Londoners. Miss Beston's words about George come back to me. 'I'm not surprised George always gets caught on a job,' she said. 'He can never even find his house keys.' While waiting for my partner in crime I treat myself to a few headlines in the popular press: 'Art Critic Caught in TV

Haul' or 'Cambridge Grad in TV Grab'. All very catchy. Gusts
of gritty wind keep coming up from the tube and getting into my
eyes. I got this far, but now I'm beginning to weep. What the hell
am I doing here? It's 12.20 and the tension of waiting is almost
worse than the idea of being caught smashing shop windows and
looting. There's no George on the horizon. All the people who
were here have been replaced now by other little groups, all of
them about as apt to do a job nicking TVs as me. And George.
Where's George? Punctual mind! He can't be serious. Perhaps
he's still looking for his keys or passed out with drink. The hands
of the clock meet at 12.30 and start slowly crawling up the other
side. I'm not going to stand here all day, I start harrumphing to
myself. Got better things to do. Far, far better things. And startling
the couple next to me with a loudly snorted 'Who doesn't have
balls now?', I move on, away, God knows where, but with my
head held high in the still gritty, strangely healing wind.

I must have drunk more in one week in London than in an
average month in Paris, and now the drink has returned as in a
Faustian pact to claim the man. I have been matching Francis and
George glass for glass, sometimes over twelve hours or more.
One binge with Francis went from champagne at the Ritz to a
dinner in Soho with several vintages through several clubs on
champagne to a late-night supper at Annabel's accompanied by
more champagne and claret. So we got through a dozen bottles
between the two of us, and I'm probably lucky it was just wine,
with only a little of the Armagnac that was being lavishly pressed
on us by the Soho restaurant manager with a view to pushing up
his tip. I like to think I can hold my drink but it's caught up with
me, and from having felt vaguely woozy I am now definitely off-
colour. How would Francis cope with the problem, I wonder, as
I often do when I'm trying to resolve a situation, but I already
know the answer: crack open yet another bottle to wash your
liverishness away. I can actually picture Francis, pink with
health and chuckling, filling my glass once more to the brim. My

gorge rises, and I almost vow, like John, never to touch the stuff again.

The only remedy I can think of, as I lie inertly on David's sofa, would be to sweat out some of the alcohol in a Turkish bath. I know of a hotel that has one where you can sit in various hot rooms for as long as you like for a few quid, so I force myself up and get myself over there. I'm aware that this establishment is known not only for its health benefits but as a relatively respectable pickup place for homosexuals; however, I tell myself that if I've managed to come through so many queer bars and clubs unscathed there shouldn't a problem of that order. Once I've paid my entry fee I'm provided with a towel and a red-and-white-chequered loincloth. In the gents changing room, several middle-aged men are sitting around discussing a deal where, one of them says, 'everyone will clean up'. I notice they are all completely naked so, ever mindful of etiquette, I decide to take my loincloth with me, like a large hanky, and put it on only if others do. Among the suits, there are several military uniforms hanging round the changing room, including a Guardsman's scarlet tunic with its accompanying bearskin rearing up on a brass hook. I make my way gingerly through a couple of tiled rooms with stone slabs to sit on and a few deckchairs. In one of them a red-faced man is fast asleep with his loincloth on his head and his mouth open. I creep past him towards the steam room, thinking almost sensuously of all the poisons that are about to gush out of my pores. The steam presses up so tightly against the glass door of the Turkish bath itself that it's impossible to see inside. Knowing there must be numerous other naked men already in there somewhere, I sidle uneasily into the room's hot vaporous embrace. The steam is so thick, swirling up into my face, that I can't make out the size of the space or any shapes or forms at all. I move cautiously forward feeling for the stone slab that I suppose must be there to sit on somewhere and gingerly settle down on what feels like a tiled bench. Then to my horror I become aware that something hard is poking into my buttock. I

freeze with embarrassment despite the heat, then edge discreetly away, sweating as I try to control a panic attack. Not a sound can be heard from within the hot white cottonwool that envelops us all, whoever and wherever we might turn out to be. Then the door opens again and the steam parts for an instant to reveal a large, pink, prosthetic limb stretched out next to me. The hangover I came in with evaporates as I clutch my loincloth and dash for the ice-cold plunge.

A Death Foreshadowed

Francis has been coming more often to Paris over the past few months. I know it's to do with a big exhibition here, and they've offered him a choice between the Musée National d'Art Moderne and the Grand Palais. He says that the Grand Palais's big, high galleries would suit his work best, but of course it's also considerably more prestigious. Picasso had a huge retrospective at the Grand Palais a couple of years ago, and Francis is very aware that he will be the only other living artist to have been invited to exhibit there. Paris is still very much the absolute centre of the art world for him, and he's said to me several times that he considers a success here to be the greatest accolade he could ever receive. I'm proud and excited, as several of his other close friends are. Sonia keeps popping up here, too, and I think she's played a role in the whole thing because of her friendship with Leiris and other Paris bigwigs.

I've been to three lunches with museum directors and curators while Francis has been over. They've been a welcome break from an otherwise pretty lacklustre round of writing for art magazines and newspapers, though I'm pleased that the *New York Times* has recently shown interest in some ideas for articles I've submitted. I've also managed to get *Le Monde* to take a short preview of Francis's show, which has been timed to coincide with his sixty-second birthday. Stupidly I go out of

my way to show Sonia a cutting of the article, thinking she'll be impressed because it's in *Le Monde* and I've written it directly in French. 'Not very *big*, is it?' she says with a sniff. Even so, I feel I must be making some headway because I was introduced to the feared, famously vituperative art historian Douglas Cooper at an exhibition opening here the other day. He was standing there, with an alarmingly choleric complexion and dressed in a loud tweed suit, surrounded by what I took to be acolytes. I know that he and Francis knew each other well and fell out spectacularly at some point. Cooper was pleasant enough while we chatted but the moment I moved on I heard him calling me the 'impertinent Peppiatt' because of an essay I had written about Nicolas de Staël. So even if Sonia still dismisses everything I do, some people do actually read my art criticism, if only to disparage it. I feel sure that Cooper would think that anyone who dared write about art apart from himself was impertinent.

During the lunches we've had recently I've helped Francis find a few phrases in French and done some interpreting for the culture vultures who will be curating the show, but otherwise I can't think of any particular reason why I'm invited. I'd been expecting the conversation to be about choice of works and the catalogue, but it seems to be purely social with Francis ordering bottle after bottle of wine and of course always paying. To ensure he'll be footing the bill, he sometimes makes an arrangement with the restaurant owner or management in advance. It must cost a fortune each time, but I suppose always being the host gives him a certain subtle power over people. The museum officials certainly lap it up, as I do, and everybody seems very enthusiastic about the great event, though whether they ever get any work done after all that wine is questionable.

I certainly can't go back to writing, so I'm pleased as we stumble out into the afternoon sunlight after a long lunch at Lucas Carton that Francis suggests going to look at Monet's *Waterlilies* in the Orangerie. We do a bit of window-shopping as we weave down from the Madeleine towards Concorde and I

notice a pale-green V-neck sweater in an Italian shop and before
I know it Francis has gone in and bought it for me. I'm delighted,
though it dawns on me as we cross the Tuileries that there's not
much difference between the sweater and the money he offered
me in London, apart from the fact that if I'd taken the money I
could probably have bought a complete new wardrobe.

'I think Monet went very far indeed with the *Waterlilies*,'
Francis says. The basement gallery is cool and the muted light
ideal for looking at these extraordinary frescos of flowers and
water and mirrored sky merging together. 'I think he became
really extraordinary towards the end of his life. He's given the
whole thing here an extraordinary tension by taking it as far as
he can into abstraction without losing the specific image. There
are only a few great works like this where technique and subject
are so closely interlocked that you can't separate one from the
other, the technique is the subject and vice versa. I often come
down here just to look at the technique of them.'

We've moved round the whole oval of the room and are
standing in front of the last composition, which at times looks
like an expanse of pure colour until a recognizable detail brings
the lily-pads and the shimmering surface of the pond back into
focus.

'There are very few great things, you know,' Francis continues,
'because I actually think there are very few artists when it comes
down to it. All the fuss of big shows and reviews and so on
means nothing. No one ever knows in his own lifetime whether
his work has any real quality. Just think of all the fuss that's been
made in our century, and who is there of real importance? Not the
abstract painters with all their free fancy about nothing, you can
at least be sure of that. I mean, who has really invented anything
in our time? Picasso and Duchamp. And to some extent Matisse.
Who else has made a profound innovation? No one.'

I'd like to suggest we sit down for a moment. If I'm tired,
surely Francis who is twice my age and has been going since
dawn, must be exhausted. But I know better by now than to

interrupt on one of the rare occasions that he's ready to talk so
freely about art.

'You see, I don't know how you'd say it about literature,
Michael, but I know that I've been deeply influenced by a handful
of images. I have a profound admiration for Michelangelo, but
I think what I admire most, curiously enough, are his drawings.
I love that real male voluptuousness they have. I think he says
everything in the drawings. Just as in Degas, it's the pastels I
love because the technique is so perfect. I think Degas's pastels
are among the greatest things ever made. I think they're far
greater than his oil paintings. Some of the paintings are nothing
in comparison, it's very curious. You know, for me, Van Gogh
got very close to the real thing about art when he said something
like, I can't remember the exact words: "What I do may be a lie,
but it conveys reality more accurately." That's a very complex
thing. After all, it's not so-called "realist" painters who manage
to convey reality best. I mean, I saw an extraordinary picture by
Monet in an art exhibition in London the other day. I'd never
seen it before, even in reproduction. It was one of his views of
the Thames, but you couldn't make anything out in the first
instance because everything was covered with seagulls. It's the
most extraordinarily inventive thing, and yet very real – a kind
of fog of seagull wings over the Thames.

'What I really like are very grand images that look as though
they've come about by chance – although great art is always
deeply ordered however much has been given by chance. Like
the late Rembrandt self-portraits, or that extraordinary picture
by Goya in Castres, I think it's called *La Junta*, is that how it's
pronounced? You'd know with all your languages. Have you
seen it? Well, it is the most extraordinary thing because you
have all these figures sitting in a kind of parliament, I suppose,
a whole crowd of them which in itself is a very difficult thing
to paint. But somehow Goya's given this space such grandeur
you can actually feel the light moving or weaving round all these
figures and sort of creating them. They've become facts as it

were, but they're facts twisted through artifice to make them more intensely factual.

'Now I don't know about you but I was wondering whether we shouldn't just go over to the Crillon and have a little champagne. What d'you think – *un peu de champagne pour nous remonter?*'

If I'd been by myself I'd probably have had a cup of tea and tried to close my eyes for ten minutes to put the lunchtime drink behind me. But I'm fascinated by the manic energy radiating almost literally from Francis at the moment. I've seen it before when he's had a good win at the tables or, I imagine (although I don't care to think about it much), been successful on some late-night prowl. If he's in such extraordinary form, it's probably because the Grand Palais show is coming together just as he wants it, and now, with his gambler's instinct, he's pushing the stakes higher and higher, pushing himself harder and harder (one of his refrains, I remember, is 'one is never hard enough on oneself'). So now he's going to drink for the rest of the day and most of the night, and he'll probably end up with some bad-news tough who'll beat him up and rob him. But he's also ready to talk more and more, and since finding out more and more about him has become a kind of obsession for me – though I couldn't really explain why – there's no way I won't stay the course, not least since I'm as excited as he is at the idea that the limits of normal life can be pushed back, further and further.

So now we're back in luxury-land, a flute of champagne in hand, and breathing in the slightly perfumed, rarefied atmosphere of the grand hotel.

'I don't know what we can drink to,' Francis says genially, 'so why don't we drink to us? I sometimes come to these places when I'm alone just to watch the way everybody carries on. They can be very fascinating, these hotels, because some of the rich clients staying there make a play for the staff, whatever their tastes are, so there are often all kinds of intrigues and affairs going on. After all, what's more fascinating than watching other people

carrying on, particularly if you can watch them in a mirror. That's one reason I love those old-fashioned Paris brasseries and cafés where you have mirrors going all the way round the room. I hope I'm not talking too much, Michael? I tend to get very garrulous in drink.'

'Not at all, Francis,' I say. 'I think I tend to get a bit sleepy in drink. Don't you get terrible hangovers when you've been drinking day after day like this?'

'Well I do,' says Francis cheerfully, 'and it's true those really bad hangovers can make you feel uncomfortable. But generally I don't think about them because I often find that the worse the hangover the more my mind seems to crackle with energy.'

'So you actually work well when you've got a serious hangover?'

'I think I do. I mean, if a picture is going to work for me at all, it can come at any time, whether I'm drunk or sober or hung over. It's a bit like a win at roulette, you never know which way your luck is going to turn. I've been trying to do some new pictures for the Grand Palais show, and I've done a new version of that thing of mine, the one called *Painting 1946*, they've got in the Museum of Modern Art in New York. I didn't really want to do it but when those nice people we had lunch with asked to include it in the show here, they were told it was too fragile to travel. So I said to them, well, I'll just do another one and we'll put that in instead. I myself quite like it, because it has something really artificial about it, and I think all art that's worth looking at is deeply artificial.'

'Why's that?' I say. I'm feeling a bit light-headed.

'Well, art itself is artifice. It's an illusion, and if an image is going to work it has to be reinvented artificially. I mean, think of Van Gogh. You've never actually seen a boot or a starry sky like that, have you? Or Velázquez's portrait of Philip IV in the National Gallery. You don't think he really looked like that? Well, yes, at least one hopes not. But reality has to be reinvented to convey the intensity of the real.'

We are served more chilled wine. It's like drinking a starry sky, I think, and I'm about to make a remark to that effect but sense, half-seas over as I am, that I'd do better simply to listen. Francis is on a roll:

'For some reason one still does think at times that one's going to do something really strange and extraordinary. One probably never will, of course – in any case, those are things one can never tell about oneself. But it's one of those obsessions which make life more interesting. I mean when you look around you in the street or in the bars, even places like this, and you see all those other poor things, drooping like daffodils, you wonder what can they be doing with their lives? What can they be living for? Life doesn't mean anything, I know. But when you look at people like that, their lives seem particularly meaningless. I suppose that only for creative people does life have any point at all. Well, in the sense that, very exceptionally, somebody does actually come along and thicken the texture of life. But unless you can do that, what point can there possibly be? People talk a great deal at the moment about how important it is to get more freedom. But why, really? The trouble with freedom is that once people get it, very few of them know what to do with it. Unless you have this obsession with doing something – I don't mean just painting or creative things, but anything you really want to do, that you happen to be obsessed with – what's the good of freedom? What are you going to do with it once you've got it? Of course you can just shake your arms in the air or something, but what is it going to change for you?

'I have known an extraordinary kind of freedom in my lifetime. Of course I don't think it will last much longer; things are getting more and more impossible now. That's why I'm always extremely surprised by intelligent people who say that they believe in Mao. Because of course under Mao they'd never have been able to do what they have done in life. It seems quite mad to me. I don't see at all that they'd be better off, with all their marvellous intelligence and gifts and things that

they've developed, if they were put to work in the fields or in factories.

'I know you joined in the May 1968 thing here but what struck me as odd while I was following it from London was all those students with the marvellous freedom and chances they had demonstrating in favour of a system which would only take them away from them. Things are bad enough, with the dreadful mediocre people who govern us now, but surely they'd just get much worse. I know Sonia thinks I'm on the right, or a Fascist, but I think of myself as what used to be called a liberal. I also think I'm terribly lucky to have been able to lead my kind of life, this curious kind of gilded gutter life I've led, in real freedom. It's also been a rotten life, a disastrous life, I'm afraid. But there it is.'

I want to know more, in fact I want to know everything, and occasionally I wonder why Francis is telling me all this beyond the fact that he likes to talk about himself and I enjoy listening. Each time we meet and he's in the mood to open up, I feel I'm filling in a piece of the jigsaw puzzle, the enigma that he and his paintings represent for me. I suppose it might all be of use for some future article I might write for this or that publication. But there seems more at stake. I begin to think I might write about his life as well as his work, pretentious as this sounds since I only have an interview, one essay and a short announcement about his forthcoming show to my credit.

'I know you say that your whole life goes into your painting, but could you ever put it into words?' I ask.

'Well, I could what's called tell all,' Francis concludes, 'if anyone could be bothered to listen. After all, whoever tires of talking about himself? Although when you hear others droning on about their lives you think how dreary you must sound yourself. Anyone's life sounds dreary, I suppose, unless it's presented in a certain way. At times I feel there are a great many things I'd like to talk about. Growing up in Ireland. And about Berlin, when it was very, very curious. Or about why I think

painting is in the situation it is in now. Those kinds of things, but I don't suppose anybody would be at all interested.'

Francis has a posh dinner to go to with Frank Lloyd, his dealer from London, and they'll probably be discussing some strategy or other for the Grand Palais event. Apparently Sonia's coming over too. I'm heading back to my new studio flat in the Marais, which I'm very proud of and still in the process of buying, where I will note these exchanges down without worrying whether they will ever be used for anything. They don't need to be. They are being used right now. Hearing about him helps me form or clarify my own attitudes to life and sort out my contradictions. It helps me to live.

It's very odd to think that, from that very first moment in the French pub, I've never stopped interviewing Francis in one way or another. I admire him and I have been hugely influenced by his work and by his way of life. I've adopted all kinds of positions that he holds, though perhaps at a less extreme degree: I'm more of a mild agnostic, for example, than a fervent atheist, because my core belief is that we are aware only of the tiniest fraction of existence, like mayflies dancing for a frenzied instant in a shaft of sunlight, knowing nothing of the dark about to envelop them. He's also influenced my behaviour and, as I'm sometimes embarrassingly aware, quite a few of my mannerisms. You could say I've modelled myself on him in many ways, even though my temperament and my talents, whatever they are, have little in common with his. I'm not willing to put myself continuously at risk, as he appears to do, partly out of his deep-seated masochism and partly out of pride – an innate confidence in his toughness and ability to withstand what life throws at him. I, on the other hand, am at pains to avoid extreme situations because I doubt that I have the capacity and stamina to handle them. What I find most attractive about Francis, I think, is the freedom and energy and total individuality that exude from him. I want to live my life too on my own terms. And so I suppose it makes perfect

sense that I want to spend time with him and listen to what he says on virtually any topic that comes up.

What is more puzzling is why Francis bothers to spend so much time with me. I hadn't really thought about it much before our conversation at the Orangerie and the Crillon the other day because it seems natural enough for him to want me at least to know, if not to actively transmit, his point of view when I write about his work. Most of the artists I've met try to get some control over what you say about them. But the conversations Francis and I have go way beyond the 'do you do preparatory drawings?' and 'have you got several canvases on the go?' type of question that usually crops up. Obviously he's drawn to much younger men who are reasonably good-looking and not too stupid but, given his fame and money, he can have his pick of them. With me, he likes the fact that I'm a good listener and, for some reason, he's impressed that I speak a few foreign languages. Part of what he finds attractive about me, perversely, is that I'm not queer, and he takes that as a challenge to his undoubted powers of seduction – 'séduire', as he often likes to say, 'c'est tout' – although after all these years of nothing happening on that front, I should think whatever charms the notion once had are beginning to fade.

When I got back from the Crillon, I did write down what Francis had told me pretty much verbatim. He regularly returns to what he's already said with a slightly differing intonation or emphasis, and since I've developed a good ear for imitating the way he talks, the result is like a recording without all the ums and ers and at least some of the continuous repetitions. Looking at this 'transcript' along with others I've made over the past few years, I see there's a pattern emerging. Francis proffers a certain amount of information about his life or his work or his attitudes to this, that or the other, and then breaks off in a tantalizing fashion, with a dismissive 'I don't suppose this will interest anyone' that leaves you hungry. It's a story being told in instalments, a feuilleton, and you're impatient to

know what's coming next since each episode throws up more questions than answers. I think Francis must like the idea of riddles. He's referred to the Sibyl at Delphi at least once when we've been talking, and of course he has painted the Sphinx on several occasions. The pictures themselves talk in riddles. They tell a story, utter a prophecy even, which we are left to interpret as we can.

I don't suppose I'll get another instalment from Francis tomorrow evening as we're meeting Sonia and one of her great Paris friends, Marguerite Duras, for dinner. I've already spoken to Marguerite by telephone because Sonia told her I might have the right voice to dub into English some character in a film she's working on. It sounded like a great idea, so I tried to make myself sound interesting when Marguerite called, but she must have been looking for something else because, disappointingly enough, I haven't heard from her since. We're going to a small bistro called Le Petit Saint-Benoît, just opposite Marguerite's flat, that Francis quite likes because he thinks it's more 'French' and authentic than a lot of the grander restaurants he goes to; at least it's considerably cheaper. I know I should probably have read one of Marguerite's novels or plays, even though I'm not very convinced by the whole *nouveau roman* idea. Now it's too late, and it doesn't seem to make much difference because Francis arrives in a very exuberant mood and talks almost non-stop, while Marguerite, who's tiny and wears huge spectacles, is quite withdrawn. As for Sonia, she seems mostly preoccupied with whether Francis and Marguerite are getting on well, because Francis has made several rather snide references to how *célèbre* Marguerite's become since the film of her novel, *Moderato cantabile*, came out. Apparently, a French friend tells me, Marguerite's been saying that there have been only three writers in France in the twentieth century: Proust, Céline and '*moi*', so perhaps I'd better read her after all. The wine has been coming thick and fast since we all clearly like our drink, but towards the end of the meal, when Francis orders another bottle, Marguerite

protests, 'Dear Francis, we've already drunk too much,' and Francis, suddenly imperious, comes thundering back: 'Only too much is enough!'

The evening winds up quite rapidly after that, and Sonia decides she should walk Marguerite back up to her flat. I expect to get home in reasonable time for once, but Francis clearly has other ideas and suggests we go on for 'one last leet-el drink' at a bar he's found just off the Boulevard Saint-Germain. As we pass the Deux Magots and the Flore, I half expect to see a couple of my heroes, especially Giacometti and Beckett, finishing off the evening together with a *fine à l'eau*. But one is dead and the other not to be caught dead at such obvious places, now filled with tourists lying in wait for a wall-eyed Sartre or a vaguely familiar, decrepit Surrealist of which a surprising number can still be seen flitting around the old haunts, striking attitudes and making arresting remarks. Francis leads the way. He's gone silent and seems to be focusing on something. We go into a discreet, elegant hotel on the rue de l'Université. The bar is dark and almost deserted, and it takes a while for the barman to appear, but he seems to know exactly which champagne Francis likes.

'I don't know what Sonia and Marguerite find to talk about the whole time,' Francis says once we've settled into the room's restful gloom. 'Of course Sonia's much more interested in writing than in painting. As you know, she used to work with Cyril on *Horizon*, and I suppose that now Marguerite has become so famous with her books and films and so on Sonia loves to spend time with her. But in any case Sonia's much more interested in women rather than men. Perhaps she's lesbian. I don't really know, and of course I wouldn't be what's called so rude as to ask. I don't actually think she knows herself. After all, most people are neither one thing nor another. They're just waiting for something to happen to them. What did you make of Marguerite? I suppose she's highly intelligent? I *suppose* she is.'

'I didn't really get a chance to talk to her, Francis. It's odd and a bit pathetic, but because I want to write so much myself

I feel very shy when I meet a well-known writer. I sat next to Henri Michaux at a dinner the other day, and I really admire his work both as a writer and a painter, but I was absolutely tongue-tied and embarrassed. And if I do talk I usually get everything wrong, like when you introduced me to Stephen Spender whose poetry I don't really know, and I talked to him the whole time about Auden.'

'Well, I detest Auden. I detest that whole hypocritical religious side to him. And I detested Evelyn Waugh, whose books I know you admire, when I met him. He talked all the time in farts, just a series of farts. But I do know what you mean about shyness. I myself was so shy as a young man that I couldn't even go into a shop to ask for something. But of course when we were living in Ireland during the Troubles my father always used to say to us, "If anyone talks to you, run and find a policeman." You can imagine what a good start that gave us in life, on top of all the gaucheness of having been brought up in Ireland.'

'But you managed to get over your shyness, didn't you?'

'Well, as I've probably already told you, I just thought as I got older that it was mad to be both old and shy. I've worked on myself a great deal since then, and in that sense I'm completely artificial – I'm probably the most artificial person you'll ever meet. But my parents were awful in a way. I can't say I actually loathed my father – he was a good-looking man, and at one time I was attracted to him physically, though I was so young I hardly knew it was a physical thing at the time. I didn't really hate him, but he certainly didn't understand anything about me. At first he tried to marry a relation of my mother's who had a good bit more money. Well, when she wouldn't have anything to do with him, he tried my mother. Her whole family was against it, but she just went ahead and married him. All parents are impossible, I suppose. Do you get on with yours?'

'Not really. I don't see a great deal of them. We have sort of diplomatic relations. But not much more I'm afraid,' I say,

realizing that I'm much happier when the conversation is about Francis than when it veers suddenly towards me and my background. 'But in what way did yours make you shy?'

'They did this awful thing of putting me at this very minor public school called Dean Close in Cheltenham in mid-term. So I was led with them right the way down the dining hall where the whole school was sitting. And of course what's called all conversation stopped and everybody just sat and stared at me. Naturally, I felt I was finished after that and I just went wandering up and down the corridors, up and down the whole time, not daring to talk to anyone. Then this very nice-looking boy came up to me and said, "You can be my friend if you like." Of course at the time I had no idea what he really meant by being his friend. I thought, how nice to have a friend. Then this other friend – a Persian boy – came along who had "developed" early, as they say.

'It was all rather ridiculous my life at school. But then, for some reason, I'd always known that life was ridiculous. Even as a child, I knew it was impossible and futile, a kind of charade. I was a complete fool – I could never learn anything, just as I can't learn a foreign language properly now – but a sophisticated fool, and so I became a sort of clown and I used to get along by amusing the other boys.

'In the end I left Dean Close just before they asked to have me taken away. My younger brother was asked to leave too, for going with other boys. And then he developed TB, which as you know can be an emotional thing, and he died from it. My father had thought he was the one who would follow him into the army and when he died it was the only time I ever saw my father cry. I had an older brother too. We went to Anglesey together on a holiday once and my brother got this crush on the hotel owner's daughter. And once we were back home, he managed somehow to disappear and go and see her. Then my father found out and thought it was so absolutely impossible that Harley should be going with someone of that class that he sent him off to a job in

South Africa. Well, he worked there for a bit then he went up to Northern Rhodesia and joined the police force. And he was out somewhere with them when the Zambesi flooded and by some accident he got lockjaw and they couldn't get him to hospital in time and he died.

'I don't know whether yours has been like that, Michael, but my family was really a series of disasters. My sister Winnie, for instance, had one catastrophe after another, even before she developed multiple sclerosis. She only had to get on a train for it to burst into flames. She went out to Rhodesia too, after the war, and she fell in love with a man who was sent to prison shortly afterwards for fraud or something. So like a fool she decided to wait for him, and when he came out he simply vanished, she never even saw him, and then she found out he was already married in any case.

'Towards the end of her life I got to know my mother much better. She was far younger than my father, and of course she was overjoyed when he died. The thing is she just couldn't wait to begin living her own life. She managed to marry twice after his death, and in a way I think she did remake a life for herself. I remember when my father was very ill she kept saying to the doctor: "Can't you help him out? Can't you just help him out?" He went on hating her right to the end. About the day before he died, he said to the nurse, "For God's sake keep that woman out of my room – tittering-tottering all over the place in those high heels!"'

'Often it seems you have to get away from home to become the person you really are,' I hazard.

'Well, I certainly had no idea who I was or what I wanted to do, or anything, My parents had told me that I looked horrible and I think I just accepted it. So I was terribly glad when people picked me up because I used to think, well, perhaps I'm not so awful-looking as that after all. It just made me want all the more to get this person or that person to take a fancy to me. Of course you'd never think it, with my looks, but for a moment I

did seem to attract people. When I was very young. I suppose people thought I was pretty. For some reason. Anyway, I used to get by in that fashion, and I don't think I was too particular about how I did it.

'All human lives are ridiculous – unique and ridiculous,' Francis concludes with an apologetic smile, 'but sometimes I think mine has been a particularly ridiculous one. Ridiculous and disastrous. You know, my intimate friendships have all been disasters. I mean there was this man, Eric Hall, who thought he liked me. He was very rich and had never had to do anything, and he took me round all the grand hotels eating and drinking too much. In that sense he gave me a kind of education. And he also encouraged me with my painting, which helped a great deal at the time. He was married but he decided he wanted to leave his wife and children and come and live with me. Well, then I got all these threatening letters from his wife – even his father came round and got absolutely furious with me.

'Then, of course there've been others, like Peter, who I think I told you about. Then there was this other one called Robert Heber-Percy, who was rather pompous, that I met in the Ritz bar, and he said to me, "I'm just off to South Africa," so I said, "How lucky you are," and he said, "Well, why don't you come with me?" and I thought, well, why not. ¿Por qué no? So I did, and everything went wrong, naturally. We travelled out together with him in first class and me in steerage, which I must say was a great deal more fun. But nothing worked. We ended up by having this enormous row and by what's called parting on the banks of the Limpopo . . .'

The barman has been discreetly straightening chairs around us. Francis looks as if he's said most of what he's been wanting to say. I walk him back to the hotel where he's staying near by on the rue des Saints-Pères. We say goodbye quite formally, as though no confidences have been exchanged, and I take one of my favourite ways home, down the small streets to the Seine, then snaking alongside the tall, dark buildings on the Ile de la

Cité, wondering why I have so much information from a man about whom, his violently clashing images apart, next to nothing is known.

The posters are up, all the way down the Champs-Elysées and then at points right through Paris. Francis's amazing bullfight image is literally everywhere, and for me it's as though the whole city's tempo has quickened. There's no point sitting around in my little room wondering about the meaning of life now, I realize. The show has come to town and there's a new vitality in the bright autumn air.

Everybody's over. Sonia, John Deakin, Dickie and Denis, Isabel Rawsthorne, and loads of Soho cronies. Francis has brought George over, too. 'He's in so many of the pictures,' he said to me, 'I couldn't really tell him not to come. He's been on a cure to get himself off the drink. I mean, it sounds ridiculous coming from an old drunk like me, but George becomes absolutely impossible in drink.'

It's pretty obvious that Francis wants George out of his life. He thought he was getting a muscular East End tough who would thrash him to within an inch of his life and instead George turned out to be confused and gentle and clinging, which Francis hates. There was a drugs scandal in London, when George planted some cannabis in the studio and the police were tipped off and came round with a sniffer Alsatian and of course found the weed. The police charged Francis and he protested that he didn't smoke anything since he was asthmatic. Francis contacted his solicitor, the influential Lord Goodman, thinking that, as Harold Wilson's 'fixer', he might be able to make the whole thing go away. But the police pressed charges, and the case went to court. 'I knew I'd get off when I recognized a few old lags in the jury,' Francis told me afterwards nonchalantly. But he was certainly upset by the publicity the whole fiasco attracted – it made the front page of the *Evening Standard* – and that has soured his relations with

George further still. But George is here, fresh out of his cure, and with the opening only a few days away the three of us are having a celebratory lunch at the Grand Véfour.

Francis is already there when I arrive, eager to be admitted once more into the restaurant's luxurious ambiance. I pause for a moment as I cross the room, looking up at the late eighteenth-century ceiling, where rosy-cheeked girls with baskets of flowers laugh as they listen to the court paid to them by slim, straight-backed soldiers. But I'm shocked when I see George looking so pale and strained.

'Been onnis cure, see,' he says to me, pushing the glass of champagne he's been served to the very edge of the table. 'Been at one evvem 'omes.'

A black-coated waiter has materialized at our side.

'Messieurs,' he says, 'today we 'ave salmon with celery and black truffle or delicious duckling from—'

'I'll 'ave that,' George says with an unimpressed snort.

'What will you have, Sir George?' says Francis, chuckling.

'Nat fing wiv salmon. First one 'e said,' George says. His eyes have roamed the room, noting the tables where the jewels glint. On an ample bosom at the table next to us, there is a diamond necklace almost within his grasp.

'The real trouble about not drinking is the boredom,' Francis says, following George's glance at the necklace with detached amusement. 'I went to one of those ridiculous health farms once to lose weight – I only have to look at food, you know, to blow up like an enormous balloon. Anyway, they give you absolutely nothing, just three glasses of water a day, and the boredom is indescribable, and you also begin to smell very bad. I used to take the train up and down to London, up and down, simply to pass the time.'

George nods, sucking his cigarette so hard it crackles.

Francis outlines the plans for the opening. I'd expected him to be a bit overwhelmed or nervous, but he seems very much in control and almost apologetic, as though we had much better

things to do than to come to the exhibition and the banquet afterwards.

'Of course most of the pictures are of George,' Francis says genially, trying to draw George out.

'Yeh,' says George. 'Mostovems of me.' He's pushed his salmon to one side and is busy flicking specks of ash off his dark suit.

Another carafe of champagne is set bubbling on the table between us, but even Francis has accepted that the lunch won't take off.

White-faced and sober, George is waiting to disappear back to the hotel. He's lost Francis, and now he's lost the oblivion he found in drink.

I walk with them down the Palais-Royal arcade towards the river. Then, impulsively, I turn back through the gardens and take a lingering look into the Véfour's windows, half expecting to see the three of us still sitting round the table, but laughing now, like old times, our faces flushed with pleasure.

It's a perfect late-autumn day, and the sun is sparkling on the silver helmets and swords of the Garde Républicaine standing to attention on either side of the red-carpeted steps that lead up to the Grand Palais. President Pompidou has decided to open the exhibition in person, and as he mounts the steps surrounded by a group of dark-suited officials, Francis is waiting at the top to greet them and take them round.

I feel a surge of pride as their backs disappear into the museum's shadowy entrance. Francis could hardly have more luck or higher honours. Even the weather has held for him, and the French state has just acquired a particularly tough new triptych that shows George seated on a creamy white lavatory. The advance press has focused on the extraordinary power of the paintings, saying they're like 'a punch in the face' and wondering out aloud why France has taken this long to recognize an artist of such overwhelming importance.

The plane trees along the Champs-Elysées have lost some of their leaves, but the high blue sky overhead gives no indication that we'll soon be plunged into winter. A long line of birds in perfect formation moves southwards over the Place de la Concorde towards the Seine. They look like letters in a sentence being written and unwritten, an indecipherable message etched for a moment on the void. Then they pass out of view.

I'm excited to see the show, because it will fill in all sorts of gaps in my knowledge of Francis's painting and above all give me a better idea of what he did in the earlier part of his career. Somehow I've come to feel personally involved as if, having studied the recent work, I now have an urgent need to know what came before.

Getting here early means I'm in the first batch of VIPs and journalists waving engraved invitations to be let in. Francis has probably moved on with the official group. As we pour into the first gallery I don't know quite what I've been expecting. The first few works are smaller and darker than I'd imagined. They don't have the exuberant assurance of the canvases Francis has done over the past few years. They're rougher and more tentative, as if the artist were still working in the shadows, unsure of what he was looking for or achieving. Blurred figures are isolated in dark enclosed spaces, dark moving on dark. Francis's voice speaks out of each image. As I walk past it follows me, clearly, insistently.

'Life is nothing more than that, I'm afraid. Simply this moment between birth and death. We're like grass. We grow and we're cut down. And then we go on to the great compost heap of the world. We don't know much, but that I think we do know.'

The writhing Popes. The great blood-red-and-black Crucifixions.

'When I was young I needed extreme subject matter. Then later the subjects came out of my life and the people I knew.'

A white face, its features half washed away, is screaming from one gilded frame to another.

'Peter was hysterical, almost mad really, the whole time. We had these four years of hell together. I'd never been really in love before and I was utterly physically obsessed by him. In the end he just left me. He rang up one day and said, "Consider me dead." And when that exhibition of mine opened at the Tate, among the telegrams, I got this one saying he had just died.'

Screaming in pain, screaming in pleasure. White bodies humped on creamy sheets, abandoned in the grass sprouting through the canvas weave.

'That side of life has always been disastrous for me. So many of my friends have been drunks or suicides. They're all dead now.'

Posthumous portraits rising mysteriously out of the fleshy metaphor of paint. Bring him back.

'It seems mad to paint people once they're dead. You know if they haven't been incinerated their flesh has rotted.'

In another room the first self-portraits appear. Francis twisted by Francis.

'I've had a disastrous life, but in a way it has been more curious than my paintings. It's gone deeper than what are called the *moeurs* of my times. I think I'm unique. Everyone's unique, of course, it's just that I have been able to work a bit on my uniqueness. I've tried to make myself profoundly artificial.'

Then a burst of small heads of women, pulled every which way, anger-red in their deformity. Muriel, Isabel and Henrietta, as ancient and as regal as Nefertiti, attacked down to the bone.

'There's nothing you can do about death. Death exists only for the living. It's working on you all the time. You can't prepare for it, as they say. All you can do is to go on living.'

More self-portraits. Himself attacked most furiously, a cheek excised, a cranium axed, an eye elided.

'When I want to know what someone looks like I'd never ask a woman. I'd always ask a queer. They're very accurate. After all, they spend most of their time pulling other people's appearance to pieces . . .'

Portraits of Lucian, caught close up, pinned on a sofa, coiled on a stool like a snake about to strike. Full figures or portable heads, done from photos, from memory, in the seething silence of the studio.

'If they were sitting in front of me, they would inhibit me and I couldn't practise on them the injury I inflict in my work. I like to be alone with the way I remember them. And then I hope to bring them back more poignantly and violently.'

Then comes George. George caught in a black mirror, welded to a bicycle, corkscrewed to a chair.

'George was down the other end of the bar and I was with John Deakin and all those others, and he came over and said: "You all seem to be having a good time, can I buy you a drink?" And that's how I met him, I might never have noticed him otherwise.'

The lover in the lover's eye, cut in half, head split, sheared to a topknot, ringed by fag ends, capped with a cheese-cutter. Poor George, so bashed around his own mother wouldn't recognize him.

''Ees done masses of 'ese pic-yeres of me. I fink they're reely 'orrible. All 'ese uvver people fink they're terrific. I still fink they're orful.'

George dominating the last part of the exhibition, bobbing up bewildered beneath the battering.

'He asked whether he could come with me and since he's in so many of the pictures I could hardly say no. Even though there's been nothing between us for ages now, I couldn't say no.'

So many cries and blasphemies echoing through the lugubrious galleries, so much outrage against the human form has taken the elegant Parisian public by surprise. They came in expecting some Hogarthian whimsy and leave having witnessed scenes of savagery so intense and yet so subtle they have no idea how to react. Far from the self-satisfied nonchalance with which most museum *vernissages* end, a shocked silence reigns throughout this

vast theatre of cruelty. At the very end of the exhibition, Salvador Dalí in full fig, with a big blond transvestite in red hotpants on his arm, lies in wait, clearly intent on stealing the limelight. '*C'est très, très rrraisonnable*,' he announces dismissively at regular intervals, rolling his 'r's loudly and waving his silver-topped cane at a couple of the most disturbing images in the whole show. Prized though Dalí's clowning usually is in Paris, the well-bred visitors are so shocked by what they have seen that they barely glance at him, much to the Great Masturbator's annoyance, before they make hastily for the exit.

'Hey you, yes you, frogs' legs, let's have a refill, twiggez-vous? I know the bugger speaks English. Ah cahm on, let's see you down this end for a fucking change!'

The shaggy and the smooth drinking friends, rounded up at Muriel's and brought over to cheer the home side, are making few concessions to being in foreign parts.

I've agreed to join John, Dickie and Denis at a café beside the Gare de Lyon before going on to Francis's big banquet at the Train Bleu, and word has clearly reached the whole Soho contingent that this is to be the pre-dinner meeting-point.

'What a rabble,' John says in urbane dismay.

'All they're interested in is getting plastered and abusive,' says Dickie, casting an anxious eye on Denis, whose wine-lit countenance is twinkling at a riposte he has just shot. 'I do hope they don't think all Englishmen are like that.'

We move to the other side of the bar in an attempt to dissociate ourselves.

'Four, cat-rer, bee-airs, comprenny? And chop-chop while you're at it!'

The circle of red faces darkens with barely bottled mirth. Their spokesman is waving twice two fingers in the barman's offended face.

'Oh they'll think we're barbarians to a man,' John sighs, sipping his pastis. 'To think we'll be stuck with this lot all evening. I

had seen myself, *au contraire*, waltzing at Maxim's until dawn, ospreys in my hair and my throat ablaze with diamonds. But that is clearly not to be.'

A few more of Francis's friends have come into the café. I notice Sonia talking rapidly to one of the beer drinkers. She's looking distraught, pushing her hair back with nervous, jerky movements. The man she's talking to laughs. Sonia slaps him round the face.

We're all looking at her as she comes over towards us.

'Well, you must know,' she says to me.

'I'm sorry – what?' I say, rolling the liquorice taste round my mouth.

Sonia is staring at me with red, watery eyes.

'That George is dead,' she says.

'Dead?' I say. It has no connection with anything. Seeing John, the others, the exhibition. I'm staring at her now.

'I know what you're thinking,' she says rapidly. 'But it wasn't that. It was a heart attack. The alcohol stopped his heart.'

The others say nothing. They are looking down at the ground. In the silence, the café seems to sway in its bright yellow light.

George was dead.

'What about Francis?' I say eventually.

'Francis?' Sonia says. 'Well, you can imagine.'

The tears run down her face.

———

As the scores of guests settle into their places at the long tables going the whole way down the cavernous Belle Epoque restaurant the word begins to spread like wildfire. Michel and Zette Leiris, looking sad and dignified, sit on either side of Francis. Opposite him is Isabel Rawsthorne, whom Francis has painted almost as often as George, and whose majestic presence in the exhibition has the mesmerizing power of an Egyptian goddess. Her delicately beautiful face, reddened and pouchy from drink, swings from side to side, looking uncannily like Bacon's blurred

portrait heads of her. From her turning head a torrent of confused words comes pouring out as if beyond control. Now George is dead! First Peter, now George! George was found dead in the hotel! Slumped dead on the lavatory in their room! Dead from an overdose! Alcohol and sleeping pills!

With the speed of bad news, the message reaches everyone in the huge vaulted room before the first course (*filets de sole Favart*) is served, and what had begun as a prestigious *dîner de vernissage* turns into a strange wake where nothing has been officially announced and there is no ceremony, but the death is on everybody's lips. Poor George – I knew he was a terrible alcoholic and quite out of his depth in Francis's world, but I had no idea! Poor Francis – on this day of all days! But remember the Tate opening, when Peter Lacy died! Can you see Francis – he's behaving as if nothing has happened! What did you expect? He's not the kind to collapse in grief. Did you hear that when Francis took President Pompidou round the show they stopped to admire the very picture where George is shown sitting on the lavatory because it's just been bought by a French museum? What can Francis have thought – that he was being punished at the very height of his success, that once again the Furies had come to claim him?

Isabel's high, insistent voice rises like a rant, drowning out all whispered commentary in a stream of increasingly incomprehensible phrases that sound as if she were speaking in tongues, inducing an awed silence in every corner of the room. She is addressing Francis opposite her, as if he had asked her a question and she can no longer contain the truth now or for the future as it wells uncontrollably up in her. And everybody sits there, stunned, as she appears to be saying that this is what she had seen coming, fatally, and now that it was there it was final, and this was the price that had to be paid. And Francis sits there immobile, his head bowed.

Silently and efficiently the waiters have been darting round the tables plying the numbed guests with the Rully Clos Saint-Jacques

and the Côte de Brouilly Château Thivin, both 1970, as frequently and plentifully as possible. The wine first sharpens, then begins to soothe, the brutal shock. Towards the end of the evening, once the whispers and the knowing looks have faded and the dessert (*tarte tatin/friandises*) has been cleared away, Francis stands up, as if spellbound, and gives a simple vote of thanks to the Leirises for having hosted such a wonderful evening and to everyone for having been present.

Having seen Francis go through that whole ordeal yesterday I can't imagine he'll take on any more engagements, but not only has he been at the Grand Palais all day being interviewed and filmed but he's insisted that the small dinner party organized a while back by Miss Beston for this evening should go ahead. Francis does seem to be behaving as if nothing has happened, it's true. He looks pale and strained, and he's got a bad cut on his lip, but otherwise you wouldn't have any idea that an intimate friend of his has just died and in a way to make him feel as responsible and guilty as possible. Could it be that he's still on such a high, having just realized the greatest ambition of his life, that the fact hasn't sunk in? It seems unlikely, particularly as he will have spent the day dealing with the police and the formalities surrounding a death abroad. I know Francis has an unusual capacity to withstand mental and physical pain, but when I arrive at the Hôtel des Saints-Pères, the very scene of the death, I expect to see a broken man.

Francis is sitting in the lobby, drinking whisky and talking to a French couple whose solemn bearing, I realize, belies advanced drunkenness.

'It's not only the way you get that whole feeling of Dublin, but the way Joyce reinvented technique,' Francis is saying animatedly. He looks quite relaxed and casual in a thick, cashmere sweater. 'Even so I myself prefer Proust because in Proust you get something quite new as well as everything that's gone before. It might be absurd to compare them. Both have genius. For me,

genius is what breaks the mould of accepted thought. Will you have a whisky too, Michael?'

It's as if, to take him to whatever the next point in existence turns out to be, Francis has put on an old gramophone record, one he knows backwards.

'They are marvellous, all those techniques that Joyce introduced, yet I think Proust was even more extraordinary because he invented within tradition. Is that the right time? I never know. Ah, here we are. *Merci beaucoup, Monsieur. Voilà pour vous. Merci.* Perhaps we should see if the taxi's here. Here's to you. What d'you say? No, I've never read *Finnegans Wake*, I've never been able to. By that time, I think, he'd made the whole thing too abstract. He'd sort of gone over the top with it and it became abstract – and that's much less interesting, of course. Just like abstract art, which I always think of as free fancy about nothing, and of course nothing comes from nothing. What? Do you think we should go? What was the address? Ah that's right, I think the others are meeting us there. What did you say the address was, Michael? I'm sorry, it's mad, I'll forget my own address next. Ah yes, rue Rennequin. Right. In the 17th. Perhaps we'd better go then.'

The taxi drops us at La Mère Michel. Miss Beston and three other guests who have worked on the Grand Palais exhibition are already seated round the little restaurant's central table. In between introductions, Francis orders several bottles of Muscadet and, with my help at the other end, sets about getting a maximum of drink into his guests. Then he draws attention to the restaurant's celebrated pike in *beurre blanc*. Only his guests' pleasure seems to have any importance. He recalls someone's aversion to oysters and insists on a full dozen for those who like them.

The thought of George is on everyone's mind for the first half-hour, then as the meal gets under way it begins to fade. For most of Francis's guests this evening, George has never possessed a

specific existence. He had at most been a picturesque adjunct to someone well known, and there seems to be a tacit agreement around the table that the conversation should be kept as far away from any reference to him as possible. My experience of death is limited to losing two grandparents and a friend when very young at school. This is the closest I've been to it, and I'm horrified and deeply frightened by the blank it leaves behind. There was George a couple of days ago at the Grand Véfour, ill at ease but fully present, and now it seems as if he is swiftly becoming little more than a memory.

In the lulls between replying to carefully phrased questions and topping up everyone's glass, Francis is clearly elsewhere. He is paler than ever, and I wonder if he has managed to get any rest at all over the last few days, particularly since George probably ingested all the Tuinal tablets he depends on to snatch a couple of hours' sleep.

Staring in front of him, with the sleeves of his sweater pushed up to the elbows, Francis suddenly breaks through the last two hours' politesse:

'And when I saw George again this afternoon on that film they did for the exhibition, I thought how good-looking he was. He'd never seemed so present and so marvellous.'

Miss Beston is crying into her handkerchief.

'There it is. He's dead now. Nothing can be done.'

Francis looks down the table with a small tight smile, repeating:

'Nothing can be done.'

We all shift in uneasy sympathy No one speaks.

Francis leans forward in an effort to say something more, gazing fixedly into the middle of the table. Then he glances up and through his guests. No one dares look back at him.

The waitress starts collecting the empty plates.

A thin, elderly woman emerges from the kitchen and stands blinking in our direction, curious to see what the large party that

has eaten and drunk so much is like. As she comes into Francis's vision he appears to recognize her and stretches out both arms.

'You just have to keep your hand in,' she is saying as she comes closer. 'That's the real secret. And the right shallots, mind.'

'Well, it was simply delicious,' Francis says to her, as if in a dream. 'I sometimes do it, it sounds mad, but I sometimes do it with margarine. It's never as good as yours, though. Of course.'

'It's keeping your hand in that makes proper *beurre blanc*,' Mère Michel repeats, standing by his side, looking at the quietened guests. 'I make it every day.'

'Well, there you are,' Francis says, raising his arms higher in recognition.

'What beautiful arms you have,' one of the women from the Grand Palais says, her own braceleted brown arms propping up a face of smiling admiration.

'Are they? Are they beautiful?' Francis asks. He looks stern and holds them both in front of his face, considering them critically.

'Perhaps they are. Perhaps they are simply beautiful. There's nothing you can do about those things. That's simply the way they are.'

The loss and the drink and the absurdity settle like a shroud over our table.

'But so have you,' Francis says, starting out of absorption elsewhere and taking hold of Mère Michel's arm. 'You have beautiful arms too, Madame,' he says, pushing up her jumper sleeve to reveal a thin, old woman's arm and holding it out for the table to admire.

Mère Michel stands there, smiling through her uncertainty.

Letting her arm go, Francis says to her directly, discreetly, as if only the two of them could hear:

'It's never worked, has it, life with someone else? Those things never work out. Do you live with a husband, Madame?'

'He's dead, Monsieur, he—'

'I know he's dead. It never worked, I know that. It was impossible from the start.'

'But Albert and I were very hap—'

'Of course. It always goes wrong in the end. There it is.'

Francis fills a glass and puts it in her hand. Then he drains his own, looking at her over the rim, wet lips pursed, pale eyes searching.

'I know, of course,' he says. 'Those things have always been impossible.'

9

Consumed by Guilt

There's been no news from Francis for several weeks. I keep thinking of calling him but haven't called. It's not that I worry it would disturb him: if he's working, he simply takes the telephone off the hook. But he's not the kind of person you ring simply to ask how they are, how they're feeling. If you call, he expects you to have a reason. Still, I am very anxious to know how he's managing to deal with this horrible, painful situation, and it seems increasingly callous not to be in touch.

Meanwhile my work has been going well enough. I've finished all my exhibition reviews, as well as a couple of 'in-depth' and 'think' pieces, so a trip to London would, among other things, allow me to see a few editors and keep the commissions coming in. As soon as my dates are fixed, I call Francis. I don't get through at first, but when he does answer he sounds rather distant. Nevertheless he suggests we meet for lunch at Wheeler's the day after I arrive.

I make a point of getting to Old Compton Street early because I want to wander through Soho and look at a few old haunts. Everything looks much the same. The fruit and veg is still changing hands rapidly in Berwick Street and the girls in the doorways haven't got any more alluring. I find this reassuring but when I reach the murky green windows of Wheeler's I take a deep breath. I have no idea what sort of state Francis will be in.

As I go in, I'm cheered because the owner, Bernard Walsh, gives me a friendly wave from behind the oyster counter and even one of the waiters seems to recognize me. But I'm brought up short when I see Francis, who's already in the snug bar. It's not just that he's pale, he's become almost translucent, with a strange bluish hue as if he were deathly cold. I down my first glass of Chablis quickly.

'How have you been, Michael?' Francis asks.

'I've been alright, Francis,' I say. 'I've been writing reviews and things, and trying to do a little writing of my own. I'm not sure I'm getting anywhere.'

'Those things can be very difficult,' Francis says in a detached voice. 'I didn't begin to paint seriously until I was well into my thirties. I don't know why, I often regret it, but I think it was just one of those things you can't alter. I think my development was retarded – I was simply a late beginner.'

'And how have you been, Francis?' I say, swallowing hard. 'I mean, since Paris.'

'An hour doesn't go by when I don't think about him,' Francis says, very simply. 'I feel profoundly guilty about his death.'

'But there's nothing you could have done, Francis.'

'If I hadn't gone out that morning, if I'd simply stayed in and made sure he was alright, George might have been alive now. It's a fact. He'd tried it before, you know. Several times. But I'd always been able to get him to a hospital in time.'

I thought back to what Sonia had said when she announced George's death in the café: 'I know what you're thinking. But it wasn't that.' Of course it was: that much was obvious from the start.

With his mouth pursed, Francis starts brushing non-existent crumbs off the tablecloth. Things that won't go away.

'He always did it under drink. I came back to the studio once and he was there with these friends of his, they were all dead drunk and just lying round the place. And George was stretched out on the floor with his sleeping pills strewn right round him.

So I tried to ask these friends what he'd been doing, whether he'd been taking them or what – but they were just too drunk to know. It turned out he'd been taking them like sweets, and they had to pump them out of him. He was very ill after that – it did some permanent damage to his stomach.

'George changed completely with drink. Because when he was sober, you know, he was so careful of himself. He always looked to right and left before crossing the street and those sorts of things.'

'I know. I remember.'

'Well, you remember how obsessive he was about being clean? He simply never stopped washing himself. But he's dead now. If I'd known what I know now I'd have left him exactly as he was when I first met him. However mean it might have looked. Because in the end, by giving him enough money to be able to do nothing, I took his incentive away. His stealing did give him a raison d'être, you see. Even though he wasn't very successful at it and was always in and out of prison. But it gave him something to think about. When he was inside, he'd spend all his time planning what he would do when he came out. And so on. I thought I was helping him when I took him out of that life. I knew the next time he was caught he'd get a heavy sentence. And I thought, well, life's too short to spend half of it in prison. But I was wrong of course. I should have left him exactly as he was. He'd have been in and out of prison, but at least he'd have been alive.'

'You couldn't have known how things were going to turn out.'

'I should have stayed in that morning and not bothered about the exhibition. You remember he was off the drink that time we met at the Grand Véfour? Well, he went back to it of course, and then he became totally impossible again. The rest of the time, when he was sober, he could be terribly engaging and gentle. He used to love being with children and animals, you know. I think he was a nicer person than me. He was more, what's the word, compassionate. He was certainly much too

nice to be a crook. That was the trouble. He only went in for stealing because he'd been born into it, into that whole East End atmosphere where it's what's expected of you. Everybody he knew went in for it. I mean, I remember George telling me how sometimes, when he was a boy, he used to wake in the night and find his mother going through his pockets looking for money.

'He could have got a job easily if he'd had any discipline, because he was very good with his hands. I got him something with my framer, where he was going to learn gilding, which pays very good money. But he didn't make anything of it. Well, I can understand that it's much more exciting to steal than to go out to a job every day. But in the end he did nothing but go and get completely drunk . . . It's ridiculous to think you can help people. You can't.'

'You can't blame yourself for having tried to make his life better, Francis. It's a marvellous way you have – you've improved life for a lot of your friends. You've made mine more interesting, for one.'

'It's terribly nice of you to say that, Michael, but I'm afraid it doesn't change the fact my life's been a disaster. Right the way through. So many of the people I've known have been drunks or suicides – all the ones I've been really fond of have died in one way or another. I just seem to attract those kinds of people – d'you think there's a reason for it?'

'Well, I suppose George was drawn by your expansiveness, the freedom and sense of living life to the full that you communicate. That must attract a lot of people. Didn't you say he just came up to you in a bar and offered to buy you a drink because you looked as if you were having a good time? Well. Someone with your kind of self-confidence is bound to attract all kinds of neurotics because they think it might give them something to hold on to. And in any case I don't imagine you can ever stop people who really want to commit suicide. They'll always find a way.'

'Perhaps,' Francis says. The talk and the wine seem to have thawed a little of the cold out of him. 'I'm afraid I've always had those kinds of people in my life. And it's only when they're dead that you realize just how fond of them you were.'

We go on through the round of afternoon bars, ending up at Muriel's. Everyone appears to know what has happened, and people go out of their way to be kind to him. I have already had more than I want to drink and would prefer to spend a relatively sober evening with my friend David, who once again has offered me an unlimited stay in his comfortable flat. But I feel I have to go to the end of the course with Francis. So we have dinner at Mario and Franco's, where I eat a pyramid of pasta to mop up all the booze I've had, and then, as in some Dantesque punishment, we go back to the same bars but in a differing order and Francis repeats and repeats what he's said before, shifting the emphasis and from time to time adding the odd detail to what he's already told me, so that everything looks and sounds like everything else and we appear to be in a kind of ever-decreasing vortex except that really both of us by now are legless with drink and I manage to get Francis back to Reece Mews, wondering how he'll ever get up that steep ship's ladder to his studio. As I creep back into David's flat, I'm glad to see he's gone to bed, probably hours ago, but when I lie down the drink and the conversation continue to circle round my head with Francis's voice crackling like an old record that will never stop:

'The door was locked well I knew it was locked I hadn't seen him since the morning before he'd gone right back on the drink I knew that he'd gone out on one of those long bouts round the bars it sounds absurd I know for an old drunk like me to say but when he was drinking like that he became completely impossible but I should have got somebody from the hotel right away to come and break the door down I should have just stayed in with him rather than going to see about the exhibition but I didn't there it is he's dead now I should have known he'd tried things like that before I'd always got him to hospital in time and later

when there was still no answer they broke the door down and there was all this mess and things strewn about and you could see he'd tried to vomit the stuff up again but he hadn't been able to and there he was dead.'

Mercifully, as dawn comes up on Lennox Gardens and a pale light begins to play on the ceiling, I drift off at last into a deep, dreamless sleep.

Francis has asked me to the studio to look at a picture he has just finished of George. I've been wandering around the area this afternoon to see what's changed over the past couple of years. It's like gazing into the face of someone you know intimately but haven't been with for a while, and although everything is basically the same you realize that the little veins on the cheek are more pronounced, then you notice the furrow you hadn't seen before on either side of the mouth. The Danish restaurant has become a bodega and you hear more foreign languages on the streets than you used to. But the same man is hawking newspapers outside South Kensington tube, and there's still the strange collection of down-and-outs lying on the pavement just round the corner; I remember that when I walked past them one evening with Francis, they all cheered and waved their bottles admiringly at him as if saluting a hero, a moment which amused and moved me as having something almost Shakespearean about it. Dino's is also still there, still dishing out the lasagne, and people continue to have that abstractly benign air in the street peculiar to the English, and certainly not something I've come across in Paris.

Reece Mews looks the same, too, if rather smaller and greyer, and so does the battered blue door of number 7, which Francis has left ajar for me. I pull myself up on the greasy rope and find nothing much has changed here either. There are a couple of suits back from the cleaners hanging in cellophane on the kitchen door, pinned reproductions of Francis's own paintings over the sink and pieces of burnt toast on the draining board. All the lights

are on, even though it's not dark yet outside. I have the fleeting impression that something is broken that was not broken before. Francis is waiting for me in the living room. We are both formally dressed in dark suits because we are having dinner at Wiltons with Lucian Freud and the Duke of Devonshire. The Moroccan cover on the bed looks less sumptuous than I remember it, but the great crack spreading out its tentacles over the mirror is exactly the same, although it now seems more threatening. It catches us both as we talk, moving back and forth, and with the malevolently yellow electric lights highlighting our fragmented reflections, we look as though we are miming a Bacon picture, *Two Figures in a Broken Mirror*. Watching him, I say, quite without thinking about it:

'Sometimes I wonder how you'll be in ten years' time.'

We're watching each other in the mirror now, as if we have been transposed there and are watching ourselves like actors in a play.

Suddenly, his mouth arched in contempt, Francis pulls his index finger across his throat like a thick, fleshy knife, as if to say: 'I'll kill myself before then.'

Then the moment is past and forgotten.

Francis is coldly courteous, occasionally flashing a blank smile for no reason and glancing frequently at his watch even though we have plenty of time. He has been sifting through the jumble of books and papers on his table for his door keys.

'It's mad, I know I left them here somewhere,' he says. 'They just get swallowed up in all this squalor I live in.'

He pads off back to the kitchen. Beside the mirror there is an alcove with framed photographs of Peter Lacy, sometimes alone, sometimes with Francis. There is also a picture of Francis looking very young, and the one of George looking anxious. It's like a shrine, and I wonder what new images of George will come to join them.

Something crashes to the floor in the kitchen and Francis comes back gripping his raincoat.

'They were in my pocket the whole time,' he says. 'Naturally.'

'You look so young in that photo, Francis,' I say.

'Do I look young?' he says. 'Well, there it is, but I was over forty at the time.'

'You can see from the eyes that you're not really that young, but otherwise you look barely thirty.'

'Well, that's a family thing. My mother remained very young looking.'

'It's great to have genes like that,' I say, attempting to introduce a little levity into the conversation.

'I wonder,' say Francis, flashing another mirthless smile. 'I do sometimes wonder whether George wasn't right to do what he did. But if I did it, I'd want to have the right pills to make sure I did myself in properly, because some people don't and they simply end up as vegetables. On one other occasion when he'd tried to kill himself, George left a note saying, "It's not so bad. We all have to go." There it is. He's not here now. I went to the funeral, you know.'

'I didn't know, Francis. I'd been wondering.'

'It was at a place called Ilford. All his family and friends were there. I stood further back, by myself. Then after the ceremony, they started lowering the coffin into the ground and that very big friend of his, the one they call "Nipper", went over to the coffin once it was lying down there and shouted, "You bloody fool, George!"'

There's a silence and Francis glances once again at his watch.

'I don't know whether you could be bothered to look at the new painting I've done of George?' he says.

'Yes, of course, Francis, I'd be very interested to see it.'

The studio looks even more astonishingly chaotic. Paint is everywhere. Trial marks of colour explode like fireworks on both sides of the studio door and up all the walls. Open tins filled with a thicket of brushes and half-spent tubes spill out on the floor which is covered by a Jackson Pollock-like skein

of paint, though this is a comparison I am wary of sharing with Francis, knowing how little he thinks of his American contemporary. Books, maltreated and daubed, are stacked up against the walls, while underfoot, in the confined space that Francis treads a thousand times a day going up to and stepping back from a canvas under way, there is an ankle-deep carpet of images, crumpled and scuffed, with a shoe surfacing here and an old passport with its corner clipped poking up there. The room is like a violently coloured memory bank from which nothing has ever been excluded.

I notice that Francis, like a traditional Belle Epoque artist, still covers his new pictures under a sheet, which he then removes dramatically with a flick of his wrist. George is shown seated on a chair against a black rectangle, a large dark doorway leading on to nothing. Half of his body has been consumed by the darkness while his flesh-coloured shadow flows liberally on to the floor as if it were his life seeping out of him.

'I'm hoping it will be part of a triptych,' Francis says. 'Of course one never knows with those things but I have all kinds of images dropping in to my mind.'

'It's an amazing picture, Francis,' I say. 'It's very sheer and simple, and of course very tragic.'

'I'm very glad you like it, Michael,' Francis says. Then he checks his watch. 'I think we should go now because around this time it can be really difficult to find a cab.'

In the taxi's brown gloom I watch Francis's taut frame, rigid in his raincoat, as he looks at the shopfronts going by.

'What's Lucian been doing?' I ask, keen to get the latest gossip.

'Well,' Francis says, after a pause, 'Lucian has a thing about the British aristocracy and he's made it his business to become a great friend of the Devonshire family, most of whom he's painted. I myself much preferred his pictures when he worked with that tight, fine brushwork, as he did when he painted that marvellous little portrait of me. I'm not saying that because

it's of *me*. It's just that because it was more artificial I think it came across as more intense and real, and I don't think his work has got at all better since he started painting with those looser, thicker brushstrokes.'

Francis was probably right to have started off early because we've been caught in thick traffic along Knightsbridge.

'Of course he's a very intelligent man, Lucian, but I think painting has more to do with instinct than intelligence. I mean, Churchill was brilliant in many ways but you only have to look at his paintings to see what I mean. I don't know how instinctive Lucian really is. He once tried to be homosexual, you know. Or at least so he told me. But then he said that when he went to bed with some friend of his he kept thinking "Well, that's just old Bill."

'But then I'm afraid,' Francis adds, in a waspish tone, 'I'm afraid Lucian has what's called the smallest cock in England and of course you can't go far in the queer world with that.'

Lucian is already waiting for us in one of the restaurant's booths. He is wearing a beautifully cut double-breasted jacket without a shirt or vest. He has brought a tall, thin, pale young girl in a pale flowered dress with him. She reminds me of Ophelia, a silent foil to Lucian's ageing Hamlet. Lucian is affable, full of short anecdotes and private jokes. The duke arrives and introduces himself as Andrew Cavendish. I find this reassuring, since I have no idea how dukes present themselves and am half expecting him to come in trilling, as in a musical, 'and I'm the D-u-ke of Dev-on-shire'. He is tall and also affable, as well as a little shambling and vaguely apologetic.

Francis retains his withdrawn, icy composure but is infinitely attentive to his guests' wishes. The conversation is constrained, the service impeccable. Lucian's girlfriend has ordered a partridge, which strikes me because if I heard it aright her family name was Partridge. She devours the small bird and when she find its little bloody heart she cuts it out and places it on Lucian's plate, another in-joke that they enjoy together. The food and wine and

surroundings are all perfect, but for once the evening never takes off because it lacks the manic gaiety that Francis usually infuses into these events as a matter of course, and although we have all drunk a fair amount, except for the duke, the atmosphere remains unusually sober. When dessert is served, the duke starts making short work of several large balls of chocolate ice cream. About halfway through, he glances up apologetically and says to me: 'It must look rather ridiculous to see a middle-aged man like me gobbling up ice cream like a schoolboy, but I used to be an alcoholic and now I have to get my fill of sugar wherever I can find it.'

When the bill comes Lucian does his Charlie Chaplin fainting act into his girlfriend's lap as Francis pays. The party evaporates rapidly outside on Jermyn Street and I'm about to ask Francis whether I can drop him somewhere in Soho or back at the studio, when I sense, partly because the evening has lacked conviviality perhaps, that he has something else in mind.

'There is a very curious club round here,' he says. 'Ridiculously, you can't get into it unless you're in a suit and tie, but since we're wearing the right clothes I don't know whether you'd care to have one last drink there.'

The cab driver seems to know where to go, but I only vaguely catch the name of the club which sounds like the Buckingham or something like that. Given the places Francis has taken me to before, I am expecting something on the extreme side, with waiters with masks on and whips on the wall, but we are ushered into what appears to be the epitome of a London gentlemen's club. There is a porter's lodge and once we have left our coats on the brass hooks behind it we go into a room full of comfortable armchairs with, not whips, but hunting prints and various school and regimental shields on the panelled walls. As we settle in our red-leather chairs, newspapers are lowered and several pairs of eyes take our presence in. A quick dart here and there, then the eyes return to the cricket or the crossword. There is a lot of rustling and throat-clearing but no talk, as in a 'silence library'.

Communication is limited to members ordering drinks from a dour-looking club servant. We have a double whisky. For the first time since I've been back in London, some of the icy pallor seems to have left Francis's face. The atmosphere in this room appears to fascinate him.

'Of course they are all completely ridiculous,' he says to me in an animated whisper. 'I think they call this place the "poofs' Athenaeum", and they all sit round in those chairs pretending they're not queer and just waiting for something to happen to them. It never does, of course, because none of them would ever dare to make what's called the first move. So they just stay there, waiting. There's something so dreary and depressing about the whole place that I just have to come in from time to time to remind myself of it.'

———

Back in Paris, I went to the Grand Palais again several times before the exhibition closed. Now that George is dead, I noticed, the paintings have taken on a premonitory quality. Right from the screaming figures on the orange ground through the spectral figures in closed rooms to the images of George fragmented through every conjugation of chance injury, all the images spoke of death. 'Death', I hear Francis's voice repeating once more as I walk through the galleries, 'is only in the mind of the living.' Here it is all pervasive, the one ultimate and unchanging theme, and towards the end of the exhibition I half wonder whether the paintings aren't lining the walls of, and leading up to, a burial chamber.

It's been a hard year for me. I've been in and out of several short-lived professional arrangements – writing, editing or translating – as I have brief and often painful love affairs. I keep telling myself that, since my goal is to preserve my freedom and use that freedom to write more creative things, my life can be seen as a success. But when I add the difficulties of scratching a living from freelance journalism to the insecurity of serial flings

and the paucity of my literary ventures, I remain increasingly sceptical as time goes by.

It may be simply the spring and the promise of another summer to be spent overlooking the Mediterranean or watching the breakers crash on the Brittany coast, but I feel my life has taken an upturn in recent months. These things are never planned, of course, and you haven't the slightest idea where they might lead, but I have begun a relationship with a woman who is considerably older than me. Since I am now thirty – '*en l'an trentiesme de mon aage / Que toutes mes hontes j'ay beues*', as I repeat smugly to myself – I supposed that, although I fantasized about it as a much younger man, I had reached an age when this would no longer happen to me.

Alice is in her mid-forties (for a while she kept her real age from me), an exotic mix of Caribbean African and Indonesian, petite and extremely lively. Brought up in the north of France and educated in Paris, she is married to the well-known art historian John Rewald, chronicler of the Impressionists and world expert on Cézanne. They live fairly separate lives, however, he mainly in New York and Alice in Paris, though they often spend part of the summer together in an ancient, hilltop fortress they bought and restored in Provence. Not only is there a strong physical attraction between us, but we share many of the same interests in art and literature. Alice has been part of the international art world for twenty years and has known most of the leading artists, museum people and dealers on both sides of the Atlantic. Since John has been successful as both an historian and an art adviser to some of the wealthiest American collectors, Alice lives a much more moneyed and sophisticated life than I do. She drives a yellow Thunderbird and stays in the top hotels. What impresses me most is that she knows Picasso and has counted Giacometti and Balthus among her admirers, both of whom have done portraits of her.

Not the least of Alice's attributes is that she's really hit it off with Francis. We have had many dinners *à trois* over the past

couple of years and often I can hardly get a word in edgeways. I make a joke of this, but secretly I'm delighted. In age Francis could easily be my father and Alice is almost old enough to be my mother. I don't think about this much, but even to me it's obvious that I have in some semi-conscious way chosen new parents. On the whole I bask in their joint affection and suppose it can only soothe old wounds and help bolster my crippling lack of self-confidence. At the same time I am aware of how much like textbook psychology this sounds and, when I'm feeling resilient enough to be cynical, I reflect that by the time you're in your thirties you really do get the parents you deserve. And what I now have is an alcoholic, sadomasochistic, queer father and a flighty, exotic mistress of a mother.

Francis also appears to be coming out of the shadow of George's death now that it begins to recede into the past. He called me the other day to tell me he's just been down to what he calls melodramatically 'the house I shall be murdered in' on Narrow Street in Limehouse. He has always had a romantic attraction to the East End, and a belief that people there – especially good-looking young men – were more 'real' and 'direct' than their effete, devious counterparts up west. I suppose it's the attraction of opposites, and the danger attached to it (what Wilde called 'feasting with panthers'). I imagine there's also the fact that cultured homosexuals can fantasize more satisfactorily about toughs working in the docks or villains doing a job than they can about a straitlaced accountant or lawyer going in to an office every day in the City.

Francis says he loves being down there because the house gives directly on to the Thames and you get all the boats going to and fro and there's this marvellous pub called the Grapes just next door that's been there since the sixteenth century. It all sounds really exotic to me, sitting beside the phone and looking out on my quiet little street in the Marais. Dan Farson's singing pub, the Watermans Arms, isn't far away, Francis reminds me (although

Dan himself has moved on), and there's Charlie Brown's famous watering-hole on West India Dock Road. Francis bought the house on a whim before George's death and had it done up the way he wanted, making the most of the big windows going down the whole of the back that overlooks the river. But after several attempts he's found it impossible to work there, he says, because there's so much moving light thrown up by the water. 'Everything seems to be flickering and in constant motion the whole time,' he tells me ruefully. So now the house is simply lying empty and he's wondering whether Alice and I might care to move in there at some point for a few weeks or for however long we wanted, really.

The first lunch I took Alice to at what I thought might be a suitable restaurant – the cheaper annexe or *petite soeur* to the grand Chez Francis brasserie beside the Pont de l'Alma – cost me the equivalent of a week's work, and Alice always referred to it thereafter as our first lunch 'Chez Francis *pauvre*'. So I have a lot to live up to and imagine that I might cut a little more ice by offering a stay in Francis Bacon's newly redesigned house overlooking the Thames. Alice is delighted by the whole idea and without thinking too much about what we were going to do with ourselves in the East End of London, which I barely know and she not at all, we throw a couple of suitcases into her car and drive to Calais for the Channel crossing.

It's late afternoon by the time we find our way to Narrow Street, and we are amazed to find an immaculate Georgian terrace house with a jetty and three large, luminous floors all looking out directly on to the Thames. The sun is playing on the water and I see right away how the constant dazzle would make painting difficult. It would in fact be difficult to concentrate on anything given the continuously changing spectacle on the river outside. The traffic is incredible, with everything from huge barges, tugs and patrol boats to luxury yachts and liners threading through each other on the choppy waters in both directions. Then later in the evening all activity

ceases, and the only sound you hear is the cry of the gulls as they swoop down in search of food.

We luckily don't have to forage because Francis has filled the large fridge with a complete range of food from Harrods as well as several bottles of Krug. Alice is impressed by the pot of caviare and the large game pie. Looking round the house, with its sanded wood floors and brushed steel staircase, I can see that although he lives in what he calls 'squalor', Francis hasn't lost his touch as a decorator. At the opposite extreme to the clutter in his own studio, Narrow Street has been kept to a minimum of functional furniture and recalls the interiors Francis himself designed at the outset of his career. On the top floor the bedroom, to Alice's alarm and my amusement, contains a gleaming white bathtub and a lavatory in the same space as the bed, so that every intimacy is shared. What must have been impossibly avant-garde in the early 1930s still shocks some forty years later.

The phone rings the next morning and it's Francis asking if we're alright and have everything we need. He tells me his sister Ianthe is over from South Africa and very curious to see the Narrow Street place. I immediately suggest that Alice and I organize a lunch party, but Francis beats me to it by saying he has to go back to Harrods anyway to pick something up so he'll bring all the lunch food down by taxi – and had I seen there are a couple of cases of Lynch-Bages and Ducru-Beaucaillou under the deal table in the kitchen? We decide to invite Sonia as well and my old friend David Blow, whom Francis has met several times and whose regular news broadcasts he listens out for on the BBC World Service because he finds them 'marvellously clear'. He also mentions with relish that he's been following the whole Lord Lucan case in the news, and I realize Francis probably knows him from one of the gambling clubs he goes to. Certain scandals appeal to him hugely, and he's been saying for some time that he's heard from a very good source there was a 'fourth man' in the whole Philby affair who hasn't been named yet.

We're lucky enough to have perfect weather for the lunch and we sit out on the jetty with the champagne. Francis is looking considerably better than when I last saw him, and he's clearly proud that the house is so much more to his sister's taste than 'my dump in Reece Mews'. The party lasts right through the afternoon, and apart from Francis, for whom it's an everyday experience, we've all drunk far more than we're used to. David has kindly offered to take Ianthe and Sonia back to South Kensington and Alice has gone to take a nap, so Francis and I wander out and are soon on the whisky in a rather grim-looking pub he seems to know. I'm surprised how he seems quite as much at ease in this dank boozer, which is still quite empty, as in the luxury of his own house, and I'm taken back even more when he suggests that I might need some extra money to take Alice out during our stay. I colour and refuse gratefully but primly, saying that he's already given us all the hospitality we could possibly want. Without missing a beat, Francis goes on to tell me how much George liked this pub and all the East End characters and villains who drink here. He's still pale, but he laughs more often and some of the old rosiness has come back into his face. We've settled with our single malts at a rickety table in the corner and seem to be on the verge of another of our 'in-depth' conversations. It's as though Francis thinks I'm still writing that interview we began a good ten years ago.

'The thing is, I suppose I could tell everything, because it would be much better when one's talking about oneself to tell the whole story rather than just bits of it,' Francis says, while quickly scanning the two new clients ordering their drinks at the bar. 'But if I did I'd probably end up with an arm cut off or my eyes put out. It sounds a very vain thing to say but by a series of accidents, they were just accidents, my life has been extraordinary. Much more interesting than my paintings. It's been a ridiculous life as well, of course.

'But I don't know how you could ever go about putting those things down, Michael, even in an interview or an article. In a

way I suppose writing must have become as difficult as painting. The same complex question of recording, yet undercutting mere anecdote. It would take a Proust to know how to do it. It's something I could never write myself, naturally. I can't even write a letter.

'In that sense it would be interesting if you could talk about these gangsters I happened to know, the Krays, because they were really curious. Of course they were dreadful, just killing people off and so on, and it's a good thing they've been put away, but at least they were really different from everybody else. They were prepared to risk everything. One of them was quite mad. The queer one, Ronnie. I would never have known them if this actor I used to see, Stanley Baker, when I was living for a bit in Tangier, hadn't come round to me one day and said, "Francis, I've got these friends over from England and can I bring them round to your place for a drink?" And I said yes of course. So then he turned up with the whole dreadful gang of them. I suppose he thought it was terribly smart to know them. Anyway afterwards one of them, the really nasty one of course, came to me and said, "Francis, I've got this friend" – he'd fallen for some Spanish boy – "and I don't feel I can take him back to the hotel, can I bring him round to your place?" So I said, "Well, as it happens I don't think hotels here mind about that sort of thing." But he said he was worried about the impression it might make, though you would think that after cutting all those throats he wouldn't have cared. Anyway, I had a place with lots of rooms at the time so I said, "If you want to you can bring him here." Well, he did, and after that I never saw the end of him. Naturally. He always seemed to be there.

'For some strange reason someone told him it was a good thing to buy my paintings. One of their gang actually came round to see me with four hundred pounds in his pocket. I remember that seemed a fortune to me at the time, but as it happened I had nothing to give him. Together the two of them had this incredible power. Of course they're still very powerful

now, even though they're what's called behind bars. Because they have these "lieutenants" still under their orders, so they can reach beyond prison, as it were, even now. The mad one, he used to go completely mad, he would just kill anyone, was the more, I know it sounds a terrible thing to say, but he was the more remarkable of the two. The more deeply curious.

'One of the ones who worked for them broke into my studio and stole some paintings once. I suppose he'd been told they were worth a lot of money – the newspapers had printed a story about their selling for colossal sums. Anyway he'd been hanging around the studio for some time. He just wanted money I think, because at night there used to be this tap-tap-tap on the door, the whole time, tap-tap-tap, well it went on and on, and I was too bored by the whole thing to go down and open up to him. I could probably have given him something and he would have gone away. Anyway. It was a great nuisance in the end, because he took some pictures that I terribly didn't want to let out of the studio because they were very bad. Well, you know how those things are: there was just no trace of them at all. And then about a week later, I had to go and see my framer, you know, Alfred Hecht. And there he was, showing Alfred the pictures.

'He'd just that moment been trying to see whether he could sell them. When I came in he took them and ran out. But that wasn't the end of it. It never is with that kind of thing. The next day I went back to the studio in the afternoon and I found them all in there, the whole gang of them, just sitting round waiting, and there was that really nasty one saying to me how long it had been and how nice it was to see me again and so on. Of course I didn't know what to do, so I asked them whether they'd all like a cup of tea. And they said they would, so I made them some and we all sat round and they were terribly polite, and just sat there drinking their tea, but when they got up to go there was no doubt what they meant to tell me. So all I could do was drop the whole thing. A bit later, I did manage to get the pictures back, but I had to pay some ridiculous sum of money to buy them at

auction. Well, then I was able to destroy them and have done with it.

'In the end, when the police had enough on them to bring them to trial, one of these lieutenants of theirs came to me and said, "I can't turn evidence against the twins, can you give me the money just to disappear?" So I gave him the money, and he did disappear. I haven't heard of him since. But one day he could simply turn up again. That's the boring thing about people like that. You never know when they'll turn up again. I have to say that deep down I hated the idea of what they did to people. In a restaurant in Tangier, I once saw them force a man to go down on his knees and kiss their shoes in front of everybody. Well, there it is. For some reason I often seem to come across people like that. I suppose, like John Deakin says, it's because of what's called "the company she keeps".

'I still hear from them now that they're in prison. They send me these paintings they do there. They're very odd. They're always of these kinds of soft landscapes with little cottages in them. The thing is that's just the kind of life they always wanted. A life of ease in the country.'

The pub has begun to fill up. Some of the regulars are eyeing us, openly wondering who we are and what we're doing. Francis has decided to continue the evening at Muriel's and invites me and Alice to come with him, but I claim that Alice is still recovering from the long drive from Paris and wave goodbye as he gets into a taxi to go back up west.

My father wants to have what he calls a 'family conference', which would include not only me and my sister, but any other relative he can persuade to come to Stocking Pelham, the inaccessible village in Hertfordshire where he and my mother are living out their retirement years. I recoil from the idea but I can't see how I can not go without creating a major fuss. My mother has told me he's in the middle of his manic phase and

that everything's been planned, right down to organizing the travel for everyone lucky enough to have been summoned. No one knows why my father has had this idea or what it's about, but my aunt Yvonne and my uncle Mike, the two siblings of his I get on with best, have already accepted. My mother has also mentioned that my father's health has not been good and that he's been to the hospital in Bishop's Stortford several times for 'tests'. This worries me and makes me feel obscurely guilty. When the tickets arrive by post, I realize I have no choice, and I call my friend David to make sure he can put me up for a couple of nights in London.

My father may be a manic depressive, but he's not clinically mad and he's very far from being stupid. At University in the mid-1930s he got the top First of his year (compared to my miserable 2:2), and he can marshal facts or solve a crossword with impressive accuracy. But he has just staged one of the weirdest acts I've ever come across. There were about a dozen of us seated in a ring around the huge armchair he now seems welded to in the living room, with its dispiritingly low, beamed ceiling and smoke-blackened inglenook fireplace. On the tacit but quite unfounded assumption that everyone in the room was bound by a deep sense of family unity, my father spoke without pause for a good three hours, weaving a monologue that went from the stockpot that Nana, his French mother, kept going all year in the Clarges Street kitchen through the anti-Mosleyite street fights in which he and his brothers had been involved to his first major breakdown, triggered by the poverty he had witnessed in Italy immediately after the war, and his present battle with depression ('I have seen the signs of it perpetuated in my own children,' he remarked oracularly, fixing his curiously brown-flecked grey-green eyes on me). Eventually, having gulped down the gin-and-tonics my mother handed around (no mention having been made of my father's parallel battle with the bottle), we were allowed to leave on the pre-arranged transportation and resume our lives, none of us

much the wiser about the reasons why my father had launched into this Lear-like exposition suggesting (as Shakespeare had put it so succinctly but my father had not) that he was more sinned against than sinning.

I've left enough time in London to catch up with some old friends, and I'm really looking forward to it after being exposed to my father's bizarre monologue. Francis has suggested lunch and we meet at a trattoria that's opened on Romilly Street. I sense right away that his mood has changed since we were in Narrow Street. I've seen these swings in him before (my father's clearly not the only one) and realize that the best way to deal with them is to stay at a remove and wait till they blow over. We have a mediocre meal, which does nothing to improve Francis's humour, then start on the clubs. Wherever we go, Francis makes sweeping statements, delivered on hands held out flat and unanswerable, about anything that comes up.

'I hope,' someone begins.

'There's no hope,' Francis counters, 'because there's nothing to hope for. We live and we die and that's it. Can't you see? When I die, I just want to be put in a body bag and thrown into the gutter.'

'It's a mug's game,' someone else beside the bar says, 'whether you're going for the horses or the tables.'

'I don't go for anything,' Francis retorts. 'I can't think what you're saying. Can't you see, you stupid cunt, there's nothing worth going for?'

Time seems to have flattened out again into a slowly revolving plane where only the same drinks and the same phrases recur. With no noticeable transition we are sitting in another room now with two women who seem familiar. We may have met at the Colony Room, and I know one of them is the dress designer Thea Porter but I can't remember which one. I have a vague inkling that the smaller of the two is making a play for me. It amuses me but sagely I put it down to the drink.

Then I realize we're in a restaurant, but I'm fairly sure no one else has noticed. Certainly none of us can be hungry.

Menus are propped up against the decorative Chianti flask in the middle of the table.

'I've no idea what I want,' Francis says flatly.

'There's Parma ham,' I venture.

'I hate Parma ham.'

'Or grilled sardines.'

'I loathe sardines. I simply loathe them,' Francis says with venom. 'What I'd love really is a boiled egg. Something absolutely simple and delicious. But of course they're far too grand here to have anything that ordinary. In any case, I doubt we'll ever get served.'

'*Buona sera, signori*,' a waiter says, stepping up briskly.

'I was just wondering whether I could have something absolutely simple like a watercress salad,' Francis says to him challengingly.

'Water salad?' the waiter says blankly.

'Watercress,' Francis repeats. He is wheezing and clearly having trouble breathing. 'My friend here speaks more languages than exist. I'm sure he knows the Italian for watercress.'

'*Cressone*,' I say on the spur of the moment. '*Una insalata di cressone dell'acqua.*'

'*Si, si*,' says the waiter whom I'm beginning to suspect is more North African than Italian. 'Tonight we have not.'

'Well, perhaps we might at least have a little red wine while we're making up our minds.'

'*Subito, signori.*'

'He's exactly like a waiter in a novel,' the smaller woman suggests.

'The thing is, I hate novels,' Francis says emphatically.

'Well, there are some,' the woman says hesitantly. 'I mean there's Lowry's *Under the Volcano*, for instance.'

'I saw nothing in it,' Francis says, sweeping his hand flat and hard over the tablecloth. 'I know all about that life. I don't have to read novels about it.'

'That doesn't mean there's nothing in it,' I say. I feel I should come to her rescue, and I'm gratified when she shoots me a meaningful look.

Then I realize Francis is staring at me malevolently.

'It doesn't go far enough. D'you see? You have to go much further to make a work of art. D'you see? Art's above all a question of going too far.'

His face has turned into a frightening white mask of fury.

The two women nod. Their instant acquiescence irks me.

'I don't see why you have to exclude all writers and artists except the few you consider great,' I say, more heatedly than I wanted. 'There are others whose work has had a tremendous—'

'But what have they invented? Any of them? Just tell me. It's the same thing in painting. Outside Picasso and Duchamp and to some extent Matisse, who has there been?'

His eyes bore into mine. No trace of drunkenness remains.

'Who else has there been? No one else has gone far enough. That's your trouble, Michael. You've simply never gone far enough. That's why you're stuck in journalism. But then of course I know that journalists write whatever their papers tell them to write. You just write what you're told to. Deep down, all journalists are skunks, I know that. And rotten. Rotten to the core . . . Oh, look. Now of course he's deeply offended.'

I've seen this happen to others, and I've known that one day it will happen to me. It has, but at a moment when I least expected it. Francis knows exactly how to hurt, and I am touched to the quick. All I know is that I can't and won't continue to sit there.

'I know it sounds phoney to say these things,' the larger woman is saying, 'but I wanted to tell you how deeply, deeply moved I was by your Paris show.'

'I'm so glad you liked it,' says Francis mechanically.

'I wonder if you'll excuse me,' I butt in, getting to my feet. 'I'm not feeling at all hungry.'

Smarting and confused, I make for the door.

———

The next morning, coming round in David's ballroom-cum-bedroom, I ponder Francis's sudden savagery. He can be the most tolerant person in the world, accepting all kinds of weaknesses and oddities (except religious belief) in other people, but on questions of taste he's bigoted and unyielding. I'm no particular fan of Malcolm Lowry's, so I could have let it go. I was probably showing off to the smaller woman. Even so, his strictures are unfair and tiresome, and the reaction was completely out of proportion. Thinking back on it, I still find that taut white mask of fury one of the most frightening things I've ever encountered.

'Phone for you,' says David, coming in fully dressed. I'm always intrigued by the way he puts on coat and tie even when he's working at home.

'Hallo,' I say, tentatively. I can't think who can be calling me here.

'Is that you, Michael?' Francis says. 'Listen. I do hope you don't mind my calling you at David's. I've got to go out to do an interview so I thought I'd call before I left. I've got such a hangover that my brain is simply crackling with energy. I can't think what I'm going to talk about, though.'

'Well, I just hope that you don't talk the kind of nonsense you were talking last night,' I say. I want to say 'the kind of bollocks', but it doesn't come out like that.

There's a surprised silence on the line.

'The thing is,' Francis says eventually, 'I was wondering if by any chance we could meet at the Ritz this evening. Otherwise I won't see you before you go back to Paris.'

I relish my instant of power. But I have no doubt what the answer will be.

'Alright,' I say curtly. 'But I can't be there before seven.'

David has come in to an inheritance. He's always been better off than me, and very easy and generous with money. One of his passions at the moment is having white suits with bold lapels

and flared trousers made by Tommy Nutter in Savile Row and
ordering armfuls of flowered shirts in Jermyn Street. I have been
a willing accomplice on these expeditions and I've picked up a
nice Prince of Wales check suit in a sale as well as a couple of
understated but unmissable kipper ties. No one can say you're
not wearing a tie with one of these, I think as I prepare to sally
forth to the Ritz, carefully wrapping a piece of mauve silk the
width of a codpiece round my neck.

Francis on the other hand, once I've found him among the
potted palms and gentle Viennese music, is still wearing as ever
his loosely knotted black tie. His mood, however, couldn't be
more different from last night's.

'I've just spent the afternoon at one of those little gambling
places in Soho where I usually get completely cleared out,' he
announces exultantly as the waiters fuss round us bringing the
champagne and dainty little dishes of nuts. 'But this time I've had
the most marvellous win.'

He's kept his big black leather trenchcoat on, and he starts
rummaging around in one of its many pockets and produces a
thick wad of banknotes wrapped in cellophane.

'I've simply got masses of money,' Francis says loudly,
laughing, and looking round the sedate salon. A couple of the
waiters smile back at him, and one of them steps forward to pour
a little more champagne.

With his black leather arms outstretched Francis is trying
very theatrically to tear the wad of notes open with his teeth.
By now he is the undisputed centre of attention, with all the
hotel clients and the waiters following his attempts to get the
tight cellophane open.

'Ah,' he exclaims triumphantly, as there's a ripping sound
and suddenly the wad explodes and the space around us is thick
with large banknotes falling and fluttering. The room looks on
in amazement at this spectacular cascade of money. There is a
moment's pause, then the waiters all move in, as if on a paper
chase, reaching under tables, between ladies' feet and the fronds

of the plants. Whatever they bring back to Francis, he always hands over one large note as a munificent tip. He is clearly in his element, pink with enjoyment and drink, champagne glass in hand and laughing maniacally.

The temperature of the room seems to have shot up. People are talking animatedly. The waiters are darting to and fro, cracking open more champagne. The small string orchestra has moved into a livelier, more confident tempo. Francis is still laughing.

'It's mad,' he says, diving into an inside pocket. 'I've simply got masses of it on me.'

And suddenly another thick wad has appeared and it's in my hand and for a split second I wonder whether it's a peace offering and then how much of my mortgage and how many outings with Alice it will pay for before I slide it into my smart new jacket, a comforting bulge against my chest for the rest of the evening and an addictive resource for the wintry weeks to come.

The Inspiration of Pain

My studio flat on the rue de Braque is compact and sparsely furnished but it has everything I want. It's on the first floor of a seventeenth-century building in the Marais, with a high, beamed ceiling and one strikingly half-timbered wall. The street dates back to the Templars and over time my house would probably have lodged a few modest families or part of the retinue of a grandee occupying one of the big townhouses that dominate the area. At one end there are several imposing mansions on the rue du Temple and at the other the palace that belonged to the princely Rohan family before it was turned into a storehouse for the National Archives after the Revolution.

I've loved this area since I first came across it in my early wanderings through the centre of Paris. What's especially magical is the sense of fallen grandeur you get at almost every street corner. Most of these beautiful, aristocratic buildings are now in spectacular disrepair, since no self-respecting citizen would have considered living in the Marais once the detested *ancien régime* had been overthrown. Small artisans and other manual workers on the other hand moved in like mice, taking over the whole *quartier*, plying their humble trades in the grand apartments with their frescos and chandeliers and in the purpose-built, lean-to sheds they ran up round the privileged courtyards. Although it is still a fantastic place to get a frame regilded or a wrought-iron

balustrade hammered into shape, the whole area is now generally considered a bit of a slum, and although a few free spirits can be spotted buying their fruit and vegetables from the stalls on the street, it's certainly not a good address for anyone wanting to make a career in Paris.

Le Monde, the heavyweight daily newspaper where I've been employed as a writer and translator for the past year, came up with a paternalistic but very alluring scheme offering its staff interest-free loans to buy property. Realizing how much better off I would be in the future if there was no rent to drum up each month, I didn't hesitate. Since buying the room, I've been camping in its elegant shell wondering how to transform the space into the ideal bachelor pad. Luckily, among the friends I've made there is an odd character called Bernard, an upper-class misfit with a hangdog look who's been to a couple of parties I've given and who makes a living buying and doing up property on a minor scale. He's been visiting me at the rue de Braque and making suggestions about how to do it up in a clearly disinterested way, except for the fact that I'm pretty sure he's been smitten by a girl I know and thinks that by getting on the right side of me he will further his suit, or whatever the phrase is. At all events we've been to the demolition site of an ancient house on the Place Dauphine and carted away numerous old oak beams for free. With these Bernard thinks he can construct a split-level bedroom for me. I willingly act as the fetch-and-carry boy and I'm amazed at how quickly we renovate the space, with the bed and clothes cupboard upstairs, and a small bathroom and kitchen below, leaving the rest of the floor for a full-height study and sitting area. Bernard finishes this transformation with a flourish by constructing a fireplace for me as the centrepiece of the room, adding a suitably blackened, cast-iron coat of arms which we found locally, and to which I make no ancestral claim, as a back to the grate.

There's next to no furniture. Between the two tall windows I have an old refectory table from the Puces to work on, then

there are a couple of film director's chairs and a nondescript sofa disguised by a mohair throw beneath the mahogany bookshelves that take up the whole of one wall. Against the half-timbered side I've put a classic bistro table. There's one picture in the whole room: a fantastic small study for a pope which Francis gave me one evening, ostensibly because he liked a couple of things I'd written about his work. I think of it as a tribute to the decade that we have been friends, and for me its very presence in this new, hand-crafted space elevates my entire existence. It's a quintessential Bacon of the early 1950s, a ghostly head on a dark-blue background with white and gold highlights. I love looking at it hanging on a nail I've driven into one of the vertical beams behind the bistro table. I'm also conscious that it's worth more than my whole little apartment put together, and since it would be so easy to burgle the place with its flimsy front door I've had to come up with a few schemes for hiding it whenever I go out. I doubt whether there are many in the Marais who would even recognize a Bacon, but I should be devastated to lose it and I'm even thinking of renting a safebox somewhere to tuck it away when I'm travelling.

At the moment, though, I have no plans to go anywhere. There's plenty to do finding my bearings properly in the area and getting to know my new neighbours. Marie-Hélène and Bébert (which I imagine corresponds to our 'Bobbie') live next door to me and run the café on the ground floor which serves lunch and drinks all day until the evening. It doubles up as a *bougnat* and Bébert can be seen in sooty overalls from dawn to dusk delivering coal and other combustibles to clients in the area. I've become friendly with both of them and sometimes I go down for my midday meal and josh about with the regulars. There's a mixture of stallholders from the rue Rambuteau, metal-workers, gilders and furniture-makers along with the odd artist or photographer. Day in, day out, there's also a very old, white-haired Spaniard they call the 'professor' because he talks endlessly and unintelligibly in heavily accented French on any

subject from nuclear submarines to the soups he ate as a child in Murcia. Marie-Hélène is fond of him as well as of a smartly dressed younger man who I think must be her lover since I've bumped into him a couple of times coming out of their room while Bébert was busy heaving sacks of coke around the area.

I'm also having a lot of fun exploring the Marais in depth. It's unbelievable how grand some of the courtyards and staircases are, and occasionally you come across an old formal garden as if forgotten for centuries, growing wild and full of stray cats, between the perfectly sculpted, classical façades. The façades themselves are often so grimy they look as though they'd been hewn out of basalt, and it takes a while to decipher the figures, coats of arms and other heraldic devices that embellish them. A young French film-maker doing a feature for television on the decaying splendours of the area has asked me to write and record a commentary directly in English for it, and we are constantly clambering over these sublime architectural hulks to get better shots and more information.

I've got to know a few people in the area, unlikely characters for the most part. There's David Leitch, a former war correspondent who puts away the drink and is writing a book about his early life called *God Stand Up for Bastards*. In the same house on the rue de Poitou there are a couple of other shadowy Englishmen whose occupations sound so nebulous I imagine they must be spies of some sort. Ever since Vera, formerly John Russell's wife, an imposing grande dame I met through Francis, told me that spies are mostly engaged in relaying petty commercial information, I've started seeing them everywhere. A bit further along my own street, in the grandest and most dilapidated mansion of all, there's Claude Duthuit, a Frenchman who speaks perfect English. We've been practising guitar together with an Irishman called 'Spoon' O'Dwyer (I've never asked why) when Claude isn't travelling the world to indulge his passion for deep-sea diving and underwater exploration. It's almost by chance that I find out that Claude happens to be Matisse's grandson and so

belongs, I suppose, to a kind of art-world royalty. I'm impressed by this, of course, and even more so when I get a glimpse of the Matisses he has inherited. But what really blows me away is discovering that Claude's glamorous American girlfriend's first boyfriend was Elvis Presley.

At the moment I'm taking on whatever freelance work I can get, not only because I need the money to pay off the flat but because it gets me out of *Le Monde*'s office routine. I make a point of going to the more interesting *vernissages*, particularly at Galerie Maeght, and on the Left Bank Galerie Claude Bernard and Galerie Jeanne Bucher, where I know the owners and most of the staff. At Maeght I always talk to Jacques Dupin if I get the chance. I admire his rather stark, desolate poetry and he sometimes tells me memorable things about Francis. Jacques says he saw him recently in London when Francis was with some huge boxer into whose brawny embrace he disappeared regularly, only to reappear from time to time to continue the discussion he'd begun with Jacques about Velázquez's 'extraordinary technique'.

During these private views I've come into passing contact with a wide range of artists, from Miró, Calder and Brassaï to Dubuffet, Max Ernst and Tàpies. I'm thinking of doing interviews with a couple of them, though I'll keep quiet about that when Francis is around because he'll be more fiercely disparaging about each and every one of them if he knows I've been seeing them. The only one I might have got away with is Picasso (despite Francis's being very vocal about 'loathing' his late work), and while I've never been passionate about the whole Picasso phenomenon I am certainly fascinated by aspects of his extraordinary achievement and I'd been hoping to meet him at some point, possibly with Michel Leiris. But it's too late because, immortal as he had come to seem, Picasso is dead now.

One of the huge advantages of having a place you're proud of is that it's easy to invite friends there. I've done dinners and parties, none of them lavish but I think they've gone off well

partly because people like the space and feel at ease in it. Francis has come round several times. I've never cooked for him, as I have often for Alice, because I know he prefers the ritual and glamour of expensive restaurants. But I always keep something drinkable on hand and he seems to enjoy having an apéritif here before going on to more serious eating and drinking in the Halles. I always make sure the painting is in its place, of course (even if I quickly bundle it up again behind the sofa before we leave), and I notice how critically Francis looks at it, as if he were taking it apart, just as he does when he's in front of other people's work. His eyes are always piercing, even when he's in a jovial mood. He's been looking up at my unmade bed on the split level, and when I make excuses for the mess, he stares back at me with a wide smile, saying, 'I like unmade beds, but I like them unmade by love. Now how would you put that in French?'

I think for a moment, always glad to be caught up in some linguistic game.

'Well, probably something like *J'aime les lits défaits, mais défaits par l'amour*, or I suppose *par la passion*.'

'No, *l'amour* will do,' Francis says promptly, then repeats as if he's learning a phrase in class: '*Défaits par l'amour*.'

The object of this sudden attention is actually about to be made up because Marina, the cheerful Spanish woman who gives my flat a weekly clean, comes in around this time of the evening. If I hadn't completely forgotten about it, I might have put her off, thinking that her bustling about the place might prevent Francis from talking freely, but from the moment she comes in the two of them hit it off, with Marina making a special effort with her limited French to exchange pleasantries with Francis, who is as elegantly amiable with her as he would be with an important collector's wife.

Having finished my two bottles of white Burgundy, we decide to let Marina get on with her job and see where we might go for dinner. It's dark now and cold for an early-spring evening.

'She's got a marvellous smile, your cleaner,' Francis says as we go along the rue Rambuteau, where the fruit is being packed away and the stalls dismantled, leaving a trail of rotting apples and cabbage leaves in the gutter. 'I thought there was something very free and sympathetic about her, and then I realized she must have been a prostitute when she was younger.'

I absorb this revelation cautiously because it has never occurred to me that Marina ever did anything other than housework, although I'm quite aware that she isn't particularly interested or good at it. The idea that Francis is convinced she used to turn tricks for a living intrigues me, though, and I realize that this new interpretation might account for the equivocal way Marina looks at me sometimes while I'm trying to write and she's ironing my shirts a few yards away. And if I'm totally honest I would have to admit that, although she's no pin-up, I have had distinct stirrings when Marina gets down on all fours like an old-fashioned char to scrub the floor.

I mention this to Francis, tentatively enough because, although I don't often share such confidences with him, it seems only fair that I should open up from time to time to him as he does regularly to me.

'Well, I think those sorts of things are very interesting,' Francis says. 'In some ways, they are *the* most interesting because there you are operating completely at the level of instinct, and that unlocks all kinds of different areas. I mean, pleasure is such a strange thing, really. And so is pain. We experience them the whole time, but it's impossible to really analyse them or say clearly what they are. And then people make all kinds of moral differences about these things, mainly because of the Church, I suppose, but of course it's ridiculous. You can only try to follow out your instincts, though of course I don't think many people even know where their instincts lie.'

We've walked past several restaurants, including the Chien Qui Fume whose name amuses me and which seems to have been there for ever, but it looks distinctly dowdy and unappetizing

and we end up at the Pied de Cochon, an old standby for me since I often go at lunchtime to have their traditional dish of grilled trotters and chips, standing at the zinc-lined counter; with a draught beer thrown in, it only costs a few francs. Francis likes the place as well, even if it's become a little too well known as the place people go to at the end of a night out to eat onion soup under its fluorescent strip lights in the hope they will stave off the hangover lying in wait for them next day. We've been here together quite often before, and once, when we were in a party of people from the Galerie Maeght having a late-night soup, I wandered drunkenly off into the night with one of the wives, and although nothing came of it, I was mortified at the embarrassment I might have caused Francis, to say nothing of the husband, although mercifully neither ever referred to the incident thereafter.

We push open the door with its trademark trotter handle and find the counter packed with porters from the food market in their blood-smeared white gowns having a quick Calvados between hoisting sides of beef off lorries and humping them on to the huge meat hooks that line one side of the Halles's cavernous iron and glass pavilions. I think back briefly to my contact with *action directe* and reflect how lucky I am to be living still in a city that, so far, has kept both its 'belly' and its Sainte-Chapelle intact. We've been sat at a table where we can watch the flow of clients to the bar. Francis seems particularly alert and I imagine the sight of so many powerfully built, bloodied men might have something to do with it. If he wasn't so fascinated by the spectacle I suspect he would have ditched the thin, bitter Muscadet we're drinking, which tastes more like Gros Plant and compares unfavourably even to the modest Aligoté I gave him, but I can see he's revelling in the atmosphere of a place where human appetite is so clearly displayed.

'I often come here for a quick lunch at the bar,' I say, trying to re-engage his attention.

'Well, it's so marvellous that you've managed to make your way in this city, which for me has always been the most beautiful

and interesting city in the world,' Francis says, detaching his gaze from the beefy backs at the counter. 'And when you come to a place like this, you feel you can see the whole cycle of life being directly acted out in front of you. It's the most marvellous spectacle with all that meat being carried around when you see the beautiful colour of it and everything.'

'I'd never really been conscious of the actual colour of meat before you mentioned it. Now I see it not only at the butcher's but in Soutine and Rembrandt and—'

'Well, I think of all creative people painters have a particular clarity of sensation because of the particular artificiality of image-making,' Francis says, signalling for another bottle of the Muscadet. 'Being clear, after all, is so important. Was it Voltaire who said whatever can be clearly thought can be clearly expressed? Oh, was it Boileau? Ah but then Voltaire also said what's too silly to say can always be sung . . . I suppose that German king, what's his name, Frederick the Great, must have been in love with Voltaire. But of course one doesn't know what Voltaire's tastes really were.

'As you know, I've always been what you might call completely homosexual. Nobody can say anything for certain about these questions, I know, but they seem related to the very pattern of one's nervous system. I myself believe that at the very moment of conception you get a kind of blueprint of what the nervous system's going to be. And then there's not much you can do to change it later, not even with psychoanalysis and so on. It's like having a limp, and you're what's called stuck with it. But I do think that the division between the sexes has largely been invented. Terribly few people are just one thing or the other. I think that was the case for poor George – he didn't really know what he was sexually.'

Two large steaks oozing blood and fat are set before us. Francis scans the wine list for a suitable red and orders a Burgundy which clearly impresses the wine waiter and will no doubt treble the bill.

'The thing is, Michael, as I've got older, my interest has grown much more for my work than for my life. It's inevitable. You see, I don't want to be like those other old fools and be what's called playing footsie under the table at seventy. Now that poor George is dead, I know that I will never have a really intimate relationship again. I'm too cynical – or what's the word? – to believe in that sort of thing any more. In any case, there's something terribly depressing about old people in love. Well, for one thing, because their bodies no longer function perfectly. I've always liked bodies that function perfectly, and of course with age that side of things goes. I don't believe in love any more, even though I have been in love. Still it's true that when I look back on those experiences, even though everything about them was disastrous and couldn't last, they did deepen my feelings about life.

'Homosexuals become more and more impossible with age, you know. What? Well, I mean in the way they're so obsessed with the physique. They're ruthless and precise about appearance because they never stop thinking how they and everybody else look.'

Francis pauses, waiting while our glasses are refilled, as if wondering whether to go on.

'It's like an illness, or a defect – homosexuality. It's like having a limp. Real homosexuality, anyway. Of course the division's been invented to an extent. So many of the people I've known just drift from one sex to the other. Take this new friend of mine. He's like so many men. He's married, but it hasn't worked. He went with me for the money to begin with. Naturally. But now he comes back because for some reason I amuse him. They go with you for the money first, then they come back because you amuse them more. That's all there is to it.

'Sometimes I meet these young men who are in such a state not knowing what they are or what to do with themselves, and all you can do is to tell them that nobody cares. After all, who really cares about those things? All you can do is to try to what's

called pull them through their despair. It usually doesn't help, I'm afraid.

'You know, I don't actually like what are called homosexuals, and I hate it when they go on and on about being queer. I actually prefer men who aren't queer, or who don't think they are. In the beginning at least. Afterwards, of course, they're just as boring as the others. I only want extraordinary people now. As I have had one or two extraordinary people in my life, all the others simply bore me. Almost all men are terribly weak, once you get to know them. What I've always longed for was someone who was tougher and more intelligent than myself.

'Most of the time I meet only brutes. I'd love to be with someone I could really talk to – but I've never been able to talk to the people I've been obsessed by. That whole side of life has been a catastrophe for me. I mean I've always thought it would be marvellous to succumb utterly, as they say, to someone. It's rarely happened to me, and then only for a very short time. I've always turned out to be tougher. You might think that's monstrous. It is monstrous I expect. But there it is.'

Without further ado, Francis pulls out a crushed bundle of notes from his trouser pocket and settles the bill. I sit there, bemused by the amount of information he has suddenly provided me with and anxious that I might not be able to recall all the details and the changing emphasis and intonation of everything he has told me before I can get back to the rue de Braque and actually note it down. We join the bloodied backs at the bar for more drinks. To pay for each round Francis digs deep into his pocket, flashing his expensive gold watch, and pulls out the large money ball, apparently not noticing the odd large note that flutters off into the sawdust on the floor – a performance that several meat porters follow with undisguised interest. We get progressively drunker and Francis begins to repeat virtually everything he has said at dinner, adding a new phrase here – 'Well, there it is, homosexuality is both more tragic and more banal than what's called normal love' – and a different intonation there – 'I really

detest those dreary effeminate queers who drone on and on about being queer' – until the whole monologue seems to have slipped in on the back of all the wine we've had and are still having and starts going round and round my mind unstoppably, a little change here, a new word there, until I'm not so concerned about whether I will remember every last gesture and phrase as much as I am about whether I will ever be able to get the revolving refrains out of my mind and have thoughts of my own again. I long to break free as the sight of so much blood and meat at the bar and the insidious smell of grilled offal and onion soup make my gorge rise and I bid Francis goodnight, leaving him at last there where he wants to stay among the gory porters downing their chops and trotters. And I weave out into the night beside the great caverns filled with dead animals and pyramids of fruit and under the looming buttresses and gargoyles of Saint-Eustache with the smell of death and food stuck in my nostrils and the same words still drumming themselves into my head.

Francis has really taken to the area. He's been back a couple of times and when we last had drinks in my place he even said he'd love to find a similar studio space for himself in Paris. It sounds like one of those sudden enthusiasms he gets and we'll probably hear no more about it, but I'm flattered he likes my flat and the life here so much. On both occasions we ended up at the Halles. The last time nearly turned into a disaster. We'd been lurching from bar to bar and just as we were going to cross the meat market Francis slipped (on what looked like a pool of blood) and just managed to hang on to an open container. I moved instinctively towards him and saw that the container was filled with damp calves' heads with jellied eyes and neatly severed necks ending in a little ruff of lymph and blood. Rather than bringing the long evening to a close, the near-fall seemed to energize Francis who looked closely at the next container which held a mess of foam-specked tongues. They looked like uprooted screams, and

just as I was wondering whether to share that thought Francis wandered down the alleys of meat where the sides of beef were still swaying under their inanimate weight. 'Life's just like that,' Francis said, jabbing his big, meaty finger towards the nearest carcass. 'We're all on our way to becoming dead meat. And when you go in that restaurant we went to you see the whole cycle of life and the way everyone lives off everything else. And that's all there is.'

He's also been back to the *café-bougnat* beneath my place and become something of a local hero by buying drinks, as he does in the Colony, for everyone in sight. Both the *professeur*, still jabbering away, and the man I take to be Marie-Hélène's lover lapped up the largesse as did several fruit-and-veg sellers from the rue Rambuteau, including a tall, usually taciturn one who is Algerian and who invoked Allah, I think in praise, each time Francis stood a new round. Since Francis seems so at home in the place, I've been thinking it might be an idea to do a lunch for him here. The food is fairly basic, but when she puts her mind to it Marie-Hélène can produce a very decent *boeuf en daube* in the cupboard-like kitchen she has at the back, and I can make sure we've got the right wine to wash it down with. Francis would probably go for it, for the same reasons as he was drawn to the East End. He has almost romantic ideas about the working class – that they're more genuine, closer to their instincts and so on. He'll also feel that he's getting closer to *la France profonde* here than in luxury establishments like Taillevent and the Grand Véfour. That way I'll be able to repay a tiny bit of hospitality for once. The only problem I can foresee is that the kind of people it would make sense to invite to a lunch for him have probably never even seen a *café-bougnat*, let alone actually eaten in one.

I choose a date with Marie-Hélène just before Francis is due to go back to London. We plan the meal and choose a very good *saucisson* she gets sent up from her native Auvergne and a lentil salad that she can prepare in advance. I order in plenty of Côtes du Rhône which should go well with everything. Bébert

usually does the serving and everyone in the café is used to him crashing through the tables in coal-smeared *bleus* and virtually in blackface from the sacks of coal and coke he carries on his shoulders. In fact I've only seen Bébert scrubbed and in freshly pressed overalls once, and then he looked so different I almost didn't recognize him. Marie-Hélène gets the message (in her case Francis is quite right, she's uneducated but as smart as a whip) and says she'll make sure Bébert is at his most *élégant* for the fancy folk I'll be inviting. I'm impressed myself by my list of invitees. There'll be Francis's prospective new Paris dealer, Claude Bernard Haïm, and his sister Nadine (whom Francis gets on especially well with), Michel and Zette Leiris, of course, and Picasso's printmaker, Aldo Crommelynck, and his stylish wife, who have gained my vote by inviting me once to a dinner where the only other guest was Catherine Deneuve. All my guests are considerably older and better established than me, and now that the die is cast I'm half convinced this little event will backfire and cost me whatever minor standing I have managed to achieve in the Paris art world.

As always Francis is a bit early, but I'm relieved to see him greet Marie-Hélène and a smartly turned-out Bébert warmly and begin to chat to some of the regulars he knows. Claude Bernard and Nadine come next and although they're surprised by the rustic surroundings they quickly focus on Francis, whom they're hoping will agree to a show in their gallery. Aldo and his wife, both tall and chic, take the café nonchalantly in their stride. Bébert pours the wine and presents a platter of *saucisson* with aplomb. Then the Leirises, brought in the Mercedes by their chauffeur, arrive. Zette, in cashmere and pearls, hesitates at the entrance, clearly thinking there must be some mistake, but as Francis hails her cheerfully from our large table she begins slowly to cross the room as if picking her way through a snake-infested jungle, with a puzzled-looking Michel, immaculate in Savile Row suiting, bringing up the rear. Having looked round the café I realize that some of the midday clients haven't taken kindly

to this sudden eruption of *le tout Paris*, so I quickly ask Bébert
to circulate the Côtes on their side too. The atmosphere eases
a bit, rather like an aeroplane that's come through turbulence
into temporary steadiness, above all because Francis is clearly
in his element, appreciating the roughish wine and praising
Marie-Hélène's lentil salad as if a renowned chef had just set
his signature dish before him. Even Zette seems to have thawed
a little as Michel and Francis exchange elaborate cordialities
and our group provides a clearly differentiated, better-dressed
bulwark against the regulars, whose clothes make them look as
if they are about to put on a Beckett play. I feel it's about time
Bébert brought the main course and, although I keep topping
up the glasses and Francis makes sure the conversation flows, I
gesture to Marie-Hélène who gestures back that Bébert has had
to go out but will soon be there to serve the *daube*. To my alarm I
then see Bébert come lurching back with his cap askew and vivid
coal smears covering his shoulders and face like tribal marks.
I can only imagine he has been called out by some old, infirm
person in urgent need of fuel, and meanwhile I register all too
keenly the look of alarm that flits over Zette's primly composed
features. This, I think, could deal the coup de grâce to what is
already a touch-and-go situation, and I can just hear the gossip
circulating through the galleries round the rue de Seine ('Did
you hear about Peppiatt's lunch for Bacon in a coal-hole in the
Marais?' 'Doesn't surprise me. After all Bacon's done for him,
you'd think he'd have the style to take him and the Leirises
somewhere decent'). I'm just hoping and praying that no one
asks to go to the café's loo, beside which any Auvergnat jakes or
Arab latrine would seem pristine. Francis, meanwhile, appears
to be enchanted by Bébert's lumbering, coal-smeared presence,
as if it were just the note that the feast had so far lacked, and
he pours Bébert a bumper glass of wine and insists on clinking
with him, at which point Bébert himself seems transformed and
rather than whacking the plates of *daube* down any old how he
adopts the formal guise of a trained maître d'hôtel, straightening

the chequered oilcloth, rearranging the cutlery and with a hanky delicately removing the sooty imprints of his fingers from the dishes with which he regales his clients who now are so converted to the *café-bougnat* style that they wonder out aloud why they have never eaten here before and how from now on they will be back often and with friends. And as one they join Francis in raising their glasses in a toast to Marie-Hélène who has just emerged from her kitchen-cupboard in a flimsy apron with the inwardly glowing grace of a diva ready to receive her rapturous applause.

Francis has called to say that he has something to discuss with me before he goes back to London tomorrow. My first reaction is that I must have put my foot in it one way or the other, even though the lunch turned out against all odds to be a success and I can't think of anything I might have done to annoy him. We decide to meet at his hotel for a drink and when he gives me the address I realize with a shock that all this time he has been staying at the Hôtel des Saints-Pères where George killed himself. And if he's there, I suppose once I start thinking about it, he must have booked himself into the very same room they were sharing when he died, macabre though that sounds. Of course it is macabre, and if I were ever stupid enough to ask him about it I'd either get the sharp side of his tongue or he'd fob me off with some blind or other about the manager having been so understanding about George's death that he couldn't think of staying anywhere else. I wonder whether his returning repeatedly to the scene like this is a form of self-punishment, a deliberate aggravation of his guilt, or could it be, monstrous as it sounds, a way of absorbing the facts and circumstances of the death more fully, almost like a writer researching or an actor preparing himself for his role, since I know Francis has been working on several pictures directly inspired by the memories he has of George? I've seen ektachromes of a couple of them, and they have an extraordinary grandeur to them, both simple

and factual, that puts them among the most memorable paintings
he has ever done.

I always leave enough time to walk wherever I have to go in
Paris. It gives me a moment to collect myself, although I often
find I'm just as tense and confused when I arrive as before. Even
so, it's always a pleasure to cross the Seine, and I love to see the
sun sparkle on the water and light the gold ribs on the glittering
dome of the Institut de France, my single favourite building
in the city. But I feel apprehensive and I start thinking about
George and the other people I have known who are now dead,
just plucked out of the air and forever absent unless you chose
to bring them back as memories, and in particular of Danielle,
the writer I became close to during the '68 'events' who has,
I've just discovered with horror and guilt, also killed herself.
Strangely she crosses with me over the Pont des Arts and up
the little streets, hanging like a shadow in the sunlight as I walk
along the Boulevard Saint-Germain and turn up the rue des
Saints-Pères.

Francis greets me genially, which is a relief, and he seems
filled with energy, although I can hear a slight wheezing as he
breathes. He's drinking a whisky in the lobby of the hotel, and
I follow suit.

'Now listen, Michael,' he says. 'You know those interviews
that David Sylvester has done? Well, a publisher called Skira has
asked whether they can bring them out in French and David
has asked Michel whether he would translate them. Now Michel
says that he would but he's not sure that his English is good
enough to understand all of what's called the nuances. I wouldn't
have thought myself that there was much nuance in what I say,
but anyway we've talked about it and wondered if by any chance
you'd have the time to do a kind of literal translation of them for
him. I know it might be a bit of a bore . . .'

'No, of course I'd love to, Francis.'

'I know it's a lot to ask so are you sure you wouldn't mind? I
know everybody would be very pleased.'

Thinking of the jobbing reviews I would have to put to one side, my only problem is to disguise quite how delighted and excited I am.

'It would be a pleasure, Francis,' I say, taking a measured sip of my whisky. 'Think what a privilege it would be for me to work with a master of French like Michel.'

'Well, I'm so glad you think that, Michael,' Francis says, and we clink glasses.

I've done Sylvester's whole first interview with Francis into basic French and sent it to Michel. It's not as difficult as I feared, although the exchange does have nuances that are hard to catch in another language and often sound a bit weird since I have to stick to whatever the most literal, word-by-word version would be, even if it's going to make me look clumsy and uninspired when Michel gets down to transforming the lumpy result into elegant, flowing French. We've decided to have our first meeting this morning and Michel has suggested we work for a couple of hours at the Deux Magots and then go somewhere locally for lunch. I'm nervous when I arrive, not least because I feel I have fleetingly joined the ranks of the writers I admire by having a project under way with an eminent former Surrealist in a café where Joyce and Picasso, to say nothing of Sartre and Camus, have sat and worked and argued and generally carried on, somehow changing the course of art and literature as they did so. I don't think Michel and I are going to change much of anything this morning. He seems particularly buttoned up and formal as we shuffle his version and my version of the interview from side to side. Still, it's fascinating to see how much my text has changed: there's an incisiveness and flexibility in the French now that I could never have dreamed of. The only problem is that every once in a while the French conveys something manifestly different from what was intended in the English original. I broach this very gingerly but Michel is adamant, saying that he looked up the word in

his Harrap's French–English and that is one of the meanings given. I try to intimate that, even if Harrap's says so, I know it's not what Francis intended but I can almost feel Michel digging his heels into the café floor and realize this is going to be an uphill battle, though I plan later skirmishes because I owe it to Francis to ensure basic accuracy and wonder whether I might eventually have to involve him to persuade Michel to reconsider a few of his renderings.

After several more tugs of war and a couple of cups of coffee, Michel and I wander out on to the Boulevard Saint-Germain and decide to have lunch at a family-run bistro almost opposite the offices of *Cahiers d'Art*, one of the artistic and literary journals I revere most, to which among his myriad other achievements, I remind myself sharply, Michel has almost certainly contributed way back before I was even born. Suitably chastened, I sit squarely opposite him for what I imagine will be a quick, frugal meal, wondering whether I shouldn't back down over certain points in the translation out of respect. However, Michel's attention is focused on the wine list from which he eventually chooses the new Beaujolais, saying that would be best as a lunch wine because it's so light and I agree cheerfully although from past experience I know that Beaujolais has a treacherous undertow that gets you drunk more quickly than any other wine going. We're well into the first bottle before we've even looked at the menu and Michel is suggesting that since it's such a light wine a second bottle would be in order and from being thoroughly constrained, with his stern features constantly twitching, he begins to relax quite visibly, glass by glass, as thought it were a potion, which in many ways I suppose it is, and he becomes voluble about his life and his writings, which I've come to know quite well, insisting more and more that everything he has ever done is worthless and he himself is a sham because although he has taken certain literary 'risks' they are nothing compared to real physical risks which he has never the courage to take so that someone whom he detested and

whose face he would like to slap publicly like General Bigeard, famous for the torture he carried out during the Algerian War, is in fact demonstrably superior to him because he has at least proved his bravery in war.

I am caught completely off guard because I have never seen Michel this communicative, not to say so fiercely self-deprecatory, before. I remind him that during one of the Surrealist escapades he had shouted out in front of a crowd 'Down with France' at a particularly sensitive moment in the Rif war in Morocco and that he would have been lynched if the police hadn't intervened.

'That was nothing,' Michel replies in a definitive tone. 'I am a coward and a *sale bourgeois*, and that's that.' And as if to emphasize the point, he orders another bottle of Beaujolais.

I try to change the conversation. I've heard that Picasso's dealer, Daniel-Henry Kahnweiler, who has been living with Michel and Zette for years, has been very ill, so I ask him if he's any better.

'Yes, he's made an extraordinary recovery,' Michel says. Then he grins suddenly, baring large teeth, with all tics gone. 'We gathered round his bed thinking he was about to die. Then he suddenly came to and we asked him, timidly, if there was anything he wanted. "Yes," he said, "*une saucisse-frites*"!'

By the time we leave the restaurant Michel is clearly unsteady on his feet, so I take his arm and we walk back to his apartment on the Quai des Grands-Augustins. I wonder whether he'll have to confront Zette in his inebriated condition or whether he'll be able to slip unobserved through the dark discreetly luxurious interior lined with Picassos, Légers and Braques, to his study overlooking the Seine. As we stand in front of the fortress-like door, I sense that Michel is about to re-enter a world of convention where self-exposure is taboo.

Just before he disappears into the building's gloom, he turns and repeats, like an urgent message to the outside world:

'The truth is I never had the courage to risk my skin. I am just a *sale bourgeois*.'

'Michael, is that you?'

'Yes, Francis.'

'Look, I'm terribly sorry to bother you like this but I've just been wondering whether by any chance you *could* find me a place like yours in Paris, as I think you said you might be able to do. I've been thinking about it ever since I got back to London.'

'Of course I can. I'd be delighted to.'

'I'm not looking for anything grand. Something simple where I could work and sleep. That's all I really want. I do feel London is terribly dreary at times and I'd love to have somewhere in Paris.'

'Well, why don't I round up a few places for you to see and you can take a look at them when you next come over?'

'That would be simply marvellous. I'll come over as soon as you think you've found a few places.'

I put down the phone feeling both elated and puzzled. I'd jump at the chance of being useful to Francis, particularly since it would mean he'd be coming to Paris more often. But I can't think why he'd want all the bother of having a place of his own when he loves staying in hotels and having everything laid on for him when he feels like it. He's also in his mid-sixties, which seems to me rather old to be starting a new adventure in life, and it's not as though he's ever found a place outside Reece Mews where he's been able to work. Still, I like the idea of finding a perfect studio for him and I put out the word among those of my artist friends who, and there are a few of them, have a very good eye for property. Before long one of them gets back saying that he knows of a magnificent studio for sale where Puvis de Chavannes worked and that the American owner would immediately drop his price if it was Francis Bacon who wanted it. I go along to visit and the space is indeed fantastic, a traditional nineteenth-century atelier with high ceilings and

vast windows, and with the reduction the price seems very reasonable. But it's not in the Marais, so I also do the rounds of the estate agents and settle on a space more comparable to mine, but bigger and more stylish, in an impressive, classic townhouse on the rue de Birague, which leads from the Place des Vosges down towards the Seine. The main room overlooks a quiet cobblestone courtyard and has a north light coming in through two lofty windows.

Francis arrives as planned and we go to visit the grand atelier and although he is very amiable to its American owner he tells me it's altogether more than he wants. We jump into a cab and go to visit the second option. The moment Francis walks in to the room he looks round and says, 'I know I can work here,' and that seems to clinch the matter. He scarcely looks at the kitchen and bathroom. Things seem to me to be moving too quickly, particularly since the estate agents have lined up several other places for him to see and the owner's asking price for this one is exorbitant, especially in comparison to what I paid for mine. I feel I'm exercising due caution but Francis brushes this notion aside.

'Let's just give him what he wants,' he says.

'But, Francis, no one in Paris ever pays the initial asking price on a place.'

'It's so rare to find something one wants that I can't really be bothered to what's called negotiate, Michael. And I'd like you to have the place and look after it for me.'

'I can just look after it, Francis,' I say, alarmed by the sudden turn of events.

'I'd like you to have it, as long as I can stay here when I want.'

'That goes without saying, Francis. But wouldn't it make more sense if it was in your name?'

'Well, it wouldn't actually, for all sorts of reasons. And I don't want the bother of owning things. I'd really be very grateful if we could do it in your name.'

I go back to my own less glamorous flat and spend the next couple of days in feverish speculation. Obviously I could hardly have dreamt up a more marvellous offer. There's not only the fact that owning something substantial would make my still pretty much hand-to-mouth existence in Paris less precarious, but the alluring prospect that I would be a more established and more obviously useful part of Francis's existence than ever. But while his trust in me is hugely important and flattering, I'm uneasy about getting ever further into his debt. I try to reason that this kind of conflict comes from my essentially puritan upbringing, but I just can't fob myself off. As I worry over this apparently insoluble contradiction, I find myself staring at the little papal head on the wall as if the anxiety inherent in the portrait's confused, blurred features might help resolve my own. A prominent Parisian art dealer has been making all kinds of advances towards me over the past few weeks, taking me to expensive restaurants as if simply for the pleasure of my company although at some point he always mentions how keen a wealthy client of his would be to own a Bacon painting. I've told him flatly that I have no intention of selling it, but suddenly the notion takes on a new significance. If I could get enough from the picture to pay for the flat, the problem would be solved, since I'd be able to do Francis what he calls a 'favour' without increasing my indebtedness to him, and incidentally not having to worry whether the picture would be stolen or go up in flames every time I went out.

Francis is back in London now and I'm a bit concerned he won't accept this solution since he always insists on paying for everything himself, perhaps thereby keeping control of any given situation, but when I suggest it over the phone he accepts the idea enthusiastically, so I put both the purchase of the flat and the sale of the painting in motion. I'm very sad to be parting with my *Pope*, which has acted as a kind of talisman for me, the act of owning it reinforcing my sense of identity and self-belief. On the other hand, I like to think that I am growing less romantic and more mature, and that I

should heed the more practical side of my nature which argues that an artist's reputation is almost chimerical by definition whereas a property next to the Place des Vosges can hardly fail to go up steadily in value. I've never been through this kind of reasoning before, and I'm amused by the idea that from eking out a living in journalism I might soon be a man of substance as well as being very pleased that Francis will now be spending more and more time right here among us in the Marais.

There are archaic, almost medieval aspects to purchasing a property in France, and the whole transaction has taken considerably longer than anticipated. The money is being held in escrow by the notary, and tomorrow we should at last be signing off on everything and I should be handed both the deeds and the keys. Francis is already over here, clearly excited by the prospect of having his own place in Paris. We're having an early lunch at the Coupole, where I haven't been in years, and when I get there he's already sitting over a café au lait. Since he always seems to arrive before everyone and be the last to leave when we hit the bars I wonder how he finds the time to work in between while keeping so many different friendships and all the other areas of his life going, even though I know he gets by on very little sleep and that when he focuses on a new image it tends to come off quickly if it's going to come off at all. He's in a fairly sombre mood this morning. We discuss 'despair', a favourite notion of his, and when I make a remark to the effect that 'people only have the despair they can afford', he tells me, 'You've just said something very profound,' and I feel absurdly proud. Meanwhile, Francis has been eyeing a puddle of milk on the table, and as though giving in to an impulse he had been repressing for some time he suddenly dips his thick white finger into it and draws a shape. I tell him we'll have the keys to the flat tomorrow, and he suggests that I pick up some champagne and a few glasses and we meet there with Sonia, who's in town, and his would-be dealer's sister Nadine Haïm to celebrate before we go on to dinner together. A

waiter comes to lay the table and suggests we might try a *petit vin léger* that's on offer, to which Francis replies balefully, '*Pas trop léger,*' before going through the wine list and ordering a very full-bodied red Graves. The brasserie begins to fill up and Francis has focused with unusual malevolence on a flamboyant, statuesque woman who's been behaving as if she were a famous star throwing tantrum after tantrum at a table across the large, noisy room. At one point the woman gets up and sets off for the toilets. When she returns, she walks past our table in a cloud of perfume, at which Francis, as if no longer able to contain himself, bursts out: 'She goes down to have a shit and comes back smelling of roses! There it is. We eat and we shit, and that's about all there is to life if you really think about it.'

The food is mediocre, which does nothing to improve Francis's mood. I remain very neutral about everything, because I know from past experience that enunciating any kind of opinion about anything is likely to be a red rag to a bull. Just as we're preparing to leave, David Hockney arrives with a couple of American painter friends, Shirley Goldfarb and Gregory Masurovsky, and comes over to kiss Francis affectionately on either cheek. As David moves on, Francis takes out a handkerchief and wipes his cheeks very elaborately.

'Now I wonder why he did that?' Francis says to me. 'I suppose he must have some ghastly disease.'

The following evening I arrive jingling keys with several bottles of Cristal, a champagne Francis has developed a notable taste for while in Paris. Like a seasoned barman, I stow these away in the fridge and polish the glasses. Alice arrives first and admires the space. Then, clearly already drunk after what must have been an epic afternoon, Francis, Sonia and Nadine make their entry. I pop open the champagne and make sure everyone's glass is kept filled. The empty new space is suddenly filled with loud, lively conversation and slightly hysterical laughter. Sonia and Nadine vie with each other to advise Francis which bed to buy

and where to stock his kitchen. Francis seems to find the whole event hugely amusing, although I know that, like me, he hates the unsightly gold-and-black flock wallpaper chosen by the former owner – an almost comically pompous architect who has bought up and 'developed' the whole house while describing in detail to everyone who will listen the myriad advantages of his tasteful renovation of the various flats he has put on the market. Francis is clearly itching to do something about it and, as more bottles are opened, he tells the ladies how much he'd like to get rid of the wallpaper and have everything painted simply in white. Suddenly Francis goes over to the wall and rips off a large swathe of the offending wallpaper without further ado. We all applaud, then move in with gusto to help, grabbing handfuls of the stuff which peels off with admirable ease, until the parquet floor is ankle-deep in flock and we are all guffawing like student pranksters until we realize that the studio door has been left open and the pompous architect, his mouth literally agape, is standing there watching the spontaneous destruction of his art.

'Since all the people around me have been dying like flies,' Francis's most recent refrain goes, 'I have nothing to paint but this old pudding face of mine.' It's an exaggeration, like much of what he says, but it reminds me that on a couple of occasions we have discussed the idea that he might paint my portrait. Those things are easier said than done, I know. I've been seeing a bit of Henri Cartier-Bresson recently, and he's suggested photographing me but no date has ever been set and he's never come back to it, so neither have I. Perhaps when he says he wants to photograph me, he means he wants to photograph Francis, since I'm coming to be seen in the Paris art world as a sort of gateway to him. I know that someone Francis has portrayed began by deluging him with photos, so rather than bring the subject up again I've asked Alice to take lots of shots of me, full face and profile, and quite a few full-length ones stripped to the waist. Francis seems quite interested in them, then one evening he explains to me that

I'd have to shave off my beard and have the photographs done again because he needed to 'see the bone structure clearly' before he could embark on a portrait. I always keep my beard trimmed short, so this sounds evasive to me, even though it's true to say that I can't think of any bearded men in his paintings. But what, I wonder, would I feel like if I did shave off my beard, which has become part of my personality, and then Francis still didn't see his way to painting me? I decide in favour of the beard.

Francis has just done two heads of Michel Leiris which capture the extraordinary mobility of his face with quite uncanny accuracy. They are also beautiful, inventive images in their own right. What people seem to forget in all the talk about violence and distortion and the legacy of the death camps and so on is his delicacy and skill simply as a painter. Here he hasn't been as radical or destructive as in some of his portraits of George or in his self-portraits, where perhaps he feels much freer, but in one of the Michel heads he's cut out the whole temple and replaced it with a dotted line joining the nose to the isolated ear. It makes me think of the Valéry line that Francis likes to quote about 'giving the sensation without the boredom of its conveyance'. If I'm particularly impressed by this head, it may be partly because Francis has chosen to give it to me. I protested, feebly enough, but he insisted he wanted me to have it because he's so pleased with the translation I did with Michel, saying he sounds so much more intelligent in the French version (though that could hardly be credited to me). A couple of painter friends of mine have come round to see the new picture hanging on its nail, and one of them, an extraordinary character from Montenegro called Dado, has given me an enormous, very powerful oil painting of his – a collage of fragments of figures – not only because we're old friends and I've written about his work, I suspect, but because he wants it to be hung in the same space as a Bacon.

I've been down to the studio a couple of times since Francis has moved in and started working. He's obviously delighted to have a place here, and I've been wondering whether one of

the reasons he made up his mind to take it so quickly was the address: 14 rue de Birague. I'm pretty sure Francis has a thing about numbers, odd though that is in someone who furiously eschews any form of belief or 'superstition'. It may come from some gambling strategy he has devised, but the number 7 is key. Several of his previous studios have been at a number 7, or a multiple thereof, and when I tell him I'm hoping to move to a new, larger flat at 77 rue des Archives, the idea seems to appeal to him instantly. It's also not for nothing, of course, that he has his permanent abode at 7 Reece Mews, London SW7.

The chaos in the Paris studio is nothing like Reece Mews but it's growing. There's a big trestle table beside the easel that's already like an archive of the way he works. It's covered in dried brushes, half-used Winsor & Newton paint tubes, Sennelier pastel sticks, acrylic sprays, old colour-caked socks and sweaters along with several green-and-gold-edged dinner plates from Heal's and even a brand-new frying pan that have been used to mix colours. The latter always stands out, because where you might expect to find a couple of fried eggs, you get a rich, pounded swirl of bright oils that, like a signature, could only be Francis's. Similar patches of paint reappear all over the table, as well, oddly, as several scattered oyster knives. There are also photos and books, loose change and restaurant bills, notes, Métro tickets and letters flowing on to the floor, which in itself remains comparatively pristine, perhaps because the parquet was made specially, and expensively, for the space and so imposes a certain respect. What has been less respected, I'm shocked to discover, is one of the volumes of the Degas catalogue raisonné by Lemoisne that I gave Francis as a present, having gone to considerable trouble to track down the complete, original edition through an antiquarian bookseller on the Place Saint-Sulpice. It's lying open under the table now, with paint all over it and several pages clearly ripped out.

Beside it there's also a copy of the original draft of *The Waste Land* with Ezra Pound's annotations that Francis gave me once

in London and that I've brought back to the studio here because I know the whole idea of one great poet being edited by another fascinates him. We've talked about it several times and Francis says how lucky Eliot was to have Pound's editing since he thinks the poem became so much better as a result. 'I long to have someone telling me "Do this. Don't do that," but of course I've never found anybody.' Every time I try to imagine the kind of person Francis would take instruction from I come up with a total blank.

By the windows Francis has put a large, brass-bound sea chest. I've no idea what's in it because it's always kept locked, but I imagine he has other, no doubt more personal or secret photos and painting paraphernalia in it. Along with the brightly coloured frying pan, he also keeps an old wooden T-square and a large plastic dustbin lid to hand, and every now and then I'm amused to see how he has used them to get angles or circles in the paintings. There are also quite a few books that Francis has been given by friends and admirers on the bookshelves. He's become quite a star in Paris since the Grand Palais show, and I've seen people come up to him in restaurants and cafés and ask for signatures or press some publication of their own on him. We were going down the rue de Seine the other day when a woman suddenly threw her arms round him and kissed him. I imagined they were good friends until he told me he hadn't the faintest idea who she was.

I suppose this kind of fame has come to Francis not only from all the exhibitions of his work and the books and countless articles about him in the press that have appeared over the years, but also from less obvious sources like the cinema. *Last Tango in Paris*, for instance, which has been hugely controversial and widely successful, was influenced in all kinds of ways by Francis's paintings, it seems, and it featured reproductions of two of them in the opening credits. Apparently the film's director, Bernardo Bertolucci, visited the Grand Palais show several times and wanted to incorporate some of Francis's colours, notably his

very distinctive orange, into *Last Tango*. I particularly like the fact that Bertolucci took Marlon Brando into the exhibition and suggested that Paul, his character in the film, should absorb as much as possible from Bacon's figures and especially from their faces, that were 'eaten', Bertolucci suggested, 'by something coming from the inside'.

I know Francis has been working on several pictures commemorating George's death, and I sometimes wonder whether the real reason why he wants a place in Paris (whether he himself is conscious of it or not) is to be close to that loss and that pain. One of the things that make Francis stand out, I think, is what you might call an 'appetite' for suffering, which is perhaps as strong in him as his appetite for pleasure. He's said to me that he thinks that 'an artist's sensibility should always be kept stretched', and sometimes one can actually sense the tension this must set up coming off him in waves. So I suppose that by living in Paris he now feels closer to the source of pain and that, artistically, he can feed off it.

Like everything in life, death can come in by the strangest door. Francis's sister, Ianthe, has been visiting him with her whole family. They have a vast citrus farm in Rhodesia (his other sister, Winnie, is an invalid living in the capital, Salisbury) and they're in Europe mainly, I think, to see her famous brother. The two of them get on well and share the same kind of frankness. I was amused the other day, over lunch, when Francis said their parents always had wine with their dinner and Ianthe said, 'Did they?' in a surprised tone, clearly implying that that wasn't her memory at all, and I began wondering to what extent Francis's version of his early years, to say nothing of the rest of his life, hasn't been recast and closely edited according to his own needs and fantasies. Mythologizing his life is at the very centre of his existence and his painting, and of course to some degree we all mythologize ourselves, the main difference being that most of us don't do it skilfully and powerfully enough for it to be of any importance or relevance to anyone else.

Francis also likes Ianthe's husband, Ben, probably because he's jovial and very masculine, since they don't exactly have much in common. We've had several congenial meals together, with Francis playing the perfect host in grand Paris restaurants like Taillevent, and I've got on well with Ben too, so I'm shocked when Francis calls me and says that Ben has had a massive heart attack and died in the hotel room. I immediately send a letter of condolence to Ianthe, conscious of how little one can say and how little it will mean, and I know Francis has been very much on hand to help her with the unwelcome formalities and procedures surrounding a death, which he knows well. I have dinner with Francis in a local bistro shortly after Ianthe and her children have gone back to Africa, and he's clearly shaken by the sudden death, even though it opens a vein of black humour in him that is never far from the surface.

'Ben's death came as a terrible shock of course to all of us,' Francis says. 'But when you start thinking of it dispassionately there is something horribly comic about the whole thing because he came over here as this great big man and now he's being flown back as nothing more than a little box of ashes.'

PART THREE

1976–1992

'Only Francis Bacon is More Wonderful than You'

'*Sales Anglais! Sales Anglais!*'
A blind man is striking me over the head and shoulders as hard as he can with his white stick. Luckily for me the stick is hollow and although I'm rigid with shock the blows hardly hurt.

The attack has come completely out of the blue. I'm in Marseille for Francis's show at the Musée Cantini, which is due to open tomorrow evening. It's a perfect summer afternoon, I've just had a delicious bouillabaisse with Francis on the Vieux-Port and we've decided to take a stroll through the city. Without realizing it we've wandered into a fairly run-down, rough area. It's quite exotic, because the cooking smells are more spicy and there's loud Arab music pouring out of the bars. The men are North African workers and the only women to be seen on the street are clearly prostitutes, brightly dressed and some of them with big Alsatian dogs on a leash, no doubt for protection. I sense that the men are looking at us oddly, with hard, dark eyes, and just as I mention this to Francis the blind man who has been tapping the pavement in front of us turns round and starts yelling at us and raining blows on me. It's easy enough to dodge out of range but somehow we've lost our appetite to explore further. We walk

back to the main road and I expect Francis to comment on this curious outburst, which seems to have been triggered off simply by the fact that we were talking in English. I wonder whether being struck by a blind man has any particular significance. It hardly seems a good omen just before a big, official opening – and, I reflect, it may well have put a jinx on me. I can see from Francis's face that, like me, he's been struck by the odd symbolism of the incident. But since he doesn't mention it, neither do I, and we walk back to the hotel in silence.

Most of the artists I know get pretty jumpy before an exhibition, but Francis seems calm and collected, even though he's had to meet numerous local worthies and give endless interviews and will no doubt have to go through many more hoops in the run-up to the opening. He's intrigued by Marseille's reputation as an ungovernable city, riven by organized crime and racial tensions, and he's looking forward to the dinner we're having this evening with Gaston Defferre, the 'strong man' mayor reputed to have links with the Mob and to be the only politician capable of controlling the place.

Defferre, who has the extra distinction, I learn from a newspaper article, of being the last man in France to have fought a duel, has taken a private room in a well-known local Provençal restaurant. Francis, Nadine Haïm and I arrive promptly on time and Defferre introduces us to his wife, the writer Edmonde Charles-Roux, whose novel *Oublier Palerme* has been a runaway best-seller. Defferre looks satisfyingly like the 'strong man' he is reputed to be: broad-shouldered, powerfully built and with a deep tan. He tells us he's been out on his boat sailing all day. I'm still a little shaken from my beating by the blind man, but I realize that it's hardly a story worth telling this evening since it reflects badly both on Marseille and on me. Francis is doing what he can to keep the conversation flowing, which he always finds more difficult when he is not playing the flamboyant host, but since the mayor clearly doesn't know much about Francis's work and we know next to nothing about Marseille politics or

Edmonde Charles-Roux's novels, the conversation is in danger of drying up. Luckily, when baskets of bread are brought with frozen olive oil as a substitute for butter, a topic is suddenly found that tides us over for a while, with Francis exclaiming he has never seen or spread frozen olive oil before, and me taking up the refrain in a minor mode with Madame Defferre, seated next to me, and all of us extol its taste and nutrient properties as we attempt to mash the slippery, resilient substance into our crusty *pain de campagne*. I notice Francis scrutinizing Defferre's face keenly as if he'd been commissioned to do a portrait of him and had only this occasion to find how he might make it work. The 'strong man' of Marseille, who has spent an entire career being photographed, is oblivious to this more subtle kind of examination. Since little common ground seems forthcoming, we all somehow fall back on what has become the common denominator of olive oil.

'Monsieur,' asks Edmonde Charles-Roux, my statuesque, celebrated hostess, as if our future that evening depended on the right answer. '*Aimez-vous l'huile d'olive?*'

This, I realize, is a leading question. Should I reply, 'Madame, I cannot see how one could not like, love, even adore *l'huile d'olive*,' or would it sound better to remain Olympian and say, 'Everything depends, *naturellement*, on the *terroir*, the pressing and the year'?

'Yes, of course, Madame,' I reply meekly, forking the remnants of the frozen variety into my mouth. 'There are few things I like better.'

'Monsieur,' Edmonde says, though I can hardly think of her as 'Edmonde' since it sounds more formal even than 'Madame'. 'I will send you a case of the best olive oil that Provence can produce.'

I pause for a few seconds to convey how much this honour means to me, even though I suspect somehow it will never happen, and answer:

'Madame, I should be honoured and delighted but please do not give yourself the bother of even thinking about it.'

This appears to inflame Madame Edmonde's desire to fulfil her promise.

'Monsieur,' she countermands. 'Be so amiable as to provide me with your address in Paris and I shall give the necessary instructions.'

The wine has flowed as steadily as the oil and when we rise at the end of the evening we all appear to have become the most inseparable of friends, linked by a shared passion for the produce of Provence.

Once back at the hotel, I am unable to get to sleep. I slip out and retrace our steps of the afternoon. The blind man is nowhere in sight but the prostitutes are, looking more alluring now that night has fallen. I engage in preliminary banter with one of them but the big dog accompanying her sniffs and noses my crotch intimately, then growls deep in its throat so threateningly that I beat a retreat, my tail very much between my legs.

However tough the mayor and the city he rules, I suspect that Francis's new images may come across as provocatively morbid. The show opens with a beautiful *Bullfight*, a locking of man and beast with the background panel as if mirroring a Nuremberg Rally, a sea of heads beneath a Nazi banner, in the distance. This memorable picture seems to me to illustrate perfectly Francis's particular genius for bringing two quite distinct, separate images convincingly together, whether a pope and Eisenstein's screaming nanny, or a corrida and the Third Reich, so setting off in the imagination entire runs of other images and associations. There's often no knowing what his original sources are, but I experience a rush of pleasure when I notice that one of the strangest new pictures, simply entitled *May–June 1974*, shows two horse riders on the beach. That is an obvious homage to Degas's riders, and the reason why Francis ripped the corresponding reproductions out of the catalogue raisonné I gave him in order to have them in view as he painted.

Soon, however, for anyone who knows the basic facts about the artist, the exhibition turns into a poignant requiem to George, who has been brought back and held between life and death in several majestic, gilt-framed triptychs. In one of them he is shown on the left-hand panel against a black exit with half his body already excised and the rest of his vitality seemingly seeping into a shadow on the floor, while Francis appears on the right similarly diminished. In the centre panel both their bodies are joined in a blurred coupling. After several premonitory pictures comes the death itself, reading from right to left in three acts: George alone in the hotel room, trying to vomit up the drink and drugs into the washbasin; passing into the strange bat-like shadow of death; dying seated on the lavatory, his face half averted and as delicately splintered as a cracked eggshell.

Since getting back to Paris I've been haunted by the various posthumous images of George, and it is clear to me now that Francis did want to return to Paris above all to feel his guilt and pain and loss as keenly as he could in order to reconceive the few sad events with maximum intensity. I've had a recurring dream the past few nights where I've been running down a street of toppling buildings, great blocks of cement and masonry just missing me, then hands reaching out of the air to pull at me and slow me down so that the chances of being hit get ever closer until I wake up in a sweat. I can only think the dream is re-enacting my own fear of death, and I wonder whether the frequent attacks of anxiety I suffer from (and which alcohol momentarily soothes) aren't rooted in my refusal to accept death as an inevitable fact of life – as Francis's paintings do so vividly. Francis himself keeps death squarely in view, and perhaps he derives his extraordinary appetite for life from being aware of death lying constantly in wait for him, as for all of us, just around the corner.

The two big self-portraits in the exhibition are also very moving. One shows Francis alone in a circular room in which the sheerly foreshortened perspective of the floorboards presses

his corkscrewed figure tight up against the picture glass, as if all
the air had been siphoned out of the space – a sensation which
I often think must have been prompted, consciously or not, by
Francis's continuous struggle as a chronic asthmatic to breathe.
The other has him leaning despondently on a washbasin, no
different from the one where George had attempted to vomit
except that, in a brilliant conceit, the basin has been painted
as if in a void, unattached to any wall, so that Bacon himself is
portrayed as floating in a kind of limbo. I try to reconcile these
images of loneliness and desolation with the ebullient companion
I have spent so much time with over the past few months and
wonder if two such extreme states can coexist – or whether the
cheerfulness is merely a veil, a disguise put on to hide the despair.
'I'm optimistic about nothing,' Francis frequently says. 'Even
though I don't believe in anything I'm rarely depressed simply
because my nervous system is filled with optimism.'

Certainly despair hasn't kept him from celebrating life in Paris,
and to my delight we have been hitting the high spots in the
city in a very regular, determined fashion, from tea and dainty
cucumber sandwiches at the Ritz to champagne ('*juste une coupe
pour nous remonter*') at the Crillon, from gorgeous dinners
at Lucas Carton and the Tour d'Argent to new, fashionable
nightclubs like Le Sept on the rue Sainte-Anne, a predominantly
homosexual disco where Francis is greeted as a hero, even on
crowded evenings when other celebrities like Nureyev and
Yves Saint-Laurent, to say nothing of Serge Gainsbourg and
Jane Birkin, are having supper there. When Francis and I go in
there together I'm impressed that the owner, Fabrice Emaer,
who's nicknamed the Prince of the Night, always cuts a swathe
through the jostling, partying crowd to greet Francis, whom
I think of as the magician of the night; certainly, between the
two of them, the night comes fully alive. No doubt because he
has such an iconic presence at the Sept (here comes that number
again), Francis makes it a nightly port of call whenever he's out
on the town, and although I've never seen him pick up anyone

or disappear into the dark, throbbing dance floor downstairs, I know he particularly enjoys sitting by the bar watching the ebb and flow of people in the huge wall mirrors that slightly distort all the goings-on from every angle round the room, much as he must have liked watching and recording it in his mind's eye years ago in the mirrors of the Gargoyle.

All kinds of people float in and out of these long evenings around Paris, from the Irish painter Louis le Brocquy, who has been doing portraits of Joyce, Beckett and Francis, to prominent writers like Susan Sontag, with the arresting white streak in her otherwise jet-black hair (which Francis likens to 'shredded gramophone records'), and David Sylvester, forever finishing his big book on Giacometti, who pronounces the *blanc de blancs* we drink with our caviare one lunchtime beside the Madeleine as 'so good it's almost like water'.

Because Francis counts a few influential lesbians in his entourage, we also gain access to the Katmandou, a discreet shrine to sapphism on the rue du Vieux Colombier, where we are the only two men present among several dozen women. There appear to be two distinct sexes among them, the aggressively dominant, butch types in leather and denim and ultra-slender, feminine creatures in tight silk blouses. Several couples are doing the latest dances like the Hustle and the Bump and another outlandish one I think is called the Funky Chicken. There is one girl doing the Bump so unbelievably beautiful that I can't take my eyes off her until one of our lesbian companions whispers in my ear, 'Honeybun, if you go on looking at the girl like that they'll have the bull dykes on you,' and I'm not sure what she means but it sounds a bit like bulldogs, which reminds me of the crotch-sniffing mastiff of Marseille and I quickly back off and resolve to try not to break any further taboos, however frustrating it may be not to lose my heart to some unobtainable lipstick lesbian.

Fortunately we have just been joined by another tall, pale woman accompanied by a huge, male bodybuilder who I imagine

would make even the biggest bull dyke tremble in her lesbian boots. As Francis talks to the woman, whom he seems to know, I chat to the bodybuilder, who has a gentle, high-pitched voice and who I begin to suspect as I scrutinize him anxiously in the darkness of the club might also turn out to be a woman until I conclude with relief he's probably only queer. He tells me he's called Fernando, originally from Colombia, and he's a certified bodyguard, and to dispel any doubts I may have on the subject he half opens his leather jacket to reveal a neat little revolver with ivory grips in its holster. For the last year, Fernando says, indicating the tall, pale woman with a nod of his brilliantined head, he's been working for Miss Watson. I take a pull of my vodka and think that all makes sense, she's lesbian and rich, he's queer and got a gun, they must get along just fine, and to keep the conversation going I ask who Miss Watson is. Why, don't you know, Fernando says, Miss Watson's the heiress to IBM – to I–B–M, he repeats, spelling the letters out slowly so that I take on board we're not talking chicken shit here. I peer through the gloom to see more clearly what an heiress looks like. But some other, official-looking people have made their way over to the table and I haven't even noticed that Fernando's gone, interposing his considerable bulk between them and Miss Watson, and Francis seems to be indicating to me that it's time we left and, as Fernando is parrying some questions about visas, Miss Watson looks up with a distant smile and says: 'Fernando and I arrived in Paris two weeks ago. It's been really neat but we've spent so much time in the clubs we haven't seen daylight yet.'

Francis's new would-be dealer in Paris, Claude Bernard Haïm (known more generally as Claude Bernard or to his friends simply as Claude), gives some of the most lavish parties I've ever been to, whether they're in his apartment beside the Arc de Triomphe or in some public space, such as the memorable evening he organized at the Musée Grévin, Paris's waxworks

museum, where his guests mingled among the lifesize effigies on display and quickly became barely distinguishable from them, so that while you could be fairly certain that, say, Elvis and Marilyn weren't among us that evening you weren't at all sure about numerous, less recognizable French stars of stage and screen, from Johnny Hallyday on. Claude's own list is in itself so star-studded, with guests like Andy Warhol and Mick Jagger coming regularly to his parties, that as the evening progressed and the champagne flowed it grew even more uncertain who was in wax and who in the flesh. Certainly Andy Warhol could be a waxwork. I've chatted to him at a couple of these parties and he's very amiable but as deadpan as his myth, responding mechanically to whatever you say with: 'Gee, that's great.'

Francis has met Andy too, and he gets on with him better than he does with most artists. He's intrigued by the Drag Queen series but he repeats, characteristically, that he's far more interested in Warhol's films than in his paintings, in much the same way that he prefers Giacometti's drawings to his sculpture and Picasso's Dinard period to anything else in his oeuvre. Francis put his admiration for Picasso very clearly the other day when we were talking about the handful of twentieth-century artists who he admits to being influenced by. He said he likes the way Giacometti's portraits coalesce out of a mass of apparently random pencil lines. Interestingly, he also included Duchamp in the roll of honour, saying he found everything about him and his work 'immaculate', and that 'even the way Duchamp died was immaculate'. However, 'to find something that really interests me in this century', he went on, 'I always have to go back to Picasso. I don't like the late paintings, even though people are now saying they're among the greatest things he ever did. The period that interests me most is the late twenties and early thirties – you know, the beach scenes at Dinard where you see those very curious figures turning keys in the beach huts. And for me that is real realism, because it conveys a whole sensation of what it's like to be on the beach. They're endlessly evocative, quite beyond their

being extraordinary formal inventions. They're like bullfights. Once you've seen them they remain in the mind.

'You know,' he went on, 'I like things that shock and affect my nervous system deeply. But things are not shocking unless they have been put into a memorable form. Once you've seen blood spattered against a wall a few times it's no longer shocking. You think, well, that's just blood splashed against a wall. It must be in a form that has much wider implications. It has to have something that reverberates within your psyche and disturbs your whole life cycle. Something which affects the whole atmosphere you live in. Most of what is called art, your eye just flows over. It may be charming or nice, but it doesn't change you. The same is often true about photos, even war photos. They are often violent, and yet it's not enough. Something much more horrendous is the last line in Yeats's "The Second Coming", which is a prophetic poem: "And what rough beast, its hour come round at last, / Slouches towards Bethlehem to be born?" That's stronger and more extraordinary than the horror even of war photos, because they are just literal horror, whereas the Yeats is a horror which has a whole vibration in its prophetic quality.'

Francis has been working towards a new show at Claude Bernard's gallery on the rue des Beaux-Arts. The space is smaller than the grand rooms that he usually prefers, but he says he thinks his paintings will be intensified by being closer together and enveloping the spectator more. Some of the work will already have been seen in Marseille but he'll have several new works ready, including a spectacular triptych on an icy-blue background of which I've seen one panel in a transparency. No dates have been fixed yet for the show, and I'm not sure if Francis and Claude have worked out an agreement, since their relationship seems changeable. Francis operates very much on an *in vino veritas* basis when it comes to anyone he might have close dealings with, and sensibly enough Claude avoids drinking too much, so that there's a bit of a tug of war going

on between them. The other day the three of us had lunch and Francis wanted to go on drinking and expected to get his way, but Claude insisted he had to get back to the gallery, prompting Francis, who predictably enough doesn't think much of Claude's other artists, to retort: 'Vous retournez, vous retournez à vos horreurs?' I feel Francis is being unnecessarily controlling in all this, but it's not my business, and in any case I am thrilled that Claude has told me he wants to strengthen the whole publishing side of his business and produce books on art alongside his exhibition catalogues. I immediately thought I might be able to interest him in a book about Francis, but he's a step ahead of me, as if he'd read my thoughts, and he's asked me whether I'd like to run the whole thing. Of course I couldn't imagine anything I'd like more, especially as when I ask him what kinds of books he would see us doing he says, 'Well, that would be up to you.'

Meanwhile, knowing that Francis gets on extremely well and often gets drunk with his general handyman, Michel, who hangs the shows and fixes things round the gallery, Claude has hit on the idea that Michel and his family should organize a dinner for Francis in their house in the suburbs. For Francis, it's true, Michel represents the typical, working-class Frenchman par excellence. He's tough, bright and funny, as well as being very good with his hands. Francis likes the idea that through Michel he is in touch with a kind of grassroots France, which he thinks will be more 'genuine' and interesting than the etiolated, bourgeois art world that he usually deals with. Francis has been very generous to Michel, helping him pay off some bills and generally taking him out on the town. Michel, who thinks the world of Francis, recently came up with a comment – 'les cuites avec Francis sont toujours voluptueuses' (getting drunk with Francis is always voluptuous) – that shows he is far from your average workman. I suspect he thinks, as I think, that doing a dinner at home for him is going to be a bit weird and fake, particularly because Claude will be orchestrating the whole thing and basically hoping it will help him secure the Bacon show and the conditions he wants. Michel

tells me that instead of the kind of dinner he and his wife would probably offer Francis under normal circumstances – a *lapin à la moutarde* or a *pot au feu*, for instance – Claude is suggesting that a huge *plateau de fruits de mer* be spirited down from a top Parisian shellfish specialist to the suburbs.

I'm actually quite amused by the whole Marie-Antoinette-like notion of several taxi loads of fancy folk leaving their *beaux quartiers* to explore life in the humbler *banlieues*. I'm also mindful that I might be able to have another word with Claude about our books project, for which I've drawn up a preliminary list of ideas I'd like to get his reaction to.

Any such plan has been shelved, however, because Francis and I met for lunch and he seemed bent on getting drunk so we've been out in the bars all afternoon and by the time we get ourselves down to Michel's we are both pretty far gone. The house is modest but impeccably neat. As expected a couple of magnificent seafood platters are brought out, with varieties of oysters nestling on a small mountain of crushed ice decked out with seaweed and surrounded by clams, crab claws, whelks and winkles, while large pink prawns and langoustines have been wedged vertically in between them at strategic points as if poised to leap back into some illusory ocean. The kitchen door has been left open to the living room to accommodate two separate tables: one sort of high table, where Claude, Francis and other 'grandees' are dining, and a smaller one for Michel, his wife and family. I notice Francis's face has darkened, probably because he finds this arbitrary separation uncongenial. He also appears to have sobered up completely, even though he is still drinking with a vengeance, and while I continue to babble on to all and sundry he is very guarded in his remarks. We set to but the meal seems to go on for ever, not least because it's taking everybody such an age to crack claws and wheedle winkles out of their shells with tiny pins. Eventually ice cream is brought and to my alarm I see that Francis, who must now have drunk a good half-dozen bottles of wine since lunch, is completely missing his mouth every time he

aims a spoonful of lemon sorbet at it, so that several lumps of the coloured ice are slipping down his beautifully cut herringbone jacket, leaving a urine-like stain behind. Conversation stops and an embarrassed silence fills the room. Someone titters. Francis seems to be elsewhere. Then he suddenly comes to, as if waking, and loudly calls out:

'*L'addition!*'

To say that you could hear a pin drop, even of the whelk variety, would be what the French readily call *un understatement*.

'*L'addition!*' Francis comes thundering again.

The others look at me, hoping I'll intercede.

'Francis,' I say. 'I think the bill has already been paid. The bill's been paid.'

'Has it?' Francis says, almost triumphantly, looking intently round our table. 'Have I already paid? Well, there it is. You have to pay for everything in life.'

The next day the dinner fiasco seems completely forgotten. Francis comes by my place for a glass of wine, which pleases me because he hasn't been here since he decided he wanted a place of his own in Paris. I have the Aligoté on ice and my portrait of Michel Leiris on its nail. We talk about the new painting he's been working on, but he dismisses any detailed discussion about it with his habitual disclaimers. 'As you know, it's impossible really to talk about painting, one can only talk round it,' he says. 'What one really wants nowadays in art is a shorthand where the sensation comes across right away. And of course that has become a very close and difficult thing to achieve now. After all, we don't have that dimension of mythology that the Greeks had. We have to reinvent that, as well as reinventing the technique by which you can do it. I was just thinking today that in the situation we're in now you almost have to make an art out of your critical faculties. But there it is. No one will know whether my things have any quality for another fifty or a hundred years. Time is the only real critic.'

While saying this Francis has been sitting on my sofa looking fixedly, critically, at the Leiris portrait, moving his thumbnail to and fro over his lower lip. Eventually he says:

'You know, Michael, I've been thinking I could make that head of Michel so much better if by any chance I could work on it again. Looking at it now, I can see exactly how to do it.'

I'm dumbfounded by the idea. The picture has become my emblem, part of my identity, and more intimately so than the *Pope* because it represents someone I know. On the other hand, I reason confusedly, it's only here because Francis gave it to me, and who am I to stand in the way of his working further on it? It's obvious what I have to do, even though what I fear most, having seen it happen to other pictures, is that as soon as he gets going on it he will take the whole thing too far and end up destroying it, adding to the hollowed-out canvases I see from time to time in the studio.

'Of course, Francis. If you want to work on it, you must have it back.'

'Well, that's marvellous. Thanks most awfully, Michael.'

I wrap the head up in the green Harrods plastic bag I've been using to hide it in, and Francis walks off holding the portrait under his arm.

There's a space further up the rue des Archives I've had my eye on for quite a while. It's a big rambling apartment on the third floor, with a series of smallish rooms on the street and one huge continuous space overlooking the courtyard which has a makeshift rooftop terrace outside. It used to house an anarchist printing press and it now serves as a studio for a sculptor I know called Daniel Milhaud. Daniel, who tells me the space was once blown up by rival anarchists, has found a more convenient, ground-floor studio and is ready to sell the lease to the place but he needs time to reorganize. To raise the money I put my studio on the market and soon find a buyer.

While waiting to move into the Archives flat, which I'm supposed to use as a commercial space only, I have gone out on a limb and rented a small set of rooms in the imposing Château du Marais, less than an hour's drive from central Paris. The château belongs to Violette de Talleyrand-Périgord, Duchesse de Sagan, whose mother, Anna Gould, was a wealthy American heiress who married into the French aristocracy. The building, which dates from the late eighteenth century, is an outstanding example of Louis XVI style, and as you drive up to it you can see its elegant façade shimmering in the huge ornamental lake – or 'water mirror' – that stretches in front of it. My quarters are in what remains of the old, seventeenth-century château that stands to one side of it and is now known as the *communs* since the building was converted into stables and servants' quarters. Snobbishly I have decided that my château is architecturally finer than the main château, although I have never let on about this of course to Violette, whom I met through friends and who is very easy and friendly, if somewhat scatty and short-sighted. Apart from the grandeur of the whole setting, with its discreetly hidden tennis court and heated open-air swimming pool, I love the forests that surround the château where you can walk and see a medieval pageant of hares, pheasants, deer and wild boar, which sometimes crash through the undergrowth in packs with their greasy black coats bristling with fear; I give the latter a clear berth because I've been warned that their fear can quickly change into aggression. Violette has a new husband, Gaston Palewski, a former cabinet minister once close to De Gaulle, who is also very cordial towards me. I'm intrigued by Palewski because he has had a long, well-known liaison with Nancy Mitford, whose upper-class self-assurance and quick wit impressed me when I sat next to her once at a lunch in Paris. I also like the fact that every morning, before the official Citroën DS sweeps in to the château's *cour d'honneur* to take him to his office, Palewski has been down to the pool, naked under a black cloak, for an early swim.

I no more belong to this world of aristocratic and diplomatic privilege than I do to any other, but I'm grateful to have been received into it, temporarily at least, so gracefully. I pay my modest rent to the maître d'hôtel each month and I am accepted as part of the château's extended family, occasionally invited to an informal meal with Violette and Gaston, but more often left completely to my own devices. Occasionally there are receptions at the château where what they themselves call the 'old families of France' come together, with everybody braying jovially and addressing the other as *cher cousin* and *chère cousine*. The weight of historical precedent and the strange numbness it instils in contemporary relationships is so strong that, after a while, you imagine, for all the evocative princely and ducal titles bandied around, you have been included in a gathering of well-dressed mental defectives.

I am nevertheless proud, as a middle-class boy with an upwardly mobile penchant, to have gained at least a precarious foothold among these apparently harmless but not overwhelmingly bright, historic folk, and while it lasts I'm keen to share the experience with my friends. Several of them have come out to visit me in my new-found splendour, only to glimpse the château, a trembling mirage of grandeur amid its lakes and forests, and conclude, 'Michael can't possibly live here,' reversing their vehicles and scouring the environs for more likely abodes. It seems a particular pity, however, not to let Francis in on my posh little secret.

Having divested me of the Leiris head, Francis has upped the ante, if that's the phrase, by presenting me with an extraordinary new, large canvas that represents an entwined couple falling, falling, through the air in sexual abandonment while being watched by an impassive, albeit evil-looking dwarf seated on a stool. I am obviously delighted to possess this major painting, not least because it records such an intimate moment of Francis and George together. The very size of the image, propped up against the half-timbered wall, made my old flat feel particularly restrictive, and it has become an extra incentive to move into

the larger premises at the rue des Archives, which remain tantalizingly out of reach as negotiations over the new lease drag on. This being so, I am more keen than ever to share my good fortune in finding digs in a historic château with Francis, if only to reassure him that, as a protégé of his, I am not letting the grass grow under my feet. Accordingly we find a date when he will venture forth into the countryside, which he otherwise sees as a dread place 'with all those things singing outside the window' and generally tends to avoid like the plague, sticking to a city centre where, as he says, 'you can just walk in the streets and see people going about their daily round'. Francis tells me he will be coming with Sonia and Nadine, no doubt for added protection, and I make a lunch booking at the local auberge where the decoration of stags' heads mounted on burgundy-coloured walls might not be to Francis's taste but the food and wine are good, and I've been able to convince the owner not to present a bill but to keep it for me to pay subsequently.

As they arrive by car, I can see Francis and Sonia have been quarrelling and as I lead them straight into the Auberge du Marais they start bickering again about whether Francis should be taking certain pills while he is drinking heavily. I can sense this might be a potentially sticky occasion, and true to form as we settle into the restaurant's cold, empty dining room Francis eyes the stags' heads balefully and says, 'It's going to be a bit depressing having lunch with all those dead things around.' But the menu passes muster and the meal goes well enough, although I'm panicked when the owner's prim wife tells me we've already had too much to drink and she doesn't want to open any more bottles for us. I wheedle a couple more, but that doesn't seem to quell the argument that is still simmering between Sonia and Francis, who alternates between taking large handfuls of pills and huge, Burgundy-size glasses of wine. I get my unruly crew out of the inn and over the road to the gates of the château and we begin to make our way, all abreast and weaving quite noticeably, along the great tree-lined drive. Halfway down I notice Violette,

probably on some vague errand, walking towards us. I panic slightly, wondering whether Francis or Sonia will be rude to her and also how I should make the introductions. Should she be simply Violette, Violette de Talleyrand-Périgord or the Duchesse de Sagan? And how about Francis, whom she almost certainly won't have heard of, should he be *le grand peintre anglais*? I have no time to decide before Violette comes over to me, blinking in the sunlight and saying very loudly and formally:

'*Monsieur, le château est fermé au public.*'

Francis shoots me a look as if to say 'I knew it all along. Michael's made the whole thing up.'

'But, Violette,' I say desperately. 'It's me, Michael. You remember, the Englishman who has an apartment in the *communs*.'

Violette blinks again absent-mindedly and moves closer.

'Oh, it's you,' she says suddenly in English. 'I am most dreadfully sorry. People wander in here the whole time, you see. Well, I won't hold you up any longer.'

I continue the guided tour, lingering by the moat and the dungeon, comparing the old château to the new, but the wind has gone out of my sails. Francis is looking at me slyly, as if this is some elaborate hoax I persist in attempting to foist on them. I can see he's determined not to believe that I actually live here, so there seems little point in trooping them all up to my apartment, which is bound to look like part of the same pathetic make-believe now. I walk them to their car, then slink back to my own quarters and savagely demolish the chocolate cake I'd bought as the centrepiece of a lavish tea.

Claude Bernard has also managed to lure Francis briefly to the country, which I had assumed was almost impossible. Alice has kindly agreed to drive us down to the Loire, and although it's true she can become distracted while at the wheel, particularly when joining in and gesticulating with both hands during an animated conversation, I find the way Francis is holding on to

the passenger strap at the back as if for dear life a bit exaggerated. It's odd for someone who's so reckless in his behaviour to be suddenly so fearful, though I do remember once, when we got caught in traffic crossing the Avenue de l'Opéra and had to run for our lives to get to the other side, he said to me: 'I'm actually terrified most of the time.' We arrive safely at Claude's house in the soft, lush, flat countryside. It's quite extensive, with rooms for guests, but its main purpose is to hold concerts (Claude has installed an organ in the library tower) and large parties. There's a constant stream of guests here, as in his Paris apartment, and notably many of the big names in the classical music world, which I know little enough about but which comes sharply into focus when I'm introduced to such famous figures as Boulez and Rostropovich. Claude entertains with what he calls smilingly 'une grande simplicité', which usually entails a lavish banquet for a huge list of guests. He has a gift for bringing distinguished people together, and he succeeds in lining up well-known museum directors like Henry Geldzahler from the Met in New York with his French equivalent, or film-makers like Henri-Georges Clouzot, who directed *The Wages of Fear*, with the photographer Henri Cartier-Bresson, or art writers like the Giacometti expert James Lord with art-world *éminences grises* like the critic and collector Louis Clayeux, who helped select the Galerie Maeght's outstanding stable of artists.

I'm on easy terms with quite a few of Claude's guests and enjoy chatting to art-world insiders like Jean Leymarie, who was director of the Musée National d'Art Moderne here and is now apparently tipped for the French Academy in Rome. Jean amused me especially the other day in Claude's gallery in Paris, when Claude was enumerating the major works of art he had sold over the past few years. 'Did you really sell all those important works?' Jean asked innocently. 'I certainly did,' Claude replied proudly. 'You shouldn't have,' Jean countered slyly. 'Great dealers keep the best works!' Jean will be taking over from Balthus, who also makes an occasional lordly appearance

at Claude's *fêtes*, and he tells me that, at Claude's instigation, Balthus and Bacon met at one point in Rome. I knew about this, but not in detail, and it appears that Balthus took Bacon all round the Villa Medici, pointing out the great fresco cycles he had restored and the little garden which Velázquez painted when he was in Rome. Bacon was visibly fascinated by the improvements Balthus had effected in the Villa and plied him for the rest of the day with compliments about them as if restoration was Balthus's unique passion and occupation, thus ruthlessly avoiding any talk about Balthus's or his own painting.

Among Claude's guests there is also a large contingent of queer music-lovers, or *mélomanes*, just the kind of limp-wristed homosexuals whom I imagine Francis particularly dislikes. There is one who is always there, smartly dressed in blazer and white trousers, who has his own yacht on the Mediterranean and who manages to maintain a deep smoky tan throughout the year. I've never found out his name because everyone refers to him as the 'Skipper'. He's obviously just got back from sailing since his tan is darker than ever, and he's showing it off by wearing a white linen suit. I've noticed Francis has it in for him because he has been eyeing his two-tone appearance with undisguised malice. 'Have you met the Skipper yet?' I ask mischievously. 'I think you mean the Kipper,' Francis replies promptly. The joke has gone the rounds so quickly that now the poor man is already widely referred to as 'le Kipper'.

I've signed the lease on my new space at last and moved in. My few bits of furniture and belongings have been swallowed up in its vastness, particularly now that Francis has changed his mind and already taken the *Two Figures* back to work on it further. I'm getting used to having, then not having, his paintings but it's a real pity because one of the walls in the big new room would have been an ideal place to hang it. Meanwhile, with the help of an artist friend who's also a talented builder, I'm going to construct a proper wooden deck for the terrace outside. Otherwise, now

that the floor tiles have been repaired and the walls repainted a luminous white, I'll leave the flat as it is and simply luxuriate in the uncluttered space.

I've also just been down to the studio in the rue de Birague to let the cleaner in and make sure everything is ready for Francis's next visit. I get the fridge stocked with a few basics, pay the utility bills, which come in my name anyway, and I remember to go to the dry cleaners to pick up his sheets which are noticeably similar to the colours Francis uses for the backgrounds of his paintings: pink, lilac, orange and yellow. If it's at all cold, Francis likes the heating turned full on before he arrives. Even when it's been cleaned, the studio still looks pretty messy because I've given strict instructions that nothing – and that includes paint tubes and brushes on the floor – should be moved. I've also been over to Sennelier on the Quai Voltaire to order some pre-stretched canvases so that Francis has what he needs when he's ready to work.

The last time Francis was over, I brought round an American collector I know who's always calling me, probably because he thinks I'll lead him to a bargain-price painting, and when he saw the studio, he exclaimed, 'With the prices you're making, why do you live in a dump like this?' The remark tickled Francis enormously, I don't know why, but sometimes he laughs until he literally cries. He has a neighbour at the rue de Birague, a burly retired railway worker, whom he has got to know, and who popped in when I was there once and mimicked – having no idea of Francis's own orientation – two queers he'd just seen on the street. Francis found the comedy of errors so funny the tears came coursing down his face, and the neighbour, delighted by the apparent success of his clowning, went on to do more and more grotesque imitations of effeminate men.

Effeminacy is no doubt the last thing you could accuse Francis himself of. I've seen him barely able to walk or turn his head, presumably because he'd had himself so badly beaten up by passing lovers, without ever complaining or explaining, and

I know he's had stitches taken out without anaesthetic. He'll go for days without sleep and drink everyone under the table and still be ready for more. 'One is never hard enough on oneself,' he's fond of saying. I often wonder how much of this toughness comes from physical resilience and how much from willpower, both of which he has in spades. I can keep up with him for a few days, but then I have to lie low and lick my wounds. There'll be no lying low for a while, however, because Francis has just called to say he's arrived at Birague and he's asking whether I have a moment to pass by.

I suspect Francis wants to 'settle' for the various bills I've had to pay. He's very punctilious about any debts he may have, whether real or perceived. At the beginning I used to keep all the bills and tot them up to show him, but he brushed them aside and gave me two or three times the total. I have to admit that some extra cash would come in very handy now that I'm paying off all the expenses of my move to the rue des Archives.

When I get to the studio, I'm surprised to find Francis in a red-and-blue-striped dressing gown, though it occurs to me he might have just taken a quick bath. We chat for a while and to my growing alarm, Francis keeps crossing and uncrossing his white, hairless legs and tucking in his gown with exaggerated care as if by some terrible accident his sex might come tumbling out. As he acts out this drama, I train my eyes on a flare of orange paint on the wall above his right shoulder and begin talking in swift succession about various goings-on in the building and the exhibitions I'd seen and whether he'd be staying long in Paris this time. The crisscrossing and tucking eventually subsides without any tumbling, to my considerable relief, and we are able to catch up on various matters and me to invite him to dinner in my new space, along with Denis Wirth-Miller, who's joining him for a few days in Paris, and wouldn't that be nice and before I know it Francis has whipped, nothing untoward, a wad of 500-franc Swiss notes out of his dressing gown, saying he has to get rid of them because it will soon be impossible to change them

and thanking me profusely for everything I've done to keep the studio for him.

As a bachelor my cooking tends to the quick and filling. Pastas and risottos with the simplest sauces, speedy fry-ups and grills are my staples. I can however go further, and when I'm doing one of my large parties I serve a spicy chicken curry with exotic condiments, much appreciated by my French friends, or for a sit-down dinner I often make a slowly braised *boeuf bourguignon*, to which in a slight departure from the classic recipe I add mushrooms and top with diced bacon, croutons and crisp-fried parsley – the latter being something I know Francis likes especially, since we had it once in a restaurant on some grilled fish and he pronounced it 'one of the most delicious things you can possibly eat'. I also make sure that a good bottle of wine goes into it, although I can't compete with the bottle of the fabled Château Cheval Blanc that Francis told me he once poured into an Irish stew he had on the go. I now boast a dedicated dining room, sparsely furnished but with a small grate where I've lit a welcoming fire. Denis Wirth-Miller is on his way with Francis, and I've invited Alice, who inspires a degree of chivalry on such occasions, even from the irrepressible Denis. Alice is particularly amused that the 'two old boys', as she calls them, will be sharing the bed at the rue de Birague. Fleetingly we wonder whether, improbable as it seems, there has ever been anything between Francis and Denis.

Once the guests have arrived, we have some champagne in the big room, where Francis stares malevolently at the huge oil collage Dado has given me, then we move into my bare dining room, where Francis stares malevolently at the coloured landscape relief by Raymond Mason that I've hung there. I serve my *boeuf* and hope for the best. True to form, Denis goes purple in the face after a few glasses and gets increasingly garrulous. The talk and the wine take precedence over the food, I note, which is probably just as well.

'I've just seen the studio, Michael,' Denis says, 'and I think it's absolutely beautiful and just perfect for Francis.'

'Of course Michael can throw me out any time he feels like it,' Francis says, slyly.

I protest vigorously, but of course he knows I never would. He hasn't got this far in life without being an accurate judge of other people.

Although no one has expressed even polite interest in the subject, Denis starts outlining the various illnesses he has had, including an operation on a leg that had become infected.

'Somebody asked me whether Francis Bacon had bitten me,' Denis says, with mock indignation.

'And had you?' Alice asks Francis.

'Of course not,' Francis snorts. 'I wouldn't be here today if I had.'

Denis leaves for the lavatory.

'It's usually when he gets drunk like this that we have a row,' Francis says.

Denis returns and starts recounting his recent eye problems.

'For the longest time I went totally blind,' he insists, purple with wine and the satisfaction of having made himself the centre of attention.

'You were not blind,' Francis says irritably. 'It was your brain that went, not your eyes. And when it comes to illnesses, not that I'd be so boring as to mention them, I've had everything. But I don't think other people are interested in those kinds of things. As it happens.'

I've noticed before that Francis gets restless if the conversation isn't revolving around him.

'Even so, Francis, I have to say I've always found you the most extraordinary person,' Denis continues, gushingly. 'I've never met anyone who has had as much effect on me as you have. After all I have known you since 1949 . . . I remember sending you a telegram once when you were in Tangier. I was in Aix at the time

and absolutely desperate because both Dickie and I had fallen in love with the same man.'

'Who preferred Dickie,' Francis puts in. 'Now wasn't that annoying.'

'Well, I hadn't a penny to my name and I was so desperate I was suicidal,' Denis explains unperturbed.

'You weren't suicidal. You've never been suicidal. You just talk about it.'

'Anyway, as soon as Francis got my telegram, he cabled back "Will come", and on the morning we'd agreed there he was . . . Wasn't that marvellous? And even though we've known each other all this time, he still says things that stop me in my tracks.'

'What's the old fool saying?'

'Oh but you do, Francis. You say things brilliantly, in so few words . . . I'm not surprised Eric Hall loved you, I don't think you loved him – the only man you ever really loved was Peter Lacy. But you wouldn't be what you are today without Eric Hall.'

'It's true he helped me a great deal. He encouraged me. Do you know how I met him? I'd put an advertisement in as a secretary —'

'As a male whore,' says Denis, glistening with the witty accuracy of his remark.

'As a secretary,' Francis repeats firmly. 'And this man got in touch with me who turned out to be a cousin of Douglas Cooper's. And he said, I think I know someone who would be interested in your work. And he took me to this club they went to in those days on Dover Street, the Bath Club, and that's where I met Eric Hall.'

'Eric Hall's father had been a builder,' Denis says, for my and Alice's benefit. 'He built things like Hall Road in Hampstead and he left his son a considerable fortune. Eric was deputy chairman or something on the London County Council and

when he met Francis he was a family man with children. Didn't you both go to visit his son at Eton for Speech Day or whatever it's called?'

'The Fourth of June. Yes, we did, to take him out to tea. I'm afraid it must have looked very odd,' says Francis.

'You *were* a monster, Francis,' says Denis encouragingly. 'I suppose you introduced yourself as Mrs Eric Hall? Didn't the son go completely round the bend later?'

'Unfortunately he did,' Francis says musingly. 'He suddenly attacked a woman in a hotel and they put him in one of those homes. He's become very pathetic now. His arms shake the whole time. I haven't seen him in a long while. He used to come round occasionally and stand outside the studio in London shouting, "It's because of you I'm like this!"'

'You should have been more considerate about his feelings,' Denis chimes in. 'There we are – you're a pig in name and a pig in nature.'

'That kind of considerateness comes later,' says Francis. 'When you're young you don't think about those things. You think about enjoying yourself.'

'You must have met a lot of people,' Alice says.

'Well, I haven't, Alice, I've never met anyone really. At least not those kinds of people – intellectuals, I mean.'

'I remember you were invited to lunch by Virginia Woolf,' says Denis.

'That's true. There was a lunch with all those people, like the woman she was supposed to have been in love with, Vita Sackville-West. She was a monster herself, Virginia Woolf. She shouted all the way through the lunch. She began by shouting and just carried on all the way through.'

'But you've met everybody,' Denis insists.

'I haven't. I almost never go out. I see a few people in Soho. And I see you, Alice and Michael. And that's about it. I used to see Lucian Freud, but he doesn't talk to me now. When I was young, I met one or two other drifters like myself. But I've

never met anyone to talk to really ever. I always think of real friendship as where two people can tear each other to pieces.'

Towards the end of the evening, Denis accuses Francis of having once put a dozen sleeping tablets into George Dyer's hand.

'I know,' Denis repeats smugly. 'John Deakin told me when the three of you came back from that holiday in Greece.'

'Do you think I might put a dozen sleeping pills in your hand tonight?' Francis inquires sweetly.

Denis starts talking about where to find the best 'waxy' potatoes to make a 'proper' potato salad and he suggests opening another bottle, but Francis gets abruptly to his feet and thanks me for the evening.

'Yes, that was a perfect evening,' Denis joins in, struggling up from his chair. 'And the food was delicious, Michael. I can't remember ever having eaten a better *blanquette de veau*.'

The two of them make their way cautiously down the staircase, briefly suspending hostilities, but only, I feel sure, until they're alone again when they can continue 'to tear each other to pieces', as Francis says friends should, the whole night through.

In my diary I've noted down the conversation between Francis and Denis because I want to be able to draw on it verbatim. For a long time I didn't even question the fact that I jotted down what happened and what was said when I was with Francis. I even used to joke to myself that if I didn't get it down the first time I'd record it the next time Francis said it, since he does repeat himself constantly, even though there's often a different nuance made or an extra detail added. More recently, I've become conscious that all this archiving of sayings and events must be leading somewhere and that Francis himself could hardly be relaying all the information he passes on to me for no reason. Although I've wandered into the inviting pastures of art history and art criticism, I have always considered myself above all a writer, indeed, as time goes by, more and more as a frustrated writer,

since although I earn my living by my pen I haven't yet been able
to do much of what's called uninspiringly 'writing for myself'.
Put two and two together, and you'll have me writing a book
about Francis Bacon. I don't have a better subject, and, though I
say it myself, I have become something of an expert on the man,
the work and the whole Baconian universe.

That book, little by little, has been coming together. I'm not
sure how good, even how coherent, it is – Francis says it would
take a Proust to tell the story of his life – but the stack of pages,
full of whited-out and typed-over sentences, is piling up and
taking some kind of shape, even though the language tends to
the purplish. I haven't mentioned the whole venture to Francis
yet, but now, on the eve of a big new gallery exhibition at Claude
Bernard, is clearly not the time. I'll have to wait until the show is
up and running. It's been over seven years since the Grand Palais
retrospective opened, and the build-up towards this show in
Paris is almost tangible. Francis has become a cult figure, not just
in the art world but among the punks, who although somewhat
more decorous than their alarming British counterparts will
apparently be coming out in such strength that the police have
cordoned off the rue des Beaux-Arts, where Claude's gallery
is. Incidentally, I've heard nothing more about the publication
project from Claude, and when I made a point of reminding him
about his offer, he merely said, rather sharply: 'It's too late.' I
don't know what that means, beyond the fact that I've ceased to
be of interest now that Francis's new show is about to open. But
I'm really disappointed, so it's good that at last I have a book to
keep me going.

Francis has done quite a few new paintings, and the combined
effect of so many Bacons in a relatively reduced gallery space
is, contrary to what I imagined, incredibly powerful. Whereas
at the Maeght gallery you had room to step back and consider,
here you are hemmed in by Bacons on every wall. There is no
escape. If you recoil from your reflection in the glazed surface
of one alarming image, you bump into and are incorporated into

another alluringly shiny horror scene. It reminds me of a house of mirrors I went into at a funfair once with my mother and wherever you looked you were so pulled out of shape you roared with laughter and became even more grotesque. Only here it's not funny because you slip into someone else's twisted world where the distortions are ominous and go deeper, deforming the body and then the mind. The punks have arrived and the crush in the gallery heightens the nightmarish effect, effortlessly blending business suits and spiky hairdos, dog collars and pearl ropes because the real, more insidious question is whether the mangled spectators are trying to get into the paintings or the mangled figures in the paintings trying to get out.

Francis, meanwhile, is surviving the crush, glad-handing supporters of whatever stripe and signing catalogues and posters by the score. Eventually he disengages himself and like a praetorian guard a number of us accompany him in cars to the Halles aux Blés, the beautiful, covered grain market beside the meat and vegetable Halles, where Claude has laid on a memorable party, having invited people from across the globe to celebrate the event. Like several of Claude's events, there is a hallucinatory aspect to it, since although we are no longer among waxworks here the very circularity of the neoclassical building where all the guests are wandering round with drinks entails coming across people from all kinds of places and periods in one's life eternally revolving in a continuum where time itself is altered, so that having greeted someone one hasn't seen for yonks leads to seeing him or her again repeatedly and ineluctably, changing any surprise or pleasure at the encounter into a wry 'I haven't seen you in fifteen years and now I bump into you every five minutes.'

Another event that has the punks jumping is a reading by Bill Burroughs at the brand-new Beaubourg Museum, a kind of Halles *aux tableaux* officially known as the Centre Georges Pompidou. As with Bacon, there's a terrific turnout and the punks are visibly in the ascendant. Burroughs puts on his

glasses and begins to read, in a reedy voice, from a work in progress. He is dressed in a grey suit with a grey hat and looks halfway between a dodgy accountant and a frail gangster. The performance does not impress the punks, many of whom don't have a word of English between them and who in any case were expecting a livelier, more subversive event. Frustrated, several of them clamber up on to the stage where Burroughs continues in his grey monotone as they dance around him. At one point, one of them with a bright-yellow mohawk and chains waves his arms derisively behind Burroughs's head, then very slowly tips his hat over his eyes. Once occluded, Burroughs stops talking and the crowd goes wild with applause.

The day after Francis's opening, anyone wandering down the street where Serge Gainsbourg lives, a place of pilgrimage for his huge army of fans, cannot help but see a prophetic phrase scrawled on to the wall of his house: '*Seul Francis Bacon est plus merveilleux que toi*'.

———

'Your serve!'

I pitch the little black ball high in the air and smash it on to the wall, winning the point outright.

For the following serve, I try an underhand lob that loops through the air and should die in the corner, but the ball comes out a bit and my opponent uses the opportunity to drive it hard down the side wall. We play several close strokes straight down the wall until I hook the ball out into a gentle crosscourt shot which, satisfyingly, wrong-foots my opponent, grazes the front wall just over the red line above the tin and rolls irretrievably along the sidewall nick, taking the game to 9–7 and winning the set.

In the changing room, my partner says, 'I began to feel drunk on court myself with all those wine fumes coming off you!'

It's true I've come from an epic Bacon lunch and am frankly delighted not only to have managed to play squash in that condition but to have won, however amateurish the level of play.

After sweating out some of the booze and a shower, I feel on top of the world and ready to go back to the Coupole where I left Francis talking to a big, beefy young man called René whom he's picked up somewhere along the way and, I think, hopes to seduce. I doubt he'll have much luck since René, whom Francis calls '*une force de la nature*', looks as straight as a die, and he's much more comfortable talking to me, as just another bloke, than to Francis, which in turn I suppose irks Francis. I should probably just leave them to it, but I'm drawn back because the wine is still flowing and I find René good company because he laughs easily, slapping his thighs, and doesn't kowtow to Francis, who looks quite small and almost dainty sitting opposite him. I find them at the same table, but several bottles later and deep in conversation about Van Gogh, with Francis saying he prefers the *Potato Eaters* to all his other pictures. This strikes me as particularly reductive and I contend that the later works are greater and start talking about the Saint-Rémy period. I get a funny sideways look from Francis, who seems to have a bit of trouble breathing, but I'm high on my win and the new wine. Then a bit like a gramophone record Francis starts on all his usual slagging off of David Hockney, probably to impress René but also because he's irritated by the increasingly international success David's been having in Paris, where he has taken over a studio in the Cour de Rohan, an elegant courtyard behind Odéon well known in the Parisian art world because Balthus painted there from the 1930s on.

'Well, I'm not surprised he's been so successful,' Francis says. He's wheezing noticeably now, and I wonder for a moment how much Francis's asthma affects his mood. 'After all the paintings are like illustrations for *Marie Claire*, there's nothing to stand up to in them and that's why people like them. They may be pretty but when you look at them there's nothing really there.'

And I feel it's time to stop the rubbishing and start saying how original the early work was and how skilfully ironical the

California images can be and I don't notice that the atmosphere
has changed until Francis thunders:

'Well, with a taste as superficial as yours I'm not in the least
surprised you like them. You're like all the critics who just go
along with what everybody else says. And then of course you
write it, just like all the others. And that's why we're stuck with
all this dreary, anodyne art. Because of people like you.'

Francis's eyes are boring into me. His face has gone hard
and pale.

René shifts uncomfortably.

I decide to leave them together and go out into the cold
Montparnasse dusk, walking briskly to try to contain my
confusion and hurt. 'You didn't see it coming, did you?' I say
to myself angrily as I go down into the Vavin Métro. Then
out aloud, startling the other passengers waiting for the train
beside me:

'And what chance in hell does your book stand now?'

Primal Cries

I'm trying to come to terms with Francis's sudden bitchy outburst. It's wounding, as it was meant to be, since he knows exactly how to find your weak spot. But although I've seen him go frequently for other people, he's only done it to me twice, which given all the late nights and drink we've shared over the years means I've got off pretty lightly. I think Francis realizes that if he had a go regularly, as he does with Denis – but not, for instance, with Lucian, at least while the two of them were still talking – I wouldn't stick around. I think it's also fair to take into account that he is often under appalling pressure (usually of his own making) from work in progress, from gambling debts and occasional blackmail, from mammoth hangovers and exhaustion. There is also the pang, the stab, of jealousy, which Francis loves when he can watch it at work in others or reads Proust's masterly analysis of its insidious effects but from which he also occasionally suffers. I wouldn't have thought of the possibility had Alice not pointed it out when I described the scene at the Coupole to her, that Francis might have imagined René actually fancied me rather than him. This prompts a hollow laugh from me, but in fact having gone over the incident time and again has led to one positive outcome.

Although I've been scribbling away since adolescence, I've become increasingly aware that writing things down and getting

them into some kind of order or perspective really helps me deal with everyday misunderstandings and disappointments as well as my own contradictions. 'One writes in order to have written,' says my great friend in Barcelona, Jaime Gil de Biedma, but one also writes to survive the 'slings and arrows' and to give some sense to the persistent confusion in which we, or at least I, live. A great deal of what I write disappears into a series of black books which I keep as an intimate diary and where I can ramble on about whatever I happen to be thinking or feeling at a particular time without any forethought or framework, until even I am bored by what I'm saying and stop. Frequently of course I record what happens in my relationship with Francis, such as the Coupole incident, which has lost a little of its sting now that it's been written down. This in turn has prompted me to go back to the book I've been writing about him and his effect on me and try to give it a clearer shape.

At the moment it is still one long tract with no chapters or other subdivisions and little notion of a narrative moving forward. My head is too full of Joyce and Beckett, Borges, Kafka and Michaux, to think in such conventional terms. Rather I am looking for a form that will convey the strange circularity that characterizes all my encounters with Francis, who himself (quoting Gertrude Stein about Derain) frequently lambasts Balthus for trying to 'do something new with an old technique', which he sees as an impossibility, adding that you have to 'break the mould of accepted thought' in order to invent. So I suppose that's what I'm trying to do: find a new technique. Consequently there's little sense of time or any specific 'development' in my account, which ends (as I sincerely hope it will before too long) with exactly the same words as it begins. This particular 'in my end is my beginning' is exactly how it feels when you start off an evening with Francis, having champagne in a grand hotel, dinner in a plush restaurant, then a tour of the bars, all of them increasingly similar and sometimes even the same because the Colony Room might lead to the Maisonette, the Coronation, the Iron Lung,

but also back to the Colony and possibly even the grand hotel or restaurant for supper after a few hours' hard drinking, and it's not just the circularity of places and the deadening recurrence of bottle after bottle which in themselves gradually swallow up all notion of time but the circularity imposed by Francis himself as he repeats what he has just said, again and again like a mantra, until you feel imprisoned in a tightening circle of nihilism and finality.

That said, however much I experiment with form and buff up the impressionistic, stream-of-consciousness content, agonizing over a verb here, a dialogue there, I have to admit that at one hundred thousand words and counting 'Myself I Must Remake' (the working title) is not exactly a breeze to read, let alone write, especially since the main theme is interwoven with an equally implacable account of my own inner turmoil and despair, including frequent vignettes of wasted mornings, blank pages and rampant literary impotence. On the bright side, however, the backbone of the book remains valid since I quote Francis a lot and it constitutes a kind of portrait of him in his own words. Given the keen interest in Bacon since the Grand Palais exhibition and Claude Bernard's mobbed show, word of my screed has travelled through the incestuous Paris art and literary worlds, coming eventually to the ears of Georges Lambrichs, editor of the *Nouvelle Revue Française*, who gets in touch to ask if I would let him see some extracts to consider for eventual publication.

Even the luckiest man only glimpses heaven a few times in his life, and the prospect that something of mine might appear in the *NRF*, with its sublime red logo and hallowed list of authors (bar Proust, of course, whom Gide turned down for publication the first time round), appears to me like a permanent portal on to paradise, leading more or less inevitably to other distinguished publishers in London and New York soon falling over themselves to secure whatever now in this potential blaze of glory flows effortlessly from my pen. This is more alluring than

any pie-in-the-sky publication project for an art gallery and I waste no time in choosing and blending various extracts into a desirable whole while realizing that without the agreement of the book's hero the entire venture will founder. So having neatly typed out my offering on onion-skin paper, I call Francis to let him know, without any further indication, that I'll be in London next week and he immediately suggests dinner at Claridge's on the evening I arrive.

I can't pretend I'm not nervous when I get there slightly late and sweaty, clutching the extracts with their snatches of drunken talk in an incongruous brown envelope, and try to adapt to the calm, softly lit and slightly perfumed atmosphere of the hotel. I can hear a Viennese waltz being played and when I enter the salon where Francis is sitting alone with his drink the violinist, bald and wearing a Bavarian jacket, turns towards me and strikes up a livelier tune as if to welcome the arrival at last of someone new. Disconcertingly, it has the opposite effect on me, I want to bolt, envelope in my clammy hand, back out into the anonymous night, but to my relief Francis waves smilingly in my direction and looks pleased to see me. I know I'll have only one shot at getting his agreement to having the extracts published, so I decide to bring the matter up before the smiles fade.

'You're looking so well, Francis,' I say as I sit down opposite him, wedging the cumbersome envelope under my thigh. He's wearing one of the very bright silk shirts, with swirls of colour like a sunset, that he must buy by the dozen because every time I've seen him over the past few months he has a new one on.

'I couldn't look well after all the drink of the last few days I'm afraid,' he says, smoothing the side of his head with a pleased gesture. 'But it's nice of you to say so.'

A very old couple, both with canes, have started making their way across the room. The violinist swivels in their direction with an encouraging flourish, and a footman in knee-breeches hurries over towards them to offer the lady his arm. She shrugs it off, but the footman stays in attendance as they slowly proceed, step

by step. The quartet acknowledges their progress with a more stately air.

Francis seems entranced by the spectacle.

'I suppose Russia must have been a bit like this just before the Revolution,' he remarks with a short laugh. 'I sometimes think I'll move into a hotel like this, though I don't know whether I could put up with seeing all these rich old things dragging themselves from place to place like that. I'm sure they won't bother to tip that young man who's trying to help them because I just know they're mean as well as rich. Well, there it is. Very rich and very mean, and that's why you have revolutions.'

A white-gloved hand has set a flute of champagne before me.

'How have you been, Michael?' Francis asks. He's clearly forgotten, or is pretending to forget, the Coupole incident.

'I've been alright, Francis. I've been trying to do more writing. More "writing for myself", as they say.'

'Ah, well that's marvellous,' Francis says, giving me a quick, keen look. 'I know very little about it, but I imagine writing must have become very difficult now, after people like Proust and Joyce. In the same way that painting has become more difficult.'

That's just the opening I'd hoped for. I feel dizzy and slightly sick, but I have to go for it.

'I don't know whether it's generally difficult, but for me it seems pretty near impossible,' I carry on awkwardly. 'It's ridiculous. I mean, I've been sitting over a blank piece of paper since I was sixteen waiting for something I could really write about.'

'Well, it's true that a real subject, something that really obsesses you, is terribly difficult to find. I didn't find what I wanted to paint until terribly late.'

'No, I remember your saying,' I reply, wondering how I might bring the conversation round. I wish I'd mentioned the book earlier now because it'll look as though I've been doing it behind his back.

'It's marvellous you've found a subject now,' Francis pursues evenly.

'Well, I think I have. The thing is, I thought I might be able to do something around knowing you – I mean, the conversations we've had, the places I've been to and the people I've met through you . . .'

I'm holding on to the satin arm rests of my chair as if at any moment I might slide off.

'And, you know, the effect all that's had on me, how it's marked my attitude to life and, well, my whole growing up in a sense.'

Francis is gazing intently into the middle of the room, as if he'd heard nothing or was listening to another, quite distant voice.

'I mean, the idea of inventing whole situations and plots and characters seems absurd, outdated. It might simply point to a limitation in me,' I plunge on wobbily, 'but the less fictional, in the sense of made up, a piece of writing is, the closer it is to lived facts, the more interesting and convincing it can be made, I think. Well, to a large extent, I got that from you.'

Francis smiles faintly, stroking his lower lip with his thumbnail. He's still staring straight past me into the emptiness of the salon, raptly, like someone to whom a vision has appeared.

He must have heard, I say to myself, he must have heard. The absence of any reaction makes me panicky. Drops of sweat are snaking down my sides. My abrupt confession seems to have vanished into thin air.

'Of course I can understand you might be offended by a thing like this,' I continue miserably. 'It's bound to be indiscreet and perhaps betray —'

'I should think the more indiscreet it is the better,' Francis suddenly says, completely focused.

'Well, naturally, the last thing I should want is for it to affect our friendship,' I say, gushing relief.

'I don't think things like that need alter friendship at all,' Francis says, slowly and deliberately. 'The thing is, really, how

can one present those kinds of stories? Unless they're presented in a certain way, they can be very embarrassing, it's true. They wouldn't embarrass me, but there are still one or two people alive who might be offended if certain things were told. Because I think, in that sense, if you're going to tell the story, only the whole story is worth telling.'

'I agree. To the extent that you can ever tell the whole story. I mean, one can hardly help seeing it partially and differently from others. It's just like a portrait. It's bound to contain just as much of the artist as the sitter. A good deal more, perhaps nothing but the artist, in the greatest portraits.'

'I know. It would of course be fascinating to know everything about another person, the whole of the private life and so on. I think that's what probably interests other people most nowadays – other people's private lives. And, as you know, people just adore talking about themselves, I don't know why, after all, it's always the same old story. The only thing that matters, in the end, is the way it's told.'

'Absolutely,' I say. I think back to my complete typescript, lying in an inert pile on the shelf beneath the window, then shift in embarrassment as I imagine Francis running his cold pale eye over its shortcomings.

'Here they come again, they can't seem to keep still,' Francis says.

He's focused like a cat preparing to spring on the elderly couple as they hesitate before a return journey across the salon. They begin tottering towards us, and I notice the man has long white hair pulled back into a straggly ponytail. He's also wearing a Texan tie.

'I don't know why those ghastly old things let their hair grow long and wear blue jeans and things,' Francis says acidly. 'It just makes them look even more hideous than they are. I don't even like long hair and beards on young men, let alone old ones, because I want to see the structure of the face rather than have it camouflaged under all that hair. Old age is horrible.

Horrible. Well, you can see – it's like that. If there was some kind of operation to regain youth, even if it was very unpleasant, I'd have it right away, just as I'd have a facelift if I thought it would really work.

'There it is, Michael. I've spent my life watching youth slip away, hour by hour, but in the end there's nothing you can do to keep it of course. You're just condemned to watch over your own deliquescence. I was trying to think the other day what I'd want to happen to my body after death. I think on the whole I'd prefer to be incinerated, but then I thought it would be a terrible bore for people not to have any bones to dig up. I certainly wouldn't want to deprive them of that pleasure. So I don't know. In any case, you're what's called condemned to watch your life slip away. I remember you told me about marvellous holidays you'd spent by the sea with Alice. And I couldn't help thinking those days spent by the sea mean less and less as you get older because they are basically about hope, and with age there is less hope. They're like happiness – which is really a problem you only have when you're young. But then, if you think about it clearly, happiness itself is a kind of tragedy.'

Francis's mood has darkened. We move into the dining room, flanked by the string quartet, and a masterful head waiter ushers us into our seats. As we order, preferring the *goujons de sole* to the caviare, the duckling to the lobster, Francis returns to his refrain about age, and it becomes the leitmotif for the whole evening, as one delicious dish gives way to another and the costly vintages are kept coming in rapid succession.

'Baudelaire talks about "*l'éternelle tyrannie du bonheur*",' I remark brightly at one point.

'That's a marvellous way of putting it,' Francis says. 'But with me, as I've got older, I have to say, I think less and less about happiness, because my interest has grown much more for my work than my life.'

We then go into another discourse I know almost by heart about the body not functioning with age and his never expecting to have

an intimate relationship again. It's as if the wine has set Francis going on his groove, and the book fades into the background. I myself feel happy, even if happiness itself is a tragedy, because my explanation for the extracts has been accepted: the book is momentarily out there, a potential reality, and the first hurdle to its being published, in this condensed version at least, has been cleared. But this is only the first hurdle, I realize, and when we leave Claridge's, heavy with rich food and wine, I remind myself that Francis hasn't even read the damn thing yet as I carefully stuff the brown envelope into his raincoat pocket, urging him to let me know if there's anything, anything at all, in the text that he would like altered or cut before it's sent to the typesetters for some forthcoming issue of the *NRF*, where in my mind's eye I see it already, crowding page after glorious page with prophetic black signs.

Since getting back to Paris, I've been thinking uneasily about Francis's reaction to my text. It shouldn't really be a problem since it consists chiefly of what he himself has told me, which I have carefully reproduced verbatim, right down to the oddities and emphases of his way of talking. But of course he may not like his own words coming back at him, just as people often dislike photographs of themselves, and just because he takes every liberty imaginable when portraying other people does not mean he will be more accepting of this portrait of himself. These fears have proved unfounded, however. Francis has actually posted the typescript back to me – I recognized the slanting handwriting in felt-tip on the envelope right away – with only a couple of changes. One concerns a snide remark about Henry Moore ('Artists are never satisfied with their work, though I believe Henry Moore is'), and the other the reference to Peter Lacy, whose name he asks me to replace by 'a friend' since 'some of his relatives are still alive'. He has also scrawled on the last page: 'All this is only half correct, but leave it as it is some of the truth is better than none – please add this paragraph.'

I'm delighted and hugely relieved, of course, and I ask Alice to provide an initial translation of the excerpts which we then go over together until we're satisfied we've got not only the meaning but as far as possible the sound of the original. Francis told me that the translation I did with Michel Leiris made him sound more intelligent in French than in the original English, so I'm hoping for something similar here. Now of course I'm worried that the *NRF* will find it's not quite what they'd hoped for, but I seem to be on a roll because they get back right away to say how keen they are to take it. Lambrichs has actually written to me on *NRF*-headed paper saying that he thinks the excerpts form a *'texte admirable, saisissant par son accent de vérité'*, and confirming he wants to publish it exactly as it stands. I am over the moon, I can hardly believe I've got this far; with all the doubt and anxiety along the way, it seems almost too good to be true. I go back to work on the book itself, riding a surge of new confidence, and as I write everything seems to flow and fall into place. If I'm looking for what some character in the book would say or how they look, I only have to wander down the rue Rambuteau to do my daily shopping and a face or a phrase will suddenly come into focus and I'll have what I want – the throwaway remark, the wizened visage – and all I need do is go back to my Olivetti and hammer out what has been handed to me on a plate. This is the first time in the process of writing that I have ever experienced a state of grace.

And yet a niggling doubt persists. I've already had an exhibition project based on the sources of Bacon's art from the Egyptians through Vélazquez and Rembrandt to Picasso at first warmly encouraged by Francis, then, once I'd found the right museum and developed the concept, flatly turned down. And I've seen other people's projects, for shows and books and films, come to grief. I want to be really sure that Francis is also happy with the French version, so I make another quick trip to London where we do an epic tour of the bars with me following him around

shoving the translation back into his raincoat pocket every time
it falls out as we get out of taxis or climb stairs to a club, and
when I leave him around dawn on a street corner in Soho I can't
be quite sure whether the manuscript is still wedged in his coat
or has dropped out and got lost in the dark.

I find out soon enough, however, because a telegram arrives
stating in no uncertain terms that publication of the text should be
stopped. I am appalled. The translation has already been sent to
Gallimard, which publishes the *NRF*, and Lambrichs, the editor,
says it's perfect; he has even decided to accelerate the schedule
and include it in the October issue. I don't know which is worse:
calling Francis for an explanation, or calling the *NRF* to say we
can't go ahead. Or rather I do, it's calling Francis because there
is a great deal more riding on that conversation.

'I got your telegram, Francis.'

'Oh good. I do hope you'll stop publication.'

'Yes, obviously. But I don't understand why you've changed
your mind.'

'What d'you mean?'

'Well, when I gave you the original in English after our dinner
at Claridge's, you sent it back with a couple of changes, which I
made, but otherwise you were apparently fine with it. You even
said the more indiscreet—'

'I didn't know what I was doing. I went on to a few bars
after our dinner and someone must have spiked my drink. I was
drugged. I had no idea what I was looking at.'

The notion is so outrageous I can't think what to say, but
Francis carries on.

'In any case, what you've written is not at all accurate. You'd
have to tell the whole story for it to be accurate. And also I don't
want any of this to come out while I'm alive. You can do what
you like when I'm dead, but there are one or two people still alive
who would be very offended if they read what you've written.
Now if you need money, you only have to let me know and I can
get some wired to you.'

I hadn't seen that one coming at all. I bleat something to the effect that it has nothing to do with money and hang up, totally distraught. I wonder what can have changed. Was it seeing his own words translated? Did someone put the knife into the project? The gallery, thinking it wouldn't reflect well on their star artist? David Sylvester, who certainly wouldn't welcome anyone else on what he considers to be his exclusive turf, *his* Francis? Possibly one, possibly both, but I have to accept that in the end it is Francis's decision. It's a crushing blow to all my hopes, but I have always known that the friendship with Francis was more important to me than any 'project'. The book, along with its various extracts, will have to go into a drawer and stay there, mouldering, perhaps for ever.

Bad as this news is, I have another, more serious problem brewing like a storm on the horizon. I have been with Alice for a good twelve years now: I was just under thirty when we met, and now I am forty-two. She has been a delightful, stimulating mistress, allowing me to continue my relatively carefree, bachelor existence and forgiving my occasional indiscretions. She has also had a maternal presence in my life, making up for the lacks and soothing the wounds left by the unfulfilling relationship I had with my mother. I have loved her more deeply and completely than anyone in my life, and I still love her loyally. We are joined by thousands of tiny threads of shared experience and affection. But there is a growing restlessness in me. I don't approve of it and I've been pretending it doesn't exist by making sure that my work includes as much foreign travel as possible, since trips in Europe and America to do articles or interviews help to put it out of my mind. I probably would have gone on denying it if I hadn't had a fling with a Polish painter that has resulted in her wanting the relationship to become more 'serious' and insisting that the two of us be seen together at various art events and openings where Alice is likely to turn up too. This has already resulted in my trying to two-time more fully, going

away for the weekend with one, then with the other, attending
this function with Alice, that cocktail with the Polonaise. Why
I have got myself into a triangle again, apart from my ingrained
waywardness, I don't really know, because nothing makes me
so unhappy as being duplicitous in love. I fret by day and am
tortured at night by the whole sleeping-with-one-to-think-of-
the-other syndrome. From relative contentment I now find
myself constantly on edge, convinced I'm about to be caught
out through some slip of the tongue or a badly told lie.

So when the Polonaise announces she's pregnant, I panic.
Normally this would be something I would confess to Alice, who
might even give some practical advice. But since I am attempting,
painfully enough, to distance myself from her counselling
it is out of the question. There are scenes with the Polonaise,
whose biological clock is ticking very audibly and who believes
the situation can be resolved only by our getting married.
Mournfully I contemplate the prospect of a shotgun wedding
followed by a union as increasingly joyless as my parents', and
the effect it would have both on us and on the child, all because of
one small accident (despite all the precautions apparently taken).
I try to communicate this to the Polonaise but she is deaf to
what she dismisses as my pessimism. Tension grows as we both
dig in our heels: I will not marry on this basis and she will not
consider having a child out of wedlock. Eventually, feeling like
an accomplice in crime, I accompany the Polonaise to a discreet
clinic and try to be as supportive as I can. Afterwards, when I
come to collect her, we sit in complete silence in the taxi taking
her back to her apartment.

I've barely opened the door in my place when the phone rings
and an orderly at the Hôtel-Dieu informs me that Alice has been
admitted to hospital with a broken back. She apparently lost her
footing at the top of the free-standing circular staircase leading
up from her study to her bedroom and her back hit the hard,
sharp edge of the steps as she fell. It's strange this should have
happened now, because although the staircase was a potential

danger from its very inception by a fanciful architect she knew, there has never been the slightest mishap before. I go down to the hospital immediately, clutching flowers, but Alice has been given a strong sedative and she's out cold. I walk back bewildered through the old streets of the Marais, gazing blindly at the familiar sooty façades of the great townhouses as if they might provide some clue to why everything is going wrong. The blackened coronets and lions rampant on the crests indicate only the passage of time and the progress of decay, but a woman in dark glasses guided by a big, patiently plodding dog is coming along the pavement towards me through the lengthening shadows of the late afternoon. I remember the blind man in Marseille hitting me with his white cane, and the jinx, yes the jinx, and panicking I scuttle down a side street out of sight.

My flat on the rue des Archives is like a sanctuary these days. I have all my books neatly aligned in a large alcove beside my writing table and my best pictures hung where I can see them while I work. For years I have been a useful single man, making up numbers at dinner parties in Paris and country weekends, and I rarely declined an invitation, particularly when the food and company were good. But I have started going out less, seeing far fewer people, and the entries in my diary are growing longer and more introspective as I grapple with the reasons why my plans for writing things and getting them published have gone so completely awry, and what in all the confused emotion welling up in me I really feel about Alice, the Polonaise and the lost child, and how I can live my life in a less disorderly, damaging way.

The only bright spot I can find on the horizon is that *Connaissance des Arts*, a magazine that belonged to the same publishers as *Réalités* when I worked there, has asked me to review an exhibition called 'Primitivism in 20th-Century Art' that will open at MoMA in New York in the autumn. I've seen some of the advance material and, visually, it's a knockout since it

includes some of the most powerful tribal carvings and of course an outstanding line-up of modernist masterpieces. It should be an extraordinary show, and I'm delighted to have the chance to get away from Paris for a while and spend a few days in a city which, although it intimidated me on my first few visits, now seems the most exciting and stimulating place in the world. The idea is that my review should come out to coincide with the opening of the exhibition in several months' time, so when I come off the hot, noisy Manhattan streets into the chilled calm of the museum there are no works to see yet but only photographs of them in an advance proof of the catalogue. I've heard that William Rubin, the chief curator, is very powerful in the art world and correspondingly imperious. But he receives me cordially and lays lots of photos out on his large desk to illustrate some of the highlights the show will include. Then, in a more professorial tone, Rubin gives me an overview of the theme, stressing his convictions about its groundbreaking importance, and I listen enthusiastically, make appropriate notes and carry away the bulky catalogue proofs so that I can absorb the concepts underlying the exhibition and their various ramifications before I begin to write. For a couple of days the sun shines, New York is filled with its characteristic, jolting energy, and I come back to Paris revived and begin straight away to plan the outline of my review.

The trouble is that the more I read and, above all, the more I see the two totally different cultures juxtaposed – an African mask, say, paired off with a Picasso painting – the more sceptical I become about the exhibition's underlying thesis. Once boiled down and simplified for what the curators clearly hope will be a wide audience, the show basically suggests that whenever a European artist came across this (an African mask or tribal fetish) in the earlier part of the century, he hurried back to his studio and painted or sculpted that (a Cubist portrait, say). Here was an idea that not only the man in the street but a child could readily understand: Picasso saw an exaggeratedly frontal Nimba mask

from Guinea, then started doing female heads with big noses. Similarly, Giacometti may have wandered into the ethnographic collection in Bern and admired a slender, anthropomorphic Nyere walking stick in the 1920s (a pure supposition that the catalogue cannot confirm) and, hey presto, he begins to think in terms of long, thin people, eventually creating armies of them in what becomes his signature style. I am amazed that such a simplistic, fundamentally flawed idea can have become the crux of a weighty New York cultural event, buttressed by a two-volume catalogue brimming with scholarly disquisition and accompanied by the usual PR firm razzamatazz. It seems to me that it does a disservice all round: to the European artists who look like devious copycats; to the 'primitive' artists whose works have been taken completely out of their primarily religious context and function; and to the public, most of whom surely know that artists' imaginations work in more unpredictable and subtle ways.

But I'm embarrassed to have found this whopper out all by myself and feel like a dissident pygmy, about to wave its fist in the face of a vast, renowned institution. Truth to tell, I have never been a particularly critical critic and I usually manage to review exhibitions or write about artists that convince, interest or please me, which is one of the few prerogatives of being freelance. Occasionally I have a sideswipe at something I find preposterous, like a show I saw recently that consisted uniquely of electric wires ripped out of a gallery's walls; and, no doubt partly under Francis's influence, I wrote a sceptical essay, also for *Connaissance des Arts*, about the legacy of Jackson Pollock, which I was surprised to find won me plaudits whereas most of what I write disappears for ever into a silent black hole. I still feel enthused by the quality of many of the works on show, however, so there is no reason for me to wax scathing and write the whole venture off, especially as I have taken a few knocks myself recently and am not eager to go around trailing my coat, looking for a fight. I will put all the positive aspects forward

while being duty-bound as a critic to speak my mind and say in as amiable prose as I can muster that the pairing of a big-nosed mask and a big-nosed Picasso, a slender African walking stick and a Giacometti *Walking Man*, is tendentious and misleading. I send the review to *Connaissance* diffidently enough, half expecting them to protest at the least negative comment about such a prestigious-sounding event at MoMA, but they respond enthusiastically to my argument. The magazine, which has been bought and relaunched since I first knew it, now belongs to an American, and his son, Philip Jodidio, not long out of Harvard, has been appointed to run it. We'll put a tribal image on the September cover, Jodidio tells me, and it's good the review raises important questions since it will be the lead story. I'm delighted by this reception and forget what now seem like overscrupulous misgivings, especially since I have to look after Alice, who has moved into one of the smaller rooms on the rue des Archives side of my apartment to recuperate. She does not appear to have damaged her spine permanently but she needs to rest undisturbed and be looked after until the bone reknits. Several friends have offered help, and to give him his due Francis was the very first, calling to say that if I need money to settle medical bills he will wire whatever's necessary right away. I still feel raw about his bizarre behaviour, a sort of senseless double-cross, over the book, but I'm touched and pleased by his solicitude. Meanwhile, I assume a carer's routine, not displeased by the diversion it provides, but it's clear that I now inhabit a parallel universe, still very close to and fond of Alice but unable to share any of my deeper preoccupations with her. After a couple of weeks, fortunately, Alice is well enough to return home.

The summer goes all too quickly. I love the days that lead up to the longest day, then regret that the best is then over and that daylight is diminishing even as we enter the hottest months. I keep meaning to go away, to get back to the beaches in Brittany or Biarritz, but now I have no one to go with and, after a brief skirmish with the Club Med, I decide the only holiday I'll have this

year is with a friend from Kyoto who visits me every September. This is a curious liaison, begun several years ago after a casual meeting in a restaurant in the Marais, but I find it very soothing because, although we know each other well in certain ways, we have almost no conversation, Setsuko speaking little English and my Japanese being non-existent. She arrives as always with a strange present, a fan covered in ideograms, a table mat with a view of Mount Fuji or a pair of brown nylon socks which prove too small. I cook for her, and she is always very appreciative, except that anything she does not wish to eat, like fat or gristle, she slaps abruptly on to my plate. We never speak at meal times and only rarely at other moments, when our exchanges are brief and usually wreathed in smiles. Once, when I believed we had both just enjoyed an instant of bliss, Setsuko tugged my beard sharply and asked: 'Mikkel, how you make your money?' On another occasion, after breakfast, she giggled suddenly and said: 'You want to be my honey baby?' Then, more seriously: 'What your policy regarding marriage?' I am cautious with my replies.

Setsuko has brought me a traveller's English–Japanese phrase book in case there are any outstanding issues I want to address, but most of the phrases relate to requesting train times or buying a handkerchief. I ask no questions of her because I cherish the simplicity and freedom that being intimate with someone about whom one knows so little allows. We don't talk much, which is soothing while allowing us, I think, to communicate what is uppermost on our minds. After one lengthy silent supper together, Setsuko takes my hand and confides to me that she thinks I look like Bob Dylan, only less sexy.

It is almost time for Setsuko to go back to Japan and we're spending a lazy morning in the apartment when the telephone goes.

It's my mother.

'Bad news, I'm afraid,' she says curtly. 'Your father's just died. Massive heart attack while he was sitting with a drink in his chair.'

I put the phone down and for the first time since she arrived I really talk to Setsuko and tell her what's happened and what it means to me, and I don't know how much she understands but she clasps my head tightly to her breast and holds me there in darkness and silence for a long, long while.

Over the twenty years since I left home for good, my father became a shadowy figure. Very occasionally – for a marriage, a death or on a rare trip to Paris – we saw each other briefly, but mostly I only got news of him when I talked to my mother on the phone. I knew that his health was not good: he was overweight, he smoked and drank immoderately and all the pills he used to control his manic depression took their toll. There was also a period, not long ago, when he began bombarding my sister and me with rambling letters, full of asterisks and footnotes and arrows, and the overall tenor was that he was still searching for himself, since the necessities of life, of providing for a family while battling cyclothymia, had always denied him the time and tranquillity he needed to work it all out. He felt constantly on the cusp of this discovery, a breakthrough that would lead to a new clarity about himself and his bearings in the world. Latterly he abandoned my mother halfway through a holiday (begun grandly in a chauffeur-driven car until he suspected the driver of flirting with my elderly mother) and holed up in a small hotel in south-west France. There he devoted himself to long walks and prolonged self-analysis, which was recorded in an ever more disjointed fashion in the letters he sent me on yellow foolscap. I don't remember ever replying, partly because the outpouring had no focus, merging past and present, but also because I did not want to get involved in this doomed search for my own father's identity. To an extent he involved me willy-nilly, however, because he ran out of francs and instructed the hotel-keeper to call and ask me to send a cheque to tide him over. I saw him one last time on his way back through Paris when I was still angry with him for having abruptly ditched

my mother, whom I had to shepherd back to London. We met briefly in a café on the rue de Birague, just outside the studio, and at one point while we were arguing I leant over, squeezed his upper arm hard and saw him wince with pain. He promised to reimburse me, which I knew he would. It wasn't about the money. It had never been about the money. It was the fact that we were father and son and that since I was a small boy there had been no love or understanding between us, only growing anger, recrimination and scorn. Somehow I suppose I thought there would come a time when we would sort that out, just as he had been trying to sort his life out. Now, I'm still trying to take in all the implications of his death, which multiply day by day and crowd out any other preoccupation. But what is already clear is that all the unresolved misunderstandings and conflicts between us will remain unresolved, and for that from this point on I alone will bear all the blame and all the guilt.

I go back to Stocking Pelham for my father's funeral. All the relatives are there. It's a fine day and after the church ceremony, where the new vicar is clearly uncertain how to pronounce the name 'Peppiatt' and settles for 'Pippit', giving the proceedings an extra ring of finality, everyone wanders down leafy lanes back to the house and a buffet lunch is served outside. One of the strange things about a death is the way the living group together as if to banish it in a moment's jollity, eating and drinking in the sun. He's there, wherever that is, but we're all still here.

'Will you come to mine?' an ageing but sprightly uncle asks me, waving a glass of wine, as I leave.

'Of course I will,' I reassure him jovially.

When I get back to London, I feel rootless. I belong less and less in England, but at the same time I am still an expatriate in France. My life has been very full after the first few scant years in Paris. But now it seems to be emptying out. I'm not in a relationship, I don't have a book to write and now my father has gone, leaving only problems behind. Perhaps it's cyclical, the thick and the thin . . .

Oddly I've had that sensation of thinness, insubstantiality, about lots of things over the past few weeks. I was in a little restaurant the other day in Paris – by myself, between seeing shows at galleries on the Left Bank – and suddenly everybody looked strangely transparent, as if they might not really be there. And I myself felt very insubstantial, and I kept looking round to see if anybody else had noticed that something had gone wrong, that things weren't as they should be. It was apparent everywhere. Even the walls weren't quite what they seemed, they had a kind of liquid quality and seemed to shift in and out of focus very slightly. And everything that people were saying didn't quite add up, and I began to wonder whether they had seen that I wasn't quite real and I felt increasingly embarrassed and began to sweat heavily but then I realized it wasn't embarrassment but fear, a piercing, intense but completely absurd fear because I could never explain what it is, just a terrible anxiety that seems to corrode everything, sap its substance and drain it of any sense.

I've had several experiences like this, and to try to control the panic that envelops me each time I admonish myself: it's alright, I'm just having one of my 'turns', I say, as though it's just a little blip and it won't last. But the turns have been getting worse, more powerful, and I've begun to question who this 'I' telling 'myself' actually is or are, because I'm no longer sure that either really exists. They've become like that white wall in the restaurant, a shadowy, shifting identity, as malleable as the colour white fanning out into an infinity of shades. I don't feel particularly at home in London, but I wonder whether I shouldn't stay, find a little boarding house and hole up there until I can sort some of these problems out, find a little clarity. But of course that would be like my father, my newly dead father. It would be like becoming him in order to escape him, and in any case I know full well I cannot escape him. And in any case that would be mad. Mad.

So I take the return flight to Paris, unsettled, knowing that the flat will be empty, that autumn will lead to winter and that I

have no particular prospects. When I get home, I see there are a couple of pale-blue telegrams pushed under the door and some messages on the phone. They're all from *Connaissance*, asking me to call. That's encouraging, I think. Perhaps they've got another story for me, who knows, it might even mean sending me somewhere where it's still warm.

I call next morning and have to wait a moment before being put through.

Philip Jodidio's voice is very cold.

'I've had Bill Rubin on the phone ranting and raving about your article that he's just seen in the new issue. He says they called an emergency meeting of the whole MoMA board last night to decide what to do about you. He's got MoMA's president Blanchette Rockefeller right behind him and they're taking two firms of lawyers, one in New York and one in Paris, to see what they can find out about your past and whatever else they can dig up so as to build a case against you. He thinks you've criticized the show he's spent years putting together because you're in the pay of African art dealers. Anyway, he feels confident that if they can't get you on anything else they can sue for plagiarism because you quoted extensively from the catalogue.'

I sit by the phone completely stunned. This can't be happening. I must have misunderstood. Perhaps I'm having another turn.

'What do we do?' I say weakly after a while.

'Well, there's not much we can do. Rubin's insisting on a lengthy right of reply, with a ton of photos. We're looking into that. But we're not going to back you up, if that's what you mean. You've caused enough trouble as it is.'

'Well, what should I do?'

'You'd better get yourself a lawyer.'

I've been going back and forth and round and round every angle and detail of this whole thing. It's obsessive, I can't think about anything else. I had no idea that my review would cause more than a tiny ripple, since most reviews simply disappear into the

ether and are never heard of again. The show's bound to attract hundreds of reviews, including the *New York Times*, which is what really counts in New York rather than some little art magazine in French in far-off Paris. How can it be that my mildly phrased critique has become so pivotal? I suppose it must have touched a raw nerve, a fatal flaw even, and it's the first comment to be published. But who's ever going to see it, and why is Rubin so incensed? He'll get plenty of plaudits in the press. Why has he decided to go for me? And what will the lawyers find out? That my girlfriend had an abortion, that Francis turned down my book? Or that I've been late with my tax return and pay my cleaner in cash? What will they use against me? That I never made it up in time with my father?

Somehow, I suppose, I had all this coming to me. It was bad enough agreeing to an abortion, it was a sickening thing to do, but to have upbraided my father shortly before his death is even more unpardonable. That guilt will always stay with me, and the punishment has probably only just begun, in this completely unexpected guise. That's how real punishments work, subtly, silently, in ways you can never foresee. My father is punishing me through Rubin. They're even similar in some ways, righteously loud and overbearing, and they share the same capacity for rage. I can just see Rubin pacing up and down, like an Old Testament prophet, ranting and raving and cursing me. And I deserve it. I've wronged him, I come to see slowly, as I wronged my father. And he's dead, he can't kick back. But Rubin can, he'll kick me for all he's worth and I've had it coming to me.

I've heard again from *Connaissance* that MoMA has decided to take a series of full-page ads out, especially in the *Herald Tribune*, to denounce me as having attacked the show because I was paid to do a hatchet job by African art dealers. I'm terrified. I don't know what it means, I don't know any African art dealers, but if I'm accused what can I say, how can I prove it? How can I prove I don't know people? How can I prove anything? There's no one I can ask. I don't know any lawyers either, I've

never needed a lawyer and couldn't afford one now that I do. It's funny they should have chosen the *Trib* because I used to write art reviews for them and it's the only newspaper I subscribe to. I've been scanning it nervously for the past few days to see if the ad denouncing me has come out, but I can't bring myself to do it any more and when the *Trib* arrives I just put it quickly, unopened, into the rubbish, hoping that what I don't see won't harm me.

I've wanted for years to take off a couple of kilos but it's starting to go a bit too far. My weight is about the same now as when I left school and it's still going down, rapidly, as if I can't stop it. I'm trying to force myself to eat but I can't get beyond a couple of mouthfuls before feeling nauseous. Even wine tastes bad. It's also become increasingly difficult to sleep, and I think being so tense and lying awake at night is taking the weight off too. And not eating or drinking makes it even more impossible to sleep, so it's a sort of vicious circle. I suppose I had it coming to me, I can't think how else to explain anything. Whatever made up my life before is crumbling and there's nothing to hold on to. It feels like I'm falling. Falling, falling, falling.

There's no end in sight, just crumbling and falling. Of course it's punishment, punishment for having had it too easy, having had too good a time, the carefree bachelor, always free, always available, always after the girls, the laughing, curly-headed boy. Well, he's not laughing now, he's going somewhere else, he doesn't know where, into the dark, falling.

I've stopped going out for anything that's not absolutely essential. I'm terrified when I'm in here, terrified of the phone ringing to tell me things have got worse, what the lawyers have dug up and what further revenge Rubin in his righteous rage is going to take. But I'm far more terrified outside. Even on the bright winter afternoons which I used to love, when the buildings and trees cast long, low shadows, like a mysterious, parallel universe on the ground, I don't want to go out. The streets frighten me, and I have to make an almost superhuman

effort to cross them. Crossing the street feels like deliberately stepping out in front of a bus, inviting another disaster, because disaster dogs everything I do. So if I have to cross, which I used to do just jaywalking and dodging the cars like a real Parisian, now I go and wait at the lights until they're red and even then I'm afraid.

I used to be frightened of death, but this is like death and I'm still afraid of it. Sometimes I think of George, of the handfuls of pills, but I don't think I could do it, I'm too frightened of the idea of killing myself to actually kill myself, but the fact that I entertain these thoughts makes me more terrified still. I try to put them out of my mind, both the thoughts and the pills, but at the same time I wonder whether I haven't lost my mind, gone out of my mind, leaving only this welter of weakness and terror behind. Perhaps I won't have the guts to kill myself, but if I keep going on in this downward spiral, in this agony of guilt and tension and anxiety, I might of course die. It's been weeks now that I haven't eaten properly and I can see my face pale and drawn in the mirror and my ribs have started sticking out. I have to do something, I don't know what to do. I've never seen a lawyer and I've never seen a psychiatrist, I've always made fun of seeing shrinks, it's what weak people and nutters do, well I'm weak now and a nutter, and I have to talk to someone soon, I can't keep going down any more.

There's a couple I know who both see an analyst. They're a good deal older than me, and they've always been very nice, almost parental, to me. They have a very fine collection of modern art and they often invite me to come and see their latest acquisition, even though we don't really have the same tastes in art. So they're not surprised when I call them and they ask me round right away for lunch because they've got a big, new Twombly, and even though I intensely dislike Twombly, it makes no difference now, and I go round and peer at their new acquisition and nod several times thoughtfully as if I approve. My collector friends have a lot of mirrors in their

apartment and I see how ghostly-looking I've become as I flit
from time to time through them and it scares me, but what
scares me more is the frightened look in my friends' eyes as
they watch me and take on board how far I've fallen. But they
are good-hearted and patient. I tell them a little about what
has happened, a plain condensed version, and they arrange for
me to see their analyst.

She's a Freudian, whatever that really means, and I've been to
see her a couple of times. She's very formal and distant, perhaps
that's Freudian, and she says very little. Before each session, I
rehearse the ground I want to go over, a bit as though I were
going to write it or, more accurately, put it on as a play – a little
play about my own misery. I have main characters, such as my
father and Rubin, Alice and the Polonaise, but there are others,
and sometimes the others become more important as the plot
develops, often in ways I haven't foreseen. I want to give things
some shape rather than just deluge her with all the black thoughts
that keep going through my mind. I want structure, and I want
to keep it short because it costs an arm and a leg every time I
have to inch several large banknotes on to her desk in payment.
Perhaps that's Freudian too.

I spend most of my time at the moment constructing what
I am going to tell her. I concentrate on bringing out the funny
side of things as well, since misery is always full of potentially
amusing details. I present them as sketches and when the analyst
laughs I have the first feeling of pleasure that I've had in months.
I make it my ambition now to make her laugh, it's always what
I've preferred because I'm a clown at heart, and sometimes I find
myself making up things simply to make her laugh. '*Vous avez
beaucoup de ressources, Monsieur,*' she says to me at one point,
and I take this in the context to mean I have bounce-back. I feel
about as bouncy as a punctured ball, but I am oddly flattered
if I can interest or amuse her, and I kid myself that she prefers
listening to me rather than to all the other weedy-looking patients
sitting around her waiting room.

Over the past few days we've had an infestation of rats in my building. It's spread all through this side of the Marais, like a plague. Untold thousands of them were sent fleeing when they did eventually dislodge the Halles marketplace, and most of the rats of course went underground. I don't know what's disturbed them again, perhaps new excavation in the area, but at night I hear them scuttering under the floorboards and gnawing at the wainscot along the walls. Sometimes I think I've imagined it and it's my mind playing tricks, but I see them in the daytime too, darting behind the radiators and then down some hole best known to themselves. They seem to be getting bolder by the day, and some of them cross the floor now in front of me, quite casually, as though I'm not there. They almost make a game of it, crisscrossing from different directions, sometimes running, sometimes merely ambling, out for a stroll, leaving an insolent abundance of their little turds behind.

They're right, I am barely there, and they must sense I'm no threat, but I did come to resent how much I had to pay the Freudian just to amuse her, and I've found someone else I can talk to who's very different, she's a Brazilian therapist who charges very little and we've been doing breathing exercises together in her little flat in Montmartre. I do everything she tells me to do, even absurd things like imagining I'm a baby again and crying, but I do cry, with the tears pouring out of me in a great flood of pent-up pain, even though I know that before all this, before I became so desperate and submissive, I would have laughed and refused outright. The Brazilian is very beautiful, with dark, flashing eyes, and I admire her, I am even falling in love with her, but I can't make her laugh. She is aloof and very determined, and now that she thinks I have reached the appropriate level we go out to the forest of Fontainebleau to have the space and the air and the solitude to let out the primal cry that she tells me will release all my deeper fears and tensions, and I can hardly believe it but I'm standing there opposite her in a clearing way into the forest, just the two of us, the therapist and the patient, and I'm

taking great lungfuls of air and screaming with all my might
at the sky, the impassive pale cloudy sky overhead, and she is
screaming too, louder than me, her screams are far more piercing
and terrifying than mine, and as we pause, panting, to get our
breath back I get a glimpse of her beautiful, fanatical eyes staring
fixedly up through the branches of the pines and as she breaks
into another bloodcurdling cry I know beyond doubt that, sick
as I am, she is mad, madder than I could ever be, and I have to get
out, out of this forest, out of Paris, break this circle, away from
her, away from Rubin, away from the rats, away from myself,
anywhere.

I still have one place to go, a last place I can crawl into like a
rat. My old friend David Blow has had his ups and downs, too,
and I know most of them, just as he knows mine. He comes
from a family full of strange eccentrics, including the famously
reclusive Stephen Tennant, and he's very tolerant of his friends'
oddities and misfortunes. It's been a while since I've been in
London, and when I arrive at David's large, comfortable flat,
he looks at me, and while he jokes about taking me out for a
few decent meals, he can see something has gone badly wrong. I
give him the brief outline, it comes quite easily after doing it for
the shrinks, and we relax and have a few drinks, and when I lie
down on his sofa, which is somehow more reassuring than my
bed in Paris, I manage to get a few consecutive hours' sleep for
the first time in months. Being in London is doing me good in
itself, because the distance helps me get a bit of perspective. After
all the threats, I haven't heard from the MoMA lawyers and, as
far as I know at least, there has been no full-page denunciation
of my evil deeds in the press. Rubin has however published his
riposte, bristling with references and footnotes, to my review in
Connaissance, but it is so long and involved, and so seemingly
unconnected to what I actually wrote, that I haven't been able
to take it in. I just stared at it and felt sick. Apparently he's had
a whole slew of negative reviews – I've seen one of them, by

Thomas McEvilley, that goes far further in taking the show apart
than I did – and Rubin is charging around like a maddened bull
having a go at all of them. He must have garnered a lot of praise
as well, so I wonder why he has to try to silence all semblance
of dissent. Somebody suggested to me that he'd slipped works
from his own private collection into this landmark show so as
to sell them at an increased price afterwards, but I've no idea if
it's true.

I can't be in London and not call Francis. I haven't talked
to him since this whole thing blew up because, even though I
know he would give sound advice and be ready to help, I'm
still upset by his volte-face over the book and I don't want
him to know just how wounded and stricken I've been. I go
round to the studio, which I'm always pleased to see because
all the chaos of photos and paint and stuff on the floor is like
a kaleidoscope of what's been going on in the latest paintings,
and it's oddly comforting, as if I'm not the only one to have
so much mess slopping around inside me. We share a couple
of bottles of champagne, which loosens my tongue, and I give
him the briefest overview of the run-in with Rubin. To begin
with I can see a certain cruel amusement, even satisfaction, in
his face, perhaps because he thinks I've had the comeuppance
I deserve, but also, when I come to think about it, because he
hates the press, and probably has done ever since, way back,
they dismissed a couple of his very earliest paintings as 'a piece
of a cheese on a stick' and 'a pair of dentures on a tripod' or
some such facile nonsense. But as he takes in how much I've
changed, and how desperate I probably sound as well as look,
his tone alters and he suggests we meet for dinner tomorrow
at the Ritz.

Plush hotels seem almost designed to make you feel a bit
shabby but I find I don't much care as I hand my crumpled mac
in at the Ritz's cloakroom. I'm also pleased, once we're seated in
the elegant restaurant, that after weeks of barely touched pasta
the Whitstable oysters and steamed turbot slip down so easily.

I'm a bit drunk already, because I've been off the bottle for a while and I'm trying to pace myself for what I imagine will be a very boozy evening ahead when Francis, who's been topping up my glass with the claret, suggests we go to Crockford's. I'm intrigued by the idea, not only because I've never been gambling with Francis before, but also because I've virtually never been gambling – apart from once at the casino in Monte Carlo, where I wanted to see the *salons privés* Francis often mentions and where, in about ten minutes, I stupidly lost half the money that Alice and I had earmarked for our subsequent holiday in Corsica.

That won't be a problem this time because I don't have much more than a cab fare on me, and when I mention this to Francis as we're ushered very cordially into the roulette room at Crockford's he nods and, as if it were customary in the circumstances, he hands me a wad of large banknotes, which we change for some brightly coloured chips. I don't have time to protest because he's already off among the green-baize tables, settling a little bunch of chips here, another there. I walk round to get the general hang and start playing as well, without any system, betting on a couple of random numbers and impairs without really thinking about it, because the whole thing seems arbitrary, not to say silly, when you're using money that's not yours and you never even expected to have.

I start circling round the tables, among a few jovial punters finishing off an evening and a larger number of pale habitués, many of them slender, almost emaciated women who are gambling as if their lives depended on it. With beginner's luck I've started winning a lot more than I've wagered. Francis comes back, saying he's completely cleaned out, and I give him my winnings and simply take another turn round the room, savouring the champagne that's being liberally served free of charge and watching the raptness of the other gamblers crouched over the baize.

Eventually Francis comes back and tells me he's lost it all so we should go and get some more money from the studio. I expect him to be downcast but he's exuding pleasure and vitality. Out of thin air Crockford's provides a chauffeured car and we set off towards South Kensington, and Francis starts up a bit of banter with the driver, who's wearing a peaked chauffeur's cap.

'Are you Mr Bacon then?' the driver says after a while.

'Mr Bacon, Mrs Bacon or Miss Bacon,' says Francis. 'However you like it, dear.'

We go up to the studio while the Daimler purrs on the cobblestones outside.

'I *know* I've got some money here somewhere,' Francis says, picking up odd tins of dried paint out of the mess on the floor and shaking them.

I join in, beginning to giggle at the scene.

'Ah, there we are,' Francis says triumphantly, shaking a tin over his head as scores of notes come floating down.

We collect them all up, shove them into Francis's pockets and go back to Crockford's.

Francis wanders back to the tables and loses even more quickly than before. Once again, this does not appear to affect him. On the contrary, he appears exultant, as if losing were far more desirable and welcome than winning. Once again, the Daimler awaits us and drops me in Knightsbridge before taking Francis home. Francis seems particularly keen that we should meet again tomorrow, and although I'm slightly anxious that he might turn if he sees too much of me, I agree. I'm still quite high on the wine and my win.

Next evening is almost like a replica. We have a delicious dinner, but at the Connaught this time.

'I've got the money you gave me,' says Francis when we sit down, and he passes an even thicker wad of cash to me under the table.

'But Francis, it was your money,' I protest weakly.

'No,' he says, very firmly, in a voice I have learnt not to counter. 'It's the money you won and lent to me.'

After dinner we go back to Crockford's and start gambling. I am still as inexpert but I play with a bit more purpose, while still feeling it's play money, like Monopoly notes, I'm using. I have several wins, no doubt modest in comparison to the sums in play all around, but when I tot the total up, I have made more than I earn in a year. I scrape my chips together and have them turned back into hard cash.

Francis arrives beaming. I suspect he's lost again, but he's clearly undaunted.

'I'm absolutely ravenous,' he says. 'Why don't we go to Annabel's and have some bacon and eggs?'

The chauffeur whisks us down the street into Berkeley Square.

'It's there,' says Francis, chuckling. 'There where all those things with cockades in their hats are standing.'

The car stops at Annabel's and the footmen hold the door while we clamber out.

There's more champagne, and when the bacon and eggs appear Francis orders a very fine Château Latour. I find I'm hungry too, although I think my appetite is for the sheer luxury and fun of the evening rather than food.

Then we go back to champagne and sit near the dance floor which is raked by coloured strobe lighting. The music is good and I still recognize all the hits they're playing. There are a few dancers on the floor. On the sofa next to us there are four girls laughing among themselves.

'Why don't you dance, Michael?' Francis asks.

'I don't know who I'd dance with,' I say, laughing. The idea seems preposterous.

'You could ask the girls over there,' Francis suggests unhesitatingly.

'I can't just ask like that,' I say. I'm embarrassed now.

'My friend says he can't just ask you to dance,' Francis says, leaning forward in the gloom to the row of girls. I've noticed that a couple of them are quite pretty. 'But what d'you think? I've told him that these places are made for dancing. Don't you agree?'

The girls seem all up for it, so I get to my feet a bit awkwardly and accompany one of them on to the floor. She turns out to be one of the more attractive ones, but it hardly matters because all her friends have joined us on the floor as if they'd been waiting all evening for this and everybody lets themselves go to the music and when certain old favourites like 'Satisfaction' come up I feel some of my old prowess coming back and start strutting stuff I haven't done for years and we're all caught in the light and the movement and the music and the laughter, and by the time the club closes I'm still laughing and I realize in the cab going home I've got a small fortune bulging out of my jacket and that in turn makes me laugh even more, alarming the cab driver who thinks he's got a right one in the back and looks distinctly relieved as he drops me off at David's front door.

Drunk and exhilarated, I make myself comfortable on the sofa and drift off into a deep sleep for the first time in months, and when I wake up I'm still laughing, laughing at the marvellous frivolity of it all, and although I can't forget I'm still beaten black and blue on the inside, I know now something fundamental has changed. I know now that, whatever darkness I still have before me, I'm going to get my life back.

13

Whose Turn is it Now?

'You remember Michael?' Francis asks.

'Course I do dear,' Muriel says in a warm boozy wheeze.

'He used to be much better looking before he grew that beard,' Francis informs the handful of drinkers gathered round. I recognize Frank Norman, with the big scar down his cheek, and Robert Carrier, the TV chef they call the 'Carrier bag', as well as a couple of others I haven't seen in years.

'But there it is,' Francis goes on, waving his champagne glass. 'I suppose he thinks he looks better with it. He thinks he does. I myself like faces where you can see all the bone structure. Without any of those disguises.'

'You might say that shaving itself is a disguise,' I say, grinning uncomfortably.

'Touché, dear,' Carrier chimes in genially, touching Francis on the sleeve.

Two more bottles of champagne are ordered from Ian behind the bar and all the Colony's other members are drawn in. Francis launches into a more metaphysical theme. It's just like old times, almost like going back to school, with all the old boys showing off, cracking jokes and talking dirty. I haven't been back to London in months, but after a few minutes in Muriel's dingy green den, with the afternoon sun highlighting the smoky fug inside, I feel I'm back home.

'He's really like Jesus. A superstar,' says a baby-faced giant in blue jeans standing next to me, forcing the barely formed words round a cigar and pointing at Francis.

He moves up the bar, plucks the cigar from its moist mount and repeats, giant-gentle:

'You're like Jesus's become, man. A superstar.'

Francis whips round, deliberately, knowingly, but his face is drawn up in pained surprise.

'A what? A superstar?' he asks mockingly, champagne glass aloft. 'I'm not sure I know what you're saying. I may be a lot of things, but I don't think I'm a superstar. I can't even think what you mean. What is a superstar?'

The colossus grins, happy to take Francis closer to the heart of his meaning:

'Well, you know. A kindavver cult figure. Come on now, man, you know you're a kindavver cult figure yourself.'

'I simply don't know what you're talking about. Cult figure? Superstar? Perhaps you could say it all again, more clearly this time. After all, what can be clearly thought can be clearly said.'

'Well like you know . . .'

'Of course Voltaire also said, "What's too silly to say can be sung,"' Francis adds with a winning smile.

From her corner stool, Muriel leans over and taps Francis sharply on the arm.

'You're not a superstar,' she says rapidly, 'you're just a cunt, dear.'

'Well, I suppose I am,' Francis concedes, almost gratefully. 'If you say so.'

'Who's a cunt now?' queries an adjacent drinker, swinging his grey face up from a long brood and pushing back a lank of lifeless hair.

'The big one's been calling him a superstar, dear,' Muriel explains kindly, 'so I said he's not a superstar he's just a cunt. You didn't think I was talking about you you silly old ballock did you, dear?'

'I don't care who calls who what,' the grey-faced man announces with abrupt fervour. 'We'd all be better off dead. The whole lot of us.'

All attention turns on him.

'I mean I can't see why people cling to life. Why bother to come through one of those ghastly operations, I mean. To live a sort of half-life afterwards. What's the point, you know, with everything difficult as it is anyway. Might as well die straight off and have done with it.'

Francis moves a little nearer, his head cocked to one side in curiosity.

'Well, that only depends on how much you really want to go on living,' he says evenly.

The grey-faced man's yellowish eyes flicker in alarm at finding himself the centre of interest.

'Now, myself, I do want to go on living,' Francis goes on, watching the man's face closely, watching his words at work. 'I want to go on living even if I have to have one of those ghastly operations. Because there is nothing else, do you see? There is only life. Death only exists in the minds of the living. It's nothing and it goes on being nothing for a very long time. So you can only go on living. Because that's all there is. All one asks for, in the end, is a mind that works and a body that can somehow get itself from place to place. Because, in the end, life is about nothing more than that. We come from nothing and go into nothing, I'm afraid. So we must try to make what we can of the brief interval between. Now, tell me, what are you drinking?'

'Mmm. Oh, whisky. Thanks. No, I mean death does sometimes present itself to one as a, well, as something of an attractive alternative. I mean at times, really, don't you think?'

'I don't. No. Because death just isn't anything. It's absolute nothingness. Do you follow me? Now you can of course simply do yourself in. I always keep enough pills, because I hope that if ever I have a stroke, I'll just manage to reach out for them in time.

But I also hope to go on living for ever. It would be dreadful for everyone else, I'm sure, but what else is there to do?'

'Well, I mean yes, I suppose. If you think of it like that.'

'How else can you think about it? Unless you want to become compost. Unless you want to become compost for someone's roses. Now do you want to become compost for someone's roses?'

'Ah. Haha. No, well, put that way of course I don't, no. Still. No, put like that who would?'

'There you are. Those are what are called the facts.'

'All the fucks did you say, dear?' rejoins Muriel, seated in noble repose against the wall, the bar light playing on her pearls. 'When did you last have all the fucks then, daughter?'

'Now that's another story. About two weeks ago. Someone new I met and melted with. At least you pretend to melt with them, but you only pretend of course. And then it's what's called just another experience brushing off on you.'

'Just think what must have brushed off over the years on *her*,' says Ian with sudden venom from behind the bar. He makes an embittered moue and fussily tops up some more glasses with champagne.

'Well, of course everything and everybody has brushed off on me over the years,' Francis says, carefully sweeping his finger along the bar and inspecting it. 'But it's been the best of everybody. So I really don't see why', he goes on, turning the collar of his leather jacket up in mock protection, 'you have to pick on a poor little thing like me. Now let's have some more champagne. Yes, let's have some more. Even if we do all drop down dead. Here's to you, Muriel, I was just thinking how marvellous you look this evening. You have a beauty that goes right back to Egyptian or Babylonian times.'

'He's a real top-grade superstar. Like they've brought back Jesus,' the giant youth whispers, holding out his glass. 'He's Jesus superstar.'

The worn door at Muriel's black-satined back swings open. In comes a new card, cheeky hat acock, eyes swiftly taking in the room.

Muriel turns her severely beautiful head, ready as ever to assert her authority over her den.

'You can take that hat off right away. Not in here, dear. Hats are not de rigueur. How d'you like my bit of parlayvoo, dear, is it alright? No, not you, dear, you wouldn't know a French word from an arsehole, dear. Perfect is it, dear? I always said culture must have rubbed off on me during all me long years in this refined club. Not the only rubbing that's been going on is it, dear? Ooh look how she drops her eyes. All fucking blushes and cream, dear. Cream's not in it. It's alright, dear, I'll shut up now. I've got a sore throat that could do with a bit of a rest. You can look up, dear. No one's going to ask you what you've been rubbing.'

'Got a bit of a sore froat, have you then, love?' queries the new arrival, hatless now, firmly nursing a drink.

'Yes, sore throat. You know me, dear, sucking cocks in furnished rooms. You remember me – come on, now, dear.'

The newcomer flashes a mirthless laugh then scrutinizes the room for someone evidently not there.

'You've not seen Miranda then have you, love?' he asks.

'A pleasure we haven't had in some time,' says Muriel. 'She's too grand for the likes of us really you know, dear. Ever since she took up with that what's his face, dear? You know the one that's been in all the papers talking about how brave he was in the war against Miss Hitler. Anyway, someone told me that a couple of nights back they had an orgy at his place. All ballock naked, dear, a dozen or so they were. They say Miranda was having it away non-stop, on the old dining-room table if you please, dear. Or against it. I'm sure she likes a bit of mahogany under her bum.'

Paler, the newcomer forces a chuckle and all of a sudden is no longer there.

Having absorbed these fresh confidences, the colossus lets out a booming laugh. Here was truth. Here was how people really were, if only they'd admit it. Guts didn't lie, man.

'That's what I'd really like, more than all you superstars,' he says, with a toothy leer, 'bit of cunt spread out on the table.' 'You can keep your trap shut for a start, dear,' Muriel retorts sharply. 'You only open it to let out a load of ballocks. If any cunt comes in here, dear, it'll be for me. I'm chief cunt-catcher here aren't I, daughter?'

Francis raises his glass in assent and toasts her with a tender, glistening smile.

After a long session at Muriel's there can be no odder place to be spending the night than at the Athenaeum on Pall Mall. I was told the moment I entered the neoclassical portal and stood gazing up at the great central staircase that I 'will be needing a jacket and tie at all times in the public areas, Sir'. After a good look round, I discovered that most of the other club residents weren't wearing ties at all, but dog-collars, and I was tempted to make a joke of it with the porter until I met his steadfastly unamused gaze. The libraries and the drawing room on the first floor are magnificent, but the bedroom I've been given is as poky and comfortless as the one I had at school. The divines, who tend to be tall and thin with big red bony hands poking out of their dark jackets, are very cordial and constantly grinning, as if we were all playing parts in a farce as we cross in the dining room or meet on the stairs. It is something of a farce, but they seem to take to it with much more gusto than me, cheerfully accepting the creaking beds and the clanking pails of the cleaners who wake us all just after dawn – some five minutes, it seems to me, since I came back from my odyssey in Soho. As it happens, I nearly stayed out even later because, after leaving Francis, I was invited by a husky female voice in a doorway to another kind of gentlemen's club just upstairs. I hesitated for a moment, then just in time I remembered the photographer David Bailey telling

me once how he had been propositioned by a hostess in a similar
joint: 'I don't come 'ere for sex, love,' he'd told her. 'I come 'ere
for degradation . . .' I walked past, determined to return to my
clerical friends instead.

I should have much preferred to be sleeping on David's sofa,
which I consider my real home in London, but he has left on a
trip abroad. Actually I now have my own club in London, and
I don't mean the Colony or the other Soho drinking clubs I've
signed up to. I probably wouldn't have thought of it, but when
Alice announced that she had never known an Englishman
who didn't belong to a gentlemen's club I thought I'd better
conform to type and I joined the Oxford and Cambridge as the
one I had the best chance of getting into. They're closed now
for the summer but they offer a number of 'reciprocal' clubs
for their stranded members to eat and sleep in. After roaming
round the Oxford and Cambridge and discovering all its nooks
and crannies, including a small 'Silence Library' where all talk
is forbidden and a weighing-seat where you add various brass
weights until the scales balance (and tell me that I've put some
weight back on), I have grown increasingly curious about the
other clubs that line the southern side of Pall Mall. After all
my years of living in France, this is where, behind the august
façades and members-only barrier, I think I can find the secret
heart of my own country, faintly beating. So in idle moments
I've been prowling around as many clubs as I can, noting
their idiosyncrasies, such as card tables with niches cut out to
accommodate prominent bellies, and savouring the strangeness
of enfilades of empty, smelly reception rooms, smoking lounges,
members' bars and ladies' annexes, many of them commanding
choice views over the West End. Nothing is more startling in
these inaccessible spaces than to come across another human
being, either asleep or possibly dead in a dark library or, even
more disturbingly, alive and prowling around the premises
like oneself in suspended wonderment that such privileged,
forgotten retreats still exist.

The Athenaeum's public rooms are particularly impressive, and knowing that Francis likes grand spaces – he often harks back to ballrooms and large, bow-windowed drawing rooms in country houses he knew in Ireland – I've asked him to come here and have a drink in the bar, which is exotically and bizarrely decorated with embossed gold wallpaper. I've made sure that a good champagne is on ice, but when Francis arrives he says he'd like a whisky, which I hope means he's had too much champagne rather than an attempt to keep my minor expenses down. We then move around the club, whisky in hand, until we find a comfortable place to sit in the drawing room overlooking the club's garden. I've been expecting Francis to mention that he knows the Athenaeum well since one of the most important men in his life, Eric Hall, was a member and must have come here frequently with his young companion. But I've also noticed that Francis has regular lapses of memory these days, perhaps particularly after heavy drinking bouts, and I remember the last time we had dinner in Paris at a very fancy, Michelin-starred establishment where we'd been before (and where they address him as *maître*, which he hates), he resolutely denied ever having eaten there, even when they brought out their *livre d'honneur* for him to sign and we both noticed his signature already there, scrawled on the opposite page of pretentious-looking mock parchment.

'You must have been here before, Francis,' I suggest eventually. We are almost alone in the great room, apart from a club servant tidying up the newspapers and carrying away coffee cups.

'You know, I never come to these kinds of places,' Francis says, regretfully. 'I do find the rooms absolutely beautiful, but they'd never have someone like me here.'

'I'm sure they would,' I protest, taken aback by this sudden self-deprecation. 'They have all kinds of artists and writers here. It's a tradition. Eliot and Yeats were both members, and so I seem to remember was Turner. They'd make you a member in a trice, Francis.'

'Well, I'm not really the right person for these places, not with the kind of gilded gutter life I lead,' Francis says, firmly terminating further discussion.

He seems to be depressed, not in the vitriolic way that feeling down often takes in him, but melancholy, although his life, like mine to some extent, has gone through a distinct upswing of late. For all his protestations that he'd never have an intimate relationship again, he's been for some time now with a good-looking East Ender called John Edwards, whom I've already met and whose cheerful frankness appeals to me. One of John's projects is to open a pub called the Bacon, but although Francis seems to go along with the idea quite genially I'd be surprised if it came off. We're actually having dinner with him, along with Francis's sister Ianthe, on a visit from Rhodesia, and David Sylvester, who's bringing some new girlfriend, this evening. Then, on the professional front, he has his new retrospective exhibition being organized at the Tate. Most painters never have a show there, and no one else as far as I'm aware has ever had two in their own lifetime. So I'm wondering why Francis seems depressed and the only thing I can come up with is the sheer volume of alcohol he's ingested over the past few days. Even Francis must have his limits, though God knows I've never been aware of them. I know he doesn't like being probed about his habits – I remember him savaging Sonia for it – but conversation is proving such unusually hard work with Francis so withdrawn that I chance it.

'I find really heavy drinking gets me down after a while. Does it have the same effect on you, Francis?'

'I can't say it does. I do drink heavily, of course, but I don't really think about the hangovers and things, though of course they can make you feel very uncomfortable. I don't believe I'm what's called a complete alcoholic. Not yet, anyhow. Because although there's always masses to drink in the studio, I don't actually touch a drop when I'm alone. I love the sensation you get in drink, because it relaxes me, but nowadays if I'm drinking

very heavily I get blackouts and can't remember anything when I wake up, and then I'm filled with guilt.'

'Of course alcohol is a kind of depressant,' I say, draining my whisky. 'After a couple of days on the drink I can feel it depressing me.'

'I'm almost never depressed, unless of course what's called your friends are committing suicide all around you and dying off like flies. For some reason, although I believe in nothing, my nervous system is filled with this optimism. It's mad because it's optimism about nothing, though I have to say with this country in the state it is now there's really no cause at all for optimism. D'you know, Michael, things in England are just grinding to a standstill. Nothing works any more here, unlike Paris, where even the waiters seem to work hard. There's this atmosphere now that it's stupid to work. It's true that people can get just as much on the dole. But it can't last. London's filled with young layabouts, all run to fat already and with nothing to do. The pound's gone to confetti. I suppose it'll go on going down and down until it's worthless. I'm not a Fascist, as Sonia says. I'm what used to be called a liberal. I can't see why Sonia and all those upper-class friends of hers keep going on about helping the workers. It means nothing. They never change anything, they just sit in their expensive houses talking about it all day to give themselves a good conscience. There's something really rather disgusting about those rich people who are so terribly worried about the working class. It's as if they're trying to play both sides at once.'

'Well, you feel that about Michel Leiris, don't you?'

'I'm very fond of Michel, as you know, and I think he's a superb writer, but I really can't see how he manages to be both a communist and a millionaire. He says how marvellous life seems to be under Mao, but of course if he lived under Mao he'd never have been allowed to do all the books and things that he has done. The thing is today, there's simply no one in politics. Who is there? They're all mediocre wherever you look. I did feel

terribly depressed the other evening when I was listening to the news because I thought how similar the conditions were now to Munich. There's a whole atmosphere of Munich, though of course it will be the Russians this time. It's obvious that in the next few years they will invade Europe. Sometimes I feel I can almost hear their boots marching. There it is. If I were young, I think I'd go to America and try to make films or something. America will be the last place left when Europe has gone to the Communists.'

As we come out of the club and begin walking along Pall Mall in the evening sunshine, I sense that Francis's mood has lifted a little but he still radiates a kind of distant, cold sadness.

'I've probably been talking too much, as usual, Michael. I've noticed I'm becoming more and more garrulous with age. But this is the thing. When you reach my kind of age, you realize you only have a short time left and all you can do is sort of watch over your own decay. And that's not a pleasant thought. If there was an operation you could have to restore youth, however disagreeable it was, I'd be the first to have it. Old age is ghastly. It's like having a terrible disease, and there's nothing, nothing you can do about it.'

We catch a cab to Wheeler's where Francis has booked his usual large table just behind the mullioned window. The jovial owner, Bernard Walsh, comes over to greet us, as do several of the waiters. The art world grandee and Picasso expert, Roland Penrose, crosses the restaurant to ask Francis cordially how he is. A distinguished-looking couple at another table wave at Francis and the man gets to his feet. We go over and Francis introduces me to Joan and Paddy Leigh Fermor, whose reputation as a kind of writer-adventurer in Greece rings a faint bell. They are both very charming and as we go back to our table laid for six with a bottle of champagne in its silver bucket I realize that along with Muriel's this is Francis's real club, where he knows all kinds of people and is greeted enthusiastically, and I can see his spirits rise almost visibly like the golden bubbles springing off our first glass

of champagne. As we wait for the other guests to arrive, a slight, middle-aged man begins to weave his way through the room, clearly drunk and bumping into several tables, until he crashes to a halt by ours, holding on to it like a man in a shipwreck.

'I don't think you've met Jeffrey Bernard, have you, Michael?' Francis asks as if nothing were untoward. He's beaming now, as if this chance encounter had reunited him with the comedy of life. Jeffrey Bernard attempts to focus on me for a long, blurred moment. He has ruined good looks and an aura of misfortune. He tries to speak, first to me, then to Francis, but no words come out as he sways there.

'It's alright,' Francis says to him. 'We've all been like that.'

He slips some banknotes into Bernard's jacket pocket, swiftly and firmly. Bernard again tries to speak, but he seems to be falling forward and for a moment I think he's going to fall headlong on to our table, smashing glasses and shattering plates, but in one last heave, with his eyes closed and as if by pure instinct, he pushes himself away from the table and towards the open door and still falling disappears out into the night.

'I wonder what Jeffrey will do, now that he has lost his looks,' Francis comments mildly.

Ianthe arrives on the very dot of eight o'clock – clearly the Bacon children were brought up to be punctual – then comes John, curly-haired and grinning, followed by David Sylvester, whose girth and ponderous air always make an impressive entrée, and his slight, much younger, blonde girlfriend. I am seated opposite Ianthe, with the girlfriend to my right, which pleases me because she's attractive, and Sylvester is already looking anxiously down the table as we begin to chat animatedly. Wheeler's swings into its polished nightly act and platters of oysters on crushed ice appear along with more champagne and Chablis, and I discover that my dinner companion is also an art critic and a university lecturer and she appears very keen to discuss art and engages me closely in her acute, detailed analysis of conceptualism while over her shoulder I notice Sylvester

looking increasingly distraught. The soles have been served, our glasses topped up and I'm enjoying myself but beginning to feel that as a good guest I should also be talking to Ianthe and John, who are looking a bit out of it, but the girlfriend has squared her shoulders very deliberately towards me, half blocking out Sylvester, and she's begun an intricate discourse on the predominantly political significance of all art and my eyes start wandering beyond her determined monologue up the table to where Sylvester is beginning to heave with what looks like uncontainable emotion.

'I think David's getting a bit upset,' I say to the girlfriend.

'But don't you see, Michael,' the girlfriend continues implacably, 'that art can't be anything but political, entirely political, given that everything is political and politics itself is ubiquitous?'

At this point there is an eruption at the top of the table, and David bursts out weeping. His whole massive frame is shaking and tears are streaming down his cheeks in unnatural quantities and dripping on to the table. He gathers up several napkins to try to staunch the flood but it continues in a belligerent wailing that rises over all conversation, bringing a sudden hush to the whole of Wheeler's. Dotted around the room the other diners are fixated by the spectacle and wait in silent suspense to see what will happen next. Even the owner, a veteran of Soho antics, is standing by hesitant and perplexed. As the girlfriend ceases to talk so Sylvester's weeping slowly begins to subside into a series of sighs and heaves. His face emerges from the napkins, moonlike and fleshy, with a few teardrops clinging like tiny translucent fruit to his abundant beard.

Tenderly amused, Francis leans forward to pluck them away. Then he turns to our waiter and asks him to call for a taxi.

The whole restaurant still can't take its eyes off our intimate drama. How will the girlfriend react? Will she leave with her aggrieved partner? Or will she continue to talk and turn her shapely back on him? The cab arrives and revs noisily outside

the door. Will the couple make it up in time? An almost audible sigh of relief rises from the room as the girlfriend gets to her feet, icily angry at being upstaged but having little alternative now but to sweep out of the restaurant, in high dudgeon, with her corpulent lover in tow.

'*Vous pahtay déjà?*' Francis calls after them in his best Mayfair French. '*Vous pahtay déjà vers le bonheur?*'

The dinner ends quickly once the drama is over, but the whole incident seems to have restored Francis's ebullient good humour.

'After all, who enjoys a lovers' quarrel more than the spectator?' he says, paying the bill and slapping down several large notes as a tip. 'We used to go night after night to the Gargoyle simply to watch couples carrying on the same old argument – it was like a terrific row played out in nightly instalments . . . Now I wonder where we might go to finish off the evening?' he adds brightly. 'I know John feels his luck is in and terribly wants to go and have what's called a little flutter at Charlie Chester's.'

Ianthe says she's too travel-weary, so we find a cab to take her back to her hotel and then plunge through Soho on a short cut that John has devised. On our way over we come across a crowd of people milling around a couple of fire engines and several police cars. John asks someone in the crowd what's happened. 'Stupid bleeder on the third floor,' the man says. 'Shot his girlfriend, then turned the gun on himself.' Francis listens to him intently and looks up at the building. 'Well,' he says as we move on, 'I suppose it's a gesture. But it's a gesture you can make only once.'

Violence is in the air. We cross another couple of dark streets and come upon a gang of youths kicking a curled-up boy in the gutter. With the courage of recently drunk wine, I make to intervene. 'I wouldn't do that,' Francis says sharply. 'They're like animals. They'll kick your head in too.'

I've heard of Charlie Chester's but I've never been there, and as soon as we arrive it's clear we're not there for the atmosphere

since the place certainly has none of the panache of Crockford's, where I went gambling with Francis before. There are various games with evocative names, like crap and blackjack, and numerous silver fruit machines stuck round the walls. Some punters appear to be playing on a couple of tables at once, taking a passing crack every now and then at the one-armed bandits. Francis, pink-faced and chuckling, soon gets into his stride, dropping off little piles of coloured chips. It's clear that he's following some system of his own, placing the chips very deliberately. I feel I wouldn't know where to start, so I just look on, reluctant to risk the money I have set aside to pay for my stay at the Athenaeum. Much like last time, Francis is quickly cleaned out and the three of us go back to the studio to hunt for a wad of cash he's hidden – again in a dried-out tin of paint – and return, rearmed, to the tables. I'm tempted this time to try my luck with part of my money, and I'm annoyed to find that I lose it almost immediately, with all my chips raked in and nothing to show for it. Fortunately, a bottle of champagne has materialized, no doubt provided by the watchful 'house', and I join Francis at a small table where he's keeping an eye on John's progress.

'I really don't know why I keep coming back to these places,' he says, clearly delighted by a significant new win. 'I always think that for a moment my luck might change. It's mad. What's terribly nice, though, is that I've already managed to win back everything I'd lost earlier and just a bit more. You always lose in the end, naturally, but now and then, if you're really lucky, you get that marvellous feeling that luck can only work your way. It never lasts for more than an instant, but for that instant it makes life really exciting. If one didn't lose, of course, these ridiculous places wouldn't exist. They live off all those fools like me who for some reason think they're actually going to twist luck in their favour.'

I consider telling Francis that I've just lost but think better of it in case he insists on topping me up so that I can play and lose some more. It occurs to me that if I won last time it was

partly because I simply didn't care. Now I care very much and I don't want to get into money problems, like running up an overdraft or having to borrow some cash. I also wonder whether the fact that I was so down on my luck in every other area of my life didn't help me win then. Over the last few weeks I've been hatching a plan to relaunch the Lugano-based art magazine called *Art International* from my apartment in Paris. The prospect is hugely exciting; it's a bit as if I'd fallen in love again and that almost certainly will not favour my luck at the tables. I decide to hang on to my remaining loot and just enjoy Francis's new-found loquacity.

'And did you ever manage to twist the way luck went?'

'It's happened terribly rarely over the years. Not very long ago, when I was on my way back from the south-west of France with Dickie and Denis, we drove through that what's it called, that place where you can walk under all those marvellous arcades and never get wet when it's raining, yes Dinard, and I did for some reason have a bit of luck there and manage to get out with enough to pay for the whole holiday.

'I don't think you can know the tremendous draw gambling has unless you've been in that kind of position where you terribly need money and you manage to get it by gambling. When you need it and win. It can get a hold of you then. Of course you spend the rest of the time losing it again and God knows how much more. But at those moments there's this feeling you get of being able to control the way your life goes.

'I had a marvellous win, years and years ago now, it must have been about 1950, when I was in Monte Carlo. I was playing on three different tables and I kept thinking I could hear the numbers called before they came up, as if the croupiers were actually calling them out. I had very little money and I was playing for small stakes. But by the time I'd finished I'd got sixteen hundred pounds, which was a very great deal for me at that time. So I went out and took a villa and stocked it with food and drink and invited a lot of people to come and live there. At the end

of it all, I didn't have anything left, naturally, hardly enough to buy a train ticket back to London, but it was marvellous while it lasted, and I had lots of friends.'

'Do you still go back there?'

'You know, I don't much, but I adore the atmosphere of those places. They have a kind of grandeur, even if it's a grandeur of futility. There's something so beautiful about the view you get from the casino in Monte Carlo, when you look out on to the bay and the curve of the hills behind. I love that kind of landscape. That and just desert. I love the feeling of all that space with absolutely nothing in it . . . It sounds ridiculous, liking a landscape from behind a window, but I actually can't stand the countryside itself. After a day or two, I long for streets and people, just to be able to walk and see them.

'Those places like Monte Carlo fascinate me too because of all the odd people who seem to be able to exist there and nowhere else. Well, the curious kinds of doctors who I suppose can only practise in those sorts of places. And those incredible old women who queue up for the casino to open in the morning. Anyway, the evening I had that marvellous run of luck in Monte Carlo, a very handsome man was standing opposite me at one of the tables, just watching everything that was going on. Well, he came and stayed with me at the villa I took. And we were standing outside one night looking down at the sea and he said, he had some foreign accent, "That eez my yacht over zere," and of course I knew he hadn't got a yacht and I said, "That's not your yacht," and he said, "Ah perhaps it eezn't zat one, it must be over zere somevere . . ." Anyway, later I said to him, "Why don't you go into the films with those marvellous looks of yours?" And he looked very serious for a moment, and then he said, "Vell, I might go into ze films. Yes I might, I vill tink about it." Anyway, the next morning he disappeared. And a couple of hours later the whole of the Monte Carlo police was in the villa wanting to know about him. It turned out he'd worked his way all round the Riviera, from casino to casino, as a confidence

trickster, making people pay dearly for their fun, and probably everything else besides. 'I've lived the life of all those fools. In many ways I regret it now. I wish I'd begun to paint seriously much earlier. I didn't really begin until I was thirty or so. For so long I simply enjoyed myself, without knowing what I wanted to do with my life. At the time I was with this friend who had money, and we drifted together round the Mediterranean, going to all those kinds of places, staying in grand hotels and eating and drinking too much. The barmen there were fascinating, they were like nursemaids. People would come in and sit at the bar and pour their life stories out. And the barmen would keep filling their glasses and telling them what they should do. It was absolutely mad, but for some reason we spent all our time there. There was such boredom in the place you simply sat there and couldn't believe it. One woman got so bored she just went up to her room and threw her dog out of the window. Well, it landed on that thing, the awning, below, and someone had to be sent to rescue it. Of course everyone loved that. It gave them something new to talk about. Relieved the unbelievable boredom of it all for a moment. Just for a moment.'

I realize that if I hadn't had such a complete breakdown I should never have left my impecunious but stylish, agreeable life as an art writer to get into the rough and tumble of trying to launch a specialist magazine. It was a bit like a drowning man grasping at a spar. Just as I began to resurface, Jim Fitzsimmons, who founded *Art International* in Switzerland in 1956, died. He was still relatively young, and alongside excessive drinking and smoking the main cause of his death was the unrelieved stress of running a high-quality, poorly funded magazine. Ever since I wrote my first article on Bacon for him, Jim and I had become good friends, and while I was suffering from my run-in with Rubin, he gave me all the moral support he could. On his death

he also left me his whole, extensive library of first editions of modernist poets, from Pound and Eliot onwards. Like my fellow contributors, I was aghast at the idea of life without *Art International*, which I considered head and shoulders above other art magazines and for which I had been not only Paris correspondent for a good decade but also a senior editor (when Jim had no money to pay even his key writers, he would bestow prestigious titles on them). For a while there was discussion among the most faithful contributors about who might walk the plank, none of us having illusions as to how perilous and thankless the responsibilities of producing a niche art magazine would be. Like a sleepwalker, I stepped forward. Then in the dead of winter I made the trip to Lugano, handed over a symbolic Swiss franc to a lawyer in return for the rights to the magazine's title and, from a lugubrious storage site covered in muddy snow, I collected the remains of this internationally respected magazine: a few hundred copies, some shoe boxes filled with subscribers' addresses, and numerous letters, including a long, lively correspondence with Jean Dubuffet.

Now that I've got these fragmentary archives back in my apartment, I'm wondering quite what the next step is. It reminds me a bit of when I manoeuvred myself into the driving seat of *Cambridge Opinion* all those years ago, then realized I didn't know how to drive. Here the problems are more daunting because I am no longer a feckless student but a man in his early middle years, *nel mezzo del cammin*, who is about to have the entire moral, financial and fiscal responsibilities of an international publication suddenly visited on him. There are a few glimmerings of light in this dark tunnel. Several friends have pledged support of one kind or another, not so much in the form of cash, unfortunately, as advice and introductions. I've also been absorbing the correspondence with Dubuffet which reads almost like a manual on how to launch an art magazine. Fitzsimmons himself clearly had to learn as he went along, and Dubuffet is constantly guiding him, insisting above all on which

art dealers he must cultivate to ensure they take, and pay for, advertising space – the only revenue a magazine of such inevitably limited circulation can aspire to. I wonder who my Dubuffet might be. Although I plan to do my first issue on the 'School of London' artists (again not so different, although hopefully more professional, than my *Cambridge Opinion* venture), Francis is the only one with the influence and the generosity to help. But I particularly don't want to ask him for anything because in this new undertaking I want to stand very much on my own two feet. For the moment at least, I realize, I will have to be my own Dubuffet.

Meanwhile, news of my editorial acquisition has gone the rounds of the Paris art world in no time. One variegated group, which might be loosely characterized as my artist friends (who range from the middling successful to the irretrievably obscure), are celebrating the fact that, if I have not extolled their achievements in print earlier – because, I pleaded, my philistine editors always refused – now the way ahead is clear: as owner and publisher, I will be able to open my pages to them unconditionally, reproducing their works full page, and preferably slap bang on the cover. Some of them have taken to dropping in at my flat, already becoming better known as the *Art International* offices, to gently or quite crudely press their claim. I can barely give them the time of day, however, since I am overwhelmed by the need to set up a financially limited company, study methods of boosting circulation so as to stimulate advertising, while staying within the peculiarly constrictive French laws on commercial undertakings. I have started visiting bankers and accountants as if I can't live without them. I also need constant legal advice, and luckily an old friend from Cambridge, Charles Campbell, who has set up a flourishing law firm in Paris, generously gives me both counsel and the comforting impression that I no longer stand totally alone, naked and unprotected, before the law. One thing everyone seems agreed on, however, is the doubt as to whether my undertaking can be conceived of in any sense as 'commercial',

since all the signs are that art magazines devour money, hope and goodwill, chalk up losses, then die.

If money is scarce, enthusiasm for the new project is becoming almost embarrassingly abundant. Offers to write, to solicit advertising or to mastermind subscription drives and promotional campaigns pour in, as if a deep swathe of the Paris art world cannot resist the seductions of working on the relaunch of the high-minded, beautifully produced magazine that *Art International* has always been. Among this number I discover one who appears able to do everything, from knocking out a useful text to organizing subscriptions and chivvying potential financial backers. Above all this clever, hugely keen American academic proves to be a dab hand at computers, whose use and very existence has escaped me until now. The American and I tacitly agree to join forces, and my elegant bachelor pad is slowly transformed into a functional space, with cheap, severe-looking desks and several boxy Apple computers. In what used to be my storage space at the back of the apartment, we also install a gleaming fax machine, and every time it rings, the American and I run down the corridor to watch in wonder as sheets of typescript spew effortlessly out on to the red-tiled floor.

My household arrangements are necessarily changing apace. The dining room, where not long ago I entertained Francis and Denis, has been taken over by the American, who has assumed the sonorous title of 'Editor-in-Chief', which sounds more desirable to me than my own onerous position as 'Publisher'. The big loft-like room, where I used to work and sleep, has also taken on a predominantly professional air in which the bed covered by a vivid green-and-pink Indian quilt looks increasingly incongruous. The small, gilt-framed triptych, the latest painting Francis has given me, still hangs above the fireplace at the end of the room. It acts like a magnet, drawing everybody's attention the moment they come in. It's made up of three studies of the photographer Peter Beard, whom I've met several times with Francis. Peter is strikingly handsome and has sent Francis

sheaves of photographs of himself that I've seen lying around the studio here. Francis talks in a detached, clinical way about liking the 'bone structure' of Peter's face, although I assume he is also very attracted to him. Each 'head' is beautifully, intricately contrived, and I know I should insure the picture, since it's easy to break into the apartment and in any case so many people are now coming through all they'd need is a minute alone to pop the three studies into a bag and slip off. I did get a quote from Lloyd's but the cost plus the security measures they insisted on were way beyond anything I could afford, either this year or next. So I just leave it there, like a major statement, a symbol of our involvement in art, and hope for the best.

An English secretary has joined us, and sometimes she arrives in the morning before, still stuck in my nonchalant bachelor habits, I have even woken up. Since our little triumvirate works at all hours day and night, I'm finding the lack of privacy frustrating, and although I set out not to request any favours I have now asked Francis whether I might have the use of the studio from time to time. Francis has not only agreed, but he's actually encouraging me to take it, claiming that he has to focus on new work over the next few months for the retrospective that the Tate is organizing in his honour. So I flit between the two spaces, wondering where I feel less uncomfortable, the rue des Archives with all its office furniture and electronic equipment or the paint-daubed chaos of the rue de Birague.

Even before we have cobbled the first issue of the new *Art International* together, our team is growing exponentially as we move towards publication date. Not only have we got designer, printer, foreign correspondents and advertising reps in place, but Eli, my long-standing Filipino cleaner and odd-job man, has graduated into a full-time role by undertaking everything from expediting mail drives and running errands to preparing lunch and being on standby to package the actual magazines when they eventually arrive and hump them over to the post office for international delivery. I am too preoccupied by the

whole constantly accelerating process to ask myself whether I
am enjoying this radical change in my circumstances. I'm aware
of how much I dislike schmoozing with gallery owners in order
to win advertising and how impatient I become when sitting
with bankers and accountants going over profit forecasts and
other equally abstract concepts. I am also regularly peeved
by having to commission writers to do the kinds of more
interesting articles I myself used to spend my time writing – a
now distant, idyllic state to which I sometimes crave to return.
I am also growing more and more anxious about whether the
whole venture will survive financially and what my future
would look like if it doesn't and I'm simply left with crippling
debts. Whatever cheques I've managed to garner for prepaid
advertising space have already been gobbled up by mounting
costs, even though everybody on the team has agreed to work
for minimal wages. And since we have splashed out on colour
in this first issue and gone way over budget, I am already living
in dread of receiving the printer's bill, which I suspect will leave
us penniless.

Then, just as we seem doomed to go under before we've barely
even begun – the most ephemeral of ephemeral art magazines –
the miracle occurs. An Italian painter friend who has positioned
himself strategically among the wealthy tells me that one of his
collectors has heard we are relaunching a prestigious art magazine
and wonders whether she might be of help. Apparently this
lady, Mariella, a well-known cinema actress before the war who
married an extremely rich lawyer, now lives between her several
properties while frequently battling manic depression in discreet
Swiss clinics. If she could play a role in the magazine's success,
my friend tells me, it would help her enormously to deal with
her condition. One other thing that she has to contend with, he
adds slyly, is her guilt at discovering that she is fundamentally
lesbian, which she thought I might understand better than most
because of my privileged relationship with Bacon. Depression,
homosexual guilt, gifts of money, I thought: these are all stars

that in one way and another have lit my way. I agree immediately to a meeting.

The date has been set and I make my way to a plump white villa sitting in an immaculate garden in Neuilly. The maid takes my coat and ushers me into an overheated room filled with orchids. It is tea time, and the tea things have been daintily set out with two large dishes of livid-green and shocking-pink macaroons. The moment Mariella enters the room, I fall in love with her. Even though clearly of a certain age, she is still strikingly beautiful, with delicate blonde hair and amazing, oddly wounded blue eyes. Rich and attractive, living in the lap of luxury, she seems vulnerable and she regularly mocks herself. We laugh a great deal, and I munch alternately on the little green and pink confections. Then after a while, tea having been cleared away and a welcome glass of champagne in hand, we talk about the magazine's prospects and the focus of our first issue (she worships Bacon from afar, and we make plans for a meeting next time he is in Paris). And when I think our meeting is over and I should make myself scarce, Mariella says:

'You have been doing a lot of writing. Now it is my turn to do some writing.'

At which point she produces a chequebook out of her handbag, carefully writes out a cheque and hands it to me.

I am embarrassed but delighted, and the delight gets the upper hand. I kiss her goodbye. We agree to set up another meeting soon.

The moment I am out on the street, I stop under a lamp, take the cheque out of my inside jacket pocket and gasp. The sum is sufficient to cover the current issue and the following one. *Art International* has been saved. Life can go on.

Life does go on, and the tempo at the magazine is considerably quickened. Mariella will now appear on our masthead as 'Director of Public Relations', and we have had some smart business cards with the red-and-black *Art International* logo printed for her. True to her new calling, Mariella has suggested that a good way

to attract advertisers to the magazine would be to organize a launch party for our first issue at the George V or some other grand Paris hotel. I endorse this wholeheartedly, realizing that, although I should actually prefer to have the cost of the party in cash against future issues, a reception on this scale would convince the galleries that *Art International* was an ideal, solidly funded publication for them to announce their forthcoming shows. And no sooner have the invitation cards, proper stiffies edged in gold, gone out than our advertising revenue for the second issue doubles. I am both relieved and deeply pleased, but no one is more delighted than our languid English secretary who has come into her own in deciding who should and should not be invited and dealing with the avalanche of RSVPs. When the evening comes round, attendees at the reception are deeply impressed not only by the flowing champagne but by the abundant caviare Mariella has ordered. Dealers who normally didn't acknowledge my presence before now come over to pay their respects, champagne in one hand, blini in the other.

I like to be inclusive and I've invited all our tiny staff including Eli, our factotum. He has brought his attractive Filipina girlfriend, and the two of them, chattering away together in Tagalog, are so slim and elegantly dressed they stand out even in this well-heeled art gathering. At a pinch, I suppose, Eli in his dark-blue suit, white shirt and conservative tie could be taken for a Japanese collector, and since the Japanese have been investing spectacular sums in Western art, I imagine he can only lend a positive note to the evening. I forget about them both and circulate, making sure that prospective advertisers meet Mariella, who is looking ineffably chic and reassuringly wealthy in a silver couture sheath with diamonds discreetly blazing round her neck. The evening is going with a swing. Mariella has invited some of her rich friends, and the dealers have picked up on the wealth in the room like a scent. Mariella was absolutely right. A show of money is the surest way of attracting money, and several galleries have already confirmed their intention to advertise in our pages.

Towards the end of the reception, I have a moment of rare delight. With their Far Eastern allure Eli and his fiancée have become a centre of attention. I go over to see what's happening. Several prominent art dealers from Paris and New York are circling round them, almost literally rubbing their hands as the couple agree, nodding their heads eagerly and politely, to the picture deals that they have been offered. It seems that, having expressed interest in a Renoir, Eli has indicated that they are also in the market for more contemporary masterpieces, thereby keeping all the dealers in a froth of expectation. When pressed for his contact details, Eli nevertheless refrains with true oriental inscrutability, advising the dealers he can only be contacted through me.

A few days later the bulk of the new issue arrives at our office. Eli has commandeered a few migrant fellow Filipinos to come in under cover of night and slap the magazines into individual cardboard cases that will protect them on their journey to the four corners of the earth. The magazine's old subscriber list has come alive, and we realize that we have readers in the most outlandish places in the world. New subscribers have since joined. The wind is squarely in our sails. We are on our way.

Francis has just written – a much longer, scrawled letter than usual – to thank me for the 'very generous and flattering article' I've written on his work for *Connoisseur* magazine in New York. A friend of mine, Hans Namuth, has taken a series of portraits of Francis to accompany it, and I can't think that Francis was unaware when they met in London that Hans is best known for the famous photographs he took of his bête noire, Jackson Pollock, at work. It doesn't seem to have got in the way, however, despite Francis's much aired antipathy to Pollock. In any case, I'm very pleased he likes my text, because although it could hardly be construed as anything less than positive and admiring you never quite know whether Francis isn't going to take issue with some statement or allusion he finds inaccurate

or ambiguous, particularly since he believes that most, if not all, art critics are stupid and they have to be told what to say, rather as he has done, in his maniacally controlling way, in his interviews with Sylvester. He corrects me, rightly enough, on a mistake I made in quoting his favourite line from Aeschylus, 'The reek of human blood smiles out at me,' then goes on to say, 'I particularly liked your emphasis on enigma, which as you know is difficult to achieve. I wonder if at Delphi the Sibyl still gives it out.' Francis himself is about to be the Sibyl now, since his big new retrospective will soon be opening at the Tate, which is why my article, along with scores of others, has been commissioned, in order to apprise the wider world of what is about to hit them.

I've been invited to the VIP reception at the Tate and the dinner afterwards, not just as a friend of the artist's but also as a lender, since they have requested my triptych, which I am all the gladder to lend since it will be properly insured for once, not only in London but in the subsequent venues in Stuttgart and Berlin. Unexpectedly, when I go over to London for the opening, I don't get the same intense rush of excitement – that peculiar mixture of dread and pleasure – which seeing a number of Bacons together has always given me so far. There is a degree of familiarity that makes the dread less dreadful, although going through the first half of the exhibition is as emotional an experience as ever. These dark, often almost clumsy images were painted by another Bacon, before I knew him, a young artist who was struggling with the burden of the terrible truth he *had* to express, if he were to survive, but didn't yet know how to express. There is a sense of an elemental struggle here, of the forces of life and death being confronted head on, that you never get except in the greatest paintings. Here Bacon joins the masters, the artists who continue to enthral us through the generations. Perhaps later on, and certainly in some of the most recent paintings, he has become almost too adept, too technically cunning and practised, at evoking the central enigmas of existence.

I know Francis has been particularly insistent that there's no lack of champagne for the party afterwards, and since a large contingent of Soho friends and hangers-on has turned up the evening looks like it might be lively to the point of getting out of hand. There's many a face I vaguely recognize from years of trawling all the pubs and clubs with Francis, and he hasn't left out any of the old-timers, like Gaston Berlemont, with his buffalo-horn moustache, from the French pub, and the one they call 'Maltese Mary', the former policeman now presiding over a particularly unruly Soho nightspot. If I were a Proust, I guess I would be having a Proustian 'moment', with all kinds of memories and smells and phrases flooding back, but my main reaction is relief at having got away from this frayed, inward-looking little world, fond of it though I still am. As I listen in, the boozy talk goes suddenly from booming to *sotto voce* as odds are taken on the most likely victim to be claimed this evening. First it was Peter Lacy, then it was George Dyer, whose turn is it now? goes the refrain. Eyes turn to where John Edwards is chatting and laughing, but he looks far too poised and cheerful to be considering any drastic action. In any case, as I leave the Soho brigade and scan the seething, guffawing mass of people to see where else I might mingle, I am struck by how death has already plucked too great a number from our midst: Sonia Orwell is no longer here, nor is Muriel Belcher, and John Deakin died a good while ago.

Francis is standing in the middle of the swell, moving from one ring of fervent admirers to another and beaming with pleasure. He is particularly good in these circumstances. Once all attention is totally and unambiguously focused on him, he makes nothing of it and becomes unusually attentive to all those around, kissing and greeting and making charmingly self-deprecatory remarks. I go over to congratulate him, and he greets me warmly, but I don't see much of him for the rest of the evening because the lionizing never stops. We've arranged to meet at Wheeler's, just like old times, later in the week once the hubbub has died down. I wonder

whether Francis will have recovered from all the exposure and
compliments by then, since most people would probably prefer
a week on a health farm to such relentless carousing. But then,
of course, Francis is not 'most people', and I'm sure his appetite
for praise is as boundless and voracious as it is for food, drink
and sex.

One thing I feel fairly certain of when I get to Wheeler's and
tuck into the mouth-puckering combination of briny oysters
and acidic white wine is that, if ever Francis is going to be
relaxed and generous about other artists, this moment of barely
contested triumph will be it (though I was amused to see a *Punch*
cartoon showing a crowd of people going into the show hale and
hearty only to come out of the exit bent over and vomiting). I
want to do a new interview with him, and I'd like to get him to
discuss his contemporaries in a measured, if not even slightly
positive, way. The inevitable sole hasn't even been served up
before I discover my mistake.

'I still think Pound was right. You have to "make it new",'
Francis says the moment I mention Freud's big, newish picture,
Large Interior, W11 (after Watteau). 'There's something so
infinitely boring, so academic, so depressing really about that
way of painting.'

The moment Freud's name comes up I sense him go aggressively
tense, as if the hair at the back of his neck was suddenly bristling
like a dog's – just as it did, I remembered, years ago when a hapless
hostess in Paris introduced him to Jasper Johns. I'd been talking
about the picture to Ron Kitaj the day before, and he'd praised it to
the skies. 'It's the greatest painting to have been done in years,' Kitaj
enthused. 'At least, the greatest in what I call "straightforward"
painting, where there's no modernist intervention. In my work,
in Francis's, there's intervention, Surrealist, Expressionist or
whatever. Freud paints without that, directly.'

'I think he's managed to achieve something very difficult,' I
say. 'To record a certain reality faithfully, without distortion, yet
forcefully, memorably.'

'I don't agree with you at all,' Francis says. 'The difficulty has got nothing to do with it.'

'But it is difficult nowadays to stay that close to visual fact . . .'

'But nowadays you have to reinvent the way you communicate those facts.'

'Well, I think there's a whole generation of artists who feel they have to come back closer to direct representation of reality, who feel that invention and distortion have been taken so far there's not much more to be achieved in that direction. I mean, after Picasso—'

'Oh but there's a lot more, a very great deal more. There are all sorts of ways still of bringing fact back in a more violent way. But you have to have the talent to find them.'

'Well, after Picasso and you, Francis, the field has been pretty well covered, surely?'

'Well, of course, one doesn't know about oneself . . .'

During this short exchange Francis has topped my glass to the brim twice. I've seen the warning signs and know that I should head the conversation elsewhere. But I'm annoyed at coming up constantly against this blank wall, so I give it one last try.

'There must be some contemporaries whose work you like, Francis.'

'I'm not sure there are, really,' Francis says, after a pause. 'The trouble is when you have no really great art, you don't even get good minor artists. Nowadays, since no one has been able to reinvent that whole mythical side that the Greeks were able to draw on, you almost have to make an art out of your critical faculties.'

'Well, what about Frank Auerbach?' I persist. 'I know you admired some of his paintings.'

'I used to think Frank Auerbach's work had quality for a moment,' Francis concedes. 'But only for a moment, though.' Then, turning more waspish, he adds: 'I've certainly never liked those ghastly sculptures your friend Raymond Mason does. They look like the brains you see laid out on slabs in French butchers' shops. They're coarse, terribly coarse. Just like him.'

I play my trump card, knowing I will probably pay dearly for it.

'Well, I suppose you would say that, now that you've been acknowledged right across the world as the "greatest living painter".'

I half duck, expecting a broadside.

'Well,' says Francis, brightly, with an ironic smile. 'There's not much competition, is there?'

Back in Paris, just before waking up this morning in the office (barely in time to get my clothes on before our secretary arrives), I had an odd, disturbing dream. Francis had died, quite suddenly, while he was here, in a room I vaguely recognized. I was notified almost immediately, and shortly afterwards a group of Parisians, mostly museum directors and officials at the Ministry of Culture, contacted me to let me know that they had decided to erect a bronze statue of him, either in the Tuileries gardens or beside the Deux Magots at the big crossroads in Saint-Germain-des-Prés. I told them I thought Saint-Germain would be the more suitable location, and I also took issue with the fact that they wanted simply to have Francis's initials, 'F.B.', carved into the stone plinth. The name, I insisted, should be carved in full. During these discussions I was obliged to go into the room where he had died. His body had been removed, but that vaguely familiar space was alive with his recent presence even though it smelt like a hospital of surgical disinfectant. The room started to take on a nightmarish aspect, as if it were the room where I also had to die, and I struggled against having to go back there. I also became anxious that, once cast in bronze, Francis would look rather ridiculous, particularly if the sculpture accentuated his paunch and made him look dumpy. I began to worry whether or not the sculptor would put him in a double-breasted jacket, like the ones he has taken to wearing recently, and so give him a better figure. Then I realized I had lost an important part of my past and that I would keenly regret Francis's not being there any more. It made me feel lonely. But I also felt freer and lighter, as though a new perspective had opened up in my life.

14

An Ancient Simplicity

You start off thinking how interesting, challenging and even fun it might be to have your own magazine and, after fantasizing about it for a moment, you wake up to find it's consumed your whole life. You are no longer a person, you are *Art International*, not just to the people working with you but to all the artists, writers, dealers and hangers-on who want something from the publication. *Art International* has taken off, it's in mid-air now, and the recurrent nightmare I have of being plucked out of my passenger seat to actually pilot the plane while it bucks and plunges randomly across the sky with the instrument panel going crazy is very close to present reality. I've always needed to feel in control of what's going on in my life, but now I am up to my neck in the chaotic and unforeseen, lurching from one new crisis to another.

Wherever I look, trouble is brewing. Our secretary becomes pregnant and I find that under French law I have to continue to pay her while taking on another in her place who in turn insists that she must have her own part-time assistant. We now also employ an office manager and a publicity director, both of whom have brought in various smiling accomplices paid on a complex system of retainers and commissions. Our costs are going through the roof, and although Mariella supports us loyally, it is never clear when she will make out another cheque or in what

amount; she has an uncanny knack of knowing just how much will keep us from going under before the next issue comes out. I pace round my former flat, once a haven of romantic assignation and youthful revel, to keep a sharp eye on the proliferating staff as they commune with typewriter and screen, fax and telephone. But the amiable old terracotta tiles shift uneasily under my feet, as if at any moment they might open and swallow me into a bottomless pit of debt.

It's not just the acceleration of outgoings that worries me, but the regular shortfalls in eagerly anticipated revenue. Some advertisers simply default on their payment. Others default while making a fuss about it. How could we, they protest, have got the colour or the design in their artwork so wrong? Others claim they have not been displayed advantageously enough, with one refusing to settle the bill because their ad appears opposite a gallery with whom – didn't we know? – they have fallen out with a vengeance. Staff and advertisers are only part of the problem. A museum director in Australia feels slighted because we haven't reviewed a show he has curated, telephoning long-distance to insult and threaten me personally; an influential German artist insinuates that his dealers will cease advertising unless a painting of his appears on the next issue's cover, while an ageing American painter who considers we have overlooked his achievement follows me all the way down the rue de Seine loudly chanting 'Fuck you and fuck *Art International*' – to say nothing of the renowned Marxist art critic who vociferously demands four times what our other timid, bourgeois writers are paid. While visiting more art fairs and exhibition openings than ever, I mingle less freely, frequently looking over my shoulder. Meanwhile, since Eli and his fellow Filipinos have no papers and our whole little operation falls woefully short of France's complex labour and fiscal laws, a definite paranoia has set in, so that, while refining a sumptuous choice of paintings by Crivelli or a collage of Surrealist poetry, we live in daily dread of the surprise knock

on the door and being busted by the sinister-sounding *brigade financière.* Whenever I feel severely oppressed, I take refuge in the company of a close painter friend called Zoran Mušič, an exact contemporary of Francis's and a survivor of Dachau. Over the past decade Zoran has produced a series of poignant paintings of the dead and the dying as he saw and lived with them in the death camp. I have interviewed him and written about his work, and in the relationship that has developed between us he has become a parallel father figure, albeit a less flamboyant and demanding one than Francis. Zoran's high-ceilinged, silent studio on the rue des Vignes is a haven of peace. He knows the stresses I am under and often we sit there together for an hour or two without talking. In the extraordinary calm Zoran radiates I attempt desperately to get my situation into perspective and find the best way of muddling through before I return to my self-inflicted responsibilities as owner and publisher of an art magazine.

One very bright spot on this otherwise darkening horizon is that, after a period of celibacy and a couple of passing affairs, I have fallen in love with *Art International*'s new correspondent in London. She is called Jill Lloyd, and although fourteen years my junior she is already a recognized authority on German Expressionism and a valued lecturer at University College London. We met briefly at the opening of a 'School of London' show in a Düsseldorf museum, whose sympathetic director was her long-standing fiancé and where, with a little help from my artist friends, I managed to stage a powerful display of works by Bacon, Freud, Michael Andrews, Kossoff, Auerbach and Kitaj. At first sight each of us found the other distant and arrogant; then we met again for a drink at the RAC to discuss how Jill might cover the art scene in London for the magazine, but we began laughing so much that all business was forgotten and we spent an extraordinary, exhilarating evening together, ending up in Soho in search of small drinking clubs I'd known with

Francis. We have seen each other at every available moment since, in London and Paris, New York and Venice. We are so swept off our feet that neither of us doubts for a second that our future lies in living together. Jill plans to cut all her ties in London and Düsseldorf in order to move to Paris and work with me on the magazine. Meanwhile I hope to get Francis's approval to take over the studio definitively for a period so that Jill and I have somewhere to begin our new life.

Falling in love has given a huge boost to my vitality and self-confidence, enabling me to confront pressing, professional problems that I have been dodging. I clamp down on associates and assistants, sacking an advertising rep whose expenses regularly dwarf whatever revenue he brings in. The atmosphere in the office seems to improve, though I do wonder whether this is not mainly because I am seeing everything through powerfully rose-tinted spectacles. I try to tone my new-found optimism down, since I'm aware it might well annoy those unfortunate enough not to be bathed in the same radiant light. Even so, I catch myself exuding a conviction that carries all before it, descrying sense and harmony in what seemed an inescapably haphazard and cruel universe before.

Francis is back in Paris, and I've told him a little about what has happened with Jill. He's always been perfectly at ease and charming with my girlfriends, particularly with Alice, whose lively company he seemed to enjoy. But I'm wary of Francis's reaction because his opinion still counts enormously for me and I want him, almost like a parent, to approve of Jill. I also have to be careful that he isn't made too aware of the influence he wields in case that triggers the sadistic, treacherous streak in him. For the moment, however, he couldn't be more generous and encouraging. Knowing that the studio is so useful to me, he has booked himself into the Hôtel des Saints-Pères, and when I protest about this (I've got the studio completely ready for him, right down to milk in the fridge and a single yellow rose on the marble-topped bistro table), he claims in his best, unanswerable

way that he's far more comfortable there, not least because he's been unwell and the hotel has a doctor always on call.

I go and pick Francis up at the Saints-Pères around tea time and find him a little pale but in jovial mood, drinking whisky with one hand and grasping his coat in the other. He orders a whisky for me, almost unthinkingly, then another round, as if he can't wait to get a certain degree of alcohol into his system. I try to go easy, knowing that we have a long evening ahead, and I'm still on the first glass as two others stand waiting to be drunk on the table. Francis is talking volubly and doesn't seem to notice, then he leans over suddenly and says: 'You don't have to finish those drinks if you don't want to. I always drink everything, I don't know why. To pass the time, I suppose. After all, you have to do something. It's very silly, I know, to go on drinking like that. The odd thing is, when I'm alone at home I rarely take any drink. But I've spent so much of my life drifting round these bars, because when you live alone you just seem to go out more to those kinds of places. And drink does make things easier, or at least it has for me. Once or twice it has helped me to work. It helps to loosen you, I think. I also love the sensation you get with drink. There's something so marvellous about that feeling, although I sometimes get so drunk it doesn't make much difference.

'But I do know it makes me less nervous,' he goes on rapidly. 'I keep saying to myself, ye're too old to feel nervous. But there you are. I always am nervous. And then those dreadful hangovers make me even more nervous. Yet they also make me much more concentrated. It's a curious thing but when I have a hangover, nothing exists outside the thing I happen to be thinking about. Sometimes it makes me particularly clear about what I want to say. It sounds mad, but with a really bad hangover my mind crackles with electricity.

'That doesn't mean I don't hate those mornings after. They make you feel really uncomfortable. But in spite of everything

I always go back to the same old dreary places and start all over again. Like all those other fools.'

This seems to give the signal for us to move on to other drinks, since Francis has been invited by a Russian painter he knew in Tangier a long time ago to come for cocktails in his apartment not far away on the rue de Saint-Simon. It's dark now and there's a slight drizzle. We both put on our raincoats, me an old Burberry, Francis a brand-new leather coat with epaulettes which he belts up so tightly he looks half strangled.

'The thing is this Russian lived in Tangier because he only liked very young boys,' Francis tells me as we make our way towards the crossroads at the rue du Bac. 'And as you know, at least at that time, people in Tangier were very easy about that kind of thing, because it often meant that if a foreigner showed an interest in him their son could simply look forward to a better kind of life. But then things changed, and I think he had to get out very quickly to escape being charged and imprisoned. Anyway, he got in touch and left me his address. Apparently he calls himself *Prince* Viktor now. He certainly wasn't a "prince" when I knew him. I let him take over a room I had there to paint in, and I left a whole lot of canvases that hadn't worked and I hadn't thrown out because I thought he could use the primed side to paint on. But he didn't, of course, and he must simply have kept the lot because now some of them are coming on to the market, which is a real bore because I terribly didn't want to let any of them out.'

Just at this moment, a thin, elegantly dressed young man comes up to Francis and says:

'Are you Monsieur Bacon?'

'Well, I can hardly say no, can I?' Francis says with a smile.

'I was sitting in the café and recognized you as you walked by,' the young man says in an intense, self-preoccupied way. 'May I ask you a very important question, Monsieur Bacon?'

'*Pourquoi pas?*' Francis says ironically. '*¿Por qué no?*'

'I have this problem which I think you can understand,' the young man goes on. 'I started taking cocaine about a year

ago and now I take it more and more. I have become totally
dependent on it, even though it makes me ill and gives me bad
anxiety attacks. My friends are worried, so are my parents. So I
wanted to ask you, Monsieur Bacon, whether I should try to get
off it somehow, with one of those cures.'

Francis has been looking at him very curiously, as though
weighing something up.

'Why shouldn't you take cocaine?' he says after a moment.
'I've always taken anything I can get my hands on. It's a way of
stretching the sensibility. No, I think cocaine's a very good idea,'
Francis adds warmly, as if recommending sea air or an apple a
day. 'I'd go on taking it if I were you.'

The young man disappears swiftly into the gloom.

'The thing is, he was quite sure I was going to tell him to stop,'
Francis says. We walk on in silence. The incident is forgotten.

'I've no idea how Viktor manages to afford living here,' Francis
remarks as we turn into the rue de Saint-Simon and try to find
the right number. 'It all looks very chic. I suppose he must have
been selling those dreadful old paintings of mine. But there's no
point in asking him. He'll simply deny it.'

We key in the door code and take the lift up to the second
floor. A lean, muscular man with close-cropped hair opens the
door and greets Francis, who introduces me as 'a great friend
from London who's now living here'. The apartment is totally
white, with white rugs on a pale concrete floor and minimal
white furniture. Everything seems to have been accorded its
precise place in the room, from the pleated white curtains to the
white tulips in the glass vase on the white plastic table. Viktor
asks if we'd like a gin and tonic, clearly the only acceptable
drink in this blanched space, then he and Francis talk about the
people they knew in Tangier – Paul and Jane Bowles, Ahmed
Yacoubi, Burroughs and Ginsberg, and some other names I don't
recognize. But the two men are clearly wary of each other and
the conversation never warms up. After a while Francis starts
congratulating Viktor extravagantly on the 'beautiful interior'

and contrasting it to the 'dump' in South Kensington where he lives. I take this as a signal that we are about to leave, and within minutes we're out again on the Boulevard Saint-Germain, with Francis struggling to breathe, then expostulating:

'That ghastly flat looks like an operating theatre,' he says, 'but what really struck me was the ridiculous toupee that Viktor was wearing!'

I have to admit that I hadn't noticed.

'Well I certainly did,' says Francis. 'It was sitting like a patch of grass on top of his head, and I kept wanting to pull it. In the end I just had to get out ... Now where do you think they might give us something to eat?'

'We could try Brasserie Lipp, if you like, Francis,' I suggest. 'The food isn't so great, but it's close enough to walk.'

'Well, why don't we do that then.'

There's an inconsequential feel to the evening, as if it's made up of loosely floating fragments that won't cohere. We're drifting, I think, simply drifting through space and time, along the Boulevard Saint-Germain with the rain and the leaves falling, drifting from moment to moment, which Francis says is the only way you ever find yourself. He seems to have warmed up on all the whisky and gin we've drunk, and I'm happy simply to drift along and watch and listen.

'I can't think what Viktor can do with himself now,' Francis says. 'I didn't see any signs of painting, thank God, because he was a ghastly painter from what I saw of his work in Tangier. And now I suppose he has to be very careful with those tastes of his. The thing is, he can only fall in love with boys of about twelve years old or less. It's tragic, really, but then homosexuality is tragic. It's both more tragic and more banal than what's called "normal" love. There it is. I mean, it's tragic to get to my kind of age and to still desire. I was in the tube the other day in London and there was this very young, very good-looking man who was staring at me – can you imagine, at my age? – and I looked back at him and when the train stopped at the next station he got off and

motioned to me that I should follow him. Then just as I decided to get off and see what would happen, the doors closed and he was left there, standing on the platform, as the train pulled out. That in itself was tragic in a way, and I've been thinking ever since of using those closing doors in a picture.

'There you are. I think there are a great many men who don't really know what they are sexually. Often of course they're neither one thing nor the other. And then some of them who are really homosexual simply can't accept it. They probably think it's not manly or something. At the same time I have to say I find that homosexuals are often better, more enlivening company than most people. They have that marvellous kind of wit. I mean, a long time ago, I was once in one of the homosexual bars and I started talking to this friend of someone I knew and we were getting on rather well, perhaps too well, because of course then the other one, who was getting annoyed as he watched us, had to come over and say to his friend: "When I knew her" – meaning me – "she was more famous for the paint she put on her face than for the paint she put on canvas." It was a marvellous thing to have come up with, just like that, and I've never forgotten it.'

I'm delighted that Francis is talking so easily and openly, and all the more dismayed when we get to Brasserie Lipp to find it already thronged with early diners and bustling waiters. The drizzle has turned into a soft, steady rain so we stand inside, wondering where else to go. I sense Francis's mood changing, but luckily the manager, who's reputed to know every famous face, recognizes Francis and whisks us off to a corner table that's just being relaid. To my relief, Francis brightens again, as if he's realized that his luck is still in. He must also be aware that if he's accorded this treatment, it's because he's become an established star in the Paris art world. Gilles Deleuze, the well-known French philosopher, is devoting a book to Francis's work, and this in itself is enough to make him a legend in the incestuous, intellectual village of Saint-Germain-des-Prés.

'I love the atmosphere of this place,' Francis says, pleased at the speed with which a bottle of Chablis has been placed on the table. 'I don't know why I don't come here more often. For some reason, I don't go anywhere new. I just go back to the same old, dreary places. I don't travel any more, even though there are lots of places I'd like to go to.'

'Well, you liked New York, didn't you, when you went there for your show at the Metropolitan?'

'I did, and I'd love to go back and spend more time there. New York has a real fascination to it. I found it beautiful and exciting, and I terribly liked the Americans. They have a marvellous kind of, well, I suppose good manners, of the kind you used to be able to find in England. A kind of real courtesy. I met De Kooning and Rauschenberg and even though I don't actually care for their work, as you know, I thought there was something terribly sympathetic about both of them. I also went to the Factory while I was in New York. I must say it's rather extraordinary, and Andy Warhol is very charming. He was doing the portraits of all the well-known drag queens of New York while I was there. Well, there was certainly something rather curious about *that*! I've always been a great admirer of his films. I'm not so sure about the painting, but I thought *Flesh* was an extraordinary film. The technique is so fascinating . . . If I weren't obsessed with painting there are all sorts of places I'd like to go to. I've always longed to go to Lebanon because I think I would have adored the atmosphere of Beirut. But with the situation there that's become completely impossible now.'

A Baltic herring has been put in front of me, but I'm more interested in keeping the conversation going.

'You've never even been back to Ireland after all these years, have you?' I venture.

'It's true,' Francis says, 'though I should love to. When you think about it, English literature in our century has been made either by the Irish or the Americans. Of course the Irish have always had this way with words. They talk marvellously, talking

is really a way of life with them. They seem to exist to talk . . .
Somebody in London the other day sent me all the novels he's
written. I believe he's quite well known but I can't even remember
his name. But the thing is, I can't read novels. I find them so
boring. I really prefer either documentary things or great art, great
poetry. I don't think there's anything between the two nowadays.
I love poetry that's a kind of shorthand about life. When you
have everything there, in a most marvellous brief form.'

The plain grilled sole seems to have found favour with
Francis, and he accepts the waiter's suggestion that, if we want
to go on to red wine, we drink a Bourgueil with it. Almost
predictably, Francis finds it 'trop léger' and we drink it quickly
so that he can order a full-bodied Bordeaux. I'm pleasantly
drunk by now and as pleased as a photographer with a scoop
to have got so much varied new material from Francis, even
though I've heard bits of it before. I know he'll start repeating
himself, again and again with a slightly differing emphasis each
time, as he gets progressively drunker. The phrases will be
hammered home into my head by the time we're finished, and I
wonder sometimes if that's the reason Francis does it, endlessly
repeating himself so that I can reproduce whole passages of
his table talk verbatim, like an actor who has learnt his lines
perfectly by heart.

'I've never been back to Ireland,' he's saying, and we've moved
up a notch from a well-balanced Montagne Saint-Emilion to a
powerful Pomerol. 'I don't know why. But nowadays when I
see them killing themselves, I'm afraid I can't get really worked
up about it. I just think, oh well, there's ten or twenty less of
them. I would like to see new places, of course, but then I think
I can find everything I want between London and Paris. I've
always wanted to live between the two, and it's so marvellous,
once you're bored with one to move to the other. I like the
people here so much. They seem so much more intelligent and
better informed than their counterparts in England. Waiters in
cafés and people like that. Of course it's true that when you live

in Paris for a while you do see that other side to them, as you say.
I noticed going to the market and so on that they're not very,
well, amiable. I'd always found them absolutely charming, but I
do see that other side now.'

Francis pays the bill, which seems to have quadrupled with the
wine we've drunk, but I know he's pleased because he leaves an
even larger tip than usual. The waiters, who have gravitated more
and more attentively round us in the course of the meal, look
pleased too, and the manager comes over with the cloaks lady to
add his thanks and as we are helped into our coats and escorted
deferentially towards the door I realize that Francis's magic still
works, not only on me but on the whole staff of the restaurant
where we arrived like wet dogs and are now leaving like top
celebrities. I'd like to go back home, while we're still on a high,
but I know that's not going to happen because, with Francis,
we always have to go too far to go anywhere, and although
I'd dearly love a normal night's sleep when I think of all the
magazine problems I'll have to face the next day, if I'm truthful
the idea of pushing the boundaries excites me too, perversely
enough, although I've come to dread the sudden volte-face in
Francis that takes him from genial to abusive and wounding in
the space of a single glass.

We're silent in the taxi that takes us over the dark river to the
Halles, and when we arrive Francis is put out because we're told
at the Pied de Cochon that if we only want drinks we should go
to a café, so we settle on a dingy, neon-lit bar round the corner
where we're offered a sticky-looking bottle of Calvados that
looks even more dubious as it's trickled out into cloudy balloon
glasses. Francis begins to repeat what he's said earlier, adding
odd bitter phrases, 'Well, that's been cancelled out now, just
like the night train between London and Paris. The few things
that give people just the slightest bit of comfort have been done
away with. That's why I don't travel anywhere any more . . .'
He's clearly drunk now, as well as wheezing audibly, and I begin
looking for a way out of what I know will be an ever-decreasing

spiral of words, and to bolster my resolve I think about Jill coming to join me soon and say:

'It's been a fantastic evening, Francis, but I have to get back to check the proofs for the next issue before morning.'

Francis looks taken by surprise. He's about to say something, but checks himself. Then he gives me his sharpest abrupt stare, so that even in the café's gloom I feel I've been suddenly X-rayed down to the bone.

'You've changed in some way, Michael,' Francis says eventually. 'I've noticed it all evening. As if you'd gone religious. You haven't gone religious or something, have you?'

Out in the street I make my way against the rain towards the rue Rambuteau, past the late-night scavengers going through the dustbins and the last tired whore standing in a doorway in her blood-red dress and white plastic thigh-boots. I start laughing to myself in little, hysterical bursts. Religious! Francis could have been much more upset by my having fallen so deeply in love and becoming to that extent less under his dominion. Religious! Given how aggressive that realization might have made him, I think as I come out of the rain into the arcades around the Place des Vosges, I've got off very lightly, very lightly indeed – this time at least.

Between financial forecasts and deadlines I've been thinking about *Minotaure* and *Cahiers d'Art*, the great French art magazines of the 1930s, and wondering how they managed to stay afloat. They would of course have attracted the occasional benefactor, as we – to my lasting wonderment – have been lucky enough to find Mariella. But they would also have counted on the support of the artists they championed, from Picasso and Braque, Miró and Giacometti onwards, receiving the odd work from them for sale. Both the publishers and some of the foremost writers, like André Breton and Paul Eluard, bolstered their and the magazines' slender fortunes by doing some picture-dealing on the side ('with their left hand', as the French say). Things have

changed radically since, however. The art world has grown out of recognition, and the relationship between artists, publishers and writers is far less cosy. There are also much clearer indications as to what constitutes a 'conflict of interest'. It would be deemed unacceptable if I devoted an issue of the magazine to Dubuffet or Tàpies and financed it by selling a piece of their work. I have avoided any involvement in any aspect of the art market until now, but I realize that the very fact of owning and running an art magazine makes me part of that market – and that, if the whole ship is to avoid capsizing, I'd better rethink my aloof attitude to commerce. For some reason, while I'd feel ill at ease trying to pry paintings out of the more important artists I know in order to boost the magazine's finances, I have no such scruples if it's a question of doing a limited edition of prints with them, possibly because it would be a joint venture with the proceeds shared.

As a result, after much soul-searching, I've decided to publish a numbered edition of engravings with Tàpies while devoting part of an issue to his work, in which the prints will be put on sale at a special, advantageous price for our subscribers. This, I hope, will supplement our other income and help the magazine survive. We have several other major artists on our hit list, with of course Francis in the number-one slot. I'm not sure how he would react to a request of this kind, although I suspect that, unlike Tàpies and most artists, he would waive any financial benefit for himself because of our friendship. I dither for several months, uncomfortable with the idea of asking a favour from someone who has shown me so much generosity. But when the magazine's finances dip alarmingly into debt and the bank starts raking in a hefty commission on it, I allow desperation plus a couple of bottles of expensive wine to take the lead and put it to him bluntly over dinner.

'Of course I will,' Francis says unhesitatingly. 'You should have asked before. But why bother to do just one image? Why don't we do a complete triptych? It would make a more interesting lithograph and you should be able to get a better price for it.'

I make up for lost time and go from magazine publisher to fine-art publisher overnight. Printed on Arches paper, trial sheets of each of the *Three Studies of the Male Back* have been seen and corrected by Francis, and now the full edition, with separate *épreuve d'artiste* and *hors commerce* suites, has been delivered in large portfolios to the office. They sit there, numbered but unsigned, awaiting the alchemist's touch to transmute them into gold. A large table has been cleared, numerous graphite pencils sharpened and several bottles of Cristal stowed away in our ancient, wheezing fridge. When Francis arrives, he has several hundred sheets to sign. Consummately professional, he gets down to work, refusing a drink until later. His hand races over sheet after outsize sheet, and he pauses only once to say, in a distracted voice, 'I can hardly remember what my name is,' before the whole edition has been signed. Our staff gathers round, cheered by the prospect of a celebration, and the champagne corks are popped. They confidently expect him to say 'Champagne for my real friends, real pain for my sham friends,' but instead he toasts them all individually by name, thereby winning their vote for ever. The large salmon that Eli has poached is brought to the table and consumed amid merriment with a cucumber-and-yoghurt salad and a big, sunny Rhône wine.

The next day Francis and I have a lunch appointment with Michel Leiris. I am always delighted to attend, whether the occasion takes place at a very grand restaurant like Taillevent or the Tour d'Argent or somewhere more modest, and more easy-going, like L'Escargot in the Halles or Le Petit Zinc. Yet often I wonder why Francis bothers to take me along since, although he'll ask me for the odd word or phrase, he speaks French too well to really need my interpreting skills. Francis has actually become very much himself in French, moulding certain expressions to his own needs and bolstering his opinions with a few choice idioms. He says '*au fond*' the whole time, as if unearthing new depths of meaning in the phrase that follows, and he likes to make what he thinks of as self-evident truths

about life even more self-evident with a very emphatic, sibilant *'bien sûr'*. So apart from being younger and enthusiastic, I don't feel I'm contributing much to the proceedings. We go to the Petit Zinc where Francis expatiates so fulsomely on the silvery zinc bar that I wonder whether he isn't thinking of incorporating it into a picture as he has already done with a similar structure he admired in the casino at Monte Carlo. Michel, resplendent in a recently broken-in Savile Row suit, is as punctual as we are. The conversation is fairly stilted until the first few bottles have been drunk, but then Michel opens up with almost alarming cordiality, laughing immoderately, attentive to every allusion and double-entendre, his face wrinkling and unwrinkling like a piece of pastry kneaded and smoothed. Suddenly Francis cuts across the conversation to say something that has been on his mind for a good while now:

'*C'est horrible la vieillesse, n'est-ce pas?*'

'*Oui,*' says Leiris. '*C'est horrible et c'est sans remède.*'

'*Voilà,*' Francis repeats triumphantly, as if old age had at last been nailed down into a definition. '*C'est horrible et sans remède. Ghastly and irremediable.*'

They then get down to trying to sum up what 'realism' means in as few, concise words as possible. This concept has preoccupied them for some time now, because Francis maintains that he is not an Expressionist ('After all,' he repeats disarmingly, 'I've got nothing to express') but a realist, in the sense that he attempts in his painting to convey as intensely as possible the 'reality' – or, as he puts it, the 'facts' – of life. This is very important for him because he feels that, despite other people's claim to the contrary, he has in no way exaggerated the 'violence' of life in his work ('You only have to open a newspaper to see the horror that goes on in the world every day'). Michel agrees with him on this point and has resolved to write an essay that will attempt to pin down the slippery concept of 'realism' as he has experienced it while studying Francis's paintings. The discussion takes a more problematic turn when Michel suggests that it is almost

impossible to define 'realism' until one has defined the larger, more amorphous notion of 'reality'. A further bottle is called for and definitions are batted to and fro, with the 'realism' of Van Gogh invoked, as well as the stark realism of Shakespearean tragedy. 'What could be more poignantly realistic than those marvellous lines in *Macbeth*,' Francis remarks, 'where Shakespeare says that life is "a tale / Told by an idiot, full of sound and fury, / Signifying nothing"?'

Much of the lunch is also spent in exchanging volleys of praise about Michel's writings and Francis's pictures. It seems at times like a diplomatic occasion where two powerful countries are exchanging tributes before getting down to the substance of their negotiations. But there is not much substance left. Michel has given his support by writing several prefaces to Francis's exhibitions, from the key Grand Palais event of 1971 to Claude Bernard's show. Francis realizes that his success in France was in part due to Michel's prestigious endorsement, although he no longer needs it. For his part Michel, having been the close writer friend of both Picasso and Giacometti, is conscious that Bacon seems to be the most worthy successor, not least because he himself is a lifelong Anglophile and adores letting himself go in the tolerant pastures of Muriel's Colony Room (to me he has recounted his surprise when one Colony member took him in his arms late at night and asked him longingly: 'Are you alone?'). But more than anything now, they enjoy exchanging phrases and pithy definitions. 'One is never disciplined enough,' Francis says. 'You have to be disciplined even in frivolity, perhaps above all in frivolity.' And both he and Michel agree that 'art is a métier for the old'.

I don't agree but since the idea clearly appeals to them both I don't say anything. Once Michel has left the restaurant to be taken back home by his chauffeur, Francis says to me: 'I kept looking at the way those veins stick out on Michel's temples and wondered what would happen if I pricked them with my fork. I suppose they'd just burst.'

This annoys me, a bit drunk as I am on lunchtime wine, because it seems unnecessarily cruel and disloyal.

'Well, why don't you give it a go, Francis?' I ask.

'Are you mad?' he says in an aggrieved tone. 'I was just wondering out aloud.'

I sense a row brewing so I pretext a meeting at the office about the special issue we're planning to do on him. Francis looks at me rather sourly but says he'll call so that we can meet again for lunch before he goes back to London.

People often ask me what Francis is like. I could say he's strung between extremes – very generous with his time and money, for instance, but very critical and unforgiving in his opinions of other people and above all their art; very supportive but also very destructive; very vain and arrogant yet surprisingly realistic and modest. But then I have to go on qualifying all these characteristics, and I need a single phrase, so I say: whenever you're with him, the temperature goes up. And that's just what has happened today. When the two of us meet at Le Duc, it looks like any prosperous, lunchtime gathering in Paris: a mixture of businessmen, staid bourgeois couples and the odd couple of not-so-young and presumably adulterous lovers. Although the fish here is excellent, the restaurant's atmosphere is distinctly formal and dull. The moment Francis arrives, greeting the staff affably and ordering champagne, things change. The manager comes over to say hallo, the waiters move more alertly and the clients begin, very slowly at first, to shake off the conventional torpor that they seem to think is called for in these staid circumstances. The temperature goes up. Francis engages the wine waiter, dark-haired and good-looking, in a spot of banter, then orders a very expensive Bordeaux. The wine waiter compliments him on his choice, at which, once the wine has been decanted, Francis invites him to have a glass of it with us. He would adore to, the wine waiter says, but it would be against house rules, so Francis pours him a large glass which he takes away with him through

the service door. The door then opens several times during our meal, as in a French farce, to reveal the grinning wine waiter toasting us discreetly but enthusiastically from across the room. Somehow this charade and Francis's manic good humour seem to generate a wave of jollity: people begin to laugh, more wine is ordered and what would otherwise have been a good but average lunch eventually turns into a feast.

Even Francis is drinking more than usual, which means that after the champagne and the white wine, we have a couple of bottles of Saint-Estèphe before settling down to some port. As we leave Le Duc and wander unsteadily up to the Boulevard du Montparnasse, it becomes clear this is going to be a bender. We stop at La Rotonde and have some more port, which Francis pronounces 'filthy' but nevertheless drinks, then we weave our way along to the Sélect, which I know is where Francis used to hang out with the homosexual crowd when he first lived in Paris in the late 1920s.

He certainly seems very at home here, as if he'd been in the night before, which I suppose he might have been, and he orders two more double ports and begins to clown about, suddenly producing a small pink plastic mirror from his leather overcoat and combing two tendrils of hair carefully across his brow, saying to me:

'Do I really look that young still? Well, there it is. I'm simply a brilliant fool, brilliant and idiotic, and there it is. I don't believe in anything and I don't care about anything. There's just my brilliance and the brilliance of life. And when you're old you are never really less than your age and that's an abominable thing but every now and then someone does actually come along and thinks you are younger than you really are and when you tell them your age they're really shocked. It's tragic still to desire at my age, even though in a sense I've never been young, I was born without innocence, I always knew how things were from the start.'

Francis has now leant his head on the back of the customer standing next to us, who's too embarrassed to move as Francis

starts looking at himself in his hand mirror again, a pink, chubby, chuckling Silenus. 'You see, I've always known. And even though I've always been a fool I think I've just painted the best picture I've ever done. I wanted to do a wave, and it turned into a jet of water, it's nothing but this jet of water, simply a bit of water smeared over the canvas, but there's something very mysterious about it. *Encore un porto,*' Francis says to the barman. '*Non, un double!*' and when he tastes it he throws it into the sink on the other side of the bar, saying '*Il est très mauvais, votre porto,*' and there's an expectant ripple among the other customers that things are going to turn nasty, and I'm wondering reluctantly if I'm going to have to step in to protect him, but the barman has produced a better port and Francis is laughing even harder, drinking the wine and holding his glass out for more, swaying and half falling over the other customers, who are clearly uncertain how to act and decide simply to put up with him. And it takes another good hour before I can get him out of the Sélect, and we weave out into the boulevard to get a taxi, swaying through the fast-moving cars. Alice and an American art-dealer friend who happen to be sitting opposite on the covered terrace of the Coupole see us marooned in the traffic and stand up in alarm, waving their arms at us and clearly bidding me to be careful, which, drunk as I am and with Francis nearly keeling over, makes me even more terrified. At last I flag a taxi down, but the driver takes one look at Francis and says, 'Your friend is ill,' before locking all doors and roaring off. Eventually we half dodge, half tumble in and out of the traffic to the other side. I ask Francis, who's standing stock still on the pavement now, what he wants to do and he says, '*Nada,*' he doesn't want to stay there and he doesn't want to go anywhere. '*Nada,*' he repeats several times and then he starts turning abusive, saying he certainly doesn't want me taking him back to his hotel, he's alright by himself, and all I can think of doing is getting him on to a bus going roughly in the right direction and I watch him standing inside, beside the driver, swaying again, trying to get his ticket into the ticket

machine, missing and trying again, until the bus is swallowed by the dark.

Francis calls me next morning and says he can remember our lunch at Le Duc but nothing thereafter. 'I think my mind's going,' he says. 'Was I alright or did I talk the most dreadful nonsense? I really must stop that kind of drinking at my age because when I wake up the next morning I have this complete blank and I'm filled with guilt.' He says that he has this conviction the world will blow up at any moment. Then we chat for a while, and he suggests that I come to the hotel before he leaves so that he can give me a colour transparency of the *Jet of Water* he's just painted.

I go over and look at it. A great gush of water rises from a hole or pipe to the right of the middle of the canvas against a background that is half blue sky, half black night. It is a desolate picture, the water pulsing up and spilling pointlessly into a void where there might once have been human life.

Francis has clearly developed a 'late style'. I'm pleased that the eerie translucence of his most recent, full-length portraits of John Edwards reflects a new serenity, as if the contradictions that have warred so dramatically in him for a good half-century are now to a large degree resolved. These new paintings put me in mind of *The Tempest* because the serenity has been achieved at a high cost in loss of illusion and the suffering that entails. They transmit an otherworldly aura, tinged with deep sadness. Our revels now indeed are ended and they have been replaced by a melancholy acceptance of age and fate.

At the same time, I also worry whether Francis's imagery, once so rooted in his own inner conflict, hasn't forfeited some of its vitality, as if the blood has been drained out of it. Bloodless Bacon, and it shows in the commissioned portraits he has been accepting of late of personalities like Gianni Agnelli, the 'King of Italy', and Mick Jagger. He has also agreed to do a portrait of an

international financier he knows well. 'I couldn't really say no,' Francis tells me, 'because he's got all my money, and I have to say he seems to have done brilliantly with it. So I asked him to get some photographs taken of himself, and I've been looking at them, but the trouble is, when you look at his face, there's absolutely nothing there. So I don't know how I'm going to do a portrait of him.' I'm sure he'll come up with an acceptable solution, not least because getting one's portrait painted by Bacon is now no longer seen as an assault but as daringly chic and desirable, and collectors all over the world, from Farah Diba, the former Empress of Iran, and Imelda Marcos of the Philippines to Greek shipowners and Agnelli himself, fall over each other to get their hands on his paintings. Meanwhile the press whips itself into a frenzy about the huge prices Francis's paintings are now making, without of course realizing that a disproportionate chunk of these goes first to his dealers, then to the tax man, and much of the remainder is spent buying champagne for everyone in sight. For all the sybaritic lifestyle the newspapers like to attribute to him, Francis still lives like a monk in his bare studio-cell.

I could never mention my doubts about the recent work to Francis without getting my head seriously bitten off. It's not really my place to make comments of this kind in any case, although I don't know who else would ever tell him. I have more pressing concerns as a publisher, and I'm beginning to forge another sense of my own identity, both as an employer and as a man who is about to get married. I'm gratified now that I'm running a magazine of my own that I am no longer quite the 'obscure young man' as Sonia, with no doubt unintentionally cruel accuracy, once dubbed me. I was pleased, too, when I came to London the other day to discuss some parallel projects I've been working on with the film director Peter Bogdanovich, to find Francis dining at a table near ours at the Ritz, mainly, I have to admit, because it showed that my life had taken off in other directions, quite independently from him. Of course the fact that during this visit Jill and I slipped into the Chelsea Register

Office to get married would have been another, more striking indication.

Francis still looms very large at all sorts of unexpected moments, even so. The other day, for instance, I felt absurdly proud when Cartier-Bresson, who's become a good friend both of mine and of the magazine's, told me that of all the people he has known in his long life the most exceptional are Giacometti and Bacon. And my continuing dependence on Francis is driven closer home when I realize that I've been carefully plotting the best way to introduce him to Jill (who, meanwhile, has been rather dreading the encounter). I decide on a dinner at the RAC where both she and I are at ease, and I suggest that Francis bring his new Spanish boyfriend José in the hope that will create a certain symmetry. I'm anxious that Francis might be a little snobbish about coming to such a large, unexclusive club but when he arrives he immediately responds to its confident Edwardian opulence and repeats several times: 'I'd love to have a place like this to come to but they'd never want someone like me.' José arrives with him, and as we drink some champagne in the bar I notice they are dressed in almost identical dark suits with exactly the same shiny black ankle boots, which they show off to each other with a smile as if they are sharing a private joke. We go into the Great Gallery and I'm disappointed that, on one of the rare occasions when I've been able to host a dinner for him, Francis says he hasn't been feeling well recently and orders only onion soup and a plate of Parma ham. It's true that he's looking paler and frailer than I've known him before. Similarly, although I've carefully picked the wine, only a couple of bottles are consumed. The first one seems to me distinctly corked. When I remark on it Francis is sceptical, but I know the wine well since Jill and I drank it at our wedding breakfast here. I send it back and am relieved to find the new bottle has a totally different, fresher taste. Once he's sipped it critically, Francis acknowledges this with an approving nod towards me, which, emancipated from his influence as I feel I have become, still gives me a rush of pleasure.

Whether Francis will approve of Jill is, however, another matter. So far he doesn't seem to have really acknowledged her, limiting what he says to the occasional memorable phrase like 'I've always been convinced that we came out of the sea,' or others, such as 'There's a kind of blueprint of the nervous system that's made at the very moment of conception,' that I already know so well I could quote them in his stead. I'm worried because Francis looks strained and distant, and he gets muddled up when he starts talking about the currency markets, presumably in an attempt to draw José, who's in the financial world, more into the conversation. 'I saw the dollar was up and the Swiss franc down against sterling,' he announces, then pauses with a blank look: 'Or was it the dollar was down and the Swiss franc up?', which sets Jill off giggling nervously and earns her a sharp look of rebuke. Eventually Francis does address her directly.

'And what do you like in modern art?' he asks her out of the blue, looking at her intently across the table.

'Well, I've specialized mainly in German Expressionism,' Jill says.

'Well, I simply *detest* German Expressionism,' Francis says sweetly. 'I can't think of anything I *loathe* more than German Expressionism.'

Jill looks as though she would like to fall through the Great Gallery floor, but she recovers sufficiently to ask Francis how he started out as a painter, and I can see this warms him to her a little.

'Well, I've spent so much of my life just drifting, you see, Jill,' he says, slipping into one of his favourite setpieces. 'From bar to bar, person to person. I often regret that I didn't have more discipline and concentrate myself when I was young. I mean, when you think of how many French artists – and probably your German Expressionists as well – have been so concentrated from the start. I didn't really begin to paint at all seriously until the war. I did a little before, but it was no good. When the war came, I was turned down because of this asthma of mine. So I had all

that time just to drift in and do nothing. It's true I'd been doing odd jobs to make my way – I worked in an office for a bit, then I tried to design some furniture. I even became someone's valet. But I had been thinking a great deal about painting. About how I might perhaps begin to make this thing work a little. 'The thing is, I've been very lucky to be able to earn my living by doing something that really obsesses me. I never expected to. I don't suppose it will last. Not with the way everything else is going. People will simply stop buying painting but I don't care. It'll change nothing for me if all of a sudden I have no more money. I shall just exist by scrubbing floors or by going back to being somebody's manservant. I've always managed somehow to get by.'

Jill nods vigorously, sensing that she has been taken at least temporarily into the fold, and the conversation moves on, with Francis turning waspish again when he mentions that an old friend of his recently accepted a knighthood.

'I've never wanted those things,' he adds. 'They're ridiculous, and besides they're so *ageing*. I want nothing really, except not to grow old. But then I never really feel old. I always think "old" is ten years away from whatever age I am.'

When we part shortly afterwards, each with a new lover, I feel disappointed that the dinner hasn't exactly gone with a swing. So I'm relieved and elated when Francis calls me next morning to suggest dinner at Claridge's. Since he makes no mention of José, I assume he is not including Jill, who I know, having not quite recovered from the attack on German Expressionism, would be happier catching up with her own old friends. I'd like her to see Francis when he is on really good form, and I'm beginning to wonder whether that will happen again now that – for all his expostulations to the contrary – he is growing visibly older. That is hardly surprising since he'll turn eighty soon. Francis complains bitterly about ageing, as though of all mortals he has been unfairly singled out to grow old. When people ask him how he is, he often replies, 'Well, I'm alive, but I can't say much more than that,'

or goes back to an old refrain: 'Getting old is like having some ghastly disease. I wouldn't wish it on my worst enemy.' Perhaps his health is beginning to fail, although I doubt that he would ever mention it. He looks very pale sometimes, as he did at dinner last night, and I wonder whether his chronic asthma and the constant drink haven't worn down even his extraordinary constitution. 'I've had virtually every illness that exists,' he said to me once, and I know he continues to consult his doctor very regularly and takes all kinds of pills. When Francis was in Paris recently I gave a buffet supper for him and a few people he likes at the rue des Archives. I know he was looking forward to it, but he didn't even turn up, I think because he had a blackout from drink. Then he sent me a letter apologizing, simply saying (for some reason in French) 'on ne peut plus lutter', as if he had accepted that life was getting the better of him. I've also noticed that where Francis used to make light of things his outlook has become noticeably bleaker. He gets darkly pessimistic about the world situation, for instance, particularly when he has a bad hangover, and sometimes when we've had a skinful the evening before, he'll call urgently and say something along the lines of 'I can just feel there's war coming. I can hear the boots marching. You've only got to look in the shop windows to see there's nothing left any more. It's like Munich. You can feel a disaster's coming just by looking in the shop windows.'

But when I meet him in the suave atmosphere of Claridge's he doesn't appear to have changed since I first met him. He's rosy-faced again and jumps up exuberantly the moment I come into the bar, smiling and laughing and thanking me warmly for last night. I'd like to ask him what has happened since then but I know I'll only find out if he chooses to tell me. As we go through the champagne ritual, I assume things must be going well with José, and when I tell Francis how charming and good-looking I found him, he almost whinnies with pride. 'The marvellous thing,' he says, 'is that I usually only find brutes and with José, who speaks every known language, I can talk about all sorts of

things. Of course, he's also terribly well hung, almost too well hung,' he adds with feigned regret. We go into the dining room and an attentive waiter notices that Francis is still carrying his black leather trench coat, but when he attempts to take it from him, Francis rears back, clutching it closer to his chest and saying in mock alarm: 'Can't you just leave it with me? I know it's just a bit of old skin but can't you just leave it with me? When you get to my age you have to have something to hold on to!' We all burst out laughing, as do the people sitting near by, as the waiter settles us at our table.

To me, it feels exactly like old times, as if nothing of any real significance has intervened in the quarter-century since Francis first brought me here. When I'm with him, time is siphoned off into a kind of strange circularity, as if there is no before and no after, simply a continuous present; and that, I reflect, sipping the excellent white Burgundy, happens even before I've had a lot to drink. I can't work out why this should be, unless it's Francis himself who exists in circular time, drawing me into it by the power of his presence. We've been here before, and no doubt we'll be back here again, but in this particular moment all the tenses have been laid out side by side. The sensation is all encompassing, as though one had stepped momentarily into a parallel universe, and for a long time it made me intensely anxious, as if I were under the influence of an unknown drug; now I relax into it, enjoy it even, knowing that the sense of circularity will increase as we follow the same route towards drunkenness and listen to the same stories that, like children, we want to hear again precisely because we already know them by heart.

'Sometimes,' Francis is saying, peering round at all the other, mostly elderly diners chatting away animatedly in the room's pinkish haze, 'I think I'll move into a hotel like this just so that I have a place to die in. I love the atmosphere of these luxury hotels, though I suppose with the way the economy is going and everything else, they won't exist for much longer.'

'I'm trying to work out the feeling of circularity I have when we meet, Francis,' I say, buoyed by the Burgundy but aware that Francis gets impatient with this kind of talk, which he tends to condemn as 'mystical'. 'I don't know if it's just a strong feeling of continuity, but it's almost as if nothing much has happened since I first came here with you in the early sixties.'

'Well, perhaps nothing has happened. Nothing changes much,' Francis says, quite loudly, in one of those silences that happen in crowded rooms. 'I still masturbate, you know, even at my age. And I still prefer the arsehole to the cunt. I don't think those kinds of things ever really change. After all, if you think about it, life is just a series of moments. It's no more than that. But you can't even really talk about it, because you're part of the whole thing and you've got nothing you can compare it with. It's just an extended moment between birth and death. And then we go out on to the great compost heap of the world. We don't know much but I think we do know that. Now, what do you think we should drink with the partridge?'

Chastened by this forthright declaration, I scurry back to my Boswellian role and steer the conversation round to his new paintings, several of which I've seen in the colour transparencies that have been sent to the magazine. I'm wondering whether Francis's old spirit of self-criticism is still as sharp and whether he shares at all my suspicion that, in his attempt to condense and refine, the imagery has become overly ethereal. But as we talk I sense that like most painters he is convinced that his very latest paintings are his best, and it occurs to me that perhaps, with the physical effort that his large canvases require, he has reached an age when destroying a large part of his output is no longer viable.

'The thing is, Michael,' he says, 'that images just drop into me like slides. One image breeds others in me. When I say that, I'm certainly not saying I'm what's called inspired. I just think I'm receptive to these kinds of things. I usually know what I want to do the moment I start working, but it's how to do it, how

can I achieve this thing technically, that is the problem. And of course one's always hoping that this one marvellous image that's both absolutely factual and deeply mysterious will come up, just rising like that out of one's unconscious with all its freshness locked like a foam around it, that will cancel all the previous images out. That's why one goes on, of course, hoping for the one image that sums everything up. But in the end it's just an impossibility to do.'

'Are you aware at all when you're painting of a link between your own experience, your own life, and the image you're trying to bring about?' I ask, a bit self-conscious about having fallen back so naturally into interviewer mode.

'I'm not conscious of anything really if the work is going well. As you know, I'm only painting for myself, painting to surprise and excite myself. And I'm always surprised when anyone else is interested in what I do or actually wants to have a picture of mine. I'm sure my painting comes out of my life. In a sense I have actually painted my life, but only in a sense because painting, art itself, is a very artificial thing. I'm not sure many people see that because very few people actually have an eye for painting. One day, in fifty or a hundred years' time, people will see just how simple my distortions are. And sometimes, when I hear other artists and critics and so on talking, I think I come from an ancient simplicity.'

'You've talked to me quite a lot about your life, but there are still huge periods and whole aspects to it that I know nothing about.'

'Well, this is the problem,' Francis says. 'I probably could tell someone what's called the whole story if they could be bothered to listen. But that's not it. The thing is you would have to know how to present these things. They mean nothing, naturally, unless they're presented in a particular way. You see, it sounds terribly vain but even though the times I've lived through have been extraordinary, I think I myself run deeper. Deeper than the *moeurs* I've lived through. But I think it would take a Proust

to be able really to record all that. It would take a real work of art . . . Now, why don't you finish your glass and have some more?'

Jill and I have found a flat overlooking the second, inner courtyard of a building in the Marais that dates back to the fifteenth century, when it was an inn called L'Auberge du Lion and catered mainly to pilgrims setting off on the route to Compostela. There is an ancient canopied well going back even further, and all around the uneven cobblestone yard, between the fig tree and the rhododendrons, there are dismounting posts for people arriving on horseback. Despite the increasing pressure of getting *Art International* out without compromising too much on our original ideals of quality and independence, as well as ensuring we don't run up insurmountable debts, we are very happy. Jill has always made it clear that she wants children (her mother confides with a laugh that Jill has a 'five-year plan' for me in mind), and since I haven't the faintest idea what that involves, or certainly how it involves me, I've never had any particular issue with it. When Jill announces she is pregnant, I am thrilled and delighted, although I do wonder whether the magazine, which has already survived most other tests, could cope with the arrival of children.

I continue to go to London, often on magazine business. We have a new number coming out on modern art museums, and I'm interviewing several prominent directors, including one in London who has never given me the time of day before but who is suddenly all over me as we talk for publication and who, I predict, will cut me again once I am no longer of obvious use. For the issue we are preparing specially on him, I also interview Francis, who always talks well on these occasions, although he suddenly waxes very bitchy about what he calls Matisse's 'squalid little forms'; since this remark has nothing to do with the main interview I edit it out in the published version. Francis invites me to lunch at Wiltons for the following day and, knowing how

punctual he is, I get there early and grow increasingly concerned when he doesn't turn up at the appointed hour; I sit fiddling with my starched napkin, watching equal numbers of vaguely familiar, shifty-looking TV personalities and less familiar but ebullient politicians arrive. Francis says Wiltons is a restaurant for dukes and picture dealers, but the only person I really recognize, because of his signature head of hair, is Michael Heseltine, who is giving lunch to an overawed-looking man with no hair. I feel a bit overawed myself, because I can't afford to eat here on my own dollar and I'm wondering how I can make the least embarrassing exit. Then a few minutes later José comes in, with Francis following shortly in his wake. Francis seems surprised to see me, although we have made a firm date over the phone, and I realize he must have forgotten and thought he was having lunch with José alone. Francis's memory is getting less and less reliable, which is hardly surprising, especially if he was out drinking to all hours. Feeling distinctly *de trop* I try to extricate myself from this tryst, but neither man will accept my bowing out, although that does not stop them from becoming totally absorbed in a lengthy, delicate billing and cooing. I sit through the meal, which seems to take for ever, like a maiden aunt there to ensure that the young couple do not get up to anything untoward.

I get a message from Francis that evening suggesting dinner at Bibendum for the morrow. I reflect on how much of Francis's life takes place, like his pictures, within four walls, from the studio to the restaurant and club, then into a taxi's solid interior and back again; I've almost never spent time with him outside, even in a street, let alone a garden, a park or the open fields. I like the idea of Bibendum because it's off the usual West End beat and housed in an architecturally unclassifiable Edwardian building that used to be the headquarters of the Michelin Tyre Company. When I arrive, I notice Francis no longer has the rapturous expression he was wearing yesterday, so I imagine a tiff of some sort may have occurred between him and José. He also seems to be very short of breath, and his hair has a very odd, bright orange tinge

which presumably means he got things wrong while dyeing it. Over the years I have seen Francis drunk and sober, in and out of love, warm and cold, so I don't really think much about the veiled sullenness he is giving off in waves. I notice he has a rim of dried red wine, like a lipstick, round his mouth, so I suppose he's been doing some heavy drinking. Whatever his mood, he remains the attentive host as always, and we agree on a simple but perfect menu of dressed crab and turbot.

As we make our way through the champagne, white Burgundy and fine Bordeaux, I keep hoping the conversation will free up but it continues to be arduous. I ask Francis a few circumspect questions, but he keeps his answers to a clipped minimum. No, he doesn't agree with this, and no, he's not interested in that at all; he actually *loathes* that. Given that I'm highly pleased with life at the moment and should like to share my enthusiasm with Francis, thus hopefully lifting him out of his doldrums, I decide to tell him about our first child being on the way. After all, he appears to have accepted my getting married easily enough, so why would he not be pleased at the natural outcome? I drop the news casually into the conversation and expect ironic politesse or at most a veiled barb. And so it proves, at first.

'Well, I suppose it's a kind of immortality,' Francis says. 'A *kind* of immortality,' he adds, clearly indicating that he considers it the lowest, most common form of immortality.

I notice that he has gone pale, but I think he may perhaps be thinking of all the new responsibilities a child will mean for me, and possibly that I won't be so available to meet and talk and go out on the town as before. But I feel sure it won't change anything in his life and that he'll probably not give it a second thought.

I try to set the conversation on a new course, introducing a little Paris art-world gossip as well as recommending a good if rather austere Breton fish restaurant I've just found, although I'm not sure Francis would care for the trawling nets that have been draped over the walls or the bibs and mallets handed out for you to crack your own crab. But to my surprise Francis keeps

coming back to the news of the forthcoming birth, as if suddenly he couldn't think of anything else. As he mentions it, he becomes increasingly agitated, tugging the whole time at his shirt collar. I begin to panic, thinking that he might start suffocating. He's talking as if this birth is an affront to him, a direct, deadly insult. I have never seen him this angry ever, and he just goes on and on, getting paler and more vitriolic by the minute. I am deeply alarmed, but I can't think of anything to say or to do, so I just sit there under the onslaught as if it were no more than my just deserts.

'And I hope,' Francis repeats, his face going white with fury, 'I just hope that if it's a monster or something, or even if the thing doesn't have all what's called its five fingers and all its five toes you'll just do it in and get rid of it. Do you see? Do you see what I mean? Just do it in and get rid of it altogether.'

We get up and go down the Bibendum stairs in silence. I can hear Francis struggling for breath as he slowly takes one step at a time. I'm stunned by the ferocity of his attack as well as worried as to how he will manage the short walk back to the studio. Once we're outside the restaurant, I ask Francis if I can drop him at Reece Mews.

'I'd rather walk,' he says curtly, turning on his heel.

I watch him disappear into the summer night, the anger almost visible, like a halo around his taut, receding frame.

Eventually I hail a taxi and I ask the driver to take me back via Pelham Crescent so that I can check if Francis is alright. Halfway along the curved street the cab's headlights pick him up, white-faced and tense, leaning against a tree with his asthma reliever clamped to his mouth as if he were fighting for every last breath.

———

Watching my daughter Clio being born and hearing her first cry transforms my entire life from one instant to the next. This tiny bundle separates everything that Jill and I have known,

individually or together, into a before and after the momentous fact of her arrival. It's unreal how much has changed already and how much more, that's already obvious, her existence will continue to change and shape ours from now on. I am overjoyed, in a giddy, confused way, but more than that I'm overawed. Although I'm fond of children I haven't thought much about them before, since neither the magazine nor marriage has really altered my deep-rooted bachelor attitudes. But it's clearer by the day now, as light-headed celebration gives way to hands-on baby care and sleepless nights, that nothing will ever be the same again. *Art International*, meanwhile, has not gone away. And as I get back, dazed and elated, into the old publishing routine and go through the motions of being as involved as ever, I wonder how much longer Jill and I can afford to have both such a demanding profession and a family.

Devastated though I was by Francis's unexpected, venomous attack, it pales in the face of this new phenomenon called Clio, who chuckles and bawls by turns, keeping us parents in a permanent froth of pride and anxiety. I am too caught up by the demands of suddenly becoming a father – was the paediatrician's appointment confirmed? did I buy the right-size nappies? – to think much about his ferocious reaction. At odd moments the memory of that white mask of fury returns, not least when Clio kicks her feet in the air or clutches my thumb with all her five tiny fingers. But however much I turn it over in my mind, I understand less and less why the news of Clio's birth should have roused Francis to such embittered spite.

Did he feel I had betrayed him by going over into a heterosexual zone where he couldn't follow or exert control? Was he jealous of the fact that I could have a child and he could or would not? Had the very notion of new life as his own life is drawing to a close touched him to the quick? Or, weird as it seems, could he have simply felt he was losing me?

———

I still go back to London regularly, mostly on magazine business. Francis and I still meet, as if nothing has happened. The incident is simply never mentioned again. I'm aware that Francis is too dandyishly steely to show any wound he can hide. He appears as welcoming and affable as ever.

What strikes me most, though, is how contented and mellow Francis currently looks, about as far from the spitting rage I last saw him in as could be imagined, even though he is now into his eighties, a prospect he dreaded volubly. I have known him at every extreme of emotion from the highest high to the blackest low, but one word that would never have occurred to me when describing him is 'happy'.

Yet Francis is happy, almost ecstatic, and when we meet one evening for dinner – ironically enough at Bibendum, where a few months ago he tore into me so savagely – I think back to certain moments when he's been exhilarated by success in love, work or gambling, but I can't recall a time when his mercurial temperament and approaching drunkenness didn't threaten to tip elation ineluctably over into despair.

Now, on the other hand, as we make our way through the usual extravagant banquet, the mood is evenly and serenely joyous. Francis seems to be radiating some kind of inner luminosity – words, and a concept, that he would normally be the first to reject with withering scorn.

Just like his recent paintings, he exudes a calm, almost mystical aura of acceptance, as if the conflicts that had kept his whole being stretched for so long have been resolved. The pink-cheeked older man sitting opposite me, exuding bonhomie, is so far removed from the white-faced prophet of hate I encountered here before that for a moment I wonder whether I didn't dream the whole nightmare up.

Bemused, I can only speculate that Francis's new radiance comes from the deep harmony that falling in love brings. But I know better than to inquire, just as I know better, however much my cheeky nature eggs me on to do so, than to ask sarcastically,

'You haven't gone religious, have you, Francis?' – as Francis put it to me when I was so obviously in the first flush of falling in love with Jill.

After dinner, we walk down Pelham Crescent towards the studio, stopping almost exactly where I had seen Francis struggling for breath after our row. We look up and admire the sweep of immaculate, white townhouses silhouetted against the night sky.

'Cecil Beaton used to live in one of those houses,' Francis says to me casually. 'He always took such enormous care of himself. But in the end it didn't do much good. He was only in his mid-seventies when he died.'

A couple of months later I am back in London briefly, but this time en route to New York. Usually I go to New York in order to drum up advertising, but now I have a more sombre plan in mind. Global recession has struck, and almost overnight our revenue from gallery advertising has dropped by over half. At the same time, after some five years' struggle, our whole staff is exhausted and generally disgruntled by working ever-longer hours for dwindling salaries.

The writing is on the wall. Neither Mariella's bounty nor our own meagre revenues will suffice. If we do not find a radical solution – such as getting ourselves absorbed into a bigger, more resilient publishing group – we will plunge headlong into debt, a spectre I have so far kept at bay. A couple of the big US magazine owners are notoriously passionate about art. Could I not interest one of them in clasping our impeccably high-class, if indelibly unprofitable, publication to their wealthy bosom?

I can hardly pass through London without giving Francis a call. The last time we spoke I mentioned the difficulties *Art International* had been going through, and he was immediately sympathetic. 'The trouble with those things is that they never make any money,' he commented, then promised to see whether he could find a backer or a purchaser for us. He seems to know

everyone in London and has suggested several people, including Terence Conran and Richard Branson, who might take an interest in it. Although I can't see what any of them would do with an art magazine, I'm sufficiently desperate to encourage the idea.

I haven't heard from Francis in a while now, but when I think of him I still see the joyous, serenely inner-lit figure who sat opposite me in Bibendum. I'm delighted at the thought that he has found such obvious contentment at this late juncture of his life, and I assume it will carry him through the old age he so dreads.

I call his number and hearing it ring for a long time I am about to hang up when Francis suddenly answers.

'I can't come out,' he says, faintly. 'I've been ill. *Really* ill.'

I can hear him gasping for breath.

'I've got no energy,' Francis says. 'I just have to stay in.'

I joke weakly that he's always had more energy than all of the rest of us put together, but I hear only a soft gasp, like a sigh, at the other end.

I ask if I can come to see him and bring him something – some Krug and caviare, perhaps – but I already know he will refuse. Only the sound of choked breathing comes down the line. I feel confused and embarrassed as I hang up, almost as if I'd been talking to someone impersonating the quick, alert Francis Bacon I know.

Once in New York, I'm caught up in a series of negotiations that always look as if they are going somewhere until they come to an abrupt, definitive end. 'It's a tough call,' my New York friends tell me blankly when I ask them what they think my chances are of being bought up.

Luckily I'm staying in comfort on Sutton Place with my old friend Marjorie Loggia, in whom I can confide everything, and when I return from yet another series of fruitless meetings she is never short of a play or a party where we can go and shake off the frustrations of the day.

Even if I do not seem to be getting anywhere, not finding the generous patron who will relieve me of the burdens of publishing and allow me to go back to writing, the only thing I really want to do and in the end what I do best, the weather in New York is scintillating, with high blue skies and bright spring sunshine. And if I think of Francis, which I don't often as I race from one high-perched office with its amazing, sparkling views over the city to another, I assume that with his extraordinary resilience he will have bounced back by now and become his old ebullient self.

So I am not in the least prepared when I come down from Marjorie's apartment one shining morning in late April 1992 and buy the *New York Times* and on the front page, between war reports and an update on riots, see the headline 'Francis Bacon, 82, Artist of the Macabre, Dies'.

It's like a punch in the stomach, coming unexpectedly hard out of the blue, making me feel weak and nauseous. I take the paper into my local coffee shop and stare at the front page, trying to make sense of the bold print. I remember Francis told me he was 'really ill' when I called him in London, but although I knew he always talked dispassionately about his own health it hadn't occurred to me for a moment that he could be in any way close to death. I was just waiting for him to recover, so we could resume that marvellous round of the best that friendship and conversation, drink and food could offer.

I study the short obituary again, as if it might yield some hidden information. For a moment I feel stupidly pleased that Francis made it into the most important international news, right up there with all the other big events of the day. Then I go into the rest room, see my pale face in the mirror and dry-retch until my stomach won't heave any more.

Epilogue

In the months and then the years that followed, I missed Francis deeply and sometimes even bitterly, especially during the big-money wrangles over his estate and the decision to uproot his studio from London to Dublin, where he happened to be born but never set foot thereafter.

I always knew that Francis would be irreplaceable, not least because he was so unlike anybody else I had ever come across, and since his death that day I have tried repeatedly to work out what set him apart. The best definition I have found is that even while he was alive Francis already belonged to history. He often remarked that in his work he felt he was 'following a long call from antiquity'. This never struck me as portentous, as it would have done in the mouths of many artists I know. It struck me as a statement of fact. Something in Francis himself reached back to the ancient mysteries, like the Sphinx or the Oracle of Delphi, reverberating across the centuries with their enigma intact.

The mythical dimension that marked Francis apart in life has continued to grow. His work poses the most searching questions about existence, questions that are asked from one civilization to the next because no lasting answer is ever found. Why has man been created, alone among the animals on earth, in the acute consciousness of his mortality? Should we not assume our animality, display our passions and contradictions without

shame – openly pant, roar and scream? What meaning, if there is a meaning at all, can we attribute to our brief span?

Francis incorporated the tensions of being human into the very grain of his paint. Examined close up, the swirling impasto appears encoded with specific evidence, specific human traces that continue to rehearse and echo our fraught existence. That is perhaps the underlying reason why his figures, spun out of this infinitely suggestive stuff, come across as a concentrate of all the impulses and confusions of our flesh, unresolved and shockingly alive.

I lost a father when Francis died. But I myself became a father. However belatedly, I also became my own man.

With Francis dead and my independence fully established, I might have expected that he would fade from my life and be replaced by other interests, since I have always been imaginatively engaged in the whole of art history, from antiquity to the medieval, from the early Renaissance to our own times.

Over the intervening years I also had the chance to change career radically. I was invited at various points to write film scripts in Hollywood, manage an Old Masters gallery in New York and join one of the international auction houses. I dithered, playing for time and hoping for a portent to show the way, until the opportunities disappeared.

In truth I was savouring another kind of freedom at that time since, shortly after Francis went, *Art International* went too. No angel for the ailing magazine had been found, and rather than watch over its decline I suspended publication, parted with the staff and spent an awkward interval refunding subscribers and winding the company up. Having emerged from the magazine's ruins, I felt shaken but liberated. Meanwhile, our son Alex was born: with a growing family to support I cobbled together a mélange of highbrow art journalism and lifestyle pieces for glossy American magazines to provide a basic subsistence. And I didn't think or look much beyond that.

But in death as in life, Francis did not go away. My reputation and career proved too closely entwined with his whole trajectory and aura as an artist. A variety of people – some convinced they owned an unattributed 'Bacon', others with Bacon book, show or film projects – began beating a path to my door. I also published articles about Bacon in the press and got involved in curating museum exhibitions of Bacon's paintings as well as writing catalogue prefaces for them. After a time, I came to put on shows of my own. For Valencia and Paris, I assembled a selection of works entitled 'The Sacred and the Profane'. For a museum in England and two others subsequently in the US, I took the theme of 'Francis Bacon in the 1950s' to highlight paintings from that amazing decade when Bacon was still struggling with the *terribilità* of his subject matter and the technique required to convey it. Then, in Rome, I was fortunate enough to work on an exhibition that brought Caravaggio and Bacon face to face among the other masters, including Titian, that line the Galleria Borghese's marble walls. When the exhibition opened to great fanfare and Roman-style rejoicing, my only regret was that Francis had not received an art-historical tribute of this significance during his lifetime.

Eventually I was also asked to write Bacon's biography, and although I felt as well placed as anyone to take this on, it became painfully evident once I got into it that, for all the areas of his life that Francis had talked to me about, there were many more he had never touched on and for which no reliable witnesses or documents remained. It had not occurred to me before that he had so deliberately restricted information about his life, with his biography in exhibition catalogues being limited to a single, curt phrase: 'Lives and works in London'.

I began my research, trying to piece together the fragmentary evidence, and discovered that for many years even Francis's date of birth could not be confirmed or the details of his parentage, let alone anything substantial about his upbringing and education. It was as if, having chosen enigma as the source of his art, Francis

had cloaked his life in it as well. Gradually I put together an archive of related background material illuminated by a handful of indisputable facts, photographs, letters and eventually early exhibition notices and reviews. Francis had said that it would take a Proust to tell his life, but I found that before any tale could be told at all it took dull, dogged fact-finding.

At times while I was writing the biography of a man who would have remained near-invisible were it not for the traces left in his oracular imagery, I wondered to what extent Francis had foreseen that I would devote a large part of my life to preserving and enhancing his memory. There is no doubt that he had gone repeatedly out of his way to impress his whole personality on me, with all the thoughts, memories and interpretations that he wanted to record. But there would have been dozens of other impressionable young people who had wandered into his orbit and who would have been equally receptive. Why had the task fallen to me? I wondered repeatedly, as I grappled with the difficulties of writing a life of someone who had so constantly covered his tracks. Francis had barely ever mentioned his schooldays, for instance, so I located his few surviving schoolmates and, from their ancient reminiscences, tried to dredge up a portrait of him as a young man. But the portrait came to life only once these pale memories had been blended with Bacon's own vivid account of his father's throwing him out of the family house shortly thereafter and packing him off to Weimar Berlin.

Francis affected dandyishly not to care whether his paintings stood the test of time or whether his life story would ever be told, with or without the Proustian insight he believed it required. 'When I die,' he told me, more than once, 'I just hope everything about me just blows up, just blows up and disappears.' But of course it didn't. Curiously, the very fact that Francis pretended indifference to what happened after his death has fanned worldwide interest in both the man and the work to an astonishing degree. In one sense, of course, Francis's whole existence was devoted to drawing attention to himself, and far

from disappearing he has seen off all his rivals in twentieth-century art except for his one-time master Picasso. And perhaps Bacon may come to be seen as even more significant in the history of art than the protean genius of Málaga. No artist since Van Gogh, it is already evident, has grown so powerfully in mythical stature from beyond the grave as Francis Bacon.

———

One late-autumn afternoon, many years later, I am back in Francis's old studio on the rue de Birague. All the furniture, including the brass-bound sea chest, the big easel and the trestle table with its paraphernalia of paint tubes, brushes and rags, has long disappeared. The walls and the heavily beamed ceiling have been repainted in the exact matt white that Francis originally chose. The room stands totally empty but nothing else has changed: the same, even northern light coming through the tall, elegant windows, the same carved wooden shutters, the same Versailles parquet on the floor. The nostalgia I feel looking round this immaculate, vacant room turns to melancholy as I reflect on how brimming with life this space once was and how neutral and banal it is now, emptied of all traces of Francis's presence and creativity. I can still see him here, laughing, full of vitality, eager to get back into the pleasures of Paris. I start thinking too of the various canvases painted here, from the intimate evocations of George, whose suicide still weighed on him, to the astonishingly vivid portraits of Michel Leiris and the starkly concentrated, translucent images of his last years.

I turn to leave, hoping to get away from the powerful feelings of loss and sadness that are enveloping me, but just before I go I pull open the built-in wardrobe where Francis always left a few clothes. It is completely bare inside now but the haunting, pungent smell of his asthma inhaler, which always pervaded the places where he lived, wafts up. The moment I breathe it in it sets off a series of images sliding through my brain that I cannot stop. Francis's face close up laughing, the spin of a roulette

wheel, *Nada, Nada*, a glass of wine spilling like blood over a tablecloth. I push the wardrobe doors to right away but the inhaler's corrosive smell is already settling in my lungs, releasing a chaotic flow of memories.

Outside it is already dusk and a fine rain has begun to fall. The ancient lamps cast a faint glow over the large, empty courtyard. Once it would have been filled with horses and carriages, with people going intently about their lives. They have gone, and coming after them others immortalized in early photographs taken here with their confident expressions and stiff clothes have gone. Generations have gone, and the courtyard is silent now. Emotional and confused, I think of people I have been close to and who are now dead. I think of you, Danielle, and you, Zoran, and I think fleetingly, awkwardly, of my own dead father. As I make my way over the courtyard towards the street I picture each of the glistening, yellowish cobblestones as marking a grave, uneven little memorials to the dead whom I knew and who are now beyond recall and whom we will rejoin, whatever and wherever they may be. And standing under the lamplight, although I know it is no more than a rush of fantasy, I find a headstone for you, Sonia, and for you, George and John Deakin, for Michel Leiris and Isabel Rawsthorne and all the others I have known through those hundreds of hours in clubs and restaurants, with the champagne pouring and the conversation rising as if neither would ever end. I think back to that mass of time bright with the hopes and illusions I once had, the unbearable excitement entwined with the blackest despair, now all gone, all past, all lost. I think of the horror of life and the beauty of life, standing there in this graveyard of my own imagining, its fleeting grandeur and its certain decay. And I can no longer hold back the tears. Emotions that have been held in check for years well up, and I cry as I haven't cried since I was a child sobbing myself to sleep, but I also cry as an adult in the awareness and acceptance of death. I cry for myself and I cry for all the dead and I cry for Francis, through whom I came to

know them and who, like a light gone out, is himself dead. And slowly it comes home that this powerful surge of feelings that he has left in me can be unleashed at any moment, out of the blue, when I come across a torn photo, glimpse a familiar face or hear a half-forgotten song. Once Francis Bacon is in your blood, he will be there for ever.

Gradually the tears subside, leaving a huge void of relief behind. The light coat I'm wearing is wet from the rain. I shake myself like a dog, then I move on, crossing the formal gardens of the Place des Vosges and into the old, dark streets beyond.

Acknowledgements

I am particularly grateful to Rebecca Carter, my agent at Janklow & Nesbit, for having advised me so skilfully at every stage of this book. Rebecca combines extensive publishing expertise with outstanding editorial flair, and I have benefitted hugely from both. My warmest thanks to my editor, Michael Fishwick, who encouraged and guided me throughout. I am also grateful to the whole team at Bloomsbury, notably Alexandra Pringle, Anna Simpson, Laura Brooke, David Mann and Oliver Holden-Rea. My greatest debt is as ever to my wife, the art historian Jill Lloyd. This book is dedicated to her and to our children, Clio and Alex.

I should like to take this opportunity to thank the following people very sincerely for their help, their encouragement and their friendship: Frank Auerbach, Kate Austin, Ida Barbarigo, Oliver Barker, Peter Beard, Alice Bellony, Philippe Bern, Tony and Glenys Bevan, David and the late Laurence Blow, Anne and Yves Bonavero, Jessie Botterill, Erik Boursier, Adam Brown, Ben and Louisa Brown, Frank and Eva Burbach, Marlene Burston, Charles and Natasha Campbell, Carla Carlisle, Neil and Narisa Chakra Thompson, Alexandre Colliex, Myriam da Costa, Patrice and Mala Cotensin, Monique Couperie, Stéphane Custot, Adrian and Jamie Dicks, Christopher Eykyn,

Rebecca Folland, Sarah-Jane Forder, Elena Foster, Colin and Sophie Gleadell, Kirsty Gordon, Catherine Grenier, Cyrille de Gunzburg, Claude-Bernard Haïm, Nadine Haïm, David Hockney, Waring Hopkins, Richard and Christina Ives, Bill and Janet Jacklin, Peter James, Jeanne Job, Nigel Jones, Sam Keller, Leon Kossoff, Ulf Küster, Andrew Lambirth, Mark and Lucy Lefanu, Magnus Linklater, Bertrand Lorquin, Olivier Lorquin, Nicholas Maclean, Rachel Mannheimer, Juan Marsé, Gillian Malpass, Pierre-Yves Mauguen, Antoine Merlino, Henry and Alison Meyric Hughes, Lucy Mitchell-Innes, Bona Montagu, Serena Morton, Martin and Smita Murphy-Davé, David Nash, Lynn Nesbit, Hughie and Clare O'Donoghue, Francis Outred, Will Paget, Edmund Peel, Ann Peppiatt, David Plante, Renée Price, Robert Priseman, Joan Punyet Miró, Tomaso Radaelli, Simon Rake, Jean-Claude Rivière, Paul Rousseau, Frédéric and Carole de Senarclens, Christopher and Carmel Shirley, Frank and Pauline Slattery, Paul Sloman, Arturo di Stefano, Jon-Ove Steihaug, Ian and Mercedes Stoutzker, Derick Thomas, Thérèse Tigretti Berthoud, Jorge Virgili, Diana Watson, Thomas West, Ortrud Westheider, Thomas Williams, Clive and Catherine Wilson.

Index

A NOTE ON THE AUTHOR

Michael Peppiatt graduated from Cambridge, where he edited *Cambridge Opinion* and wrote exhibition reviews for the *Observer*. In an international career spent between London, Paris and New York, Peppiatt has written regularly for *Le Monde*, the *New York Times*, the *Financial Times*, *Art News* and *Art International* magazine, which he re-launched as its new publisher and editor from Paris in 1985. He is the author of over twenty books including the definitive Bacon biography, *Francis Bacon: Anatomy of an Enigma* (revised edition 2008). In 2005 he was awarded a PhD by the University of Cambridge for his work in the field of twentieth-century art. Peppiatt has also curated numerous exhibitions worldwide, and he is currently at work on a major retrospective contrasting the achievements of the two modern artists he most admires: Alberto Giacometti and Francis Bacon.

A NOTE ON THE TYPE

The text of this book is set Adobe Garamond. It is one of several versions of Garamond based on the designs of Claude Garamond. It is thought that Garamond based his font on Bembo, cut in 1495 by Francesco Griffo in collaboration with the Italian printer Aldus Manutius. Garamond types were first used in books printed in Paris around 1532. Many of the present-day versions of this type are based on the *Typi Academiae* of Jean Jannon cut in Sedan in 1615.

Claude Garamond was born in Paris in 1480. He learned how to cut type from his father and by the age of fifteen he was able to fashion steel punches the size of a pica with great precision. At the age of sixty he was commissioned by King Francis I to design a Greek alphabet, and for this he was given the honourable title of royal type founder. He died in 1561.